Turning Wood into Art

Turning Wood into Art

THE JANE AND ARTHUR MASON COLLECTION

Essays by Suzanne Ramljak and Michael W. Monroe

Mark Richard Leach, Curator and General Editor

Harry N. Abrams, Inc., Publishers, in association with The Mint Museum of Craft + Design

Editor: Elisa Urbanelli
Designer: Miko McGinty

LIBRARY OF CONGRESS CATALOGING-IN-PUBLICATION DATA

Ramljak, Suzanne.
 Turning wood into art : the Jane and Arthur Mason collection / essays
by Suzanne Ramljak and Michael W. Monroe ; Mark Richard Leach,
general editor
 p. cm.
 Catalog of an exhibition that opens in June 2000 at the Mint
Museum of Craft + Design, Charlotte, N.C.
 Includes bibliographical references and index.
 ISBN 0–8109–4483–9 (Abrams: cloth) / 0–8109–2704–7 (museum:
pbk.)
 1. Woodwork—United States—History—20th century—Exhibitions.
2. Woodwork—History—20th century—Exhibitions. 3. Woodwork—
North Carolina—Charlotte—Exhibitions. 4. Mason, Jane S.—Art collec-
tions—Exhibitions. 5. Mason, Arthur K.—Art collections—Exhibitions.
6. Mint Museum of Craft + Design—Exhibitions. I. Monroe, Michael W.
II. Leach, Mark Richard. III. Mint Museum of Craft + Design. IV. Title.

NK9612.R36 2000
745.51'0973'07475676—dc21 99–41228

Printed and bound in Japan

Harry N. Abrams, Inc.
100 Fifth Avenue
New York, N.Y. 10011
www.abramsbooks.com

Contents

Foreword and Acknowledgments

Few things impact a museum more than the unstinting generosity of its patrons. When the Mint Museum of Craft + Design opened to the public on January 9, 1999, it did so with the assurance of two of its most prominent donors that their treasures would form the foundation of the museum's collection of turned wood. Washingtonians Jane and Arthur Mason have dedicated a significant part of their life together to assembling what has been described by many authorities in the museum world as one of the most important collections of turned wood in private hands. *Turning Wood into Art: The Jane and Arthur Mason Collection* is an exhibition of this dramatic and extraordinary gift. It is also a beautifully published book that offers a compelling scholarly appraisal of turned wood while examining in some depth the lasting value and contributions of many of the practitioners whose work comprise the collection's holdings.

Foremost among those whom the museum wishes to thank, we extend our deepest gratitude to Jane and Arthur Mason. The care, thoughtfulness, abiding passion, and uncommon generosity of spirit that are at the core of their collection are equally apparent in their dealings with the museum. Jane and Arthur have provided sustaining support to the Mint throughout the gift transaction, the documentation of the collection, and the bringing of this glorious project to fruition. It has been an honor and a privilege to know and work with them on the museum's behalf in this historic endeavor. Together, they have left an indelible imprint on the Mint Museum of Craft + Design, providing it with a premier wood collection and the necessary research tools to promote the study of turned wood. Equally compelling is the momentum that their gift has established and that has been a source of encouragement to others who might fuel the museum's growth into the new millennium and beyond.

Turning Wood into Art has been a Herculean undertaking, and many individuals and organizations have provided support critical to the project. Lee Eagle and Maurine Littleton deserve special recognition, for it is their enthusiasm for what is now the Mint Museum of Craft + Design that facilitated my introduction to Arthur and Jane Mason and their stunning collection.

Equally instrumental, especially in shaping the public programs that will support the exhibition, is the Windgate Charitable Trust. We are deeply indebted to the Trust for its generous support in two specific areas. In 1998, funds were made available to facilitate a planning conference to develop education programming to coincide with the opening of *Turning Wood into Art*. This forum enabled a diverse group—consisting of artists, curators, critics, and collectors—to meet, discuss, and suggest a series of education programs to be presented in a conference format to enhance and complement the existing base of knowledge on turned wood. This program will take place during the gathering of the 2000 national meeting of the Collectors of Wood Art. For sharing their wisdom and for their spirited support of this initiative, we thank the following conference attendees: Stoney Lamar, Suzanne Ramljak, Bonner Guilford, David Wahl, Rebecca Klemm, David McFadden, Kenneth Trapp, Robyn and John Horn, Jane and Arthur Mason, Cheryl Palmer, Suzanne Fetscher, Mary Beth Crawford, and Mary Douglas. In September 1999, the Windgate Charitable Trust provided a subsequent grant to facilitate the Mint Museum of Craft + Design's technology program, including capturing, preparing, presenting, and maintaining information that promotes knowledge of and appreciation for craft history, the creative and design process, and contemporary expression, beginning with turned wood. For their continuing support, the museum is most grateful.

The richness and depth of the exhibition has been immeasurably enhanced through loans provided by several sources, including the Mason's children. In this respect, we are especially grateful to Kent A. Mason, Thomas B. Mason, and Dr. Peggy Mason for their willingness to lend prized pieces from their personal collections to help accomplish the exhibit's goals of providing both comprehensiveness and quality. W. Graham Beal, executive director, and curator Bonita Fike of the Detroit Institute of Arts also merit our sincere appreciation for their willingness to accommodate our request to borrow Mark Lindquist's evocative *Ancient Inner Anagogical Vessel Emerging*.

The published record of this exhibition, with its accompanying interpretive text, joins a small but distinguished body of scholarly literature on the subject. The museum is especially indebted to Paul Gottlieb, publisher, and Elisa Urbanelli, senior editor, of Harry N. Abrams, Inc. Their confidence in this project and their commitment to excellence has produced a book of great value to those interested in the development of turned wood. This publishing effort has also provided needed visibility for a burgeoning community of artists who possess great talent and who have been largely responsible for the development of this important area of the studio craft movement.

We also thank authors Suzanne Ramljak and Michael W. Monroe. Each has lent considerable expertise and wisdom to the challenge of adding innovative scholarship to the existing body of knowledge on the subject. Both have exceeded our expectations with their unique insights and inspired appraisals of the subject's history and artists.

This book would not be the compelling document it has become without the efforts of two critical individuals. The simplicity, sensitivity, directness, and sincerity of the images that portray the beauty and excellence of this collection are the work of photographer Bruce Miller. Over many months, Mr. Miller labored tirelessly and under temporary living conditions to achieve these excellent results. Refinement, restraint, and eloquence are the enduring qualities of the book's visual character, and for her quiet and luxurious design we thank Miko McGinty.

Woodturning is a vast subject with a complex history. In preparing the manuscript for publication, the authors and museum staff were ably assisted by numerous individuals, including Jan Peters and Ray Leier of Del Mano Gallery in Los Angeles, California; and the Wood Turning Center staff and its director, Albert LeCoff, of Philadelphia, Pennsylvania. The museum is most grateful to these friends and others for their diligence and commitment to help the museum to ensure that the project's proceedings are comprehensive and factual.

We are grateful to the trustees of the American Association of Woodturners for their belief in the Mint Museum of Craft + Design and their commitment to share with their members important developments in the wood turning field. During the period June 30 through July 2, 2000, this national organization will convene at the 14th Annual National AAW Symposium, to be held at the Charlotte Convention Center. Conferees will partake in myriad programs, including demonstrations, an Instant Gallery of the attendees' best work, the annual AAW banquet and auction for the educational fund, and the complete wood turners' trade show. This important gathering enables the museum to make available to its audience an unprecedented array of educational opportunities, and we are indebted to the American Association of Woodturners for their willingness to include Charlotte and the Mint Museum of Craft + Design in their proceedings.

At the Mint Museum of Art, Inc., the dedicated and enthusiastic support of the entire staff merits my warmest and heartfelt thanks. To Bruce H. Evans, president and chief executive officer; management team members Harry Creemers, vice president of development and marketing, Cheryl A. Palmer, director of education, and Michael Smith, vice president of finance and administration; Charles L. Mo, director of collections and exhibitions; and director of community relations Carolyn Mints, I owe an enormous debt of gratitude. It has been their good counsel, enthusiasm, and untiring commitment to the exhibition that have ensured its success. In the Collections and Exhibitions Division, I am grateful to Kurt Warnke, head of design and installation; Mitch Frances, cabinetmaker; William Lipscomb, preparator; Leah Blackburn, preparator; and Emily Blanchard, graphic designer, for their sensitive and thoughtfully conceived exhibition installation. Special thanks are due to registrar Martha Tonissen Mayberry, who has been an invaluable colleague and participant in the exhibition from the beginning. She has ably assisted in the planning and coordination of the consolidation, packing, transportation, and safe handling of the collection and exhibition. I thank assistant curator Kari Hayes-DeLapp and collection and exhibitions assistant Diane Curry for their assistance with collections recording and related activities. Special thanks are due museum intern, Iris Moeller, who labored tirelessly to assemble accurately the catalogue's artist biographies and bibliographies.

My understanding of the collection and the potential impact of the exhibition have been immeasurably enhanced by MMCD's curator Mary Douglas. Mary has been a valued colleague and necessary curatorial counterpoint who has greatly assisted my efforts to achieve a successful outcome. The exhibition's public programs are rich and varied, each designed to illuminate the unique character of the wood turning field. With gratitude I acknowledge the efforts of education director Mary Beth Crawford for her role in developing a lively and provocative public program to complement the exhibition during its Charlotte run. Special projects coordinator Ginger Kemp deserves my sincere admiration for serving as the museum's project manager for the catalogue's production while attending to the myriad reproduction requirements and correspondence.

In the museum's development and marketing department, I am indebted to personnel who gave generously of themselves to facilitate fundraising associated with the project, as well as the marketing and promotion programs for *Turning Wood into Art*. Development officers, Kristin Garris and Sally Wooten, expertly coordinated and compiled curatorial narratives and budgets into successful private and foundation grant applications. I thank Elizabeth Campbell for her assistance with corporate donations. Phil Busher, public relations director; John West, assistant public relations director; and Blake Leggett developed a dynamic advertising campaign for the exhibition. Membership director Leslie Culbertson and her staff, consisting of Erin Penner and Sue Kelly, orchestrated a festive and enjoyable opening event for members.

Finally, I would like to thank my wife, Laura, and our children, Andrew and Aryn, for their enduring patience, sense of humor, and willingness to indulge the demands of this project throughout its development. They have been a source of encouragement and solace, and they have provided a humanizing counterpoint during important periods in the project's development.

Mark Richard Leach
Director
Mint Museum of Craft + Design

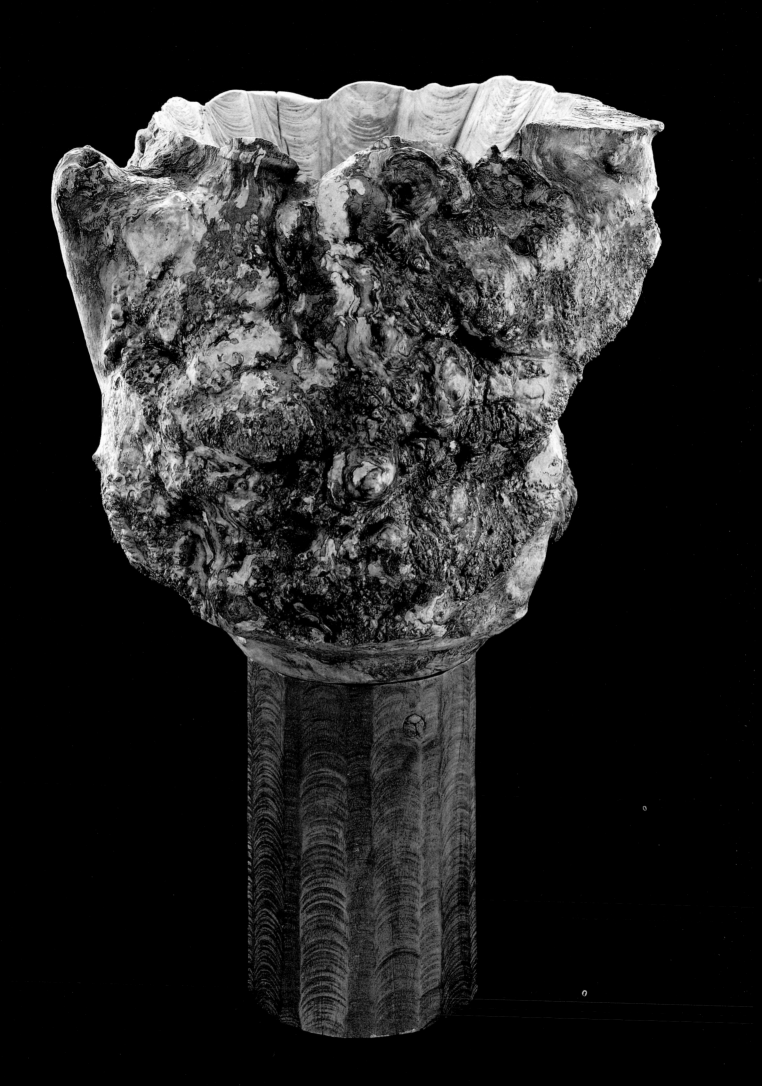

Preface

Jane S. Mason

The works of turned wood in our collection are part of our lives and identities. When we walk into our home we see Mark Lindquist's powerful *Chieftain's Bowl* in the front hall. As we sit down at the dining-room table, we see Hap Sakwa's *De Chirico Bowl*, used as a centerpiece, whimsically greeting us at every meal. Children play with Hans Weissflög's *Broken Through Ball Box* like a puzzle, taking it apart and putting it together. They swivel Stephen Hogbin's *Walking Bowl* across the coffee table so it looks as if it really is walking. Friends marvel at the shadows cast by Bill Hunter's *Kinetic Rhythms #1277*. They like to hold a bowl by Stocksdale, each a small treasure, or to feel the incredible smooth quality of an Ed Moulthrop vessel. They can hardly believe that David Ellsworth's bowls weigh so little. It is difficult to realize that these artworks, whose aesthetics and individuality are integral to our lives, will no longer be in our house.

However, there was the question of what to do with our collection in the future. We began by giving a few pieces each to the Renwick Gallery, the Detroit Institute of Art, the Art Institute of Chicago, the Fine Arts Museum of the South, and the American Craft Museum. But we liked what Mark Lindquist said after seeing our collection the first time: we must keep our vision together. He suggested we give it all to one museum and have an exhibition and a book authenticating our vision. "Individually the pieces are beautiful; together they make a strong statement about the intensity and diversity of serious wood turning as it emerged into an art form in the last fifteen years of the twentieth century."

Therefore, we looked for a museum large enough to show and store a collection of more than one hundred pieces of wood art, many quite large. Among other museum directors and curators, we had met and become friendly with Mark Leach, the dynamic curator of twentieth-century art at the Mint Museum. When Mark called us in 1996 to tell us that NationsBank (now Bank of America) was supporting a new Mint Museum of Craft + Design in downtown Charlotte, and that he would be the director, we knew that our collection should go to North Carolina.

We attended the 1999 opening of the Mint Museum of Craft + Design. We were thrilled with the museum, the incredible staff with all its energy and vision, and with the warm and enthusiastic people of Charlotte. We knew we had made the right choice.

Much as we covet the pieces in our wood collection, we want to expose others to their beauty and variety, and to the spirit that motivated us to collect each piece. These works have given us unlimited and deepening pleasure; now we send them out to speak with their simple, yet deep, sincerity to a greater audience.

Mark Lindquist. *Chieftain's Bowl.* 1988.
(See plate 60)

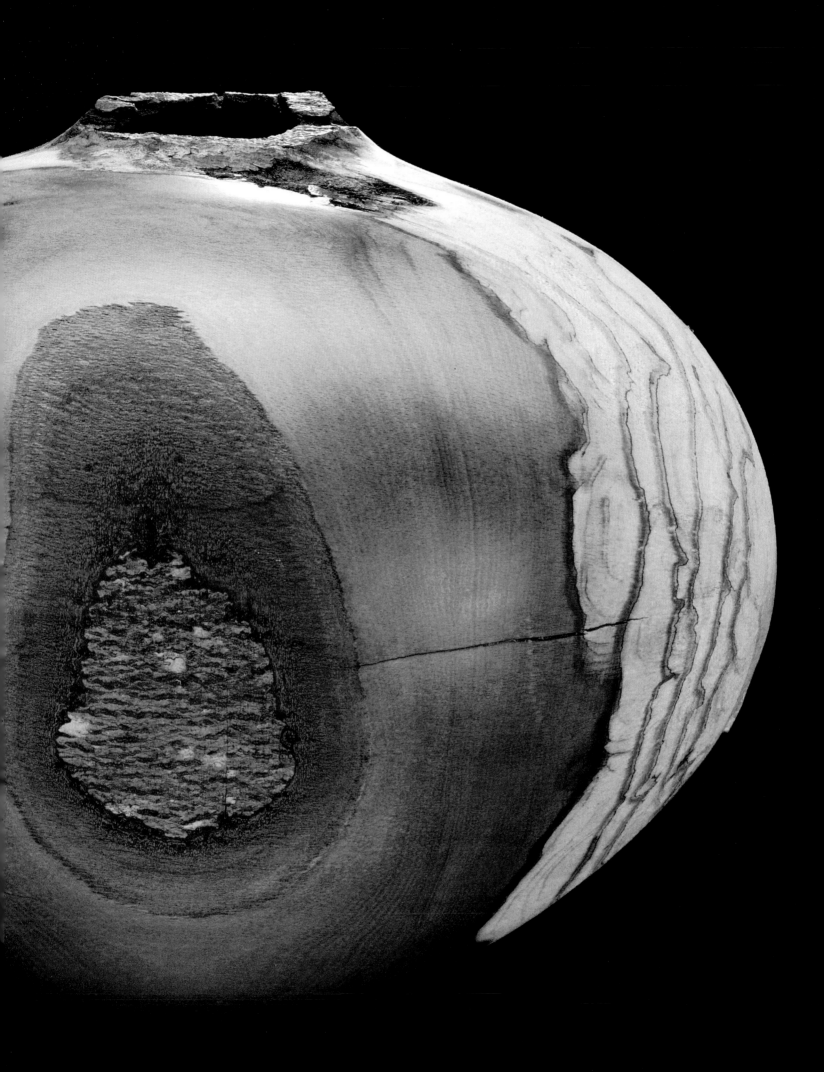

The First Year

Arthur K. Mason

The first twelve months of collecting turned wood were the most memorable period in our collecting adventure. Jane and I became excited about the craft as soon as we saw our first exhibit at the Renwick Gallery, "The Art of Turned-Wood Bowls" from the Edward Jacobson collection. My father had been a forester, a graduate of Yale Forestry School in 1911, and he instilled in me a great love for the tree and the forest. We bought our first piece in June of 1986 at a craft shop in the hills of West Virginia, one week after our visit to the Renwick Gallery. Within a year, we had assembled a collection of more than one hundred pieces. It was not my fault that the number was so low. I never met a bowl I did not like. Fortunately, Jane had, and through her influence the collection has achieved the level of quality that distinguishes it today.

When we began this journey in 1986, turned wood had few collectors—Irving Lipton, Sam Rosenfeld, Nathan Ansell, and Ron Wornick were among them. More than a decade later, the field is burgeoning with new enthusiasts.

At the outset, we decided that if we were to become collectors it would be better if we learned more about wood turning. So we looked in the catalogue of the Jacobson show and searched for an artist whose work we liked and who lived nearby. We settled on David Ellsworth from Quakertown, Pennsylvania. Having more nerve than good manners we found his number, called him up, and invited ourselves to spend the weekend with him and his wife to learn about wood turning. Finding David and Wendy's home in the woods is an adventure in itself, and I think God has decided that not everyone is entitled to know where they live. We stayed down the road and spent the weekend talking about wood turning and wood turners and everything else in life. In the course of the stay, Jane noticed an unopened computer box in the corner, and David explained that he had not learned how to use it. He got a computer lesson out of the deal, and we acquired two pieces; a third—the "football" of redwood lace burl—was still on the lathe. Most important, we better understood what to look for in collecting turned-wood bowls. It was a good place to start.

David is one of the leading theoreticians in the field and one of the most innovative. As a teacher, lecturer, and exhibitor, he is constantly exploring new ways to make the wood express itself through the lathe. We learned how wood and form work together in harmony, especially in his work. Picking up each of his amazingly lightweight bowls, we realized that, as a former ceramist, he had translated the discipline of making the thin walls of a clay bowl into his wood turning. Revered by all in the field for his insight and skill, David can turn a piece of wood that barely holds together. (See, for example, plate 11.) Though we have donated four of his pieces to major museums, we still have more than sixty pieces of his work.

Our next memorable experience came in December 1986 when we visited Atlanta and, with David's introduction, met Ed Moulthrop, already an established giant in this infant art form. In the Signature Gallery, which represented Moulthrop in Atlanta, I inquired about other turners. The proprietor, in her best Georgia drawl, said, "This is Maawwwlthrop country," and added she knew nothing about other turners, with one exception—Ed's son Phil. Ed and his wife, Mae, are a wonderful courtly couple who showed us all over their stunning rambling home, which serves as salon, gallery, and studio with an outside woodpile. There we saw

David Ellsworth. *Untitled Vessel.* 1987. (See plate 12)

for the first time the famous Moulthrop holding tanks where rough turned bowls were stored in a secret solution of polyethyl glycerine (PEG) to prevent cracking in the drying process.

Ed showed us his current work, and we asked if he ever sold from the home rather than exclusively through galleries. He said then, as he does today, that he appreciates his galleries and respects their efforts on his behalf. He told me that Jimmy Carter had called up some time back and asked to buy a piece and he had obliged. Then he mentioned that Aga Khan and David Rockefeller had also visited with the same result. So we felt incredibly light-headed when he said, "I don't know why I shouldn't sell you a piece as well." We did acquire a classic globe piece of tulipwood (plate 69), which became a cornerstone of the collection. Since then we have bought Moulthrops from most galleries that show his work.

This story raises the question of the role of the gallery in the wood-turning field. Those who have supported the field have been indispensable to its growth and development: Martha Connell in Atlanta, Georgia; Mike Mendelson in Washington Depot, Connecticut; Joanne Rapp in Scottsdale, Arizona; Veena Singh of Sansar in Washington, D.C.; Del Mano (Ray Leier and Jan Peters) in Los Angeles, California; Janis Wetsman in Detroit, Michigan; and John Sherman of Creations in Wilmington, Delaware. Recent newcomers have been Barry Friedman in New York City and Duane Reed in St. Louis, Missouri. Other settings such as Gump's in San Francisco and Heller Gallery, a noted glass gallery in New York, should also be noted. The development of the field requires a strong gallery structure. We are blessed with good people in this area but more are needed. While we often buy directly from artists or craft shows, we make a point of supporting the galleries with about half of our purchases.

Continuing on our trip to Atlanta, we heard about the Great American Gallery run by Martha Connell. There we had a field day as we saw our first works by fine artists such as Rude Osolnik, Bruce Mitchell, and John Whitehead. Rude and Bruce have become our good friends, and we have seen much of them since. Most of the artists represented in the collection have been to our home and/or we have been to their studios. We are reminded of this as we reminisce, and we realize as we gather the names for this catalogue how much they and their families have come to mean to us. It would endlessly prolong this memoir if we were to detail the wonderful times we have had with each of our wood-turning friends.

By this time we had acquired maybe thirty pieces. In February 1987 we embarked on a trip that was to double the collection. We went to Hawaii to visit friends, but, as they have noted many times since, we did not really visit with them. We ended up hunting down turners in every cranny of the islands. One of the most unusual was Glen Williams, who lived in a carport on Captain Cook Inlet in Kona with his girlfriend. The sides of his home were blankets.

We flew over to Honolulu to meet one of the giants in the wood-turning field—Ron Kent, and his wife, Myra. Ron is a stockbroker who then turned in his spare time. He has been very successful using Norfolk Island pine almost exclusively. His very thin bowls, soaked in a special oil, glow with a seductive translucency. Ron's work is probably in more collections than that of any other turner. He uses only a few forms, but they are simple and appealing. Ron is also a great merchandiser. We were captivated to learn that the chalice piece we loved was not available because the pope had first call. Is that merchandising? It was matched many years later by Liam O'Neill when he offered us a piece from the same tree that produced a bowl that the president of Ireland gave to the queen of England (plate 81). We bought two major pieces from Ron that trip. He gave us several novelty items from his studio, including a "worry" egg that acts something like the steel balls in the hands of Captain Queeg, except it is too heavy. If you drop it, you are sure to break a toe.

Upon returning to the mainland in February we had already made contact with another turner whom we had picked out of the Jacobson catalogue—Bob Stocksdale. It was the first of maybe ten visits we have made to Bob and Kay's California home in the course of acquiring some sixty of his pieces. Bob was then in his mid-seventies, with a pixielike face, a wonderful smile, and a wry, sometimes acerbic wit. He is married to Kay Sekimachi, a fiber artist of international renown, whose work is in most major museums in the country.

In the first visit with Bob he led us down to his studio, where, with great pride and many chuckles, he told us where he got each log, how much he had paid for it, and how many pieces he had already turned from it. He is extremely frugal. In the course of the day, Jane had seen a breathtaking Macassar ebony piece with a whole landscape of figuring tapered to a small foot, which had been marked with small gouged lines (plate 109). Bob told her that piece was for his permanent collection, but Jane never put it down during our three-hour stay. Finally, Bob gave up and sold it to her. It was recently included in his nationally acclaimed retrospective, which was a collaboration with Kay called "Marriage in Form."

Suddenly we realized we had very little time to make our plane. Bob insisted on driving us to our hotel and waited while we quickly packed. He then took us to the airport. That was when we became aware that turners are a special breed of artist. They are warm and genuine people who relate closely to friends and collectors. Bob and Kay have remained our close friends over the years. We see them in Washington, as well as New York, and they have even been to our home in Florida.

Scottsdale, the last stop on the trip, was supposed to be for relaxation only. However, it is also the home of Arizona State University, where the Jacobson collection was going to be permanently installed. We had a nice call with Bud Jacobson who advised us to visit the Hand and the Spirit Gallery in Scottsdale run by Joanne Rapp. We went over on a Sunday but, to our great regret, it was closed. Joanne and her husband could be observed inside taking care of various chores. We knocked on the plateglass window. Our disappointment must have been apparent because they let us in and showed us around. This was yet another example of wood-turning hospitality. It was also the beginning of a great relationship with Joanne, which we still value highly.

In Joanne's gallery that day we discovered several artists whose work has been pivotal in the evolution of our collection. Virginia Dotson, a Phoenix artist, was the first woman turner we had heard about. We purchased her lyrical bowl of spalted maple (plate 5) and since then have bought at least one of her bowls each year. On the sideboard in our dining room is "Dotson Alley" (see page 43), which demonstrates her development in a selection of bowls from 1986. We have subsequently acquired several fine works by women in the field, including Michelle Holzapfel, Robyn Horn, Merryll Saylan, Addie Draper, Bonnie Klein (from whom I took lessons), Betty Scarpino, Hayley Smith, and Mary Lacer, now administrator of the American Association of Wood Turners.

Joanne also introduced us to the work of Todd Hoyer, who, in our opinion, ranks at the very top of American turners. The Hoyer pieces we acquired at the time are among the best in our collection, particularly since he has changed styles and is no longer making the natural form work of that early period. There is one piece that we call the potato chip, which is a slice of wood with the bark still on that was turned wet; after drying, it curled like a chip (plate 33). We think it may still be curling.

Because we have been partial to paintings that reflect an artist's feelings, Todd Hoyer's autobiographical bowls and sculptures especially intrigue us. At one point, when he was in the midst of a long period of unhappiness, Todd

turned bowls so twisted in upon themselves that they gave one a sense of discomfort. Jane regrets we never bought one of that series. But we did purchase *Peeling Orb* (plate 34), with one arm lifting off into space, a happier piece done after resolving his problems. Later, when his wife was killed in an auto accident, Todd began his burned series, bowls with crosses scorched into their surface (plate 36).

No mention of our first year of collecting would be complete without discussing how we met Mark Lindquist. Mark and his father, Melvin, are towering figures in the field: Melvin for his pioneering work during the sixties and seventies in the early craft shows (when his work was selling for $25), Mark as an important thinker. Mark views wood turning as a sculptural process. His background in design and theory produces work that is detached from the lathe and yet part of it. We called Mark through the good offices of Albert LeCoff, director of the Wood Turning Center, who knows every wood turner in the world and without whom the movement as we know it today would not exist. In early June 1987, we visited Mark and Mel at their Quincy home in the Florida panhandle. In the studio was work in every stage of completion: wood and wood and wood. We saw Mark's *Chieftain's Bowl* (plate 60). Grandiose, it stands three feet high with natural burl on the outside and an interior of rhythmically carved grooves.

As in our first visit with David Ellsworth, we learned what Mark and Mel thought and why they did what they did. Unlike visits we have had with other turners, we did not talk much about how they did things, but rather *why*. Technique, a preoccupation with many turners, remains for the Lindquists simply a means to an end. The Lindquist "end" has been defined by Robert Hobbs, in a superb essay,[1] as the expression of a mysticism derived from oriental philosophers. The increasing prevalence of an Eastern influence in Mark Lindquist's work was apparent in his recent retrospective exhibition.

We decided very early in our collecting career that part of our mission would be to raise the status of wood turning, to make it as widely known and sought after as are the so-called fine arts. We have tried to bring this about through showing our collection, donating work to museums, curating shows at galleries that never had wood before (Franklin Parrasch in 1989), writing articles, delivering speeches, and supporting the field in any way possible.

We believe the success of our mission to promote and elevate wood turning as an art form is, in large part, dependent on the quality and strength of our collection. Accordingly, we have worked hard to cultivate and hone our collecting skills and sensibilities. As our collection grew, our criteria for making choices became gradually less rigid and purist, expanding to include carved and painted wood in addition to simple bowl forms. However, we continue to avoid innovation for innovation's sake, and decorative work that places as much emphasis on embellishment as on basic form and design. Decoration can be beautiful, but in our collection it is intrinsic to form rather than superimposed.

By the end of the first year we had a collection of more than one hundred works that had become known throughout the wood-turning field. We had acquired a new world and a new set of friends whom we treasure. The next eleven years saw the collection multiply by perhaps sixfold to include more than one hundred artists. A good story came with every piece. We have to give a great deal of credit to our children, who, bewildered as they must have been by this sharp change of direction in our lives, were very supportive and even learned to appreciate the work.

At the core of our vision is the reawakening, the Renaissance of wood turning as an art. Our collection encompasses the work of the 1960s when the early artists—James Prestini, Bob Stocksdale, Rude Osolnik, Ed Moulthrop, Mel Lindquist, and Dale Nish—each alone and in his studio developing his style, first met and inspired each other in a burst of creativity. It includes the next

major group of turners to emerge: David Ellsworth, Mark Lindquist, Hap Sakwa, and others from the Jacobson collection. Since that exhibition in 1986, wood turning has exploded and continues to grow exponentially in all states and now internationally. From this fertile field, we have tried to choose the most beautiful and expressive work.

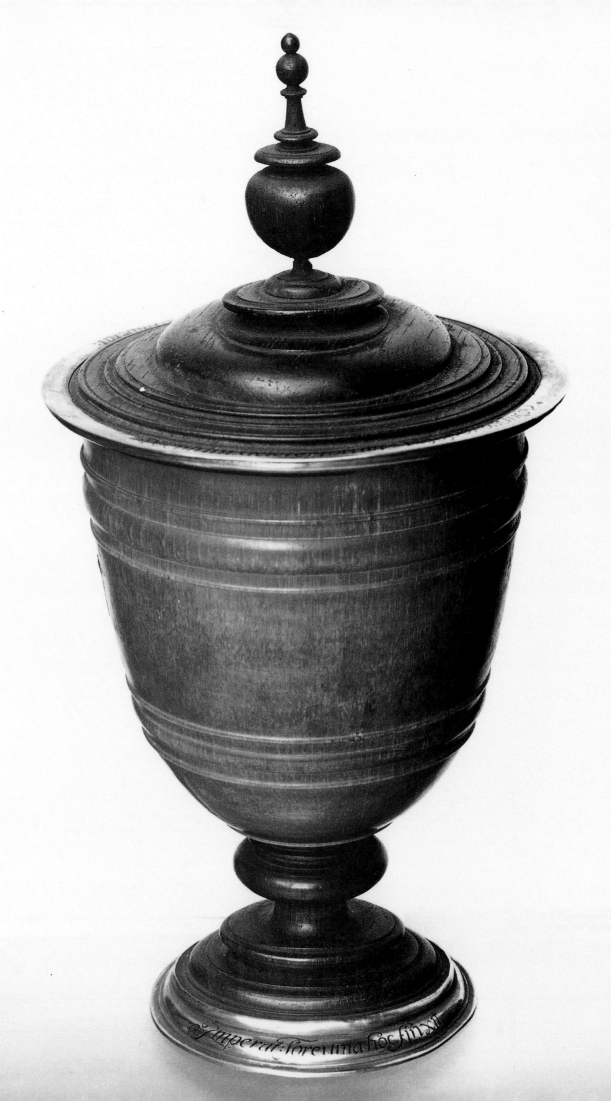

As the World Turns: Wood Turning in an Expanded Context

Suzanne Ramljak

The reputation of wood turning has taken a sharp turn over the last few centuries. Once the favorite pastime of kings, practiced in courts throughout Europe, turning in the twentieth century has been mainly a hobbyist's field. The historical path that led from the palace to the garage is now veering back to the palatial again (to museums, the modern "palaces of the people"), and wood turning is poised to regain a key role in contemporary society.[1] As the history of turning is closely linked to changes in cultural values, any assessment of the subject must address such shifts in social taste. A look back to the former glory days of lathe-turning provides insight into the forgotten virtues of this craft and points the way to a new evaluation of the field.

During the sixteenth and seventeenth centuries, lathe-turning was an almost obligatory activity within European courts, practiced by rulers such as Kaiser Rudolf II (1552–1612) and Czar Peter the Great (1672–1725) (fig. 1).[2] Following royal fashion, the lathe soon became a popular toy of the upper classes. The reasons for turning's popularity within the royal courts were complex. In addition to serving as a form of recreation, and as a means of developing technical skill to help rulers command craftsmen in their charge, lathe-turning was also central to the then-prevailing view of the cosmos. Within this cosmology, the earth and planets were thought to be perfect spheres, and it was reasoned that such concentric forms could have only been crafted on a lathe. God was therefore imagined to be a turner. The lofty status of lathe-turning during this period was thus supported by a metaphysical view in which the cosmos was seen as a beautifully turned creation, a celestial sphere (fig. 2).

This view of the cosmos is no longer tenable in the twentieth century, although it does rightly emphasize the circular and revolving nature of our solar system. Any argument for the importance of wood turning today must be built on a different foundation, and a fresh set of values must be developed for this millenniums-old art form. Compelling evidence for such a new valuation of wood turning can be found within the fields of psychology, ecology, biology, and philosophy. By repositioning turned-wood objects within these contexts, it can be demonstrated that wood turning does indeed have a vital and potent role to play in our contemporary culture.

This is a particularly ripe moment to reflect on the unique properties of turned-wood objects. The field of wood turning has matured rapidly over the past two decades and has arrived at a level of confidence and self-awareness that forecasts a promising future. The literature on the wood-turning field is striving to catch up with the rapid artistic developments, and, while artists are making startling new forms, most of the commentary continues to perpetuate habitual thinking about the medium. Though the majority of the literature is in the how-to or technical genre, turned-wood objects are slowly becoming the subject of serious debate. Recent publications have sought to position the medium in broader contexts like industrial history, wooden sculpture, and the vessel-as-art.[3] However, the well-worn issue of "art versus craft" continues to dominate the dis-

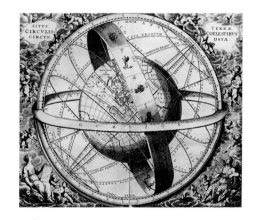

fig. 1. Kaiser Rudolf II. *Lidded Cup*. Late 16th century. Turned wood and rhinoceros horn with silver gilding. Height 9" (23 cm). Nationalmuseet, Copenhagen

fig. 2. Andreas Cellarius. *The Celestial Sphere*, from *Atlas Celestis seu Harmonica Macrocosmica*. 1661. Engraving. 17 x 20" (43.2 x 50.8 cm). The New York Public Library, Map Division

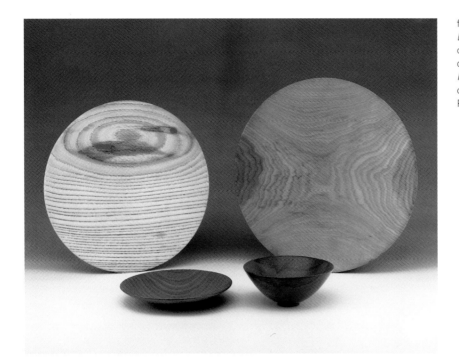

fig. 3. James Prestini. (clockwise from upper left) *Bowl.* n.d. Sandblasted chestnut. 1⅜ x 8¾ x 8¾" diam.; *Platter.* n.d. Curly birch. ⅞ x 9¹¹⁄₁₆ x 9¹¹⁄₁₆" diam.; *Bowl.* n.d. Birch. 1¾ x 4⅝₁₆ x 4⅝₁₆" diam.; *Platter.* n.d. Chestnut. ⅞ x 5⅜ x 5⅜" diam. Photo courtesy the Wood Turning Center Library, Philadelphia, Pa.

cussion, and critics persist in lobbying for the induction of turned-wood objects into the pantheon of fine art. There are still very few artist monographs, a sign that individual turners have yet to be studied in the context of their own creative evolution, rather than as part of a larger group phenomenon.[4]

It is time now to step back and take a fresh look at the key traits and virtues that distinguish turned-wood forms from all other material objects. In so doing, we might come to recognize the rich concentration of properties that together define the turned-wood object. When wood turning is situated within a broader context of interpretation, a provocative combination of features emerges: a union of the natural and machine-made, of the ahistorical and avant-garde, and of the concerns of art for art's sake and ethical commitment. The exceptional quality and scope of the Jane and Arthur Mason collection allow for a sustained analysis of the full range of issues that revolve around the turned-wood object.

Part of the reason for wood turning's dubious reputation within twentieth-century culture is its peculiar blend of the organic and the industrial, the natural and machine-made. When wood is mounted on a lathe, nature becomes subject to the forces of industry, and the prehistoric meets the modern in a marriage of convenience. The result is a hybrid of machined and organic forms, a combination that lends turned-wood objects much of their interest and even poignancy. Nonetheless, the status of wood turning is bound up with the relative prestige of the machine-made. As art historian Edward Cooke has argued, during much of the twentieth century wood turning has been a process with a reputation closely linked to that of industrial production.[5] Beginning in the late nineteenth century, lathe-turning became primarily a technique to mass-produce furniture and architectural parts, and was thought to lack artistic merit. Indeed, throughout the first decades of the twentieth century, most wood turning was characterized by a highly controlled, machined aesthetic. This industrial style was further encouraged by Bauhaus principles. The works of early practitioners in the field, such as James Prestini, embodied the ideals of Bauhaus founder Walter Gropius, who wrote, "The Bauhaus believes the machine to be our modern medium of design and seeks to come to terms with it"[6] (fig. 3). This machined and polished approach to wood turning eventually gave way to a looser, more natural aesthetic in the 1970s.[7]

The negative connotations of the machine-made are especially severe within the craft world with its long-standing worship of the handmade. Human touch is one of the cardinal virtues of the entire craft movement. Given such reverence for the hand, wood turners have sometimes been seen as pariahs in the field. Even today, the centrality of direct hand techniques within crafts is so entrenched that one risks being branded a heathen if one dares to renounce this traditional tenet and argue for the introduction of industrial processes.[8] Within twentieth-century artistic practice, however, machinery has been more readily embraced, and developments in modern art provide precedents for the machine as a positive agent within the creative process. Foremost in this vein is Marcel Duchamp (1887–1968), one of the most influential artists of the century, who rewrote the rules for producing and perceiving art. Among his many inversions of traditional artistic values was the notion that an artist's labor was not essential for creating art. Duchamp went even further to suggest that no contact whatsoever with the maker's hand was necessary, as in his *Fountain* (1917), a urinal that was made by industrial fabricators and then signed by the artist.[9] Duchamp's forays into the realm of the mechanistic included vertiginous turning devices such as his *Rotary Glass Plates (Precision Optics)* (1920) (fig. 4) and *Roto-Reliefs* (1935). He entered the latter mechanism in an industrial exposition, not as an artist but under the title of "benevolent technician";[10] wood turners can likewise be seen as working in the Duchampian tradition of the kindly technician. It is worth noting that the anti-intellectual reputation of wood turning rests on the fact that a machine is used, yet Duchamp—an extremely analytical artist—provides a prime model for the inclusion of mechanical techniques into fine art.

Duchamp's larger views about the creative process are actually more in keeping with the values of the wood turner and the traditional craftsman than those of the so-called fine artist. As Duchamp wrote, "The word 'art' interests me very much. It comes from Sanskrit, as I've heard it signifies 'making.' Now everyone makes something, and those who make things on canvas, with a frame they're

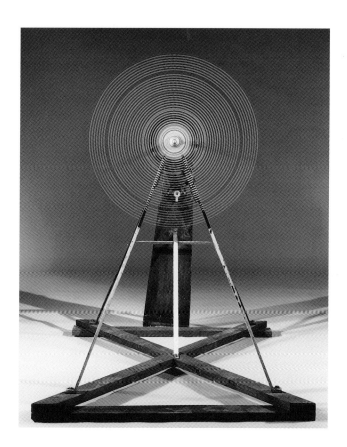

fig. 4. Marcel Duchamp. *Rotary Glass Plates (Precision Optics)*. 1920. Glass, metal, wood, paint, electric motor. 65½ x 47½ x 57⅜" (166.3 x 120.8 x 145.8 cm). Yale University Art Gallery, New Haven, Conn., Gift of Collection Société Anonyme

called artists. Formerly, they were called craftsmen, a term I prefer. We're all craftsmen, in civilian or military or artistic life."[11] Duchamp seemed perfectly comfortable dissolving the concept of art into that of craftsmanship rather than fighting for the induction of craft (and wood turning) into the fine-arts arena, as so many contemporary craft writers have been intent on doing.

Despite Duchamp's endorsement, the machine is not without its creative liabilities, and one of the key dangers of machined art is the threat of overly perfect form. Avoiding perfection may be the biggest challenge that turners face, since the lathe allows for the creation of precisely symmetrical and finished forms. From an expressive point of view, perfection is something to guard against, for it can spell the death of expressivity. While imperfection in an object imparts a sense of life, mathematical precision often produces sterility. Many art theorists, including John Ruskin (1819–1900), have warned against the artistic hazards of perfection. According to Ruskin: "No good work whatever can be perfect, and the demand for perfection is always a misunderstanding of the ends of art. In [living] things . . . there are certain irregularities and deficiencies, which are not only signs of life but sources of beauty."[12] Insistent on this point, Ruskin further declared: "Accept this then for a universal law, that neither architecture nor any other noble work of man can be good unless it be imperfect."[13]

Whether or not wood turners heed Ruskin's warning, they must learn to carefully balance the machine precision of the lathe and the natural irregularities of wood. Operating on a continuum from the mechanistic to the organic, some turners choose to efface all traces of the natural material through lacquer, paint, or elaborate carving, while others limit their manipulation of the material, allowing the wood to remain as raw as possible. In the former category are works by artists such as Maria van Kesteren, Virginia Dotson, Giles Gilson, and Merryll Saylan. Van Kesteren is emphatic about her desire to overcome the natural irregularities of wood: "How preferable if a material existed without the disadvantages of wood: discoloration, distortion of form through atmospheric influences, and sometimes too emphasized grain patterns that interfere with the intended shape. For that reason I use indigenous wood (ash, lime, elm). These have little color and grain and can easily be bleached. I love clean, logical form. All that interferes with that, I eliminate"[14] (plate 122). Conversely, a majority of turners are drawn to the medium of turned wood precisely because wood is such an irregular material and lends an exciting unpredictability to the creative process. Bob Stocksdale openly welcomes wood's irregularities in his compositions: "The shape of a log, the grain pattern, cracks, faults, or rotten spots all play a part in my discovery of new shapes."[15] Turner Dale Nish is similarly attracted to the imperfections and random patterns of wormy ash, which allow him to "explore the characteristics usually ignored or rejected in conventional woodworking, i.e., shrinkage and distortion, insect damage, and cracking"[16] (plate 79). The ongoing formal dialogue between these two key properties of wood turning—machined precision and organic irregularity—are eloquently encapsulated in Johannes Michelson's *Untitled* (1988), which conjoins a pristine lacquered base and a rough column of spalted maple (plate 66).

Along with the machine, the other half of the wood-turning equation—nature—brings with it a host of connotations. Wood turning, like wood itself, is often associated with the timeless realm of biology and botany. Indeed, working with wood is one step removed from working with actual trees, and the turner's gouge acts as a mediator between human and nature. While turned-wood objects are aptly linked to the primal natural world, they also participate in the more progressive trends of avant-garde culture, namely chance methods and the "ready-made" or found object. Duchamp again provides a precedent for this key characteristic of wood turning. Like Duchamp's found objects or assisted ready-

mades—in which he substituted the act of choosing an object (like a shovel or bottle rack) for the act of making one—the creative process of wood turning involves as much *finding* and *selecting* as it does making and constructing. While turners manipulate the wood forms that they find preexisting in nature—or make very slight modifications as in Mel Lindquist's *Natural Top Bowl* (1985) (plate 63) or Mark Lindquist's *Chieftain's Bowl* (1988) (plate 60)—they do not construct or sculpt their works in the traditional sense. This aspect of wood turning was also noted by writer John Perreault: "Turning wood is a subtractive process, like stone carving, but it also participates in the finding mode since the qualities of the result depend on qualities found in the wood."[17]

The role of turner-as-finder is widely acknowledged by artists within the turning field. Comparing wood turning to other craft media, Ed Moulthrop explains, "Unlike clay, glass, metals, and fiber, where the material is shifted and rearranged to the artist's desire, my works 'have always been there.' The wood you see is the wood exactly as it was created. I simply uncover it and there it is!"[18] The same process of discovery is described by Michael Peterson: "While harvesting and collecting burled wood, I discover and explore the physical material—a process that yields all the excitement and energy found in a treasure hunt or like that in unearthing artifacts from an ancient culture."[19] Within the wood-turning medium, the activity of selecting the wood becomes just as crucial, if not more so, than the act of shaping the material. The central importance of selection in all art was recognized by the nineteenth-century writer Oscar Wilde (1854–1900), who wrote: "Art itself is really a form of exaggeration; and selection, which is the very spirit of art, is nothing more than an intensified mode of over-emphasis."[20] Wilde's definition of art is perfectly suited to the wood turner's practice.

Another essential aspect of wood turning, cultivated by many practitioners in the field, is the use of chance or uncontrolled effects in the creative process. Chance techniques played an important role within the Dada and Surrealist movements, and later in the post–World War II American avant-garde.[21] A key figure in American Dada, Duchamp was attracted to the use of chance as "a way of going against logical reality."[22] The use of chance techniques has also proved integral to the field of twentieth-century pottery. Asian aesthetic philosophy— with its acceptance of imperfections and accidents in the creative process—was promulgated by the influential British potter Bernard Leach (1897–1979), whose *A Potter's Book* (1940) became something of a bible for the postwar generation of potters and craftspeople. Mark Lindquist was instrumental in further introducing Eastern aesthetics into wood turning. Having apprenticed with a Buddhist potter, Lindquist cultivated a more open approach to wood and inspired others to take advantage of the material's flaws and irregularities, rather than strive for the highly finished forms of traditional turning. Other turners, including Dale Nish, have sought inspiration in Eastern philosophy; as he explains, the "Oriental ability to accept and enjoy natural materials and surfaces produces a serenity and satisfaction not found frequently in Western cultures. I have tried to incorporate some of this attitude into my work."[23]

Within the wood-turning field, the use of chance techniques and accidental effects is most evident in green turning and freestyle turning. Freestyle turning-- an approach pioneered by artists like David Ellsworth—incorporates defects in the wood, such as splits, rotten areas, and bark inclusions, to produce uniquely irregular forms (plate 12). In the chance-filled technique of green turning, uncured wood is turned on the lathe and allowed to dry after turning. As the piece slowly cures, the wood shrinks and assumes surprising shapes unforeseen by the turner. Among the many turners who are drawn to the process of green turning is Todd Hoyer, who intensively explored the technique in his work of the 1980s. About his attraction to the chance effects of green turning, Hoyer has said,

the "procedure produces an asymmetrical form that allows the life force of the tree to have the final word, thus freeing me from total control over the final form"[24] (plate 33).

It is telling that wood turning is perhaps the only field where artists sign the name of the material on the finished work alongside, or sometimes in place of, their own name. By cosigning the wood on their objects, wood turners testify to the importance of nature's role in their art and acknowledge the collaborative interaction between wood and worker in the creative process. Turner and basket maker Ruth Greenberg pinpointed this collaborative element: "Each basket is a collaboration between me and the vines and driftwood which influence the final shape. . . . I have learned to respect the input from my materials and we create together—the vine, the wood, and I."[25] And Bruce Mitchell describes the process of wood turning as a "dialogue, an exchange of ideas and possibilities between an artist and his wood."[26] The field of wood turning also has cases of true artistic collaboration, such as the creative partnership forged between Todd Hoyer and Hayley Smith, which later resulted in the couple's marriage.[27] Turner Mark Sfirri has been a major practitioner of the collaborative mode, first with Robert Dodge, and since 1992 with Michael Hosaluk, a collaboration that has resulted in numerous coproduced objects, including *Boob Box on a Stick* (1997) (plate 32). Whereas a degree of cooperation and responsiveness is necessary for any act of creation, the work of wood turners strongly emphasizes these key aspects of the creative process.

Artistic collaboration within wood turning takes on a radical cast when explored against the backdrop of the individualistic values of Western culture. As a creative practice that stresses union and shared responsibility, wood turning indirectly participates in a critique of individualism. Jungian psychologist James Hillman has written about the interplay of collaboration and art, noting that "our notions of gallery art, and the 'creativity' that makes it are dominated by our psychology of individualism."[28] According to Hillman, our view of individualism has deeper roots in the concept of the soul, and "as long as we locate the soul only inside individual persons, and this soul is where the divine spark resides, then creativity can only burgeon out of the individual."[29] Hillman's analysis ultimately links individualism—a form of "psychological monotheism"—with monotheistic religion. Thus, the antidote to individualism must involve the uprooting of deep, even religious values, which for Hillman requires a form of paganism. "Pagan means the enlivened object," states Hillman, and paganism is a recognition that "an artwork has multiple sources."[30] This awareness of the multiple sources of creativity is an essential lesson that wood turners impart through their collaborative approach and open acknowledgment of nature as a creative partner in their art.

Turned-wood vessels, which comprise the majority of the Masons' collection, also engage the current debates about abstraction and utility. While many of the works in the collection give the pretense of function, they are actually decoys for use: abstract sculptures in the guise of vessels. Mark Lindquist's comments on a spalted bowl highlight the nonutilitarian nature of most turned-wood vessels: "Its function is to display the beauty of nature and to reflect the harmony of man. It is wrong to ask the spalted bowl to function as a workhorse as well, to hold potato chips or salad or to store trivialities. The bowl is already full. It contains itself and the space between the walls."[31] Such anti-functional vessels confront the viewer with a stubborn physical presence, offering both invitation and challenge. The presence and elegance of these wood objects demand that we study and assess their formal properties of texture, color, proportion, and contour. Like other abstract art, turned-wood forms primarily serve as objects for meditation or arousal, and their foremost impact is on the sensual level. The potential of

fig. 5. Martin Puryear. *Alien Huddle*. 1993–95. Red cedar and pine. 53 x 64 x 53" (134.6 x 162.6 x 134.6 cm). Collection Agnes Gund. Courtesy McKee Gallery, New York

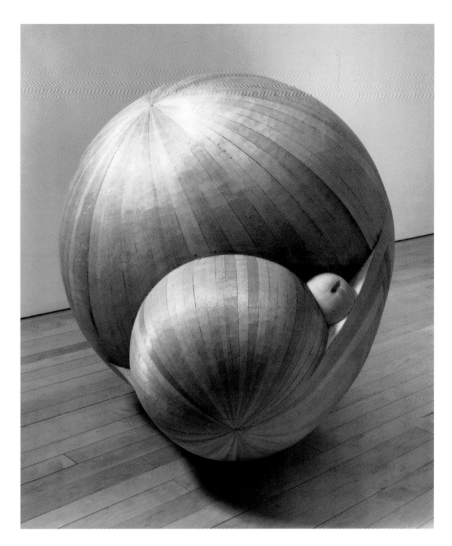

turned-wood bowls to function as sensitizing agents is expressed by turner Michelle Holzapfel, who has described her vessels as "ritual objects in that they are meant for use in the ritual of perception, as tools with which to contemplate and understand" (plate 26).[32]

With their robust volumes and strong formal properties, turned-wood bowls can be situated within the twentieth-century sculpture tradition of organic abstraction. This heritage is readily acknowledged by several turners who point to early modern sculptors like Constantine Brancusi, Hans (Jean) Arp, and Barbara Hepworth as sources of inspiration in their work.[33] This lineage of organic abstraction continues in the sculpture of today, most notably in the work of artists such as Martin Puryear, who create ripe suggestive forms, redolent of the same life force found in turned-wood objects (fig. 5).

In addition to the organic surface and shape, several turners choose to emphasize the innate vulnerability and sensitivity of wood to other natural elements, such as fire or water. Wood has a unique ability to communicate conditions of distress, and several turners capitalize on the material's susceptibility to cracking, scarring, and burning. The highly flammable nature of wood—most people still relate to wood as a material to be burned—is underscored in the work of artists such as Todd Hoyer, whose *Burned X* series of seared bowls eloquently express the artist's own personal hardships (plate 36). On a more formal level, James Partridge's scorched *Blood Vessel* series exploits the dramatic tone and texture of burnt black wood (plate 85).

A contemporary British sculptor whose approach to wood is closely akin to that of wood turners, and whose work has been an inspiration to the field, is

David Nash. As do the majority of turners, Nash only utilizes wood from natural-ly fallen trees or those that have been cut down for clearing. Like turners, Nash is sensitive to the tree's organic structure and develops his works in harmony with the innate properties of different woods. He has also created several burnt wood sculptures, such as his charred beech *Mosaic Egg* (1990), that share a vocabulary with the burnt objects of wood turners (fig. 6). Nash has written extensively about the organic properties of wood and its susceptibility to other natural forces, and the following passage captures the artist's holistic approach to the material: "damp and dry/burnt and buried/wood is given/we do not make it/in air it cracks/in fire it burns/in water floats/in earth returns." [34]

The direct connection of wood to the primordial realm of trees and forests gives it a unique urgency in our present culture. The art of wood turning carries with it an added ethical dimension, and turners can serve as models of height-ened sensitivity and responsibility in relation to the natural world. In their responsiveness to wood, and their love and knowledge of the trees from which it comes, wood turners indirectly provide us with ecological role models. While ecological concerns are usually implicit in a turned-wood object, in works such as Mark Lindquist's *Great American Chestnut Burl Bowl* (1975, collection of Joan Alpert Rowen)—carved from a tree that may have died in the 1904 Chestnut blight—the reference to ecological dangers and the health of trees is more forthright.

Our culture's growing estrangement from the natural world is documented in the recent literature on trees and their significance to human life. In *The Power of Trees*, archetypal ecologist Michael Perlman writes about our increasing alien-ation from nature: "I began this book with the conviction that a dangerous alien-ation from our natural, ultimately our *forest*, roots lay at the heart of the global ecological crisis."[35] Perlman goes on to suggest that the needed return to nature can begin through an appreciation of the restorative powers of trees and their ties to larger natural forces. Similarly, veteran photographer Andreas Feininger, in his self-described "tree-appreciation" book *The Tree,* addresses our insensitivity

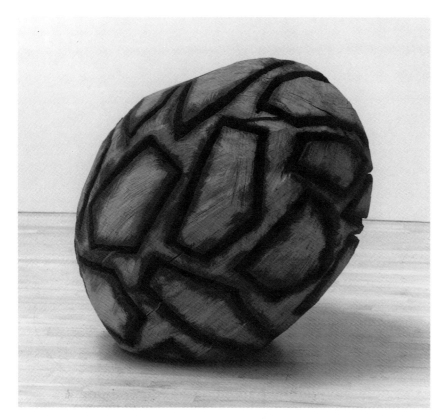

fig. 6. David Nash. *Mosaic Egg.* 1990. Charred beech. 33½ x 38 x 28" (85.1 x 96.5 x 71.1 cm). Courtesy L. A. Louver Gallery, Los Angeles

fig. 7. Andreas Feininger. *Branching in American Beech.* n.d. Gelatin silver print. 13⅜ x 10⅝" (33.9 x 26.9 cm). Collection Center for Creative Photography, The University of Arizona, Tucson

to the integrity and power of trees: "In our largely urban society, the ability to appreciate trees has become dulled. . . . Nowadays, too many people consider trees nothing more than a cash crop—so many board feet of lumber, so many dollars per acre of pulp."[36] Through dramatic photographs and lucid text Feininger produces a compelling testament to these astounding creatures that can grow up to 350 feet and survive over 4,000 years (fig. 7). Equal dismay over our utilitarian approach to trees and wood is expressed by the novelist John Fowles in his meditative essay, also titled *The Tree:* "We shall never fully understand nature (or ourselves), and certainly never respect it, until we dissociate the wild from the notion of usability."[37] Further assessing the need to reconnect with the natural world, Fowles maintains, "The threat to us in the coming millennium lies not in nature seen as a rogue shark, but in our growing emotional and intellectual detachment from it—and I do not think the remedy lies solely in the success or failure of the conservation movement. It lies as much in our admitting the debit side of the scientific revolution, and especially the changes it has effected in our modes of perceiving and of experiencing the world as individuals."[38]

As these writers testify, we have begun to lose touch with the bounty and beauty of the natural world, including the trees that are our sustenance. And the ubiquity of wood—real or veneered—in our everyday environments has gradually made us numb and insensitive to this organic material. Wood has become so common that it is now nearly invisible within our lives. By bringing wood back

into sharp focus, turners can help us to see this material again and lead us closer to appreciating the splendor of trees. Most wood turners are connoisseurs of trees and of wood. While turners must respect the properties of wood in order to create successful forms, they also engage on deeper levels with the body of a tree. Like a lover or a groom, full of sympathy and devotion, turners seek to reveal the beauty and richness of this awesome form of nature. Oscar Wilde, comparing the difference between the acts of looking and seeing, described the gift of heightened vision that wood turners can bestow: "To look at a thing is very different from seeing a thing. One does not see anything until one sees its beauty. Then, and then only, does it come into existence."[39] By revealing and enhancing wood's beauty, wood turners can help us to better see and appreciate this valuable material. Learning to *see* the world more intensely—which is what the best art helps us do—was paramount to the artistic philosophy of John Ruskin, who defined an artist as foremost a "seeing and feeling creature." About the unsurpassed task of seeing, Ruskin wrote, "the greatest thing a human soul ever does in this world is to see something. . . . To see clearly is poetry, prophesy, and religion—all in one."[40] This near-religious intensity of sight experienced by artists and other visionaries was described by master turner Rude Osolnik: "My woodworking is a labor of love. It gives me a feeling of being in a church, or in God's presence, when taking a piece of wood and making something out of it. I feel a deep appreciation to be able to discover the beauty God has given us in our trees."[41] It is just such an attentiveness to wood and reverence for trees that wood turners can bequeath us through their work. In so doing, they can help reunite us with the splendor of the natural world.

The creative process of wood turning has its own distinct properties that ultimately shape the character of the art forms that emerge from this technique. Much of the formal vocabulary and expressive repertoire that distinguishes the field is rooted in the medium's material. Along with the wood's grain and texture, which many turners emphasize, there is also the natural rotundity and convexity of the tree trunk and burl from which the medium is derived. The roundness of most turned forms—while resulting mainly from the revolutions of the lathe— also reiterates the basic concentricity of the tree's structure. Along with the ineluctable factor of wood, the other essential feature of nearly all turned-wood objects is their roundness and convexity. Like trees, convex forms can provide us with a source of pleasure and well-being. The virtues of round, ripe forms— the stock and trade of the turner's art—have been celebrated throughout the centuries, from the ancient Greeks to Vincent van Gogh, who was once led to speculate, "Life is probably round."[42] Almost all lathe-turned objects speak the dialogue of convexity, and it is hard to escape the rounded form when working on a lathe. Turner Steve Hogbin clearly acknowledges the circular foundation of the wood turner's art: "The wood turner works with a geometry of circles, spheres, cylinders and spirals. All these forms are built upon the circle, the symbol for unity, totality, and eternity."[43] Numerous wood turners, such as Maria van Kesteren, have expressed an abiding attraction to such convex forms: "On one thing I am certain, my affinity to form. In my work I concentrate on, and am motivated to develop, round forms in their limitless variation."[44] A few turners, like Stoney Lamar, see the inherent roundness of lathe-turned forms as a limitation and strive to expand the medium beyond this defining trait. Lamar has developed what he calls a "multi-axis" turning technique that employs the lathe as a carving tool, allowing him to go beyond the traditional confines of wood turning to "transcend the round object and to create a sense of image and movement."[45]

The inherent convexity of turned-wood objects places them within a formal tradition of great expressive power. Convex forms can be potent in their own

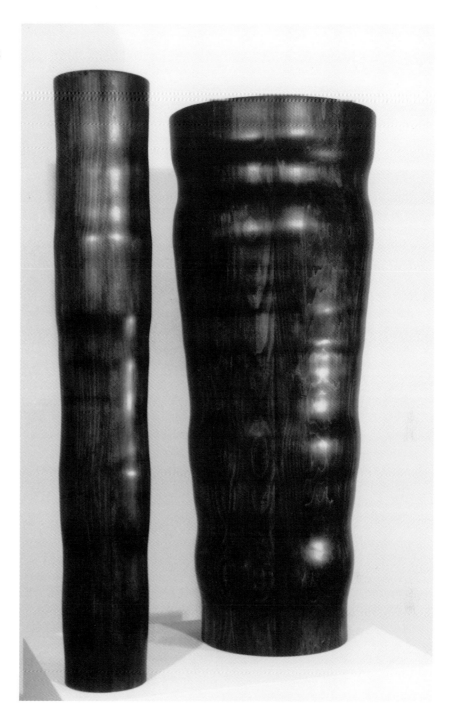

fig. 8. Loren Madsen. *Statistical Abstract: Pipes.* 1998. Ebonized poplar. 39 x 7½ x 7½" (99.1 x 19.1 x 19.1 cm) and 39 x 17½ x 17½" (99.1 x 44.5 x 44.5 cm). Courtesy McKee Gallery, New York

right or can be enlisted as a means to communicate any imaginable content— from the personal to the political. Loren Madsen, a contemporary artist outside the wood-turning field, relied on the lathe to produce his seemingly abstract yet densely informative works about economic disparity in the United States (fig. 8). Madsen's *Statistical Abstract: Pipes* are turned-wood graphs that volumetrically chart the distribution of income for the middle 20 percent and top 5 percent of households in America.[46] Whether openly engaging social issues, like Madsen, or producing full-bodied vessels with great physical beauty, turners speak a potent formal language of convexity that has the ability to move us on a fundamental level.

Recent studies in perceptual psychology have confirmed the inescapable pull that convex forms have on the human organism. Gestalt psychologist and art historian Rudolph Arnheim has written several books on the principles of artistic

perception. Approaching the entire world as "a happening of expressive events," Arnheim has concluded that "no form is mute."[47] In his groundbreaking study on compositional structure, *The Power of the Center,* Arnheim examines the basic concentric patterning and ordering of life: "Cosmically we find that matter organizes around centers, which are often marked by a dominant mass. . . . The human mind also invents centric shapes, and our bodies perform centric dances unless this basic tendency is modified by particular impulses and attractions."[48] Arnheim's research on concentricity is bolstered by the findings of art theorist James Elkins. In *The Object Stares Back,* Elkins also addresses our attraction to round forms: "Our eyes are built to seek out complete figures. . . . We instinctively repair fragments into wholes and search for continuous contours and closed curves," a phenomenon that psychoneurologists call "subjective contour completion."[49] For Elkins, such a tendency toward wholeness and continuous contours speaks to basic biological needs, and he points to studies in animal behavior that suggest there might even be an "instinct for wholeness."[50] Our urge toward wholeness and subjective contour completion is playfully tested by Bill Hunter's spiral composition, appropriately titled *Cutting Loose #1254* (1997), which seems designed to frustrate our desire for closure (plate 45).

There is further evidence suggesting that we are biologically programmed to respond to the type of convexity found in most turned objects. Our natural appreciation for full, rounded shapes seems to be as innate as our inborn taste for sweetness over bitterness. Perhaps because all organic life is curved and convex, we respond especially well to these forms and empathize with their implied energy and potential for growth. Elkins has speculated that our attraction to smooth, swelling forms may be tied to the survival of the species: "the desire for complete bodies also makes reproductive sense, because it means our eyes are designed to search for smooth continuous contours like those that would be found around a young human body."[51] Biologically speaking, life is a convex phenomenon. There are no perfectly right angles in nature. The rarity of angular forms was noted by biologist Edmund Sinnott: "An organic body that is made up . . . of watery cells tends to show rounded contours. Really flat surfaces and acute angles are rare save in occasional special structures."[52] The forms of nature are all swelling and pushing outward in an attempt to fulfill themselves.

The biological implications of turned-wood forms extends to include the sexual dimension as well. Eroticism is an essential, though often unconscious, factor in any attractive form—animate or inanimate—and the appeal of convex objects is closely linked to sexual desire and erotic energies. Various artists, among them the poet-potter M. C. Richards, have recognized the erotic dimension inherent in both the vessel and the turning process: "The act of centering and turning a pot . . . and the sexual images implicit in the forming of the cone and opening of the vessel are archetypal."[53]

Whereas a powerful case—historical, ecological, psychological, and biological—can be made for turned-wood forms, the value of wood turning ultimately must be measured within the context of contemporary culture. As we begin the twenty-first century, convex, organic art can provide a much-needed alternative to the objects of mass production. Art historian Herbert Read saw the rise of organic sculpture in early twentieth-century art as a reaction to technology and a means to satisfy our need for organicism in the face of increasing mechanization.[54] Similarly, convex forms can serve as a counterforce today—not just to industrialization—but also to digitalization. The digital revolution has even more serious implications for our lives than did the Industrial Revolution, because it threatens the very integrity of our physical experience. Electronic or digital media—television, video, computers, virtual reality—bring with them dematerialized and disembodied relations, replacing direct physical contact with mediated

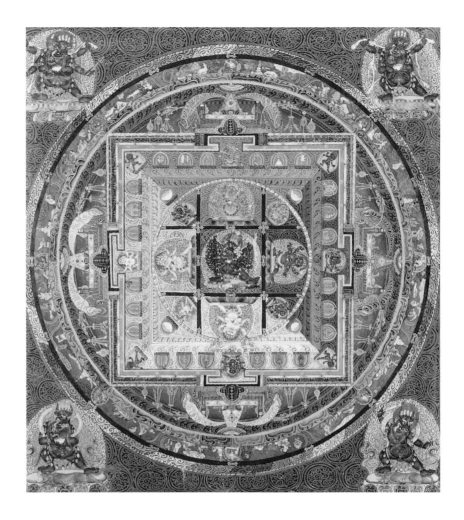

fig. 9. Artist unknown. *Mandala of Vajrabhairava.* 17th–18th century, Ngor, Tibet. Thangka, pigment on cotton. 16½ x 15¾" (41.9 x 40 cm). Asian Art Museum of San Francisco. The Avery Brundage Collection

virtual contact. Against the growing dematerialization of experience, organic and holistic art can act as a form of resistance, a means of fortifying ourselves against the synthetic and virtual. The sense of wholeness that such forms impart thus becomes more necessary today as a source of physical and psychic sustenance. There is even a moral component to biomorphic art. Writing about twentieth-century organic sculpture, art historian Jack Burnham perceived a "morality implicit in natural forms . . . [through them] man seeks and finds a positive moral position in the earth-born phenomena about him, as a kind of stabilizing factor for his powers of cognition and creativity. This seems to be a fundamental reaction to the industrial age."[55]

Perhaps the most profound function of turned-wood objects is also their most humble role—their ability to give comfort and pleasure. The integrity of turned forms, their source in nature, and even the scale of a vessel, all speak to us about home: a place in which we are most at ease. Though we often underestimate the power of objects that we interact with every day, they shape and move us in immeasurable ways. Chronicling the nearly imperceptible relations between humans and everyday objects in his book *Mechanization Takes Command*, historian Siegfried Giedion maintained: "The slow shaping of daily life is of equal importance to the explosions of history; for, in the anonymous life, the particles accumulate into an explosive force."[56] Giedion goes on to argue for the importance of organic forms within our quotidian environment: "The human organism require[s] equipoise between its organic environment and its artificial surroundings. Separated from earth and growth, it will never attain the equilibrium necessary for life."[57] The desire to make everyday experience more pleasurable and satisfying through turned forms is expressed by turner Michelle

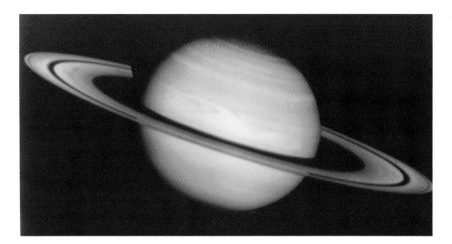

fig. 10. Saturn. Photographed from the Hubble Space Telescope, December 1, 1994. Courtesy National Aeronautical Space Archives

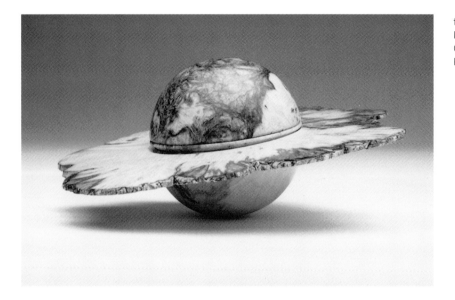

fig. 11. Hans Weissflög. *Saturn Box*. 1992. Boxwood burl. 2 x 4¾ x 4¾" (5.1 x 12 x 12 cm). Collection of the Wood Turning Center, Philadelphia, Pa.

Holzapfel: "My work originates from the desire to give shape to the quiet heroism of the domestic realm, the basis of life and culture."[58]

Partly a function of the wood itself, wood turning's power to please also derives from the wholeness and containment of the vessel format. In his essay "The Phenomenology of Roundness," philosopher Gaston Bachelard accounts for this virtue of turned-wood forms: "Images of *full roundness* help us to collect ourselves, and to confirm our being intimately inside."[59] The self-contained nature of bowls and round objects in turn serves to focus and steady the beholder. There is a simple phenomenological truth embodied in turned objects: concentric forms help us to concentrate. This potent yet quiet feature of bowls and turned forms was explored by M. C. Richards in the influential book *Centering*: "Centering is the image . . . for the process of balance which will enable us to step along that thread [of life and death] feeling it not as a thread but a sphere. It will . . . help us to walk through extremes with an incorruptible instinct for wholeness, finding our way continuous, self-completing."[60] Though vicarious, an experience of physical centering is central to our perception of turned-wood forms. Like the circular diagrams or mandalas used in Buddhist and Hindu meditation, turned bowls can serve as psychic tools to help us focus ourselves in a fragmented world (fig. 9). *Mandala* in Sanskrit can be translated to mean concentric or round site, and these circular diagrams of the universe lead viewers on a spiritual journey to the center of their psyches.[61] In the same way, the intricate grain

patterns and circular structure of turned-wood bowls can help concentrate the viewer and encourage contemplation of the natural cosmos.

A final context attending to turned-wood objects is the macrocosmic or astronomical realm. Such a consideration returns us back to the beginning of this essay and to sixteenth- and seventeenth-century views of the universe. Now as then, our cosmic neighborhood remains the wheeling Milky Way. Within this spiral galaxy, our solar system continues to repeat the same orbital dance of the spheres. Planet earth, our convex home, keeps spinning and revolving around the sun at a staggering speed. The deep affinity between celestial structures and turned-wood forms has found expression in the work of several contemporary turners. In particular, the planet Saturn (fig. 10)—with atmospheric rings around its center—has proved compelling to turners such as Ed Moulthrop (plate 72), Philip Moulthrop (plate 76), and Hans Weissflög (fig. 11). These works remind us once again of the cosmic dimension of the wood-turner's art. Although science has now taught us that God is not a turner, and that the planets were not fashioned on a lathe, turned-wood objects still have a share in the structure and motion of the cosmos. And these humble messengers of the forest still whisper to us about loftier spheres and revolutions.

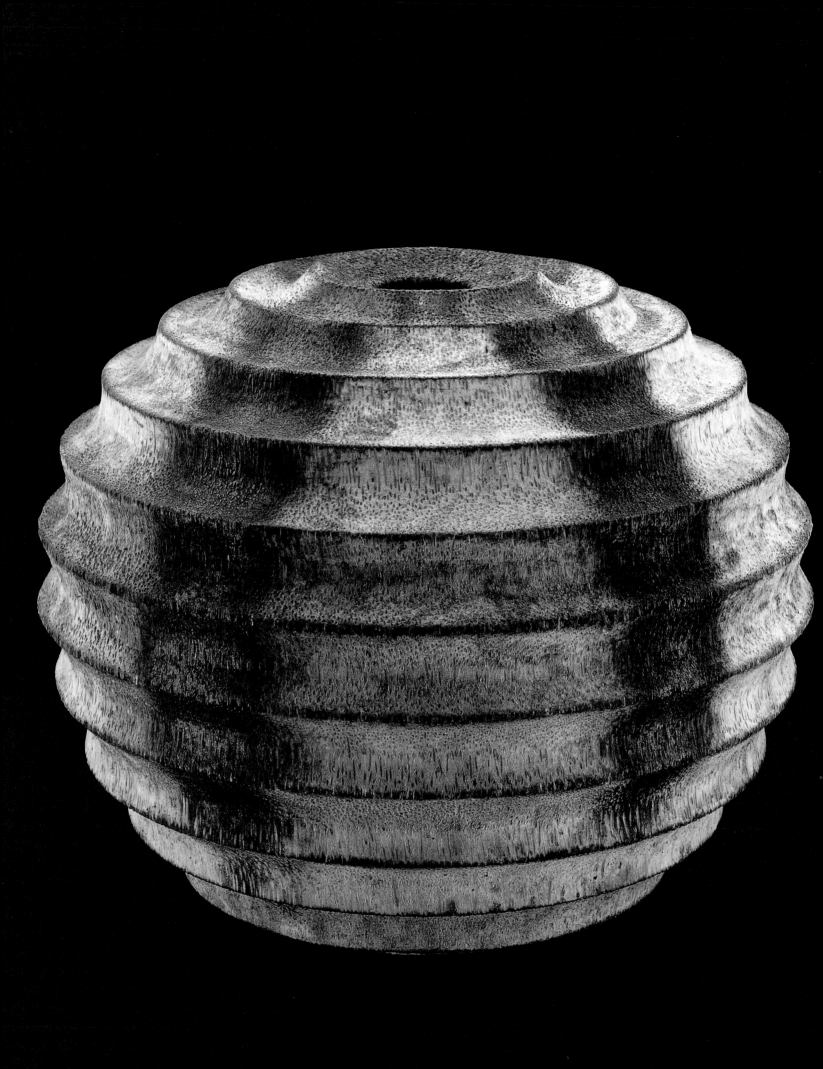

A Passion for Wood: The Jane and Arthur Mason Collection

Michael W. Monroe

> Few human activities provide greater personal gratification than assembling a collection. Excitement, romance, drama and sense of accomplishment and triumph are all present in collecting.[1]
>
> J. Paul Getty

The 123 works by forty-three artists gathered by Jane and Arthur Mason constitute one of the most significant collections of contemporary turned-wood objects in America today. Spanning the second half of the twentieth century, it is a collection that allows an examination of major North American and European turners and a meaningful investigation of both the motives and expressive poetic language of these artists. Immense pleasure is derived from experiencing the consistent high quality of concept, process, and object present in this esteemed collection, which invites the viewer to linger in contemplative appreciation of the inherent sensuality and beauty of the varied wood forms. The vast majority of the collection reflects the Masons' predilection for pieces formed primarily on the lathe rather than not, and for works by artists for whom the natural beauty of wood is to be cherished, not obliterated by artificial means.

The Masons' affinity for collecting has developed over a period of time. Paintings, prints, drawings, and sculptures by noted artists such as George Grosz, Käthe Kollwitz, Jacob Kainen, and George Segal have become an intimate part of their lives, significant contributions to the ambience of their home. Their choices reflect maturity and a keenness for selecting pieces that are articulate, purposeful, and original. These acts of commitment have brought personal joy and satisfaction to the Masons and have inspired in them a fundamental human phenomenon—the urge to collect.

The Masons' exposure to and passion for turned wood began with a 1986 visit to "The Art of Turned-Wood Bowls" exhibition at the Smithsonian Institution's Renwick Gallery of the National Museum of American Art. A traveling exhibition organized by the Arizona State University Art Museum, it featured the collection of Edward Jacobson, who subsequently donated his collection to ASU in 1989. Widely acknowledged "to be a touchstone, providing history and a standard for the field,"[2] the exhibition was a seminal force in developing a national awareness of the extraordinary artistic potential of lathe-turned wood. The Masons were captivated by the exhibition. One collection inspired the beginning of another, and the passion for collecting wood was shared and passed on.

With remarkable energy, diligence, and creativity, the Masons assembled a set of works that acknowledge that the process of wood turning requires far more than a handsome piece of wood and facile technical expertise. The turner working with a lathe is an artist whose discerning eye and intuitive spirit guide the form through its development. The Masons have formed personal friendships with many turners, and these relationships have deepened the Masons' insight into and appreciation for their collection. As strong advocates for the artists and the art of turning, the Masons have strengthened the symbiotic artist-patron relationship that has been so meaningful to them.

Todd Hoyer. *Untitled.* 1990. (See plate 36)

Rather than opting to collect numerous examples of the work of a given artist or a particular form, the Masons realized that an exceptional collection is distinguished by the priority given to quality over quantity. They wisely chose a deliberate direction for the acquisition of significant pieces by a broad range of turners. The result is a group of works that reflect imaginative variety, high quality of craftsmanship, and a diversity of expression within vessel and sculptural forms. There is a remarkable heterogeneity evident in the objects as a group: a universal material speaking with multiple voices.

As the Masons' collection evolved, a more demanding challenge presented itself. New questions emerged. How to successfully assimilate new pieces into the existing set? How to guide the refining and redefining of the collection's character? Each new piece entering the fold led the Masons to continually re-discover what they first assumed they knew intimately: their own collection. The fluid, ongoing process of evaluating and reevaluating the singular object and the collection as a whole has further developed the essential character of the collection today: eloquent integrity—integrity and awe that speak to the original form created by nature and show respect for the specific character of each type of wood.

As we experience the collection, we too are initiated into the subtle allure of wood. We not only appreciate the quality and beauty of the forms but also recog-nize that wood's appeal springs from the universal yearning to connect with an organic material. The rich texture, grain, and color of wood combine in a seam-less unity that resonates with life, inviting our touch and triggering thoughts concerning our own growth, mortality, and wholeness. The compelling surface qualities of the majority of pieces in the Mason collection exemplify the message of their forms. Rarely are surface treatments applied, but rather, they are singu-larly wedded to the object. Artist Robert Smithson observed a similar phenome-non when discussing a wood sculpture by Donald Judd: "An uncanny materiality inherent in the surface engulfs the basic structure. Both surface and structure exist simultaneously in a suspended condition. What is outside vanishes to meet the inside, while what is inside vanishes to meet the outside."[3]

Whether motivated by the formal classical qualities of bilateral symmetry, the informal dynamism of asymmetry, or the exploration of metaphorical expression, the vessel is the form favored by turners in the Mason collection. Except for Bob Stocksdale's *Salad Bowl with Servers,* Rude Osolnik's *Three Candlesticks,* Mark Sfirri's *Multi-axis Candlestick #1,* and eighteen sculptural pieces, the nonfunc-tional vessel form is dominant. Rather than creating pieces for strictly utilitarian purposes, these artists think of the vessel as a reality in and of itself, a form that leads to mysterious realms of poetic and spiritual meaning. It focuses attention on the dialectic of inside and outside, of the container and the contained. Within the vessel, suggestions arise of ancient forms continually made new in the hands of the artist. Historically, the perennial physical and emotional appeal of the vessel form rests in its intrinsic anthropomorphic references: mouth, lip, neck, shoulder, belly, and foot. For instance, the Greek amphora symbolized the perfec-tion of the human body through the skilled centering of clay. Looking at a cen-tered vessel, we are reminded of our own balancing and centering process. We sense a similar centering on the lathe and are enticed to follow the centering out to the contours of the form with our eyes and hands. Touching the grain brings reflection upon the tree's growth radiating out from a central core. We consider our own emotional, spiritual, and physical growth, and the human body. In the words of turner Michelle Holzapfel, "The three dimensional form is a body being experienced by another body. My eyes are the means by which I touch the form from a distance. My sight converges on the form and retrieves it into the space defined by my body."[4]

Home of Jane and Arthur Mason, front hall

A salient feature of the Mason collection is how well the objects document the perfect unity and subtle interaction of surface and structure. The physical properties of wood demand a constant dialogue between turner and material. This dialogue is similar to that established between a potter and the emerging clay form. For the potter throwing a vessel on a wheel, it is imperative to work with a predictably consistent and pure clay body that will allow the artist's mind, eye, and hand to focus singularly on giving shape to the spinning mass. In contrast, a wood turner has little assurance of predictability, purity, and uniformity from the material. Having been predetermined by natural processes beyond his or her control—soil condition, drought, disease, lightning, and fire—the turner's dialogue is dually complex. Act and react. Standing in front of the lathe, turners simultaneously act and react while listening to the internal messages that ultimately influence their final forms. Turner Virginia Dotson expresses the process succinctly: "We dream of perfect harmonies . . . chance intervenes."[5]

For many turners, their work begins with a physical response or relationship to a particular piece of wood. David Ellsworth expresses a sentiment shared by most of his peers.

> The material of wood is infinitely complex. Its various colors, patterns, textures, and tones provide a limitless palette with which one can explore in pursuit of a visual language in design. At the same time, its inherent tensions and varying states of decomposition present an extreme challenge to one's ability to physically work these materials. Part of the dialogue I have tried to establish involves melding these visual and physical properties, such that each object achieves a state of personal identity that is singular unto itself.[6]

Like Ellsworth, many turners share a heightened sensitivity to the complexity of wood. Similarly, art historian Herbert Read noted that forms created by sculptors working reductively with natural materials such as wood or stone evolve "under two compelling ideals—universal harmony and truth to materials. Universal harmony implies that form is determined by physical laws in the process of growth. Just as the crystal takes on a determinate form, or a leaf or shell, by the operation of physical forces on matter animated by an internal energy, so the work of art should take form as the artist's creative energy wrestles with the material of his craft."[7] While turners cannot always know the hidden patterns, colors, or textures of their material, they can, to varying degrees, exert control over the final outcome of volume and void. The surface patterns and treatments on the pieces in this collection confirm their makers' mastery of the material and their understanding of the relationships between technique, material, idea, and form.

The Mason collection represents a microcosm of the art of wood turning as it has developed over the past fifty years. Today's studio turners owe a deep debt of gratitude to the small group of what might be termed "first-generation" turners—James Prestini, Bob Stocksdale, Rude Osolnik, Mel Lindquist, and Ed Moulthrop. Their courageous and determined commitment essentially saved the art of wood turning from extinction. With little or no interaction among themselves, yet sharing an aesthetic that emphasized pure form and beautiful grain, they served as "lone voices in the wilderness"[8] recording "a quiet story"[9] that, when told to younger generations, would result in a surge of turners and the attention from museums, galleries, and collectors.

James Prestini's Mexican mahogany bowl (plate 92) epitomizes the classic ideals of extreme simplicity, beautifully grained patterns, thin and taut walls, and perfect proportion so highly valued by first-generation turners. Trained as an engineer, Prestini began turning his spare bowls according to the "form follows function" aesthetic philosophy espoused by the Bauhaus. Fellow turner Dale Nish

notes that Prestini was "the first to establish the artistic viability of wooden vessels, and his work established a firm dimension of credibility for the wooden bowl as an art form."[10] Through his writing and teaching, Prestini served as mentor to many of the younger turners represented in the Mason collection. David Ellsworth remembers him as one who was always developing images and concepts. "He was a master of consolidating ideas into the fewest number of words, almost as if he were stroking the language to discover its ultimate communicative potential."[11]

Bob Stocksdale eloquently captures the essence of the work of first-generation tuners: "I use the lathe as a turning tool to discover unusual grains and colors. Sometimes I change my initial design to eliminate a flaw or take advantage of any opportunity in a piece of wood."[12] Known for his unparalleled use of a wide range of exotic wood species to carry the surface decoration on his vessels, Stocksdale purposefully chooses formal and understated forms so as not to compete with the subtle and sometimes stunning patterns inherent in the wood. Despite delicately thin walls, diminutive size, and unassuming appearance, his vessels project a monumentality that is due primarily to his extraordinary talent for meshing color, pattern, texture, and form into a seamless whole. For more than fifty years, Stocksdale's oeuvre has reflected his faithful love of refined simple forms that belie technical complexity. He has made a lifetime searching for the most beautiful and graceful curves to describe his bowl's contours. "It is not my style to create a piece of art versus craft, or do what others are doing for the market." Never one to embrace the avant-garde, Stocksdale adds: "Nor do I turn to make a personal statement by creating a form like no other one. My focus is, and always has been, on the quality of the single turned bowl."[13]

Among the turners of the first generation, Rude Osolnik distinguished himself by a penchant for innovation. Unlike his contemporaries, who tended to develop subtle mutations of their signature styles, Osolnik preferred to explore a variety of techniques, tools, materials, and forms. His discovery in the 1940s of a nearly endless supply of wood in a mill helped fuel his insatiable appetite for the unusual. Craft writer Jane Kessler recalls: "The source was spurs—the part of a tree where it transitions from trunk to root—discarded from the logs that had been cut for veneer. Indeed, Rude's enthusiasm for castoffs inspired a generation of turners to abandon the quest for the perfect piece of wood in favor of the beauty to be found in imperfection."[14] In contrast to his fondness for turning asymmetrical vessels riddled with cracks, voids, and roughly textured edges, Rude also has a love of highly refined symmetrical forms, as evidenced by his elegant *Three Candlesticks* (plate 84) turned in tulipwood.

Mel Lindquist's discovery of spalted wood's distinctive linear patterning and his early use of natural and ruffled edges on turned burl bowls encouraged numerous younger woodworkers to experiment with the irregularities of unexpected form and pattern. Additionally, his training as an engineer enabled him to invent tools for accomplishing new techniques of hollowing vessels, allowing turners to create bottle forms with tall and narrow necks.

Perhaps it was his architectural training that predisposed first-generation turner Ed Moulthrop to conceptualize pure form, space, volume, and void on a grand scale. Moulthrop inventively applies industrial chemical solutions to wood, enabling him to turn vessels large enough for his grandchildren to hide in. Espousing the credo of his generation, Moulthrop explains his rationale: "I try to reveal the beauty hidden in wood and attempt to employ only those utterly simple shapes or forms that will display this beauty without distracting from it, or without imposing my own conflicting shapes or designs upon the beauty that is already there. I often say that each bowl already exists in the tree trunk and my job is simply to uncover it and take it out."[15]

The rich inheritance of innovative design and technical expertise from the first-generation turners has allowed younger artists to simultaneously respect tradition and expand upon their propensity to invent new and more personal languages of intermixed styles. Today's turners are more likely to consider using the lathe as only the first step of several toward a desired end. Some contemporary turners juxtapose wood with other materials, such as gold, sterling silver, baroque pearls, cloisonné enamel, barbed wire, and semi-precious stones. Another development is the introduction of color through paint and other means as a way to either contrast and heighten wood's natural beauty or, in some cases, to obliterate it entirely. Direct carving techniques to extend and enhance forms limited by the lathe have also appeared. For some turners, symbol, narrative, and metaphor have become essential components of their work. Other innovations include the application of industrial chemicals such as plastic resins and epoxies; the use of industrial power tools such as chain saws, sandblasters, and flexible drill shafts; the technique of segmenting and laminating woods to achieve precision surface decorations; and the introduction of multi-axis turning techniques.

A comparison of two candlesticks in the collection—one by Rude Osolnik and one by Mark Sfirri—illustrate two salient characteristics that document the change and growth in the development of turning in America—one technical and one aesthetic. Rude Osolnik's candlesticks were turned using a single axis from beginning to end. They not only reflect the dominant turning technique of their time but also mirror aesthetic influences of the period. Osolnik began turning his candlesticks following World War II and produced them throughout the 1950s. Their soaring and swelling forms reflect America's expanding economy, optimism, pride of accomplishment, and a primary aesthetic influence of the time—Scandinavian design. In contrast, Mark Sfirri's 1992 *Multi-axis Candlestick #1* (plate 98) breaks with tradition by using several different axes, thereby dramatically increasing the range of forms possible beyond the single-axis technique. His innovative use of several axes has encouraged today's turners to expand the formal repertoire. Sfirri's candlestick expresses, in formal terms, the unsettling nature of the 1990s, collapsing under its own weight, lacking order, buffeted simultaneously from numerous sides, and questioning its own future.

The Formal Vessel

Several turners in the Mason collection find joy in the creation of vessels that possess an elegant presence achieved through bilateral symmetry and a refinement of line, shape, and texture. Although a range of forms is evident, these vessels share the classical ideals of harmony, proportion, and balance. The artists who work in this vein exert sure and sensitive control over their forms, leaving nothing to chance.

Turner Ronald Kent purposefully limits his choice of wood to Norfolk Island pine, a species native to the Hawaiian Islands, where the artist's studio is located. His minimalist and classically inspired vessels are characterized by their extremely thin walls, narrow bases, and wide elliptical openings that gather light. Kent's elegant *Small Gold Translucent Bowl* (plate 49) seems to hover and glow from within as it reveals sublime passages of dark- and light-grained pattern, not unlike those found in tortoiseshell. "Nature has contributed rich spalting and exciting knot patterns to this log," he has commented. "I have sought a design that interacted with natural patterns to best advantage."[16] His innovative works achieve translucency from a material not usually thought of as having this quality. Although Kent works with tangible commodities—wood, lathe, and hand tools—it might be appropriate to suggest that his most important ally is an intangible one—light.

Home of Jane and Arthur Mason, living room

Bud Latven, Michael Shuler, Hans Joachim Weissflög, and William Hunter are but a few examples of turners for whom symmetry is paramount. The formal vessel provides these turners with a vehicle for the display of their technical prowess. For Shuler and Latven, the ability to control the final surface pattern and decoration is highly desired and constitutes the essence of their oeuvres. Rather than subjecting themselves to the unpredictability of pattern and grain that results from a single preexisting piece of wood, they take great pains to construct a block of wood composed of numerous small pieces glued together. This process allows them to exert tight control over the placement of color and grain patterns, thus integrating structure with design and surface decoration.

For his larger bowls measuring nine inches in diameter or less, Shuler has been known to construct a block with as many as 936 segments from a variety of species to achieve the desired effect. The bowl that emerges from this single piece of constructed wood reveals a complex geometric pattern on both the interior and exterior. Represented in the Mason collection is Shuler's bowl #592 (plate 103), constructed of maple segments bonded by glue dyed with orange pigment, which produces a pleasing overall surface design featuring an intricate geometry stunningly outlined in orange.

Bud Latven's love for controlled sequences of decoration is evident in his elegant *Triangles Series #1* (plate 54), a vase of diverse woods. An ebony foot and

lip serve to focus our attention on the dynamic surface pattern reminiscent of a woven basket. Subtle interspersed tulipwood triangles create contrapuntal accents in the rhythmic surface. Like kaleidoscopes, Shuler's and Latven's surfaces never fail to dazzle the eye.

Rude Osolnik and Virginia Dotson also find satisfaction in determining the final outcome of their vessels' patterns. Like Shuler and Latven, they preconstruct blocks of wood, but use a very different technique to achieve the strong linear patterns that characterize their work. Osolnik is credited with pioneering the artistic use of an unglamorous wood product commonly used in the construction industry—laminated Baltic birch plywood. The stacking and laminating of alternating layers of common plywood with precious walnut results in the dramatic contrast of light and dark that is the dominant feature of his *Untitled* vessel (plate 83). By juxtaposing these two very different woods in a single elegant vessel, Osolnik proved to the turning community that what mattered most was form—not the pedigree of species. Virginia Dotson, employing the laminating technique developed by Osolnik, turns elegantly fluid vessels whose large flaring circular apertures provide ample space for presenting her strong graphic patterns. Dotson's vessel *#90036* (plate 6), with its elasticlike stripes, is an outstanding example of her ability to orchestrate a playful visual exercise.

Turners William Hunter and Hans Weissflög create precision vessels whose exterior surfaces have been lathe-cut to create openings for the penetration of light. Their delicately turned exterior traceries illuminate our understanding of the ever-changing relationships between inside and outside, front and back, dark and light, solid and void. Hunter's exquisite *Fast Grass #1218* (plate 43) and *Kinetic Rhythms #1277* (plate 44) along with Weissflög's *Broken Through Ball Box* of mixed woods (plate 125) are tours de force of technical virtuosity. According to Hunter: "The sensuality of the wood's colors, patterns, and textures speak of timeless universal rhythms which repeat in all of nature." In his *Kinetic Rhythms* piece "the lush, beautifully finished wood provides a sensual and compelling complement to the curvilinear structure which resembles a DNA helix." In contrast to the restrained *Kinetic Rhythms #1277,* Hunter's *Fast Grass #1218* captures nature's powerful unleashing of young reeds of grass swirling in the wind. Speaking of the regenerative effect of the creative process, he states: "These pieces as art objects represent a microcosm of the universe and their purpose in my life is fundamentally meditative. Being able to devote time, emotion, intellect, and physical energy to the successful completion of a single piece is like rebirth each time."[17] As we move around Hunter's and Weissflög's works we see in and through them, discovering with amazement the rich and complex interplay of shifting patterns and shadows.

The Informal Vessel

As opposed to the turners who prefer the calculated geometry of formal and symmetrical vessels, a number of artists represented in the Mason collection create forms we might call informal. Rather than try to superimpose a rigid geometry onto the wood, the makers of informal vessels revel in the totally unpredictable nature of the material. Ever ready and alert, these artists welcome emerging knots, twigs, and burls as energizing opportunities for inspiration and expression. Responding to the irregular growth of the tree, they adapt the organic forms to the reality of the object developing in front of their eyes. Chance is a cherished component of the process for these turners, as it is a vital element in a tree's formation. Art historian Herbert Read discussed the term *informal* in his essay "The Disintegration of Form in Modern Art."

> Informality, by which we generally mean irregularity of form, is not
> necessarily chaotic. Nature is full of organic forms that are superficially

irregular. It may be that every form in nature . . . can be explained
as the result of an interaction of forces, electro-magnetic or cosmic—
that are measurable or predictable, but to the human eye, aided or not
by the microscope, many of the structures of matter have an informal
character. Such structures appeal to our aesthetic sensibility for rea-
sons which we cannot explain—they fascinate us. . . . The modern
artist can create forms that are irregular in this sense . . . [and] can
endow such forms with style and vitality. . . . Even if they record no
more than the graph of a gesture, in so far as it is not aimless and
therefore incoherent, is presumably significant: the calligraph records
a state of mind.[18]

The exquisite sensibility of David Ellsworth's forms grows out of his unusual
relationship with the wood itself. He addresses the enigmatic particularity of
wood with an attentive watchfulness. According to Ellsworth, part of the creative
dialogue involves melding "visual and physical properties, so that each object
achieves a state of personal identity that is singular unto itself. The result is a
collective body of work that is characterized by a broad variety of individual
statements, each having evolved as a direct reflection of myself at the time of
their making."[19] Working with wet, elastic materials and walls $3/16$ to $1/4$ inch
thick, he establishes a process that allows the inherent tensions within the mate-
rial to subtly distort the surface as it dries. As a result, his incredibly weightless
vessels seem to pulsate, to breathe from a hidden reservoir of contained energy,
as evidenced in his spalted beech *Untitled Vessel* (plate 12). Here, Ellsworth
achieved an absolute roundness, a withdrawing into the interior, with just a
slight upward curving motion at the ragged opening. He effectively used spalt
lines on the exterior surface to suggest a bird's wings embracing this completely
self-contained form. Ellsworth's understanding and mastery of technique are
fully absorbed into the integrity of the object's presence, its organic unity.

The misty and sandy shores of the San Juan Islands off coastal Northwest
Washington State and the parched landscape of the American Southwest serve
as inspirational guides for Michael Peterson's asymmetrical vessels. An examina-
tion of the titles of his pieces in the Mason collection reveal his unabashed love
for nature's effect on the environment, and on himself: *Wind Drift and Sea Drift,
Navaho Land, Landscape Series*, and *Tusk from the Coastal Series*. "These pieces
represent my approach and treatment of wood as both vessel and object. While
translating landscape imagery and exploring the natural forms of wood I try to
express the creative energy I find in the natural world. The sculpting forces of
nature such as wind, water, sun, and sand are celebrated in my use of surface
treatments."[20] Encountering his *Water Way Course, Landscape Series* (plate 90)
one cannot be sure if one has found a natural object scoured by the ravages of
time and weather or one created by man, or both, as in this piece. Peterson
explains, "I move and shape it and it in turn moves and shapes me."[21] By enhanc-
ing and highlighting the existing grain through turning, carving, bleaching, and
sandblasting, he heightens our power of observation and sensitizes our apprecia-
tion of form and contour as defined by the tree's growth rings.

By choosing tree burls, whether cherry, birch, maple, or elm, a turner can
almost guarantee that the end result will be a highly irregular and asymmetrical
creation that tells the story of knurled growth. Rude Osolnik and Mel Lindquist
were among the first to recognize and appreciate the expressive potential offered
by this often discarded part of a tree. Selecting a Manzanita burl for his *Natural
Top Bowl* (plate 63), Lindquist artfully incorporated protruding branch growths
as vessel handles. The roughness of natural-edged vessels turned from burls
increases their visual tension and drama, thus distancing them from the classi-
cally inspired vases in the collection.

Additional turners in the collection have used burls as an expressive way of reinforcing their ideas while revealing how elemental forces have shaped the life of trees. Turner Alan Stirt's *Where I Live* (plate 107) was created in response to the 1995 bombing of the Alfred P. Murrah Federal Building in Oklahoma City. The vessel's small-contained interior space is smoothly polished, warm, and receptive— a safe haven in contrast to the rough textured exterior of the knurled ceanothus burl. By wrapping the exterior with barbed wire and inserting a ring of nails in a gratelike screen covering the aperture, Stirt symbolically shields against outside destructive forces. "At best I can say that I make work that touches me emotionally or intellectually. I hope that it touches some others in a similar fashion."[22]

The Symbolic Vessel

Represented within the Mason collection are several artists who make use of symbolic language in their work, encouraging the viewer to move beyond form into connotative meaning. The form becomes a poetic experience and, as such, carries the ambiguity and the implication, the subtle charge of psychological inference. Paradoxically, the artist depends upon the materiality of the wood to move us into the language of the invisible: dreams, memories, and experiences. At the same time, the symbolic vessel requires from us a heightened awareness. We are asked to abandon our denotative formal perceptions and consider conceptual content. The symbolic vessel is a spirited space for daydreaming, imagining, and reimagining. It is not inert but alive. Its resonance provokes not one but many responses, not one but multiple questions.

Although David Ellsworth's *Man and the Forest Architecture: Mother and Teen* (plate 11) is a mere twelve inches in height, it brings us into the interior grandeur of archetypal space, into a contemplation of the tenuous and vulnerable dimensions of relationships. This pair of symbolic vessels evokes a multileveled response. We see the forms leaning toward one another but not touching. What is the implication of this gesture? We wander through the complexity of a forest where trees stand together in their solitary identity. The forest reminds us of architectural structures, and we rediscover our primal memories of architecture as womb and shelter. The thin, almost transparent membrane, the hollow core and its sensitized surface revealing the delicate tracery of spalting, speak gently but forcefully of the fragile interdependence we share emotionally and environmentally.

Michelle Holzapfel, who delights in learning from life experience, her domestic world, and natural forces, is motivated by those varied yet related interests. *Querus* (plate 27) presents a clustering of voluptuous and sinuous leaves buffeted by wind. They map the whirling wind's movement and invite us to consider the poetry of natural forces. The dynamism of separate leaves swirled together by invisible but strong air currents creates an interior space. We wonder—is the form an illusion? Will it vanish when the wind ceases? Her vibrant natural forms bring us to memories of an autumn walk, of being captivated by the wind's choreography.

Holzapfel's reverence for the domestic, for the sacred found within the ordinary, is apparent in her *Aegina Bowl* (plate 26). In contrast to the suspended movement suggested in the wind-whirled space of *Querus,* this hollow, rounded form rests majestically, open and receptive. The ceremoniously draped receptacle, simultaneously concealing and revealing a basket, is evocative of a Greek goddess wrapped in a pleated garment that captures the sensuality of her feminine form. The goddess reclines, receptive in her womanliness.

Like Holzapfel, Todd Hoyer's works explore the realms of personal and emotional responses to life's experiences. Two of his four works in the collection were created after his wife died tragically in an automobile accident. Hoyer's expres-

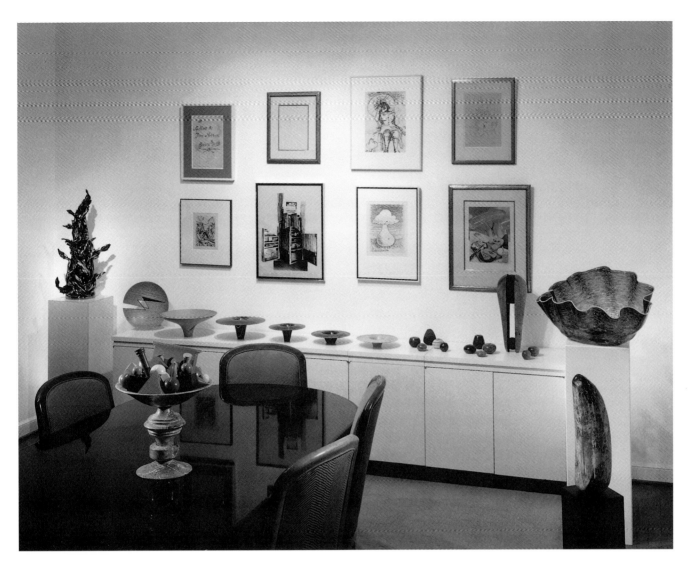

Home of Jane and Arthur Mason, dining room

sions of loss are powerfully portrayed in *Untitled* (plate 36) and *Hallowed Vessel Series* (plate 37). Their distinctive markings are the result of burning and slashing of the raw and vulnerable surfaces—gestures of anger searing into memory the loss of a loved one. When viewing *Untitled* from above, the burned image forms a darkened letter *X* centered directly over the vessel's most vulnerable feature—its opening. In *Hallowed Vessel Series* we are confronted with a silhouette of a vanished vessel—a poignant symbol of loss. Reverberating echoes of piercing sounds radiate in targetlike concentric rings from the void into the surrounding field, as in Edvard Munch's *The Scream*.

Symbolic of contained secrets, Po Shun Leong's *Pompeii* (plate 55) provokes multiple responses. A chalicelike vessel, the cup holds a wondrous microcosm of inspired intrigue. We have suddenly found ourselves in a three-dimensional Escher-like world where stairways lead to doors that open onto the sky. Its archaeological layering reveals a city, long buried in volcanic ash. According to the artist, "The sense of surprise is important. My boxes can't be seen all at once;

people keep saying, 'But wait—there's more!' Then you have to discover the more."[23] Perhaps if we pursue the circuitous paths, enter the architecture, and ponder the contained coded messages, we will decipher the object's enigmatic dreamlike content.

Sculpture

Conceive in depth.
Clearly indicate the dominant planes
Imagine forms as directed towards you;
all life surges from a center,
expands from within ourselves.[24]
 Auguste Rodin

Several objects in the Mason collection depart from the vessel motif in favor of free-form sculptural expression. The structural design of these objects is oriented toward the surrounding space rather than the contained interior. The implied dynamism of the sculptural object calls attention to the gesture and movement with which it was conceived.

 Throughout his three-decade career, Mark Lindquist has shown that like all other forms of art, turned-wood objects are human expressions, and that accident and immediacy are to be accepted as elements in the creative process. While Lindquist's early training in the fine arts accounts for some of his inspiration, he freely acknowledges the two iconoclastic sculptors David Smith and Peter Voulkos as important influences on his artistic development. It was the ceramic sculptor Voulkos, however, who provided the closer role model for what Lindquist hoped to achieve. Like Voulkos, Lindquist was trained as a painter-turned-potter, but rather than staying with clay, Lindquist gravitated to wood as his medium. He had hoped to revolutionize the field of wood turning as Voulkos did for clay by providing "crucial leadership for a medium in the throes of redefinition."[25] Lindquist drew parallels between the two disciplines and seized the opportunity to repeat the model, albeit twenty years later and in a different medium. "Until the late 1950s, pottery was pretty much what it had been for thousands of years: hollow clay forms, usually turned on a wheel and fired. Then along came Peter Voulkos. Gouging, slashing, stacking his forms, working on a monumental scale, he created a revolution in clay and became the first of a new breed of artists who cross all lines between art and craft."[26] Today, Lindquist has often been credited with being the first turner to synthesize the disparate and diverse influences of the craft field with that of the fine-arts world. His sculpture *Amalgam II* (plate 61) is a powerful testament to his ambitious attempts to push against the limits of craft, while respecting the traditions from which they spring. Art historian Robert Hobbs observes, "since he first began to rethink the major assumptions of the modern studio wood-turning movement, Mark Lindquist has made so many adventurous departures that the overall configuration of turned vessels has been dramatically changed."[27] Despite their remarkable innovations, Lindquist's pieces often look backward, with visual references to African drums, Indian arrowheads, ancient ceramics, and the early modern sculptures of Auguste Rodin, Constantin Brancusi, Jean Arp, and Henry Moore. Mark inventively uses the chain saw to achieve tempestuous harmonies in wood. The end results evoke spontaneous sequences of pattern, shape, texture, and surface treatment. With audacious abandon, Lindquist has created some of the most highly charged sculptural forms.

 For turners Robyn Horn and Stoney Lamar, the lathe represents one step among several used to create sculptural pieces. Or, they may go so far as to

eliminate the lathe altogether, as Horn did in *Narrow Spaces* (plate 30). The irregular character and rough texture on this thick slab of redwood burl are heightened by a carefully juxtaposed, smooth planar surface that serves as a foil to the precisely cut rectilinear aperture. Pierced with the aid of a chain saw, the inside edges of this opening have been painted black, focusing our attention on the crisp geometric shape. The contrast between precision cutting and the surrounding organic mass suggests the ominous conflict between man and nature.

Each of Stoney Lamar's three pieces in the Mason collection features his distinctive handling of form and surface, which results from using the lathe in an unorthodox way. Most objects are turned on the lathe using a single axis throughout the entire process. However, Lamar alters the process by stopping the lathe and remounting the wood in a different position on another axis. By repeating this technique numerous times, he achieves multiple and superimposed planar surfaces at oblique angles to one another. According to Lamar, this technique has allowed him great freedom.

> [I] transcend the round object and create a sense of image and movement that is suggestive of what I see while the object is being formed in my thoughts and on the lathe. As I adjust the work's axis and continue turning, new challenges and possibilities are constantly presented, thereby, allowing a subtractive process to become an intriguing way to construct an object. The resulting figurative, architectural, and abstract objects are an attempt to create balance and tension by juxtaposing asymmetrical and symmetrical elements.[28]

Richard Hooper, like turners Osolnik and Dotson, uses laminates of Baltic birch plywood to achieve strong linear patterns on his objects. But while Osolnik and Dotson explore the relationships between void and volume, and inside and outside patterning, which are intrinsic to the vessel form, Hooper chooses to shape solid sculptures that dismiss those relationships. *White Bipod* (plate 28) was conceived as two parallel cylindrical forms whose surface contours are fully described by the repetitive linear pattern of laminated wood. Hooper additionally applied thin washes of pigmented white stain to emphasize form over pattern, form over material. "This piece attempts to explore biomorphic archetypes in a futuristic idiom. I wanted to create a hybrid organic form in a mechanistic vein. It was influenced by my interest in science fiction imagery."[29]

The dilemma shared by all craftsmen who work in wood is that their work is often judged solely by the beauty of the material. However, all the artists in this collection have transcended the mere beauty of their material to attain an unsurpassed level of form, concept, and intellect. These artists have endowed their objects with qualities beyond wood's natural state in order to satisfy the mind, hand, eye, and spirit.

As the Mason collection enters its permanent home at the Mint Museum of Craft + Design, a dramatic shift occurs. The work moves from the intimacy of the private dwelling to the public domain. A gift is given. A passion is shared. Prestini's philosophical comment comes to mind: "The best way to honor is to share."[30] Jane and Arthur Mason's collection began with and evolved from a love of wood. The gift of their collection, like the concentric growth rings of a tree, now moves out from the private center into the public sphere to inspire and delight all who see it.

Notes

Notes to Chapter 1

1. Robert Hobbs, *Mark Lindquist: Revolutions in Wood* (Richmond, VA: Hand Workshop Art Center, 1995), 10.

Notes to Chapter 2

1. For the concept of the museum as people's palace, see Nathaniel Burt, *Palaces for the People: A Social History of the American Art Museum* (Boston: Little Brown, 1977).
2. The relationship between royal turning and cosmology was developed by Dr. Mogens Bencard, Director of Danish Royal Collections, in his paper "Royal Turning: Objects Turned by Members of the Danish Royal Family, 1600–1800," delivered at the American Craft Museum, January 29, 1998. See also Géza von Habsburg, *Princely Treasures* (New York: The Vendome Press, 1997).
3. Notable in this regard is Tran Turner, et al., *Expressions in Wood: Masterworks from the Wornick Collection* (Oakland, CA: The Oakland Museum of California, 1996).
4. Among the few artists in the woodturning field who have been the subject of a monograph are Mark Lindquist, Rude Osolnik, and James Prestini.
5. Edward S. Cooke, "Turning Wood in America: New Perspectives on the Lathe," in Turner, et al., *Expressions in Wood*, 39.
6. Cited in Alfred H. Barr, et al., *Weimar Bauhaus 1919–1925* (New York: Museum of Modern Art, 1938), 27. Prestini's involvement with Bauhaus principles was likely reinforced when the New Bauhaus was based in Chicago from 1937 to 1946, a period that corresponded with Prestini teaching at Chicago's Institute of Design at Illinois Institute of Technology, from 1939 to 1946.
7. Robert Hobbs, *Mark Lindquist: Revolutions in Wood* (Richmond, VA: Hand Workshop Art Center, 1995), 10.
8. Ceramic historian Garth Clark, among others, has openly lamented this worship of the handmade in crafts, stating, "If we [the craft fields] are going to grow then there cannot be a rule that says if you don't believe in the handmade you are a heathen." Interview with the author, June 23, 1998.
9. Duchamp's ready-made *Fountain* (1917) was a urinal turned upside down and signed R. Mutt, perhaps a reference to the comic-strip characters Mutt and Jeff or to the then-prominent manufacturer of bathroom fixtures, Richard Mott.
10. Pierre Cabanne, *Dialogues with Marcel Duchamp* (New York: Viking Press, 1971), 80.
11. Ibid., 16.
12. John Ruskin, *The Lamp of Beauty: Writings on Art* (London: Phaidon Press, 1995), 265–66.
13. Ibid., 266.
14. Cited in Albert LeCoff, *Lathe-Turned Objects: An International Exhibition* (Philadelphia: The Wood Turning Center, 1988), 149.

15. Ibid., 147.
16. Ibid., 42.
17. John Perreault, "Turned On: Toward an Esthetic of the Turned-Wood Vessel," in Turner, et al., *Expressions in Wood*, 36.
18. Cited in Stephen Hogbin, et al., *Curators' Focus, Turning in Context* (Philadelphia: The Wood Turning Center, 1997), 112.
19. LeCoff, 146.
20. Oscar Wilde, "The Decay of Lying," *The Complete Works of Oscar Wilde* (New York: Harper & Row, 1989), 978.
21. For the role of chance in post-World War II American art, see, among others, Helen Westgeest, *Zen in the Fifties: Interaction in Art Between East and West* (Amsterdam: Waanders, 1997).
22. Cabanne, 46
23. LeCoff, 145.
24. Cited in Edward Jacobson, et al., *The Art of Turned-Wood Bowls* (New York: E. P. Dutton, 1985), 32.
25. Ruth Greenberg, unpublished artist's statement.
26. Turner, et al., 120.
27. The International Turning Exchange program at Philadelphia's Wood Turning Center is designed to foster collaboration between participants and has resulted in several collaborative partnerships, including the long-standing union of Todd Hoyer and Hayley Smith, who were residents in 1985.
28. James Hillman, "Plural Art," in Hillman, et al., *Team Spirit* (New York: Independent Curators Incorporated, 1991), 60.
29. Ibid., 61.
30. Ibid., 63.
31. Cited in Hobbs, 13.
32. Quoted in "Passion and Reason Reconciled," *Michelle Holzapfel* (New York: Peter Joseph Gallery, 1991), unpaginated exhibition catalogue.
33. Among the artists who openly recognize Barbara Hepworth and other early organic modernist sculptors as an inspiration are Michelle Holzapfel, Robyn Horn, Stoney Lamar, Mark Lindquist, and Jack Slentz.
34. From David Nash, *Wood Primer* (San Francisco: Bedford Press, 1987). Cited in *Collection Extra: Three Forms–Three Cuts* (Omaha, NE: Joslyn Museum of Art, 1995).
35. Michael Perlman, *The Power of Trees: The Reforesting of the Soul* (Dallas: Spring Publications, 1994), 4.
36. Andreas Feininger, *The Tree* (New York: Rizzoli, 1991), 7.
37. John Fowles, *The Tree* (Boston: Little, Brown, 1979), unpaginated.
38. Ibid.
39. Wilde, 986.
40. E. T. Cook and Alexander Wedderburn, eds. *The Works of John Ruskin* (London: George Allen, 1904), vol. 5, 333.
41. Quoted in LeCoff, 145.
42. Cited in Gaston Bachelard, *The Poetics of Space* (Boston: Beacon Press, 1969), 232.
43. Stephen Hogbin, "Turning Full Circle," *Fine Woodworking* no. 21 (March/April 1980): 56.
44. Quoted in LeCoff, 148.
45. Ibid., 144. Also cited in Hogbin, et al., *Curators' Focus*, 97.

46. Loren Madsen, *Statistical Abstract: Pipes*, 1998. This work consists of two turned poplar columns; the small pipe represents (from bottom to top) the share of the United States aggregate income received by the middle 20 percent of families from 1970 to 1995, and the large pipe represents (from bottom to top) the share of the United States aggregate income received by the top 5 percent of families from 1970 to 1995.
47. Rudolph Arnheim, *The Split and the Structure, Twenty-Eight Essays* (Berkeley: University of California Press, 1996), 16.
48. Arnheim, *The Power of the Center: A Study of Composition in the Visual Arts* (Berkeley: University of California Press, 1982), vii.
49. James Elkins, *The Object Stares Back, On the Nature of Seeing* (New York: Harcourt, Brace & Company, 1996), 125.
50. Ibid., 128.
51. Ibid., 129.
52. Edmund Sinnott, *The Problem of Organic Form* (New Haven: Yale University Press, 1963), 6–7.
53. M. C. Richards, *Centering: In Pottery, Poetry and the Person* (Middletown, CT: Wesleyan University Press, 1989), 15.
54. Herbert Read, *The Origins of Form in Art* (New York: Horizon Press, 1965).
55. Jack Burnham, *Beyond Modern Sculpture* (New York: George Braziller, 1968), 100. Burnham made this observation in relation to the views of zoologist D'Arcy Wentworth Thompson as expressed in his book *On Growth and Form* (Cambridge, England: Cambridge University Press, 1959).
56. Siegfried Giedion, *Mechanization Takes Command, A Contribution to Anonymous History* (New York: W. W. Norton, 1948), 3.
57. Ibid., 721.
58. *Masterworks* (New York: Peter Joseph Gallery, 1991), 28.
59. Bachelard, 234.
60. Richards, 6.
61. For more on mandalas see José and Miriam Argüelles, *Mandala* (Boston and London: Shambhala, 1985); and Denise Patry Leidy, *Mandala: The Architecture of Enlightenment* (New York: Asia Society Galleries, 1997).

Notes to Chapter 3

1. Arthur Warren Schultz, *In Praise of America's Collectors* (Santa Barbara, CA: Santa Barbara Art Museum, 1977), 41.
2. Heather Sealy Lineberry, *Turned Wood Now: Redefining the Lathe-Turned Object IV* (Tempe, AZ: Arizona State University Art Museum, 1977), 10.
3. Robert Smithson, *American Sculpture of the Sixties*, Maurice Tuchman, ed. (Los Angeles, CA: Los Angeles County Museum of Art, 1967), 10.
4. Michelle Holzapfel, "Reflections of a Perpetual Student," *Turning Points* 10, no. 1 (spring 1977): 18.
5. Virginia Dotson, quoted in *Out of the Woods: Turned Wood by American Craftsmen* (Mobile, AL: The Fine Arts

Museum of the South, 1992), 26.
6. David Ellsworth, from a grant application submitted to the PEW Fellowships in the Arts, The University of the Arts (Philadelphia, PA, June 1999).
7. Herbert Read, *A Concise History of Modern Sculpture* (New York: Frederick A. Praeger, Inc., 1964), 80.
8. David McFadden, quoted in *The New York Times* March 7, 1999, 46.
9. Ibid.
10. Dale L. Nish, quoted in Edward Jacobson, *The Art of Turned-Wood Bowls* (New York: E. P. Dutton, Inc., 1985), 10.
11. David Ellsworth, quoted in *Turning Points* 6, no. 2 (summer/fall, 1993), 3.
12. Bob Stocksdale, quoted in *Out of the Woods*, 72.
13. Ibid.
14. Jane Kessler, "A Great Deal of Depth: A Portrait of Rude Osolnik," *American Woodturner* (December 1994): 22.
15. Ed Moulthrop, quoted in Jacobson, 53.
16. Ron Kent, quoted in Hogbin, et al., *Curators' Focus: Turning in Context* (Philadelphia, Pa: Wood Turning Center, Inc., 1997), 90.
17. William Hunter, quoted in ibid., 37.
18. Read, *The Origins of Form in Art* (New York: Horizon Press, 1965), 177–78.
19. David Ellsworth, from a grant application submitted to the PEW Fellowships in the Arts.
20. Michael Peterson, quoted in Alan DuBois, *Moving Beyond Tradition: A Turned-Wood Invitational* (Little Rock, AR: The Arkansas Arts Center Decorative Arts Museum, 1997), 48.
21. Michael Peterson, quoted in *Out of the Woods*, 64.
22. Alan Stirt, quoted in *Curators' Focus*, 142.
23. Po Shun Leong, quoted in Tony Lydgate, *Po Shun Leong: Art Boxes* (New York: Sterling Publishing Co., Inc., 1998), 9.
24. Quoted in Read, *A Concise History of Modern Sculpture*, 14.
25. Garth Clark, *American Ceramics: 1876 to the Present* (New York: Abbeville Press, 1979), 102.
26. Rose Slivka, *Peter Voulkos: A Dialogue with Clay* (New York: New York Graphic Society in association with American Craft Council, 1978), book jacket flap.
27. Robert Hobbs, *Mark Lindquist: Revolutions in Wood* (Richmond, VA: Hand Workshop Art Center, 1995), 22.
28. Stoney Lamar, quoted in DuBois, 34.
29. Richard Hooper, quoted in *Curators' Focus*, 82.
30. *Turning Points* 6, no. 2 (summer/fall 1993), 3.

Catalogue of the Exhibition

1. Anthony Bryant. *Untitled*. 1988. Figured sycamore, lathe-turned, painted. 5 x 11 x 11" (12.7 x 27.94 x 27.94 cm). Mint Museum of Craft + Design. Gift of Jane and Arthur Mason

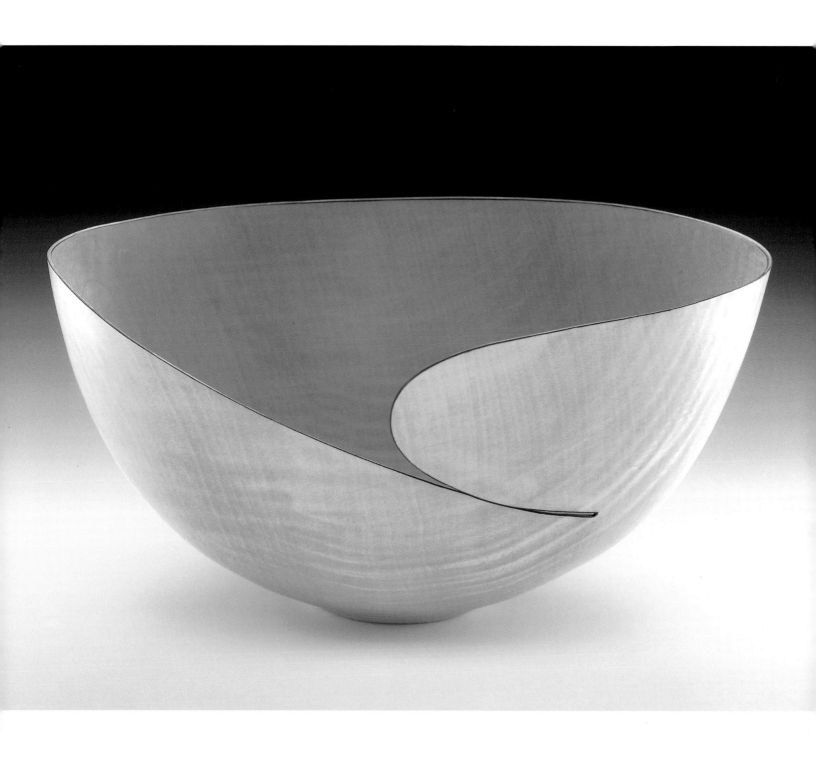

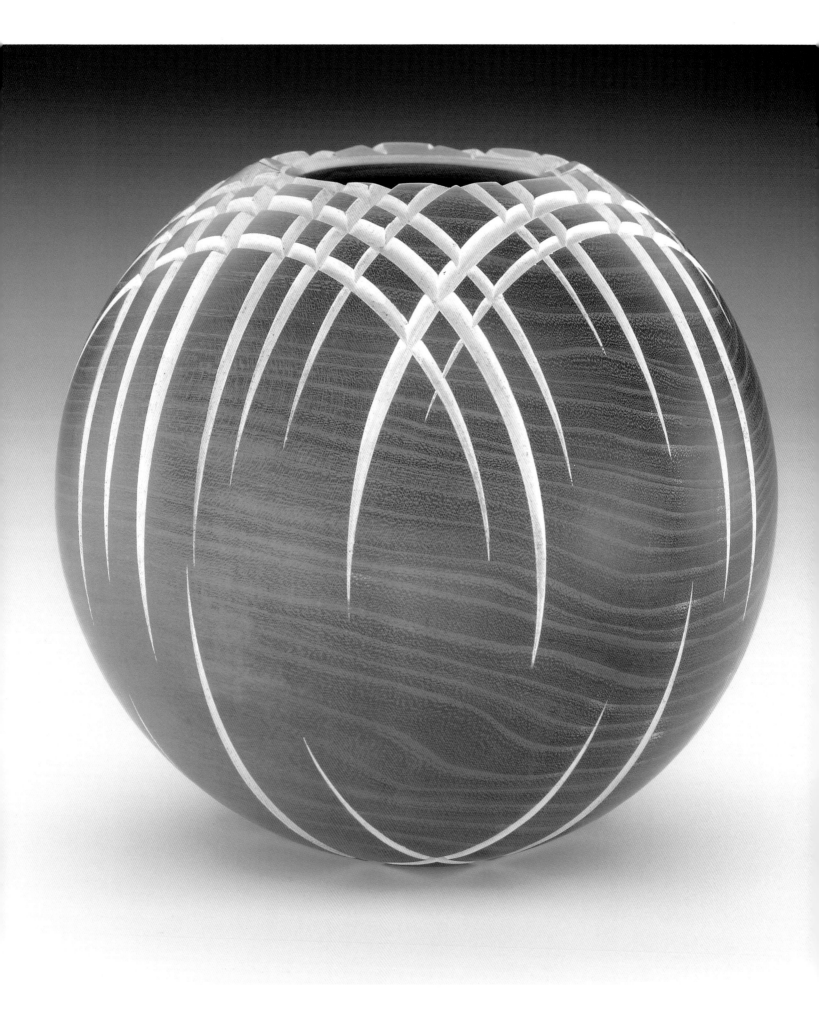

2. Christian Burchard. *Between Heaven and Earth*. 1996. Osage orange,
 lathe-turned, incised. 5 x 5 x 5" (12.7 x 12.7 x 12.7 cm). Mint Museum of
 Craft + Design. Gift of Jane and Arthur Mason

3. Christian Burchard. *Baskets*. 1997. Manzanita, 14 parts, lathe-turned, scorched. From ½ x ½ x ½" to 5 x 5 x 5" (1.3 x 1.3 x 1.3 cm to 12.7 x 12.7 x 12.7 cm). Mint Museum of Craft + Design. Gift of Jane and Arthur Mason

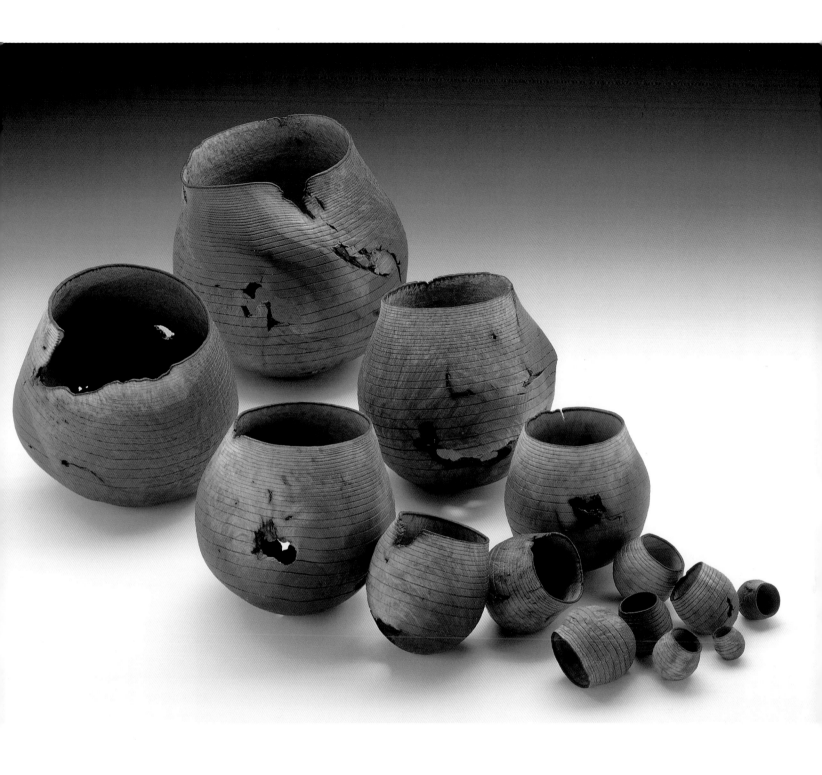

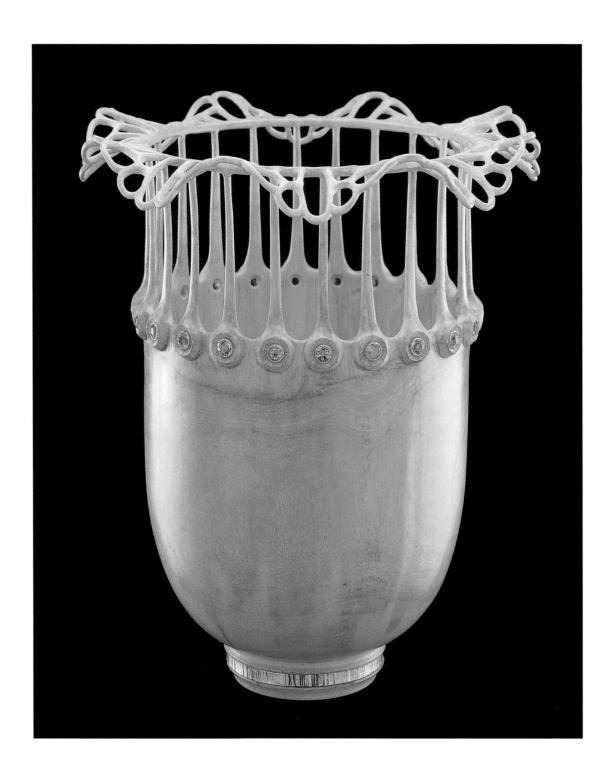

4. Frank E. Cummings III. *Citrus-Citrine*. 1989. Orangewood, 22.5 mm citrine,
 18 karat gold, lathe-turned, carved. 7¼ x 6¼ x 6¼" (18.4 x 15.9 x 15.9 cm).
 Mint Museum of Craft + Design. Gift of Jane and Arthur Mason

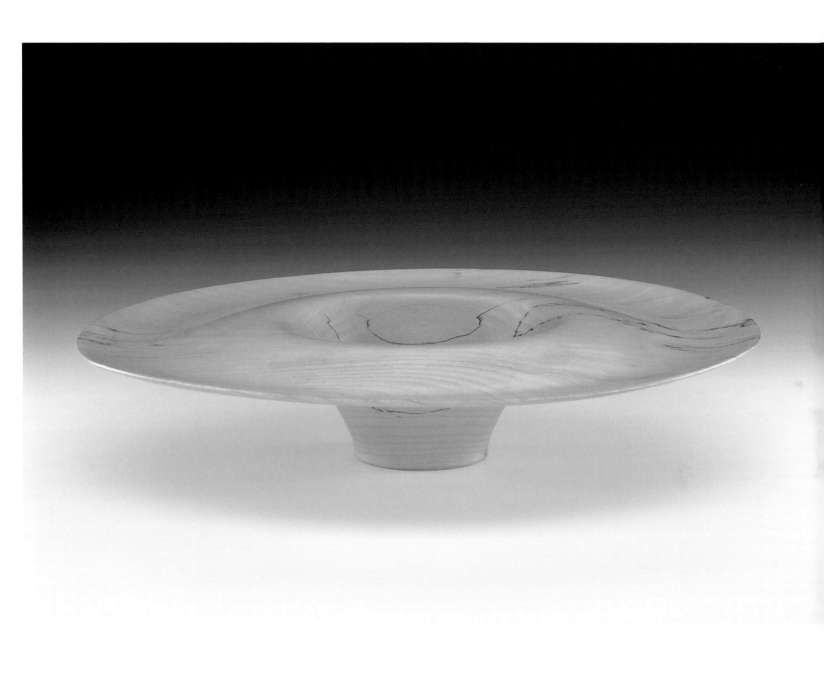

5. Virginia Dotson. *#86123*. 1986. Spalted maple, lathe-turned. 1¾ x 10 x 10"
 (4.45 x 25.4 x 25.4 cm). Mint Museum of Craft + Design. Promised Gift of
 Jane and Arthur Mason

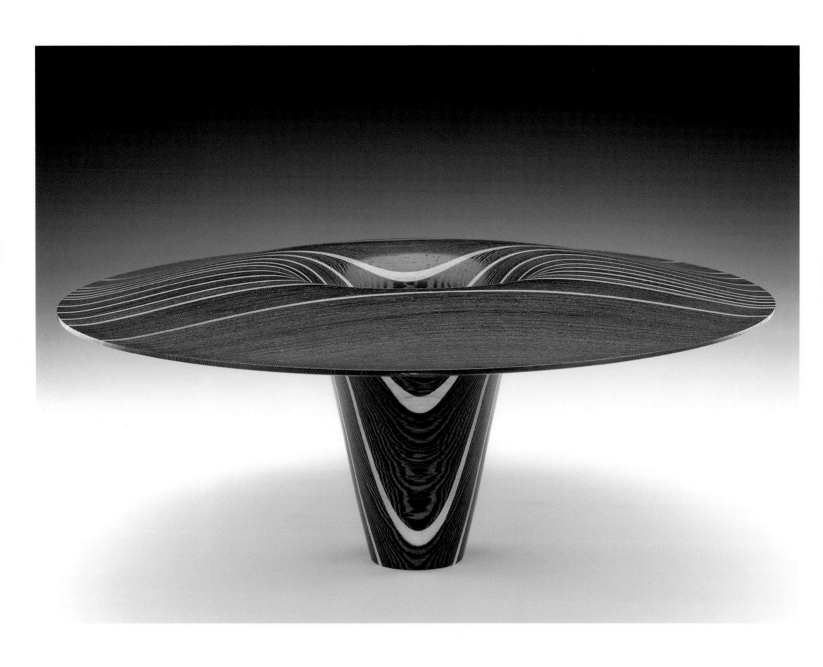

6. Virginia Dotson. *#90036*. 1990. Wenge, maple, myrtle, laminated, lathe-turned. 4⅓ x 12 x 12" (11 x 30.5 x 30.5 cm). Mint Museum of Craft + Design. Promised Gift of Jane and Arthur Mason

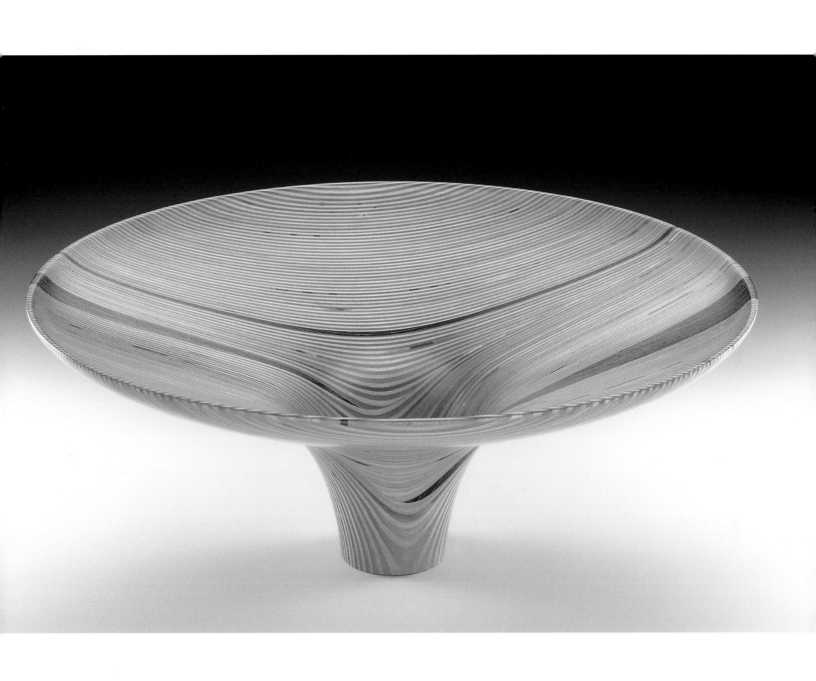

7. Virginia Dotson. *#90041*. 1990. Baltic birch, wenge, walnut, laminated, lathe-
turned. 5½ x 14¼ x 14¼" (14 x 35.2 x 35.2 cm). Mint Museum of Craft +
Design. Gift of Jane and Arthur Mason

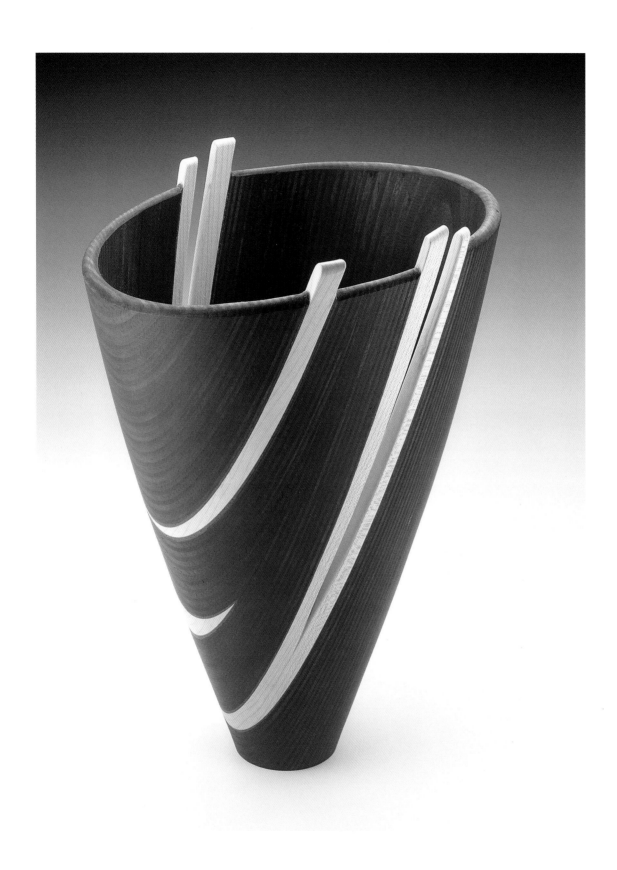

8. Virginia Dotson. *Night Music #95092*. 1995. Maple, birch, laminated, lathe-turned, dyed. 11¼ x 8¾ x 8¾" (28.6 x 22.2 x 22.2 cm). Mint Museum of Craft + Design. Gift of Jane and Arthur Mason

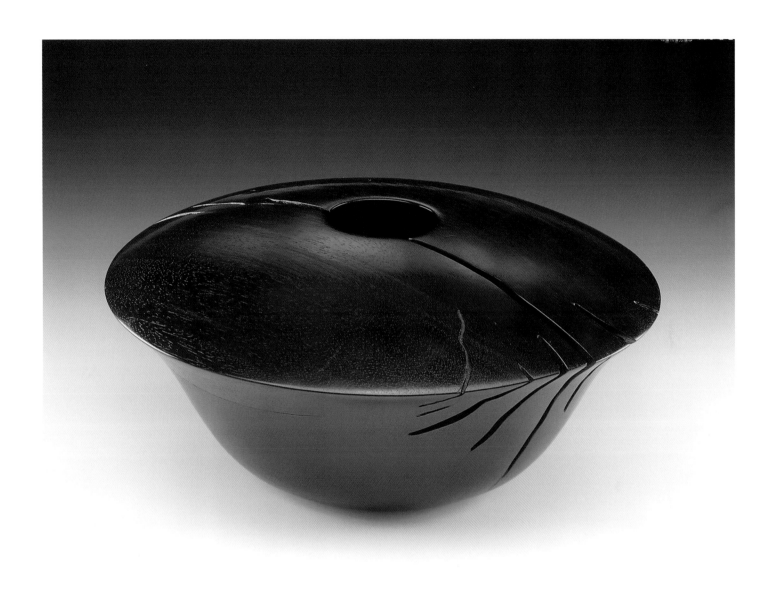

9. David Ellsworth. *Untitled Vessel*. 1978. Gabon ebony, lathe-turned, carved.
 4 x 8½ x 8½" (10.2 x 21.6 x 21.6 cm). Mint Museum of Craft + Design.
 Promised Gift of Jane and Arthur Mason

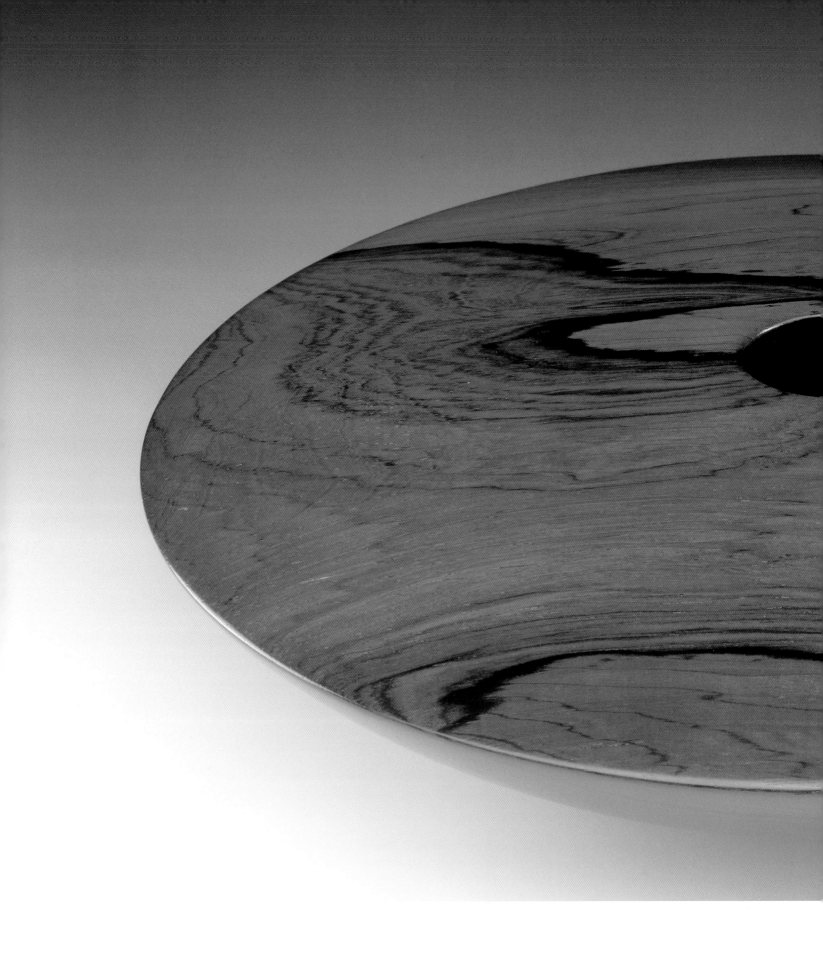

10. David Ellsworth. *Untitled Vessel.* 1979. Brazilian rosewood, lathe-turned.
2 x 8¾ x 8¾" (5.1 x 22.2 x 22.2 cm). Mint Museum of Craft + Design.
Gift of Jane and Arthur Mason

11. David Ellsworth. *Man, and the Forest Architecture: Mother and Teen*. 1982. Spalted sugar maple, lathe-turned. *Mother:* 12½ x 12 x 9" (31.8 x 30.5 x 22.9 cm); *Teen:* 12 x 5 x 4¼" (30.5 x 12.7 x 10.8 cm). Mint Museum of Craft + Design. Gift of Jane and Arthur Mason

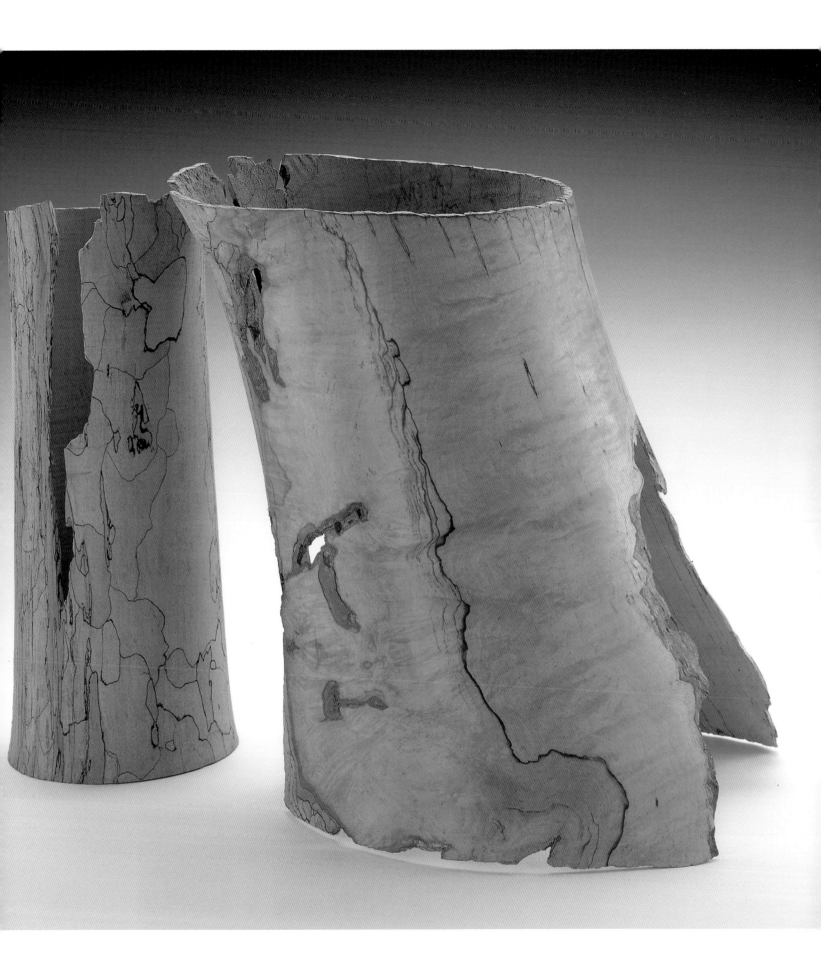

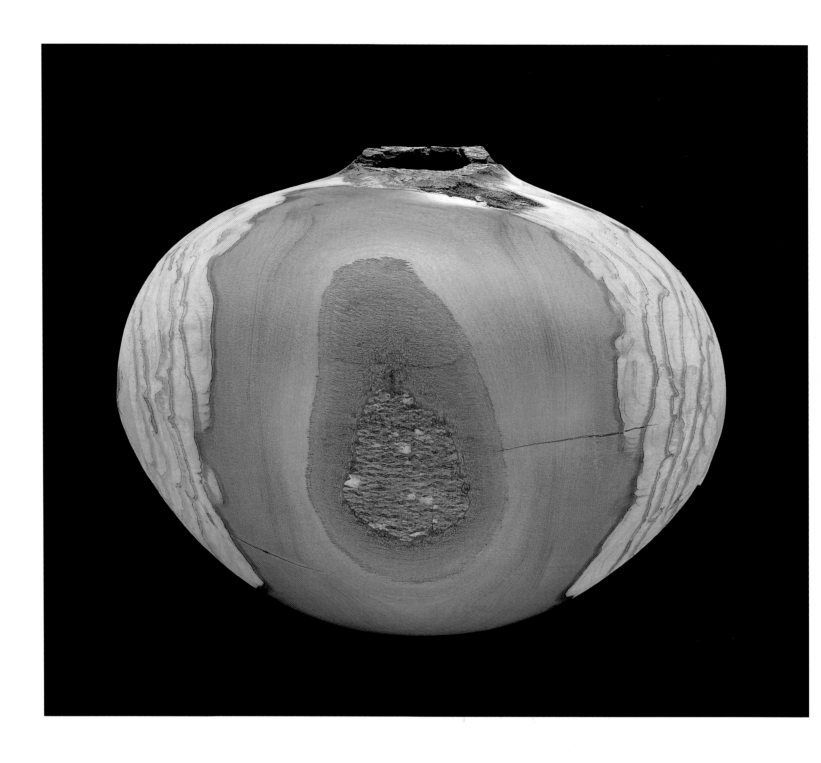

12. David Ellsworth. *Untitled Vessel*. 1987. Spalted beech, lathe-turned.
14 x 19 x 19" (35.6 x 48.3 x 48.3 cm). Mint Museum of Craft + Design.
Gift of Jane and Arthur Mason

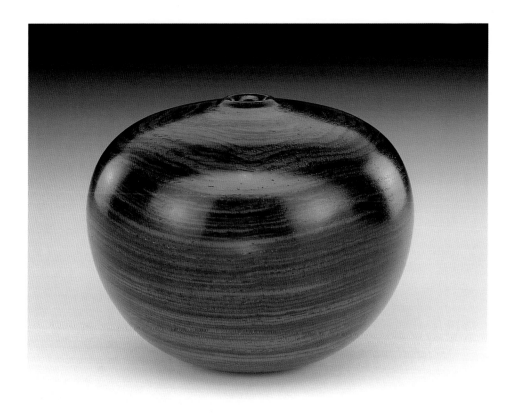

13. David Ellsworth. *Untitled Vessel*. 1989. Cocobolo rosewood, lathe-turned.
2½ x 3¼ x 3¼" (6.4 x 8.3 x 8.3 cm). Mint Museum of Craft + Design. Gift of
Jane and Arthur Mason

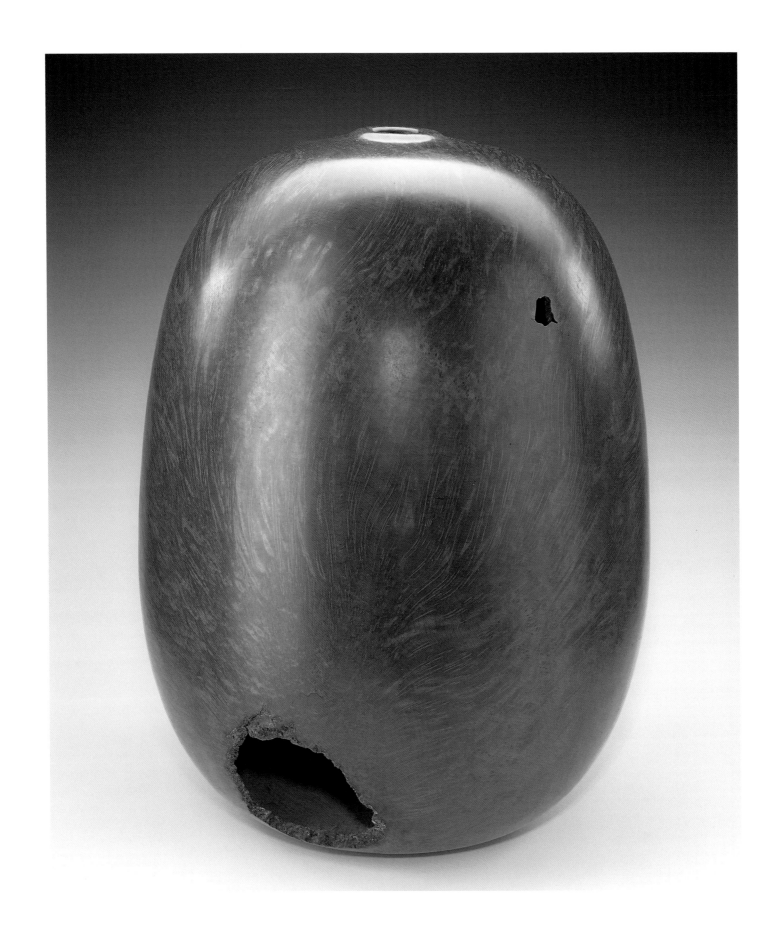

14. David Ellsworth. *Signature Bowl #4*. 1989. Redwood lace burl, lathe-turned.
22 x 15 x 15" (55.9 x 38.1 x 38.1 cm). Mint Museum of Craft + Design.
Gift of Jane and Arthur Mason

Clockwise from top:

15. David Ellsworth. *Spirit Vessel*. 1997. Grassfree, lathe-turned. 3½ x 3 x 3" (8.9 x 7.6 x 7.6 cm). Mint Museum of Craft + Design. Gift of Jane and Arthur Mason

16. David Ellsworth. *Spirit Vessel*. 1992. Spalted sycamore, lathe-turned. 2½ x 3 x 3" (6.4 x 7.6 x 7.6 cm). Mint Museum of Craft + Design. Gift of Jane and Arthur Mason

17. David Ellsworth. *Spirit Vessel*. 1998. Cocobolo rosewood, lathe-turned. 2¼ x 2 x 2" (5.7 x 5 x 5 cm). Mint Museum of Craft + Design. Promised Gift of Jane and Arthur Mason

18. David Ellsworth. *Spirit Vessel*. 1991. Brazilian tulipwood, lathe-turned. 1½ x 2¼ x 2¼" (3.8 x 5.7 x 5.7 cm). Mint Museum of Craft + Design. Gift of Jane and Arthur Mason

19. David Ellsworth. *Spirit Vessel*. 1991. Cocobolo rosewood, lathe-turned. 2¼ x 2¾ x 2¾" (5.72 x 7 x 7 cm). Mint Museum of Craft + Design. Gift of Jane and Arthur Mason

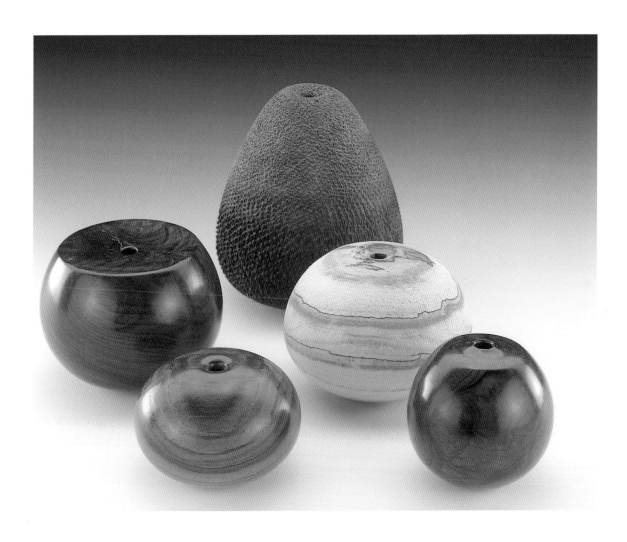

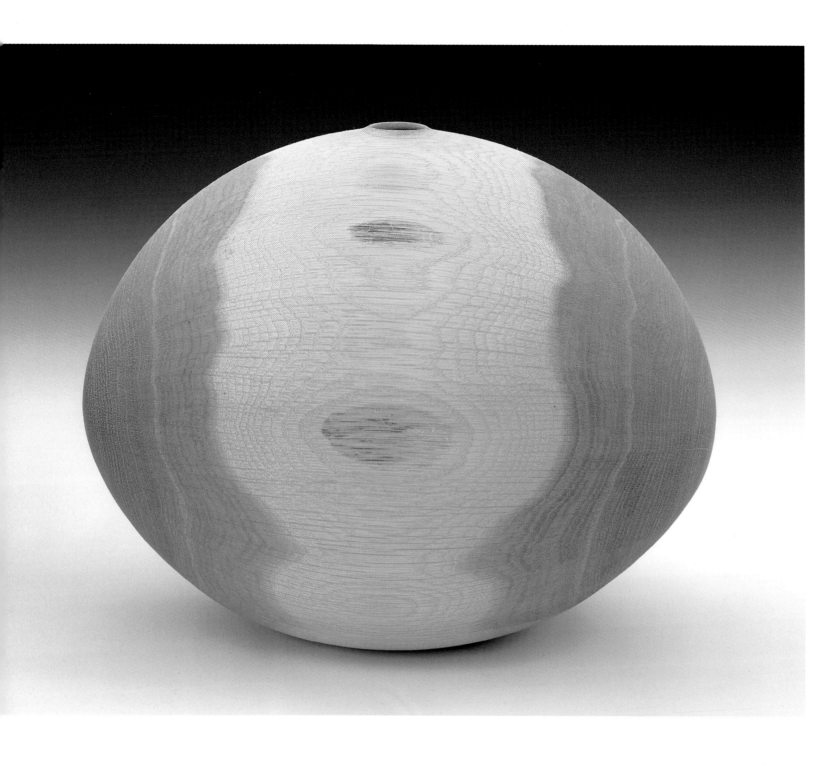

20. David Ellsworth. *Oak Pot*. 1994. White oak, lathe-turned. 8 x 9 x 9"
(20.3 x 22.9 x 22.9 cm). Mint Museum of Craft + Design. Gift of Jane
and Arthur Mason

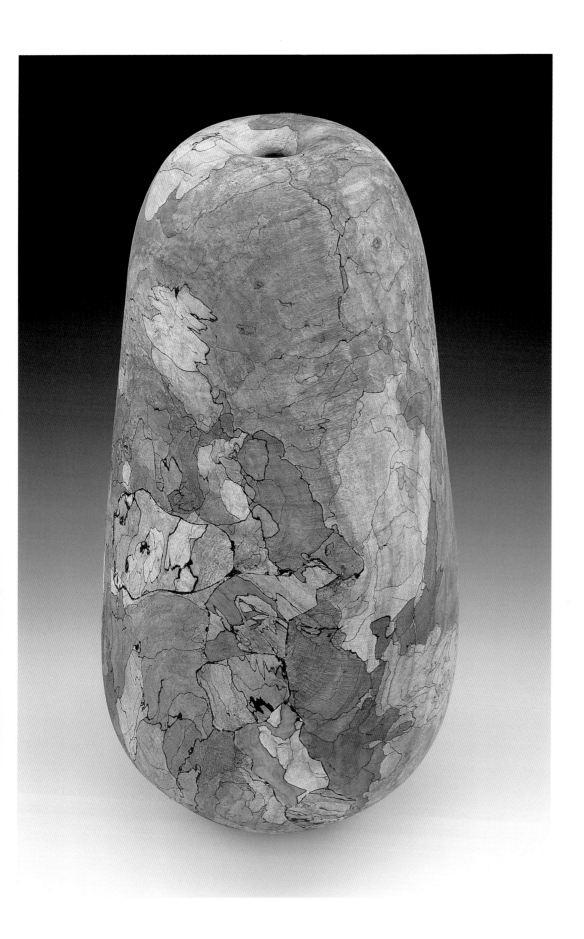

21. David Ellsworth. *Homage Pot #7.* 1998. Spalted sugar maple, lathe-turned.
15 x 7¼ x 7¼" (38.1 x 18.4 x 18.4 cm). Mint Museum of Craft + Design.
Promised Gift of Jane and Arthur Mason

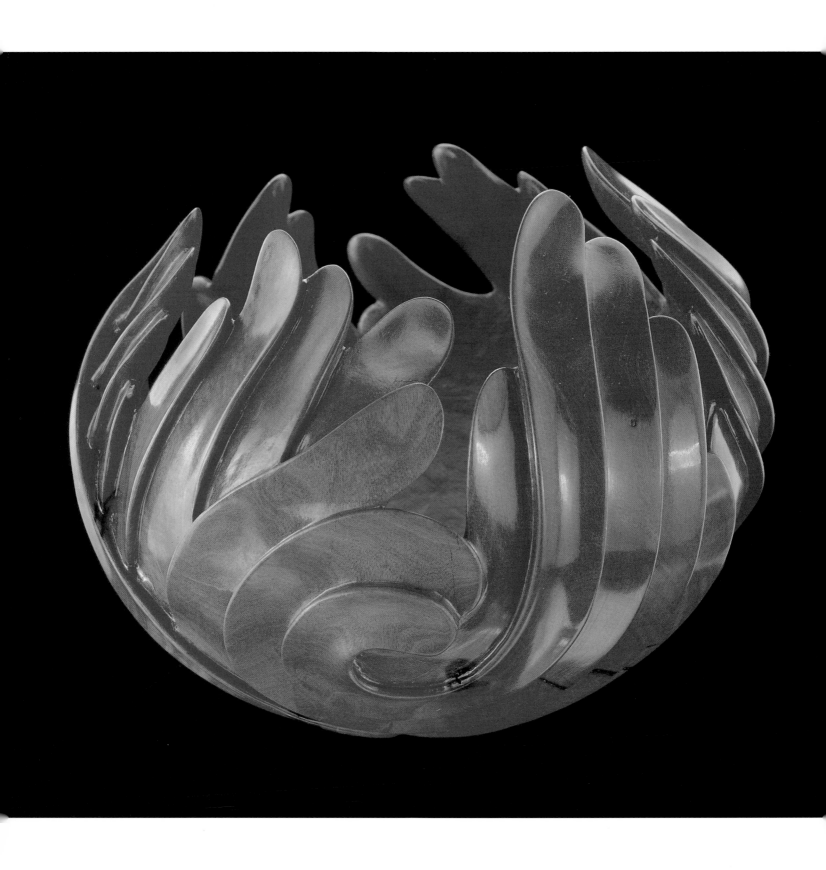

22. Ron Fleming. *Firebird*. 1997. Pink ivorywood, lathe-turned, carved.
5½ x 6½ x 6½" (14 x 16.5 x 16.5 cm). Mint Museum of Craft + Design.
Gift of Jane and Arthur Mason

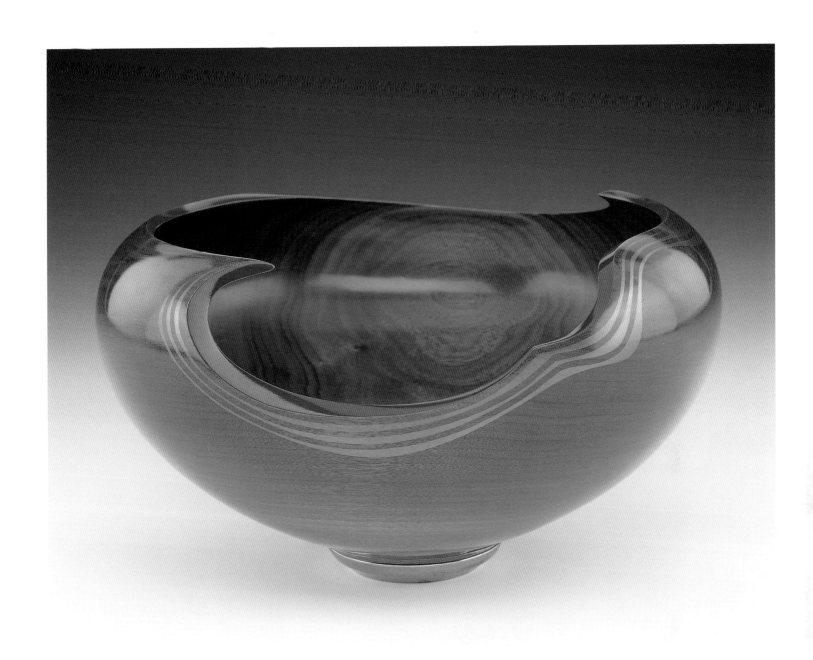

23. Giles Gilson. *Windy Day*. 1989. Walnut, brass, lathe-turned, pearlescent lacquer. 7 x 12 x 12" (17.8 x 30.5 x 30.5 cm). Mint Museum of Craft + Design. Promised Gift of Jane and Arthur Mason

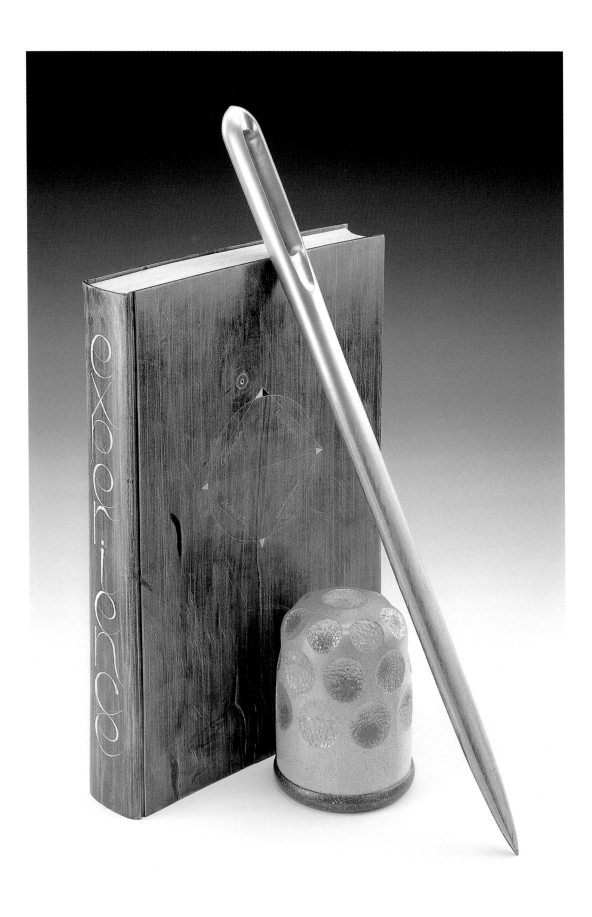

24. Stephen Hogbin. *Experience*. 1995. *Book:* Maple, carved, painted; *Thimble:* Basswood, lathe-turned, carved, painted; *Needle:* Maple, lathe-turned, carved, painted. 36 x 16½ x 12" (91.4 x 41.9 x 30.5 cm). Mint Museum of Craft + Design. Promised Gift of Jane and Arthur Mason

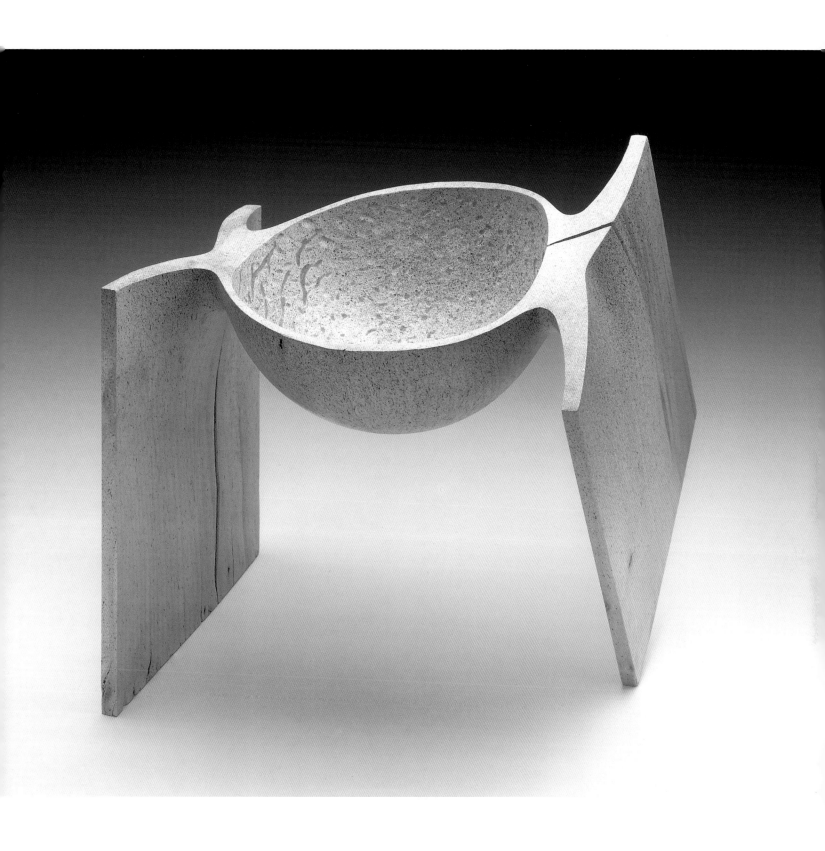

25. Stephen Hogbin. *Walking Bowl*. 1997. Limewood, lathe-turned, painted.
10 x 11½ x 10" (25.4 x 29.2 x 25 4 cm). Mint Museum of Craft + Design.
Gift of Jane and Arthur Mason

26. Michelle T. Holzapfel. *Aegina Bowl*. 1993. Ash, lathe-turned, carved, burned. 4 x 10 x 10" (10.2 x 25.4 x 25.4 cm). Mint Museum of Craft + Design. Gift of Jane and Arthur Mason

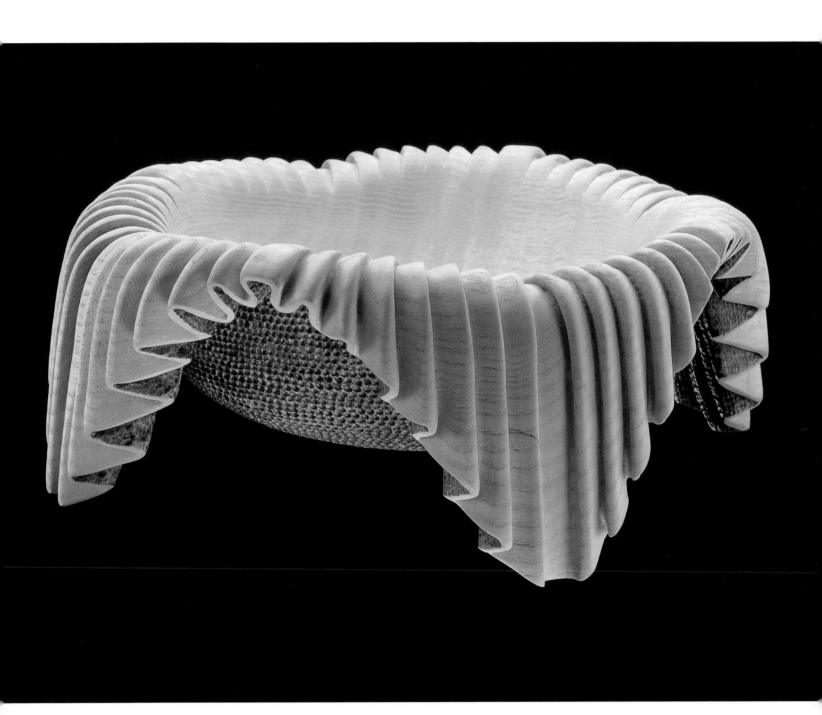

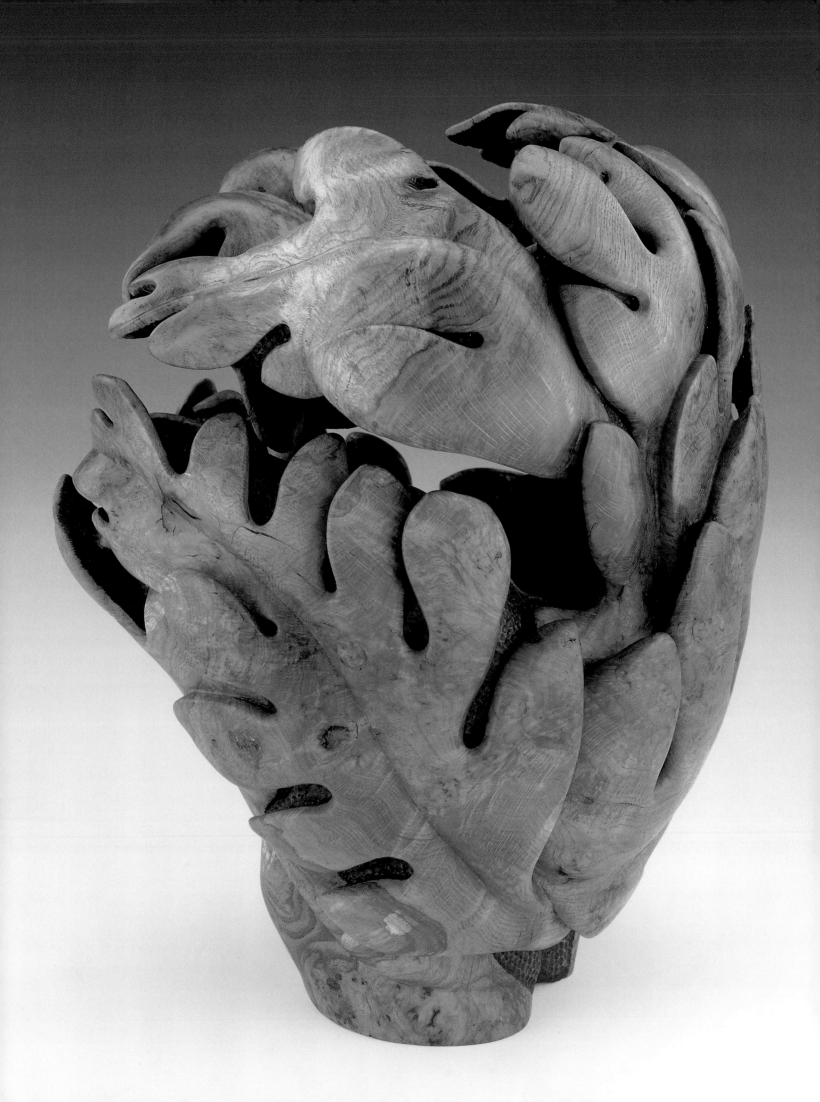

27. Michelle T. Holzapfel. *Querus*. 1998. Red oak burl, lathe-turned, carved, burned, burnished. 16 x 12 x 9" (40.6 x 30.5 x 22.9 cm). Mint Museum of Craft + Design. Promised Gift of Jane and Arthur Mason

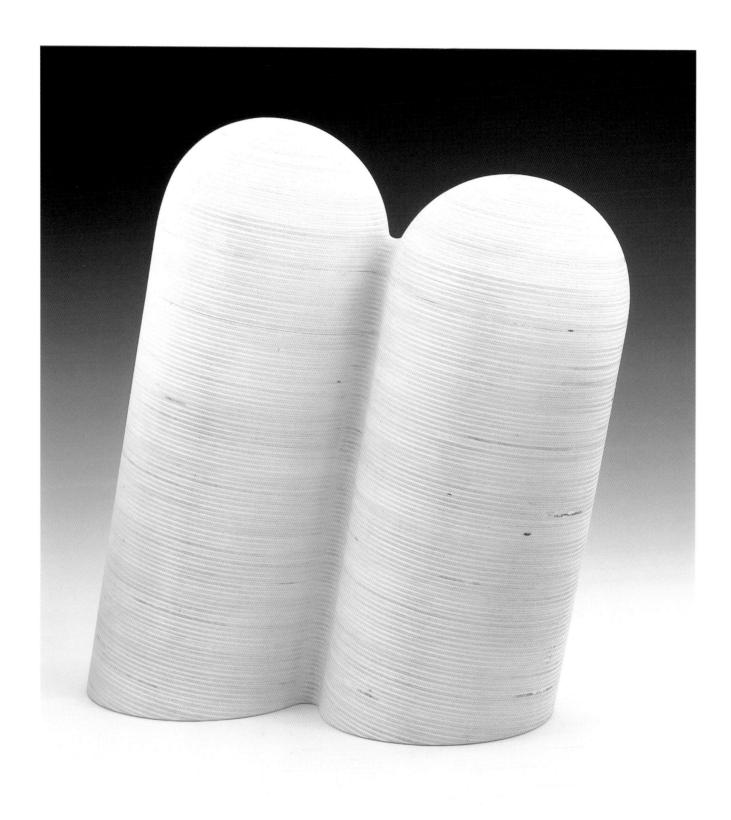

28. Richard Hooper. *White Bipod*. 1995. Birch plywood, laminated, lathe-turned.
13 x 11 x 5¼" (33 x 27.9 x 13.3 cm). Mint Museum of Craft + Design. Gift of
Jane and Arthur Mason

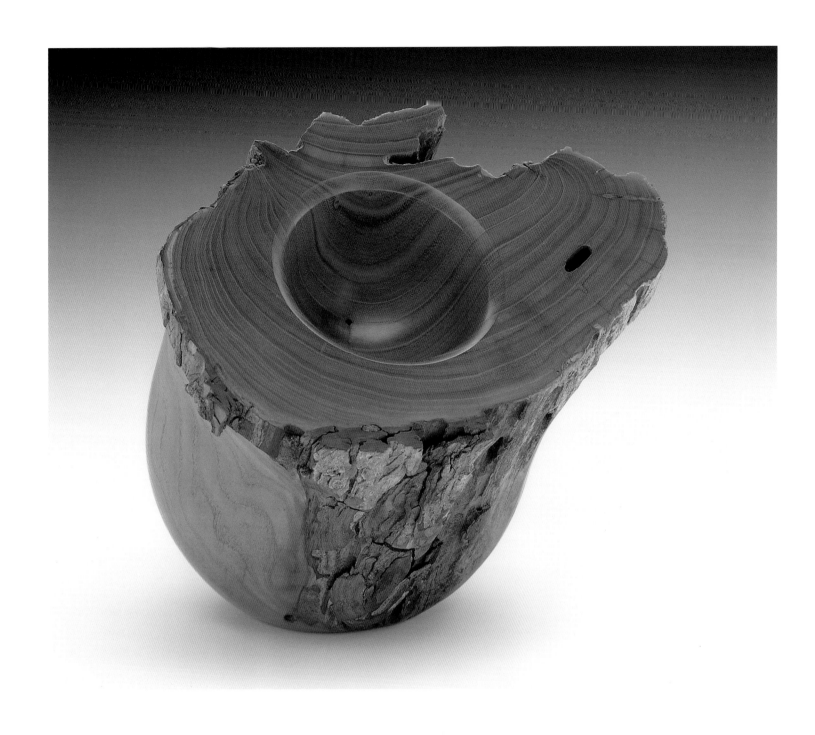

29. Robyn Horn. *Geode #231*. 1988. Smokewood, lathe-turned. 6¾ x 7½ x 7"
(17.1 x 19 x 17.8 cm). Mint Museum of Craft + Design. Gift of Jane and
Arthur Mason

30. Robyn Horn. *Narrow Spaces*. 1994. Redwood burl, carved, painted.
26 x 23 x 12" (66 x 58.4 x 30.5 cm). Mint Museum of Craft + Design.
Gift of Jane and Arthur Mason

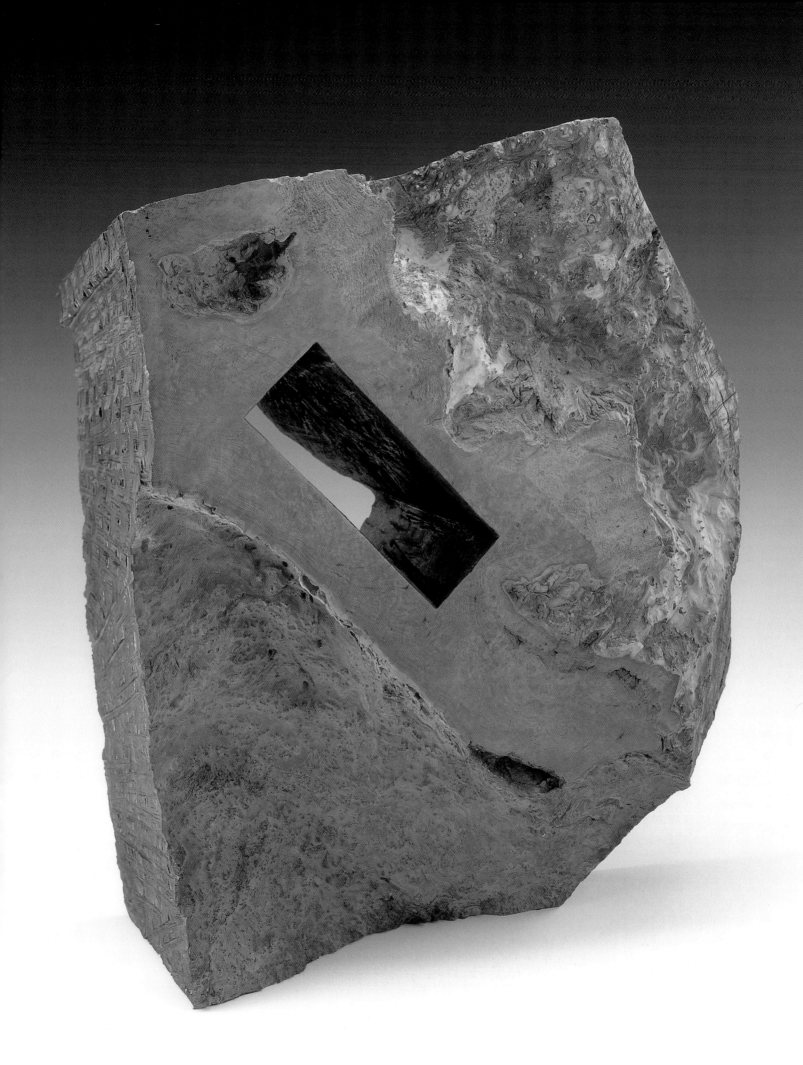

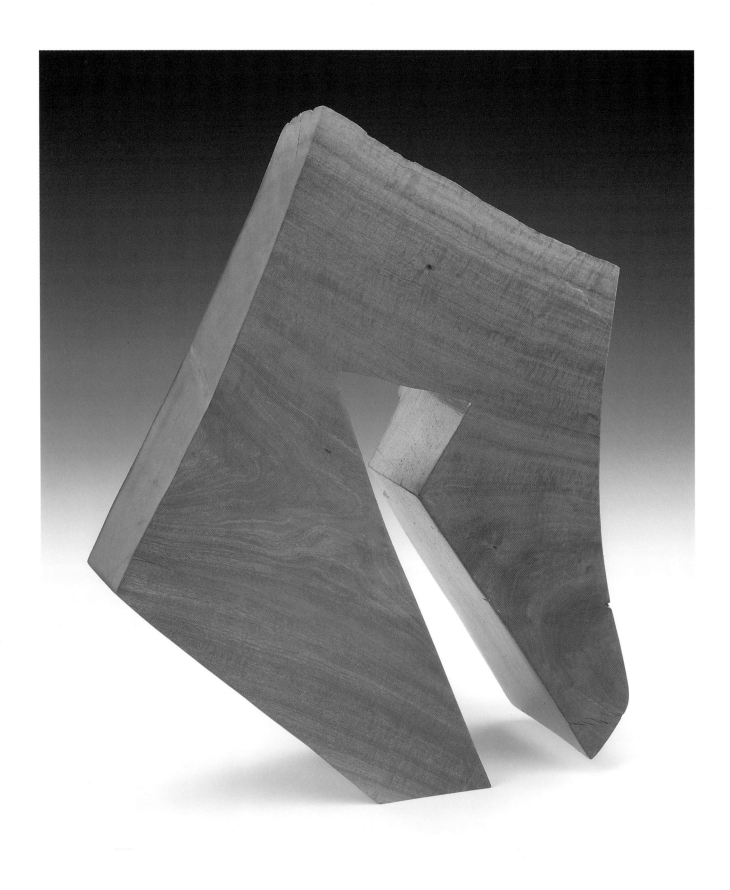

31. Robyn Horn. *Stepping Stone*. 1995. Pink ivorywood, lathe-turned, carved.
15 x 13 x 4" (38.1 x 33 x 10.2 cm). Mint Museum of Craft + Design.
Promised Gift of Jane and Arthur Mason

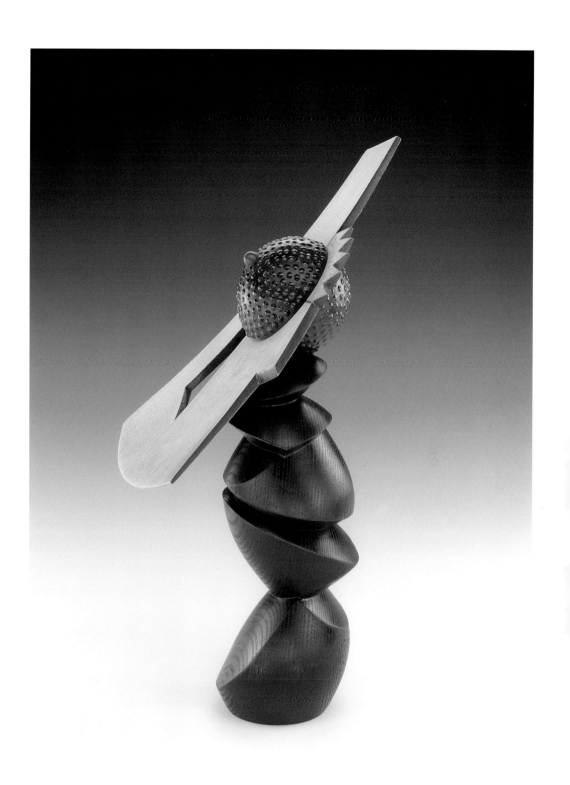

32. Michael Hosaluk and Mark Sfirri. *Boob Box on a Stick.* 1997. Ash, birch,
lathe-turned, carved, acrylic paint, dyed. 12½ x 5½ x 7" (31.8 x 14 x 17.8 cm).
Mint Museum of Craft + Design. Gift of Jane and Arthur Mason

33. Todd Hoyer. *Conical Series*. 1986. Emery oak, lathe-turned. 7¼ x 12 x 10½"
 (18.4 x 30.5 x 26.7 cm). Mint Museum of Craft + Design. Promised Gift of
 Jane and Arthur Mason

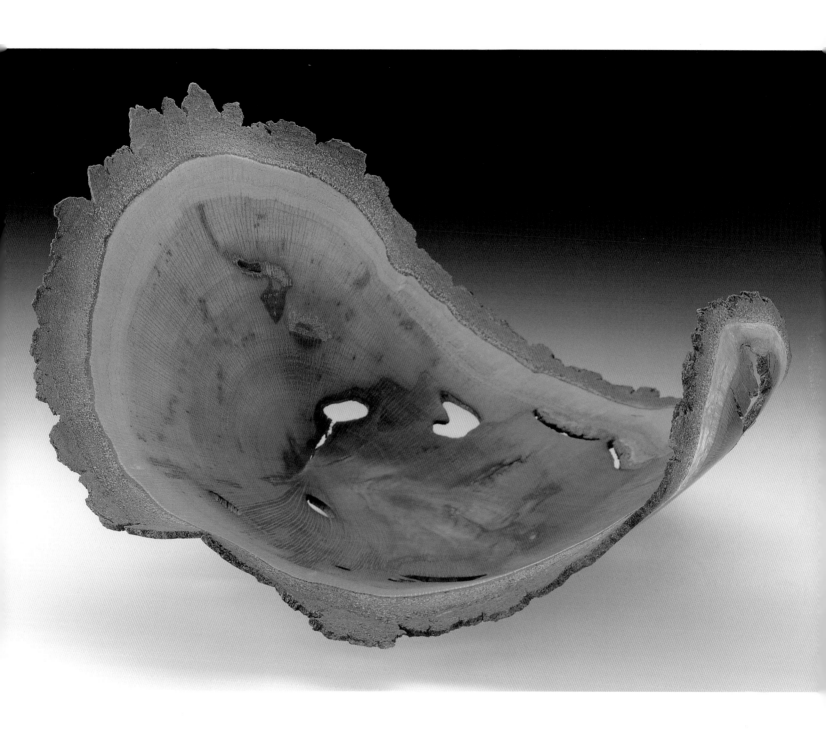

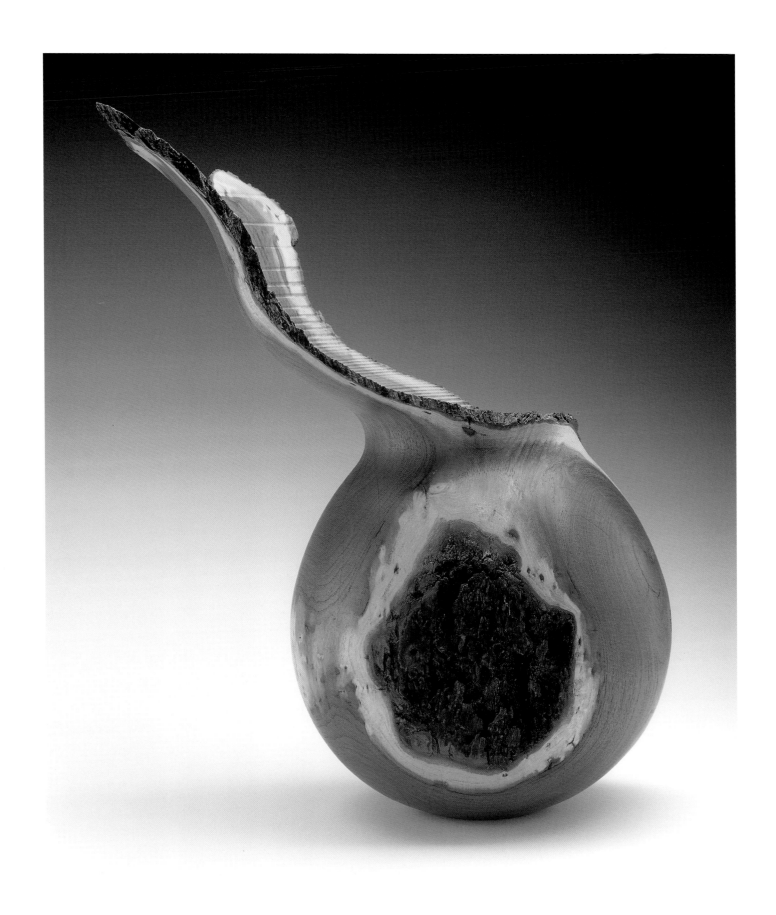

34. Todd Hoyer. *Peeling Orb*. 1987. Mesquite, lathe-turned, burned.
16½ x 12 x 9" (41.91 x 30.48 x 22.86 cm). Mint Museum of Craft + Design.
Promised Gift of Jane and Arthur Mason

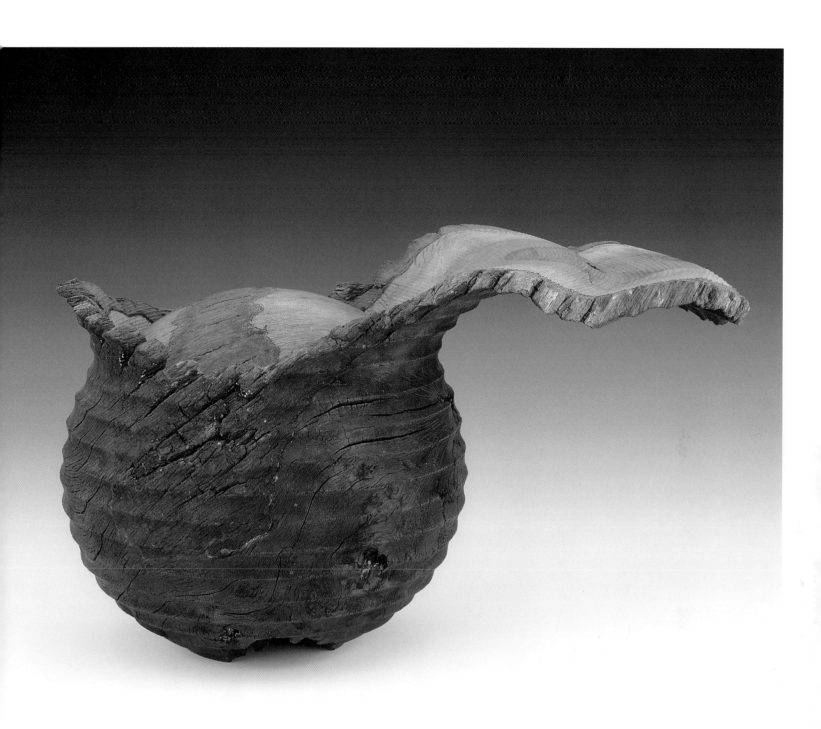

35. Todd Hoyer. *Bowl*. 1988. Mexican blue oak, lathe-turned, burned.
10½ x 10 x 19¼" (26.7 x 25.4 x 48.9 cm). Mint Museum of Craft + Design.
Gift of Jane and Arthur Mason

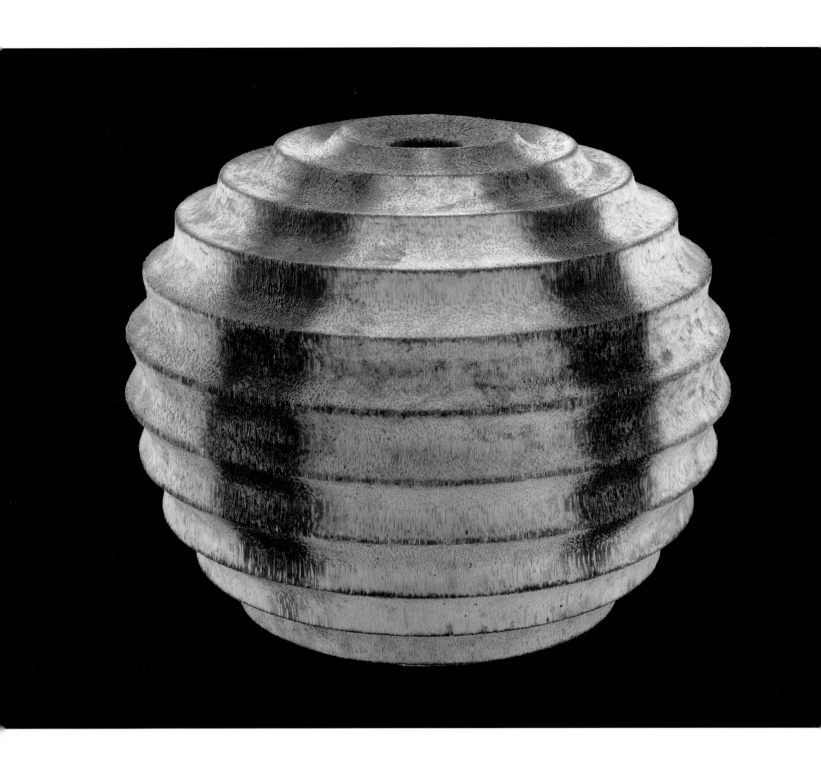

36. Todd Hoyer. *Untitled*. 1990. Palm, lathe-turned, burned. 12 x 14 x 14"
(30.5 x 35.6 x 35.6 cm). Mint Museum of Craft + Design. Gift of Jane and
Arthur Mason

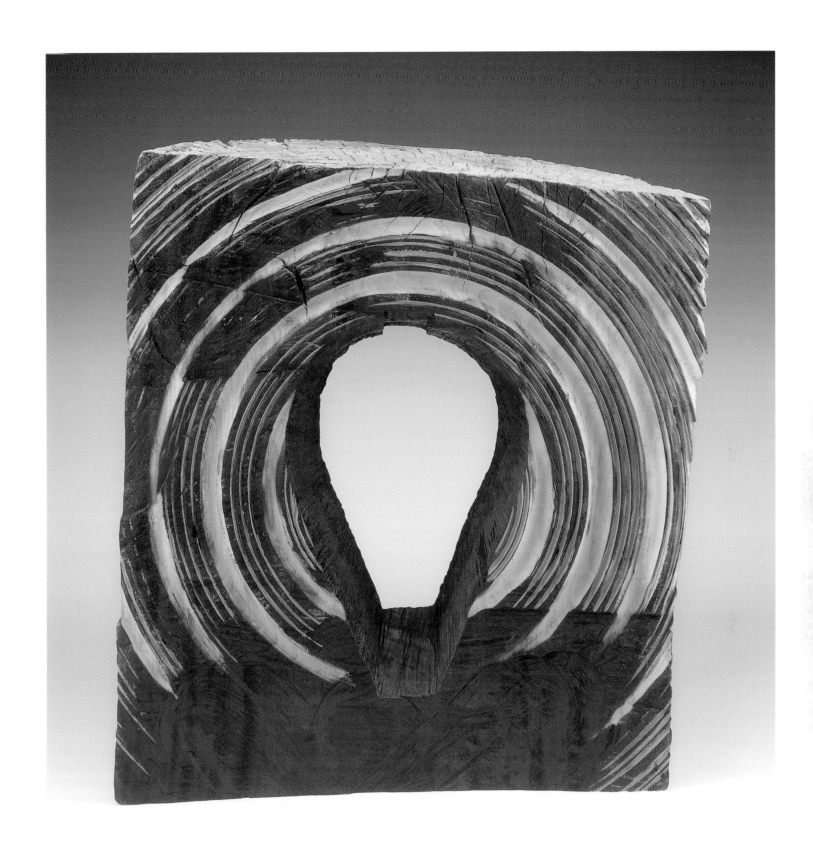

37. Todd Hoyer. *Hallowed Vessel Series*. 1991. Cottonwood, lathe-turned, carved, burned. 21½ x 20 x 5½" (54.6 x 50.8 x 14 cm). Mint Museum of Craft + Design. Promised Gift of Jane and Arthur Mason

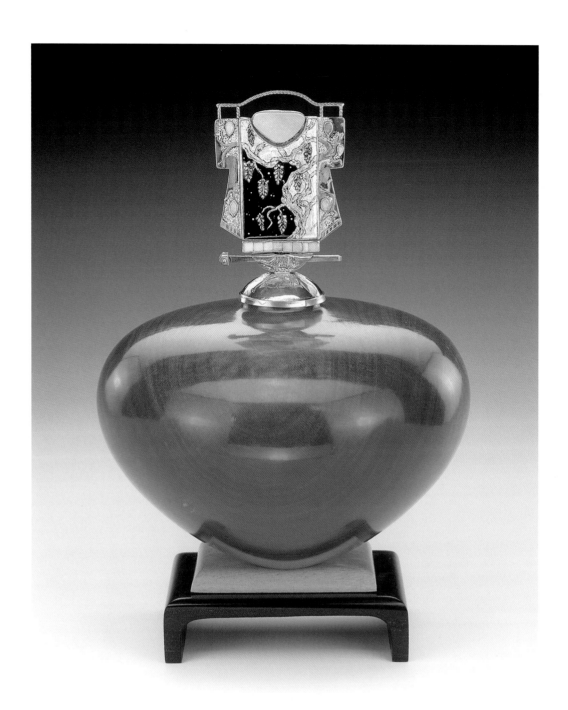

38. William Hunter and Marianne Hunter. *Untitled #1874*. 1990. Vessel: pink ivorywood, lathe-turned; Stand: constructed; Lid: *Wisteria Kimono, Edo Period*, 1991. Enamel in 24 karat gold, 14 karat gold, sterling silver, baroque pearls, opal, druzy lavender chalcedony. 9¼ x 6 x 6" (23.5 x 15.2 x 15.2 cm). Mint Museum of Craft + Design. Promised Gift of Jane and Arthur Mason

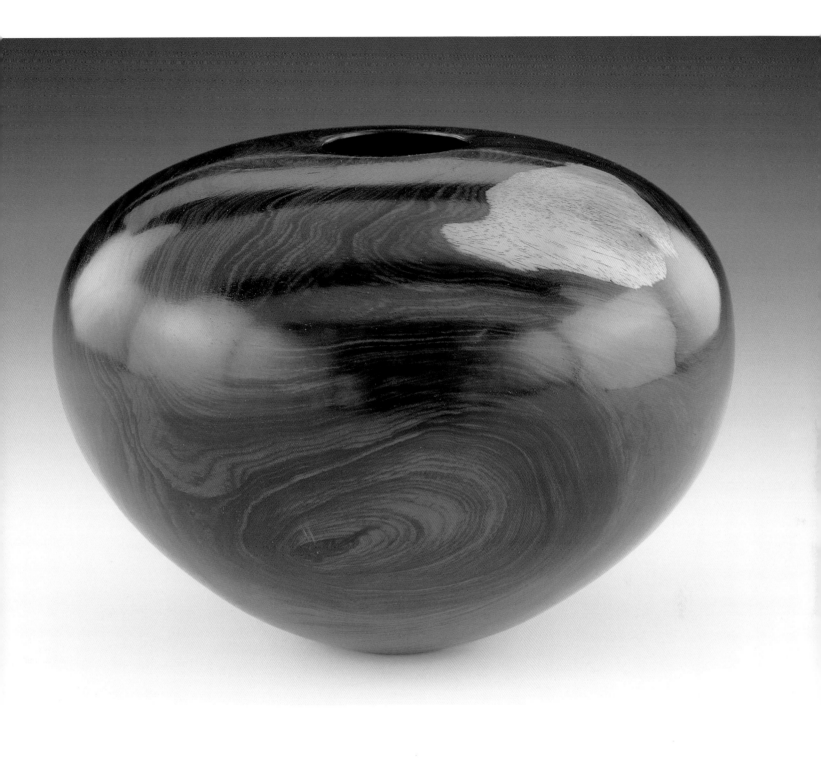

39. William Hunter. *Three Hearts #758*. 1987. Cocobolo, lathe-turned.
 9 x 10½ x 10½" (22.9 x 26.7 x 26.7 cm). Mint Museum of Craft + Design.
 Gift of Jane and Arthur Mason

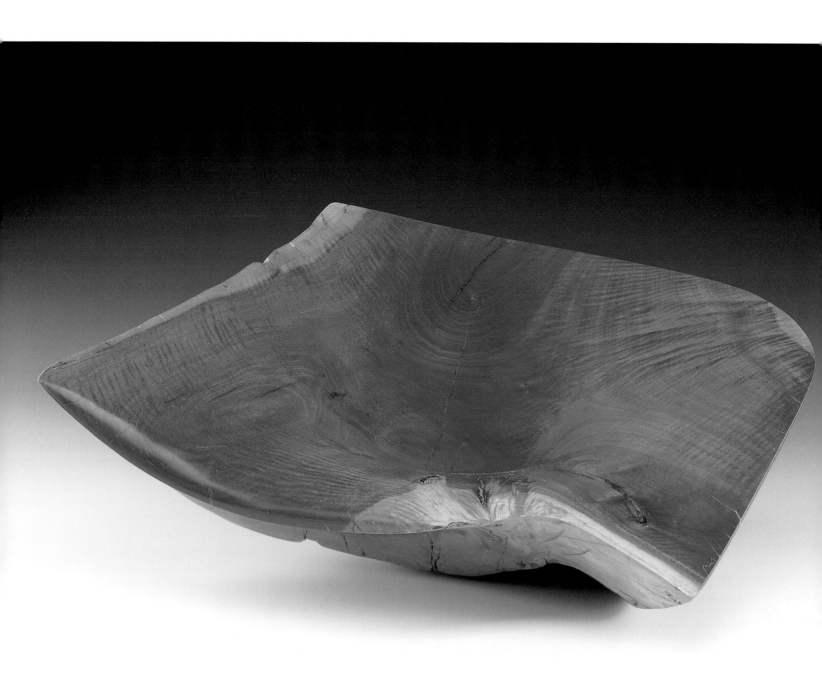

40. William Hunter. *Ruby Dish #830*. 1988. Pink ivorywood, lathe-turned, carved.
6½ x 17½ x 15½" (16.5 x 44.5 x 39.4 cm). Mint Museum of Craft + Design
Promised Gift of Jane and Arthur Mason

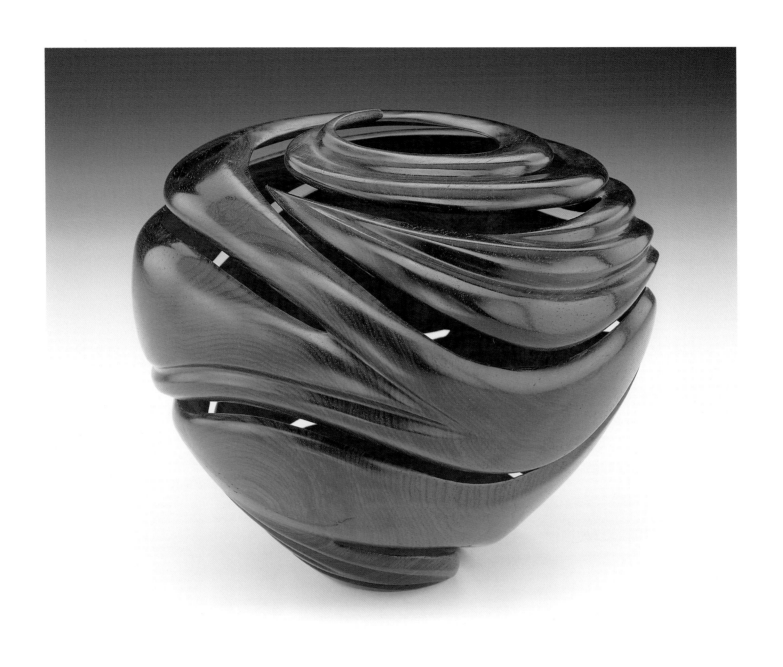

41. William Hunter. *Convergence #808*. 1988. (Retitled *Phantom Vessel III #808*, 1989). Cocobolo, lathe-turned (1988), carved (1989). 8 x 10 x 10" (20.3 x 25.4 x 25.4 cm). Mint Museum of Craft + Design. Gift of Jane and Arthur Mason

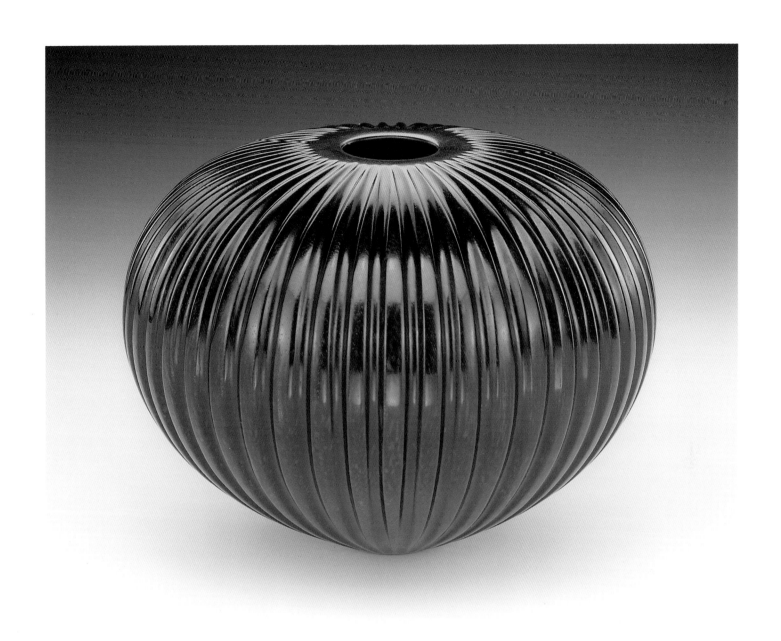

42. William Hunter. *Absolute Ebony #1107*. 1992. Ebony, lathe-turned, carved.
4¾ x 6 x 6" (12.1 x 15.2 x 15.2 cm). Mint Museum of Craft + Design.
Promised Gift of Jane and Arthur Mason

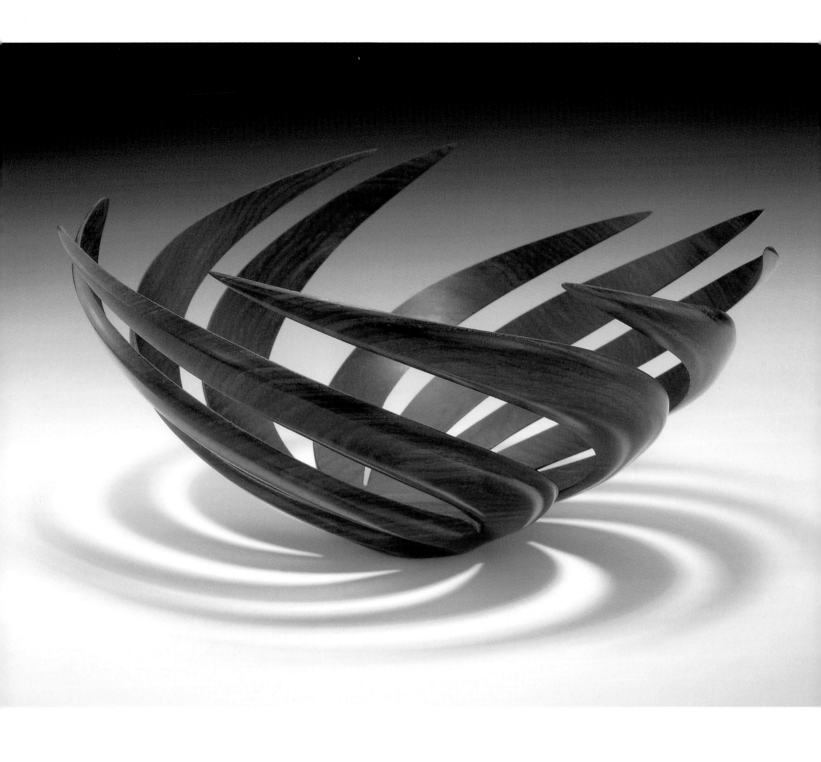

43. William Hunter. *Fast Grass #1218*. 1995. Cocobolo, lathe-turned, carved.
 4 x 8¼ x 8¼" (10.2 x 21 x 21 cm). Mint Museum of Craft + Design.
 Gift of Jane and Arthur Mason

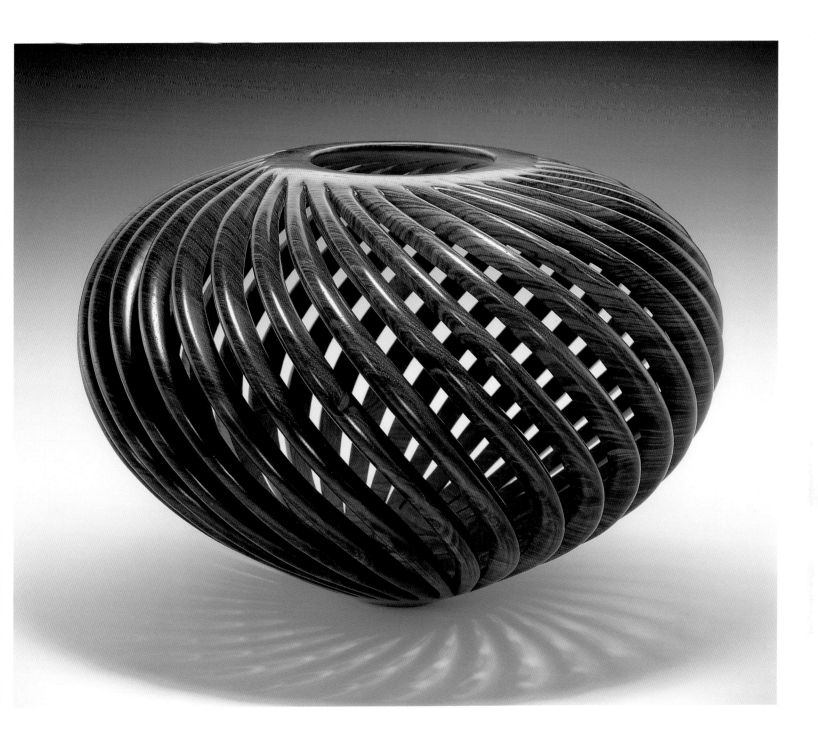

44. William Hunter. *Kinetic Rhythms #1277.* 1997. Cocobolo, lathe-turned,
 carved. 7 x 11 x 11" (17.8 x 27.9 x 27.9 cm). Mint Museum of Craft +
 Design. Gift of Jane and Arthur Mason

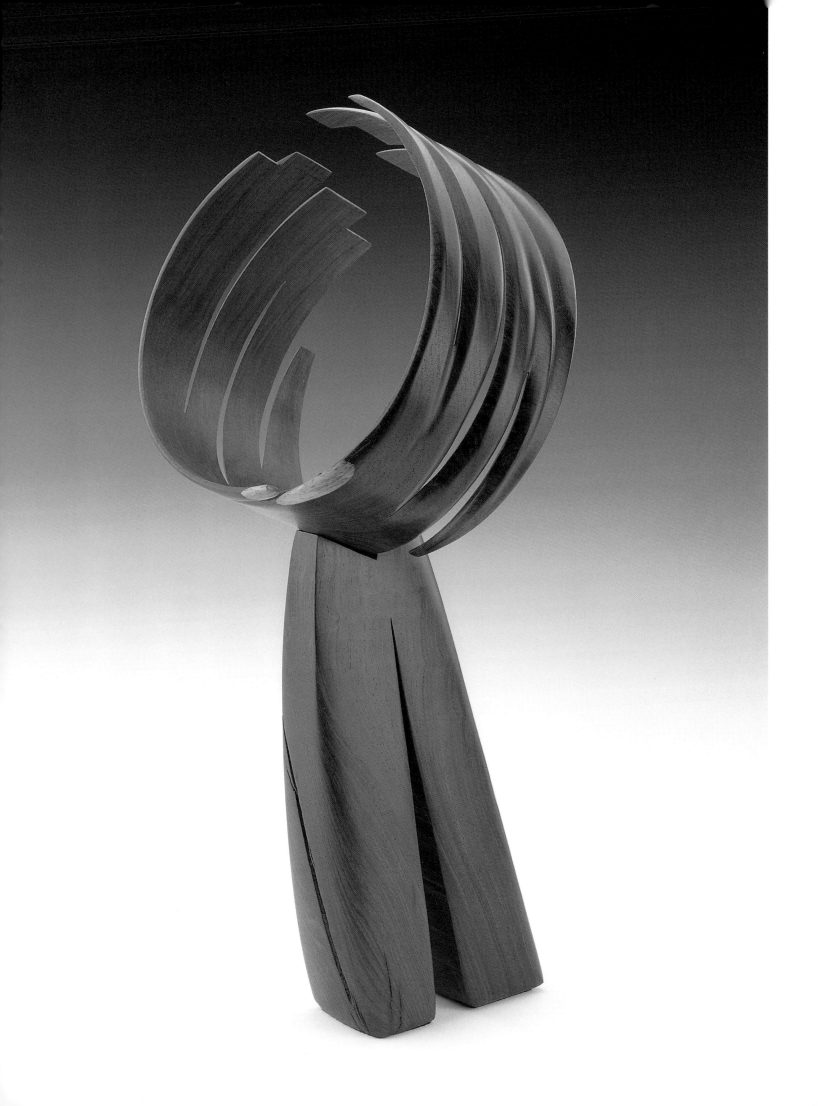

45. William Hunter. *Cutting Loose #1254*. 1997. Cocobolo, lathe-turned, carved. 24 x 10 x 11" (61 x 25.4 x 27.9 cm). Mint Museum of Craft + Design Gift of Jane and Arthur Mason

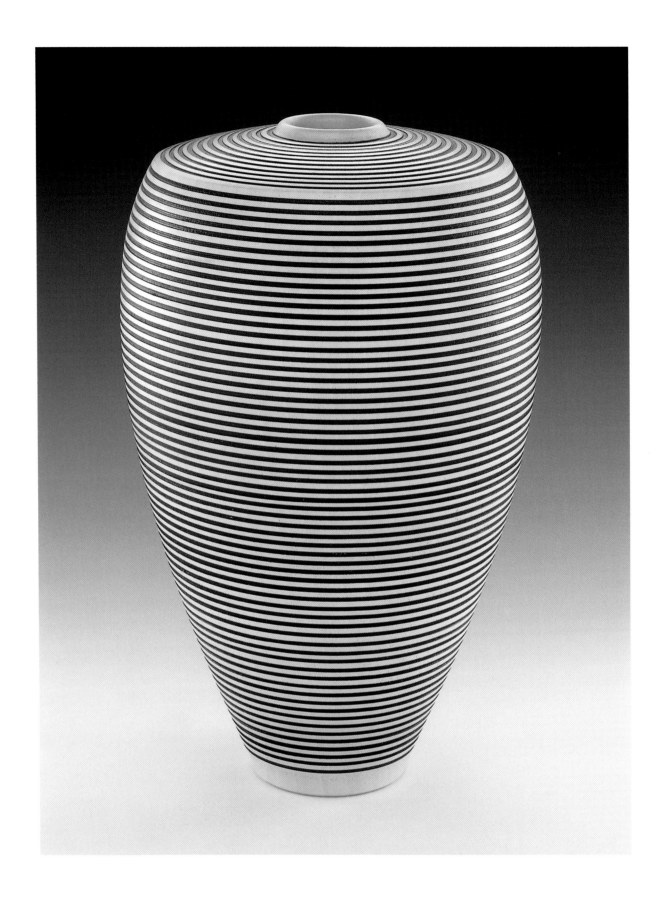

46. John Jordan. *Untitled.* 1993. Bleached box elder, lathe-turned, incised,
 acrylic painted. 9½ x 6 x 6" (24.1 x 15.2 x 15.2 cm). Mint Museum of Craft +
 Design. Promised Gift of Jane and Arthur Mason

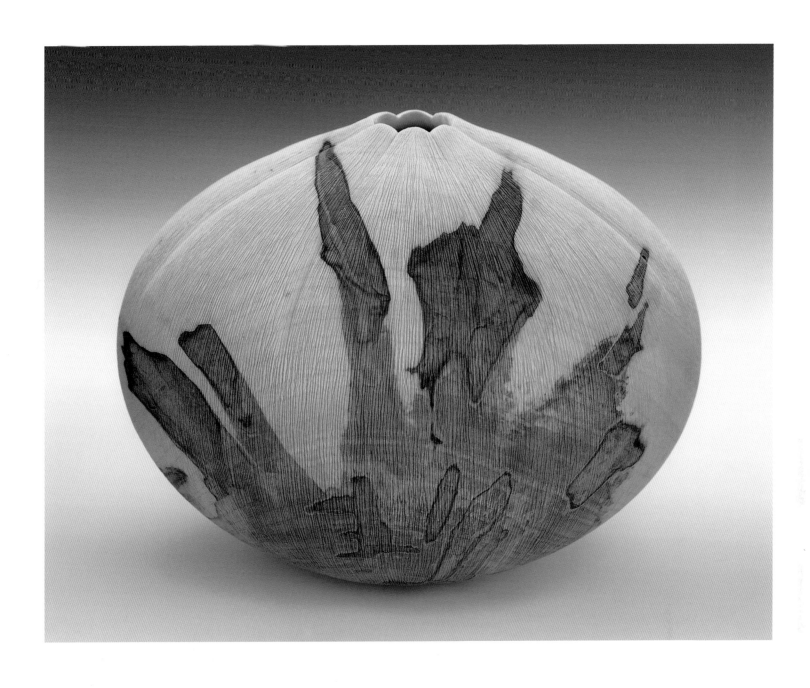

47. John Jordan. *Untitled*. 1998. Red maple, lathe-turned, carved, wire-brushed.
9 x 7½ x 7½" (22.9 x 19.1 x 19.1 cm). Mint Museum of Craft + Design.
Gift of Jane and Arthur Mason

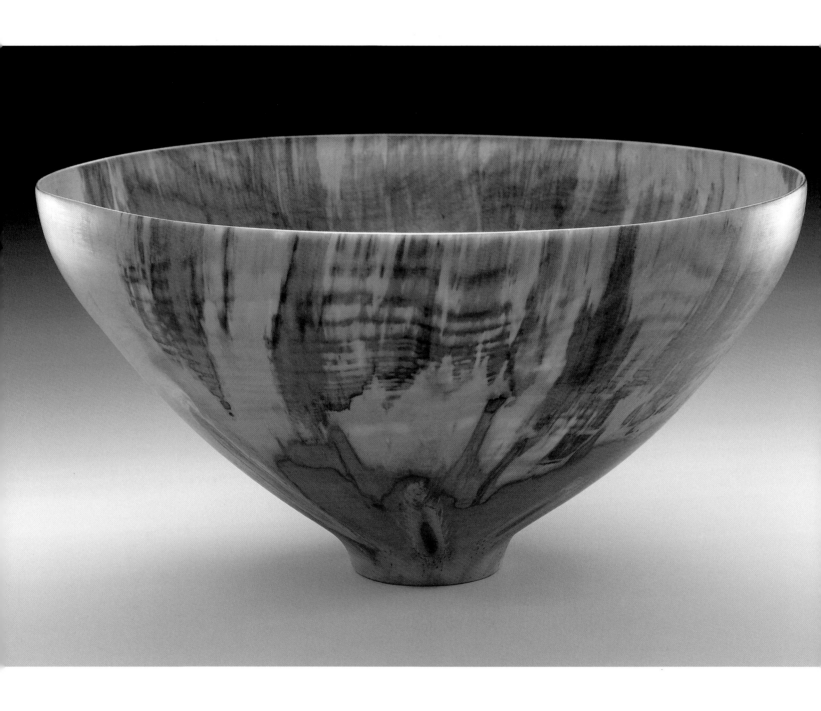

48. Ron Kent. *Untitled*. 1980. Norfolk Island pine, lathe-turned. 8 x 15 x 15"
(20.3 x 38.1 x 38.1 cm). Mint Museum of Craft + Design. Promised Gift of
Jane and Arthur Mason

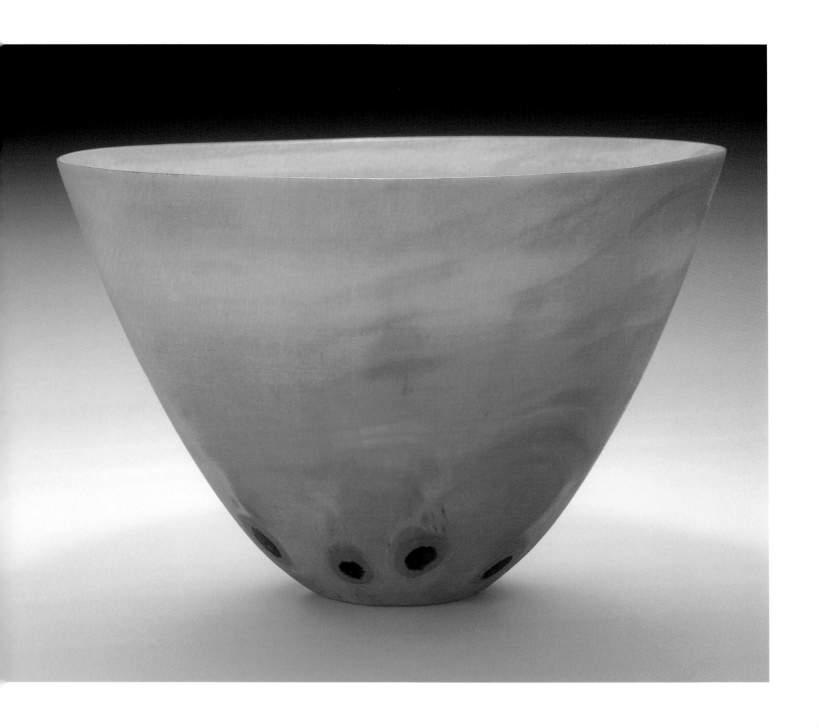

49. Ron Kent. *Small Gold Translucent Bowl*. 1989. Norfolk Island pine, lathe-turned. 5½ x 8 x 8" (14 x 20.3 x 20.3 cm). Mint Museum of Craft + Design. Gift of Jane and Arthur Mason

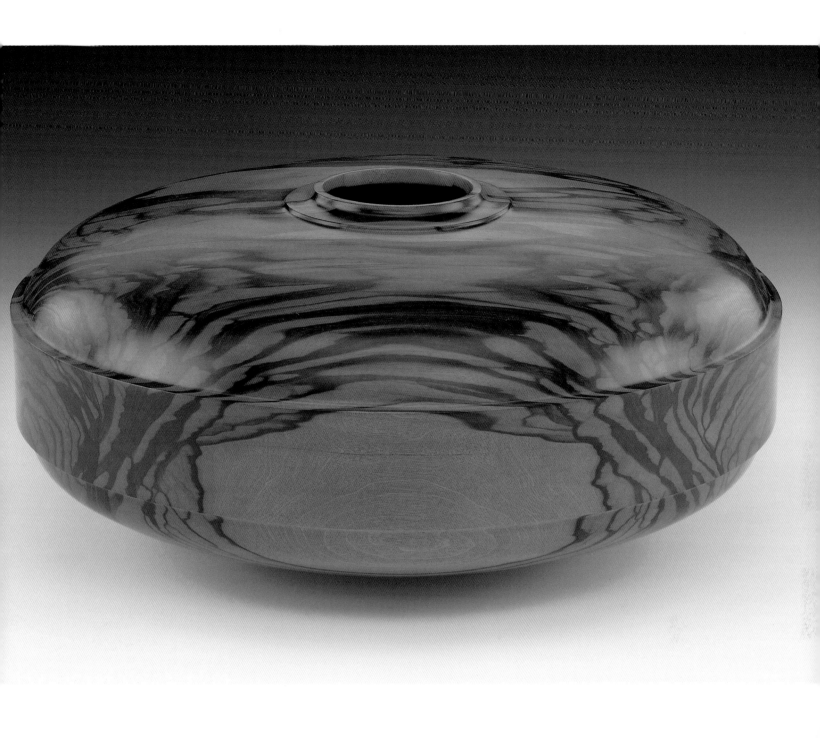

50. Dan Kvitka. *Banded Vessel*. 1989. Macassar ebony, lathe-turned.
8½ x 16 x 16" (21.6 x 40.6 x 40.6 cm). Mint Museum of Craft + Design.
Gift of Jane and Arthur Mason

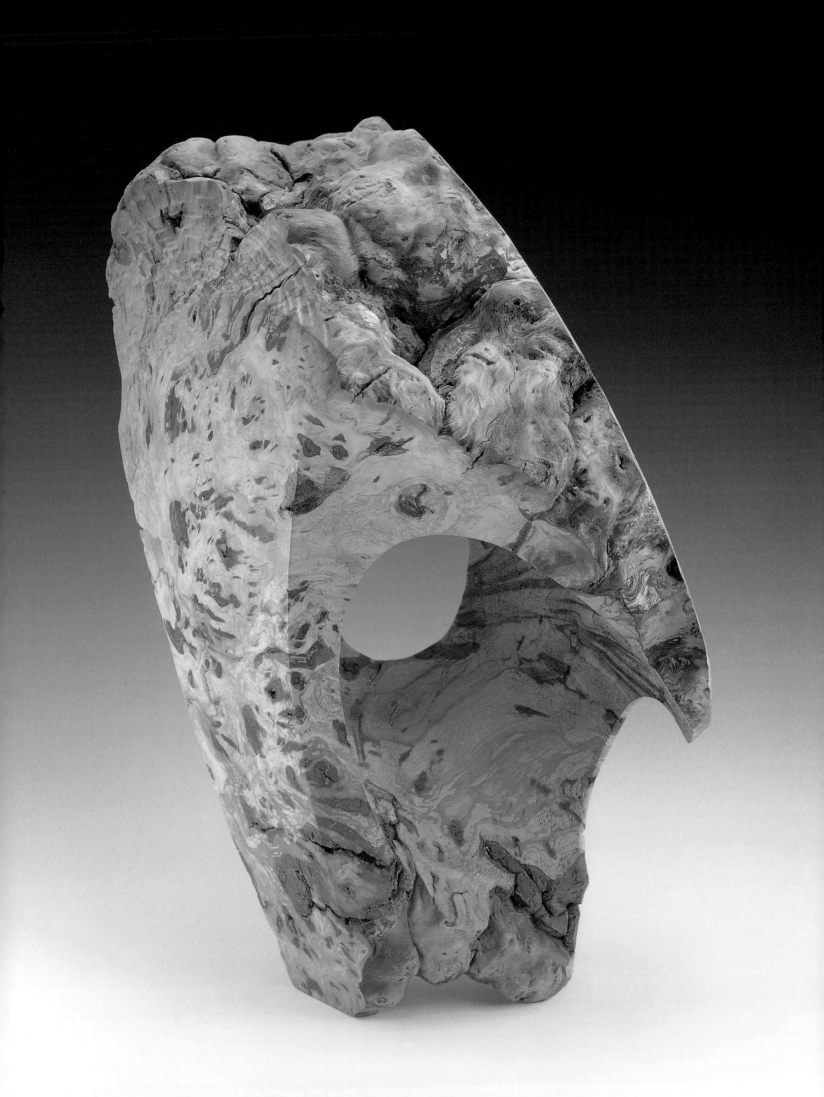

51. Stoney Lamar. *Watch in the Wilderness*. 1991. Beech burl, multi-axis lathe-
 turned, carved. 23 x 15 x 12½" (58.4 x 38.1 x 31.8 cm). Mint Museum of
 Craft + Design. Gift of Jane and Arthur Mason

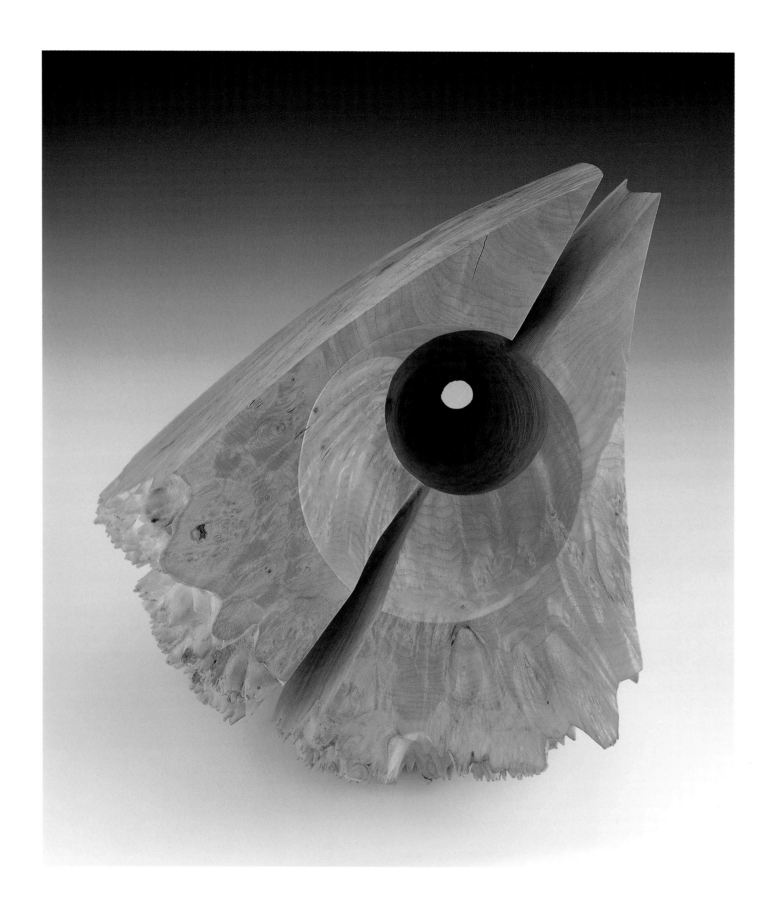

52. Stoney Lamar. *Maple Vector #1*. 1997. Big leaf maple burl, multi-axis lathe-
turned. 11 x 9½ x 10½" (27.9 x 24.1 x 26.8 cm). Mint Museum of Craft +
Design. Promised Gift of Jane and Arthur Mason

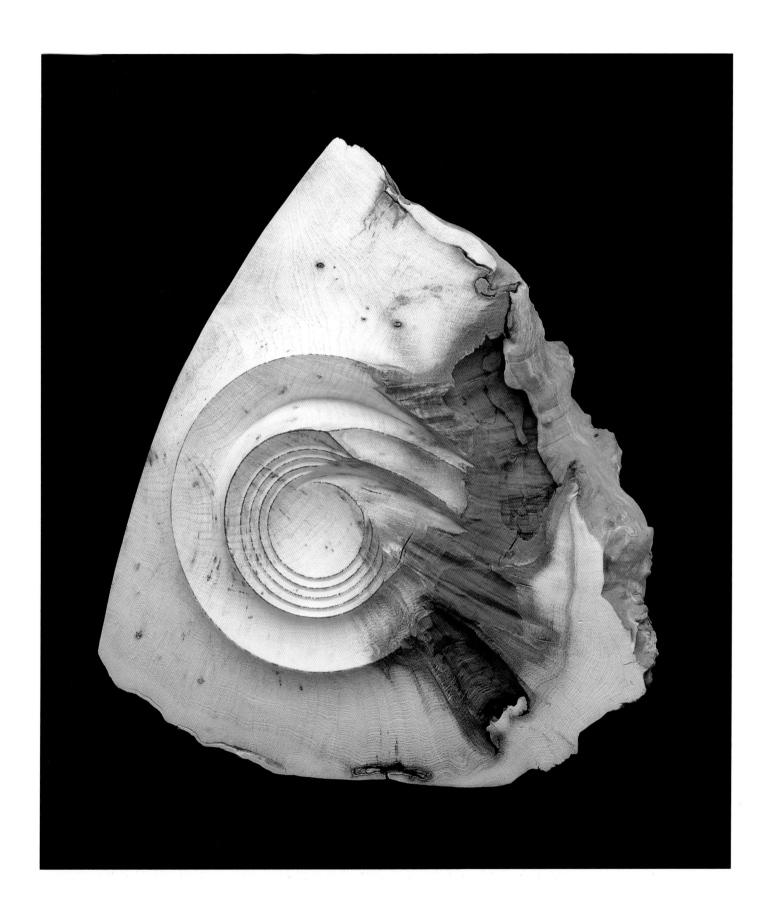

53. Stoney Lamar. *Fat Tuesday*. 1998. Bleached madrone, multi-axis lathe-
turned, carved. 20½ x 18 x 7" (52.1 x 45.7 x 17.8 cm). Mint Museum of
Craft + Design. Gift of Jane and Arthur Mason

54. Bud Latven. *Triangles Series #1*. 1990. Macassar ebony, black ebony, tulip-wood, veneers, segment-constructed, lathe-turned. 6 x 4 x 4" (15.2 x 10.2 x 10.2 cm). Mint Museum of Craft + Design. Gift of Jane and Arthur Mason

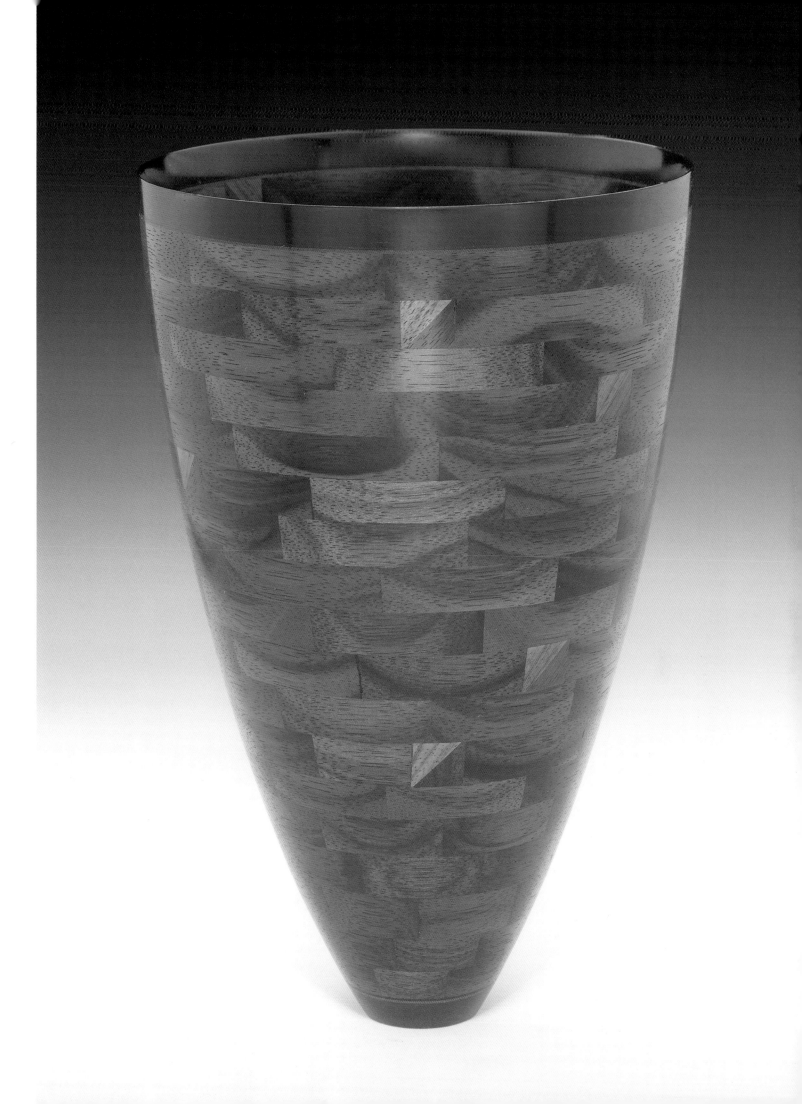

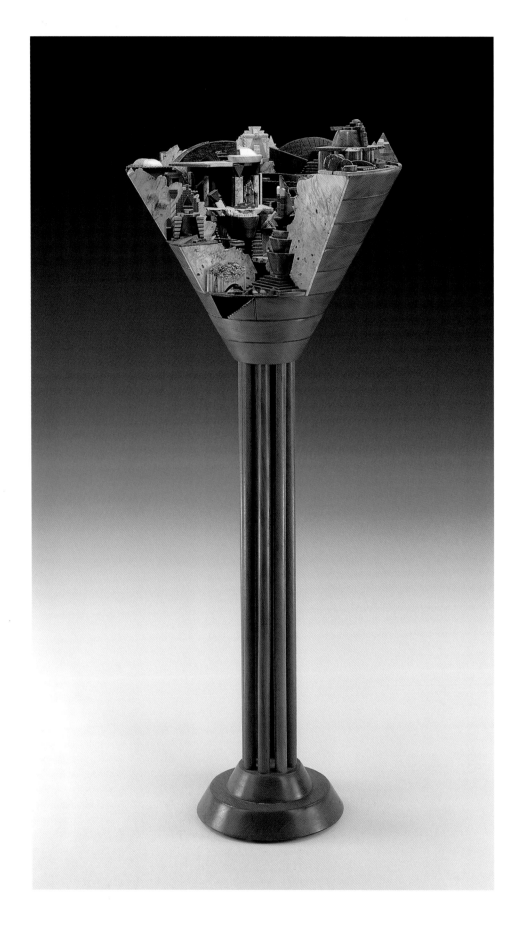

55. Po Shun Leong. *Pompeii*. 1990. Various woods, carved, constructed.
48 x 16 x 16" (121.9 x 40.6 x 40.6 cm). Mint Museum of Craft + Design.
Gift of Jane and Arthur Mason

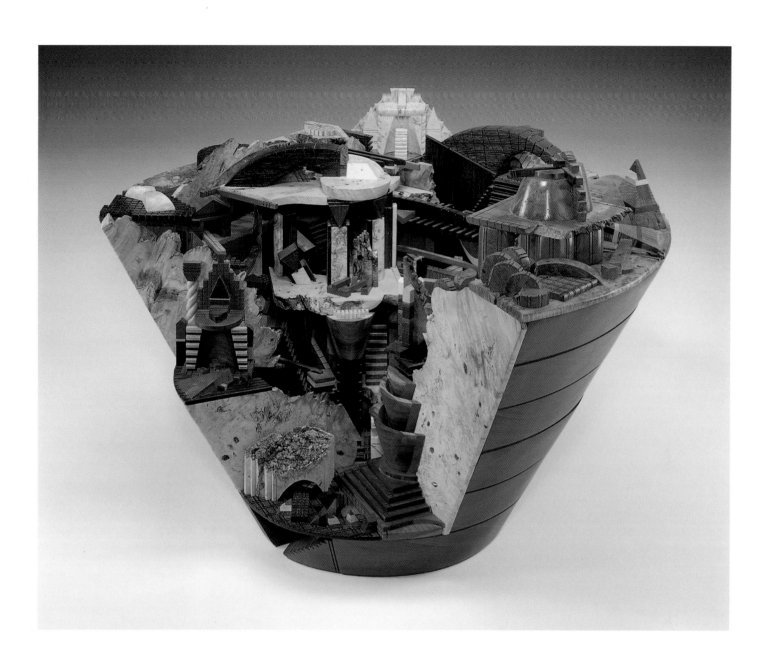

56. Mark Lindquist. *Untitled*. 1981. Spalted elm burl, lathe-turned.
9¼ x 15½ x 13½" (23.5 x 39.4 x 34.3 cm). Mint Museum of Craft + Design.
Gift of Jane and Arthur Mason

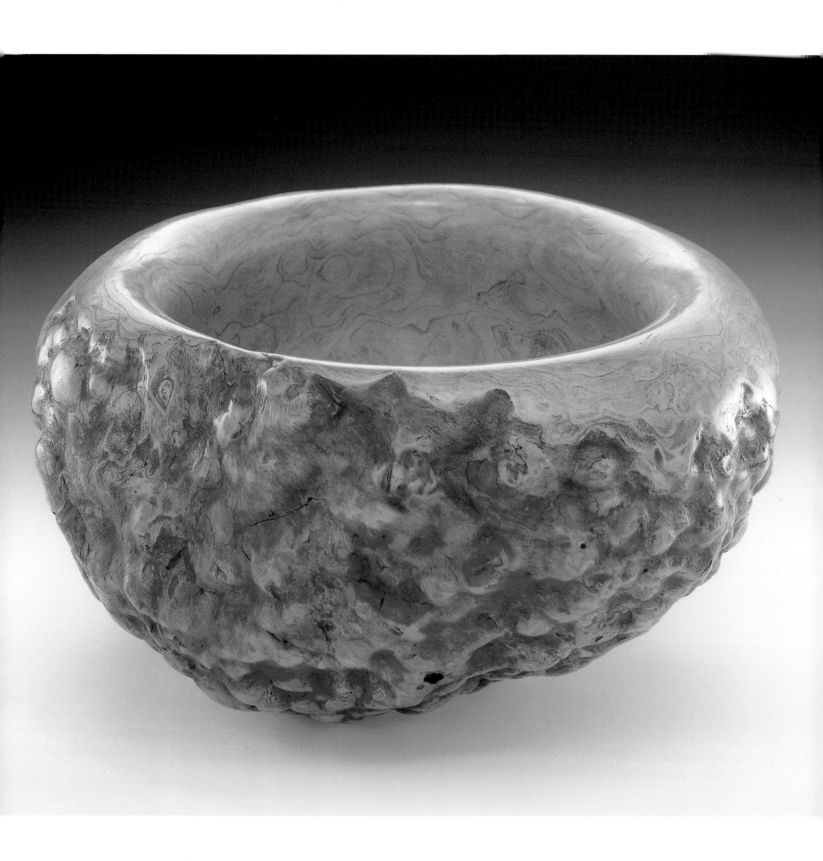

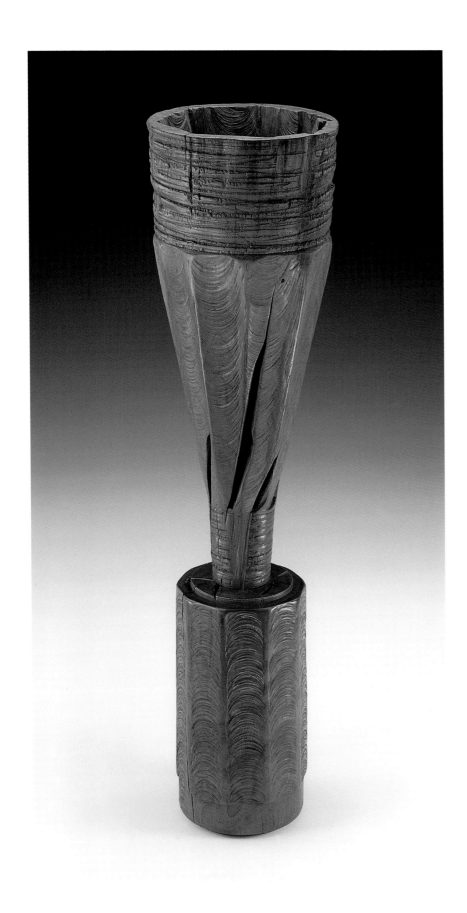

57. Mark Lindquist. *Totem*. 1987. Walnut, lathe-turned, chain-sawed.
45 x 11½ x 11½" (114.3 x 29.2 x 29.2 cm). Mint Museum of Craft + Design.
Gift of Jane and Arthur Mason

At the Currier Museum of Art

BOB LAPREE/UNION LEADER

Jane, right, and Arthur Mason, far left, avid collectors of wood-turning art, lead a personal tour of the collection at the Currier Museum of Art in Manchester Wednesday. Here, Jane describes the technique of nationally known artist Mark Lindquist, who started his career in Henniker. The traveling exhibit, "Turning Wood into Art," from the Mint Museum of Craft + Design in Charlotte, N.C. continues at the Currier through Sept. 27.

mer was used to damage a to a pretrial questionnaire.

Murder

Continued From Page B1

hearing.

Carrillo said the state is working to obtain a governor's warrant to bring her back to New Hampshire. She said Gov. John Lynch would need to sign off on a requisition warrant, which is then sent to the governor of Texas, who can issue a governor's warrant for release of a fugitive.

Saunders would then be brought before a local judge and served with that warrant. After that, New Hampshire law enforcement officials would be obligated to retrieve her from Texas.

Carrillo said Saunders could be held for up to 30 days awaiting that warrant.

Saunders' stepson, Derek Saunders, and his roommate,

Scott Mazzone, previously pleaded guilty to charges related to the murder of David King. Her ex-husband, Roy Saunders, committed suicide in April in Massachusetts just as he was due to face charges in connection with the murder.

Plea agreements in the case remain sealed by the Attorney General's Office.

In July, a judge entered a default judgment against Dianna Saunders in a civil case when she did not show up to court.

She is being sued by a Maine physician who claims she stole hundreds of thousands of dollars from him before moving to Texas shortly after King's death.

bor with a sharp metal martial arts object, and the other is a reckless conduct charge tha alleges Carrier threw tha three-pointed object at hi neighbor's son, injuring hi foot.

No plea can be entered to felony charges in distric court, so a probable caus hearing was set for Aug. 20.

Carrier pleaded innocen Wednesday to charges of disorderly conduct, assault or a police officer and resisting arrest resulting from the inci dent, and trial was set for Nov 9. Bail is $20,000 cash/surety.

Baseball bat was weapon

Eda Concepcion, 34, o 82 Third St., could enter n plea yesterday in Mancheste District Court to two felon charges of second-degree as sault that allege she hit he boyfriend with a wooder baseball bat on the forearm and lower back.

A probable cause hearing

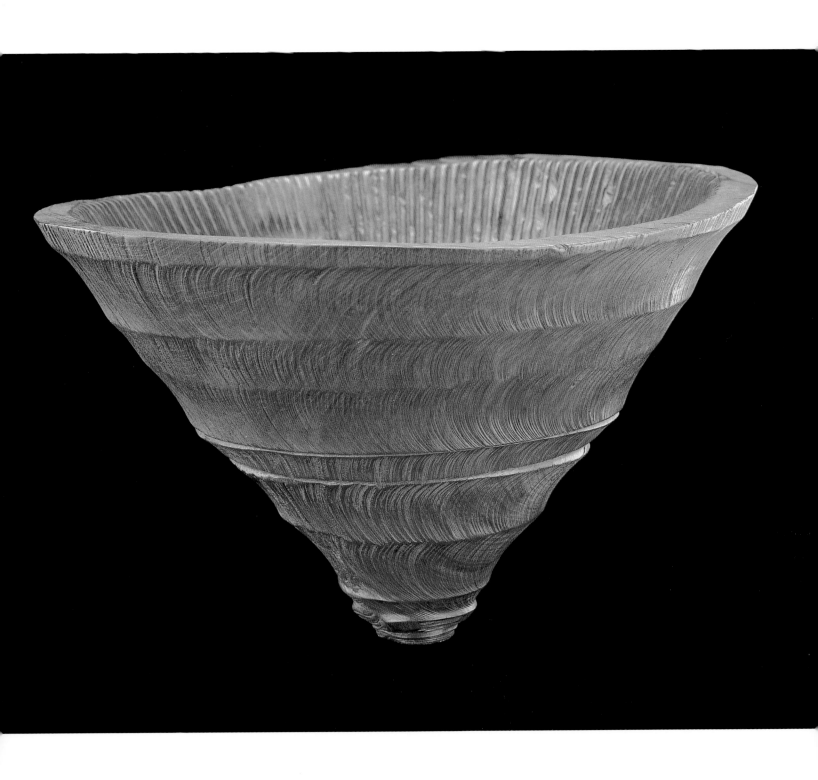

58. Mark Lindquist. *Ascending Bowl #7*. 1987. Walnut, lathe-turned, chain-sawed. Bowl: 13½ x 21 x 21" (34.3 x 53.3 x 53.3 cm); Pedestal: 36 x 9½ x 9½" (91.4 x 24.1 x 24.1 cm). Mint Museum of Craft + Design. Promised Gift of Jane and Arthur Mason

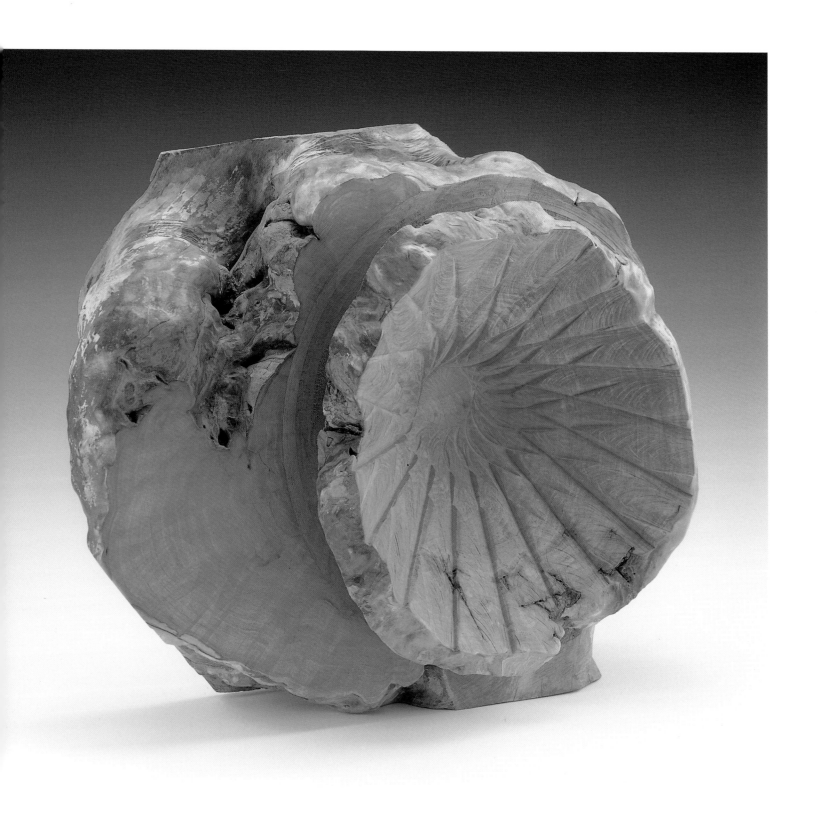

59. Mark Lindquist. *Captive #6C*. 1988. Maple burl, lathe-turned, chain-sawed.
18 x 22 x 8½" (45.7 x 55.9 x 21.6 cm). Mint Museum of Craft + Design.
Promised Gift of Jane and Arthur Mason

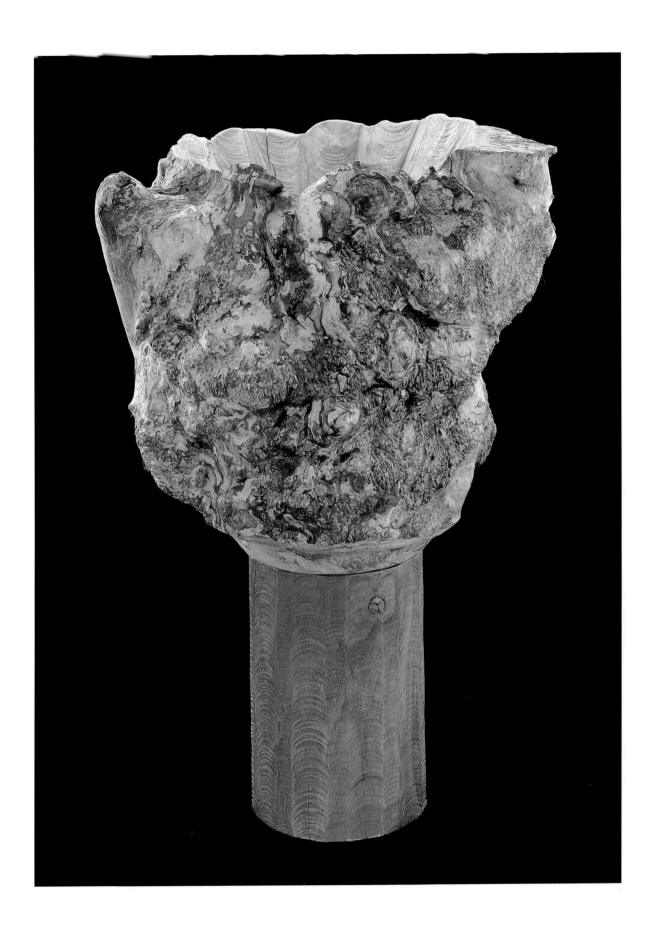

60. Mark Lindquist. *Chieftain's Bowl*. 1988. Maple burl, walnut, lathe-
turned, chain-sawed. 36½ x 25 x 23" (92.7 x 63.5 x 58.4 cm). Collection
Kent A. Mason

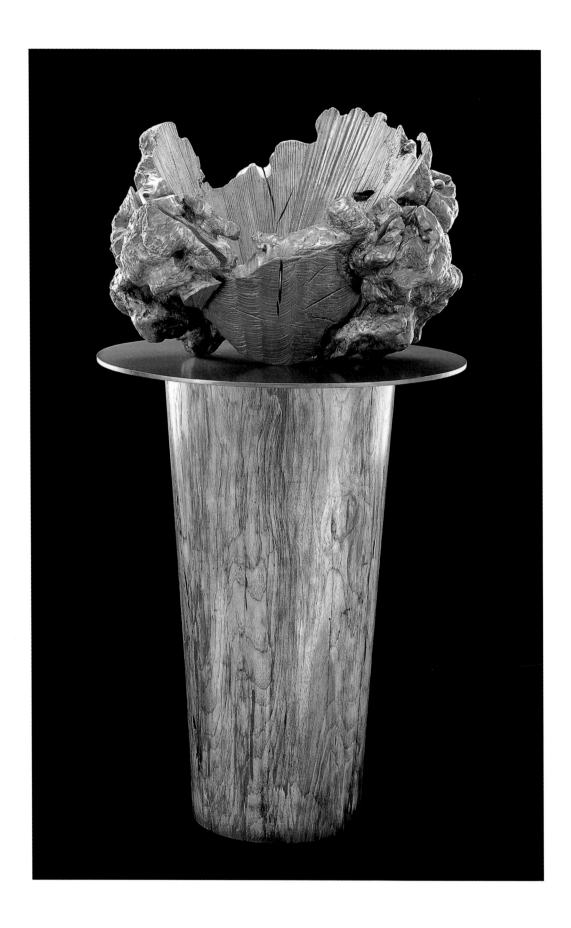

61. Mark Lindquist. *Amalgam II*. 1996. Pecan, maple, steel, lathe-turned, chain-sawed, polychromed. 63 x 32 x 32" (160 x 81.3 x 81.3 cm). Mint Museum of Craft + Design. Gift of Jane and Arthur Mason

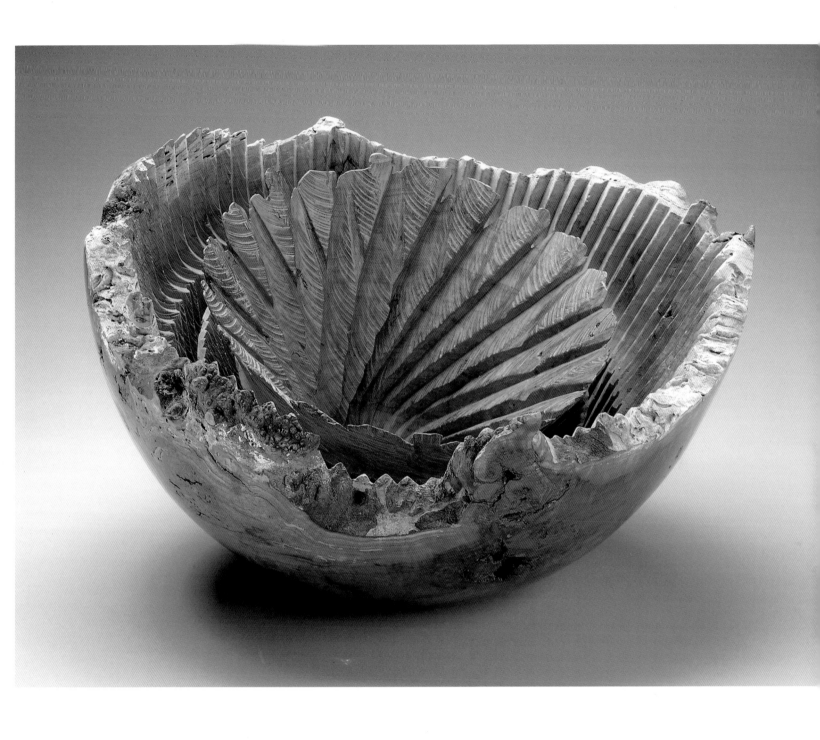

62. Mark Lindquist. *Ancient Inner Anagogical Vessel Emerging.* 1994. Cherry
burl, lathe-turned, chain-sawed. 12 x 18 x 18" (30.5 x 45.7 x 45.7 cm).
Collection Detroit Institute of Art

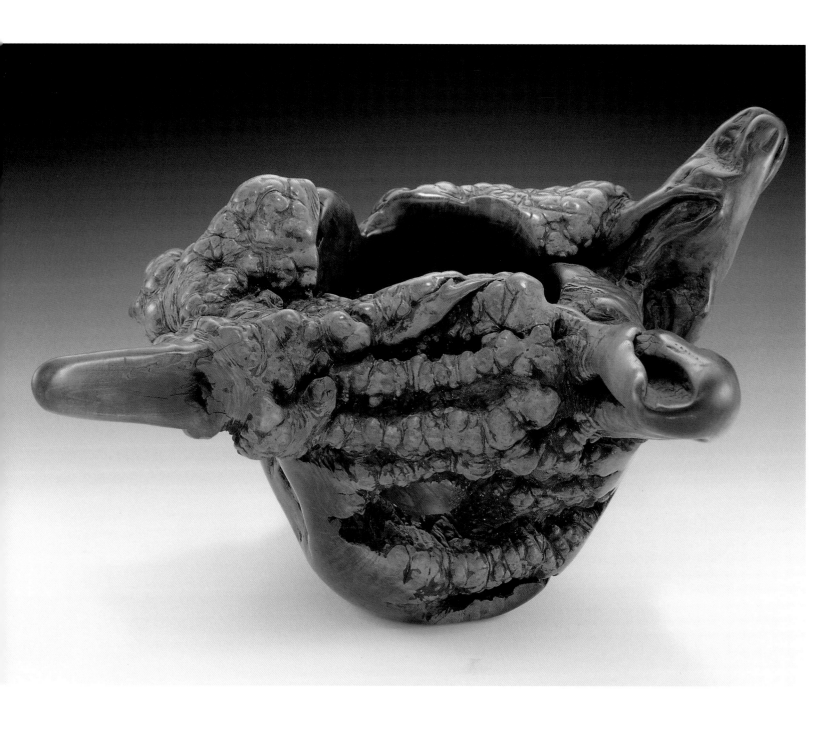

63. Mel Lindquist. *Natural Top Bowl*. 1985. Manzanita burl, lathe-turned.
8¾ x 17½ x 12½" (22.2 x 43.8 x 31.8 cm). Mint Museum of Craft + Design.
Promised Gift of Jane and Arthur Mason

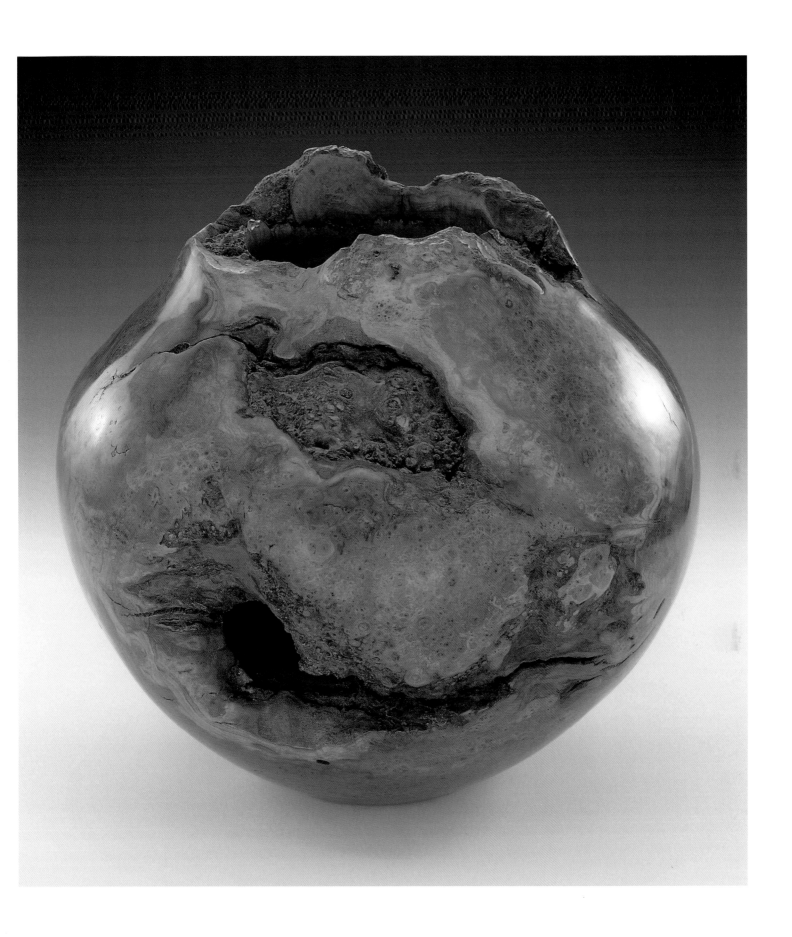

64. Mel Lindquist. *Natural Top Hopi Bowl*. 1986. Cherry burl, lathe-turned.
 10 x 10½ x 10½" (25.4 x 26.7 x 26.7 cm). Mint Museum of Craft + Design.
 Promised Gift of Jane and Arthur Mason

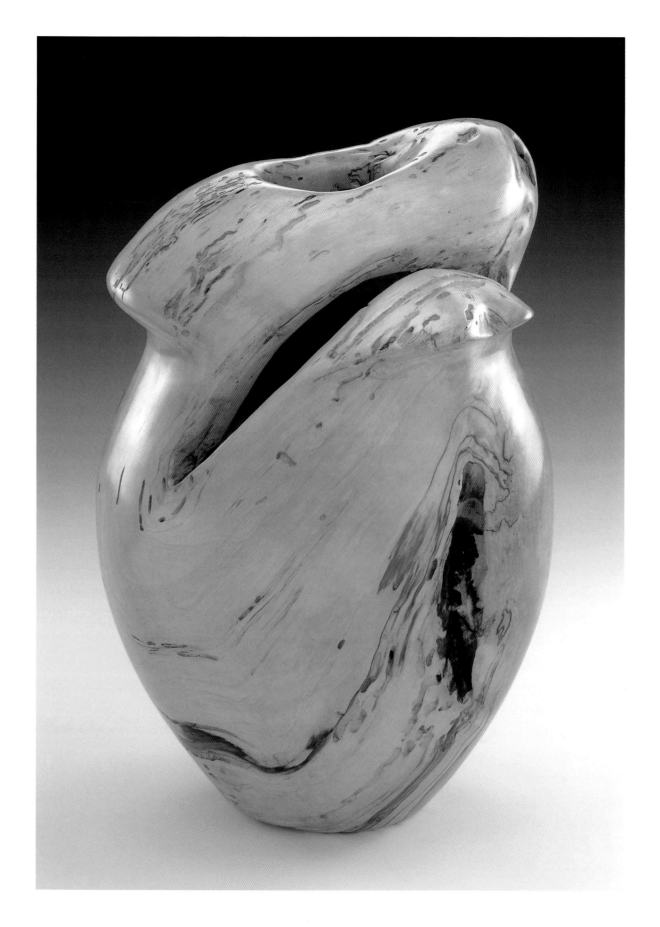

65. Mel Lindquist. *Turned and Carved Sculptural Vase #4*. 1988. Spalted white
 birch burl, lathe-turned. 11 x 8½ x 8½" (27.9 x 21.6 x 21.6 cm). Mint Museum
 of Craft + Design. Gift of Jane and Arthur Mason

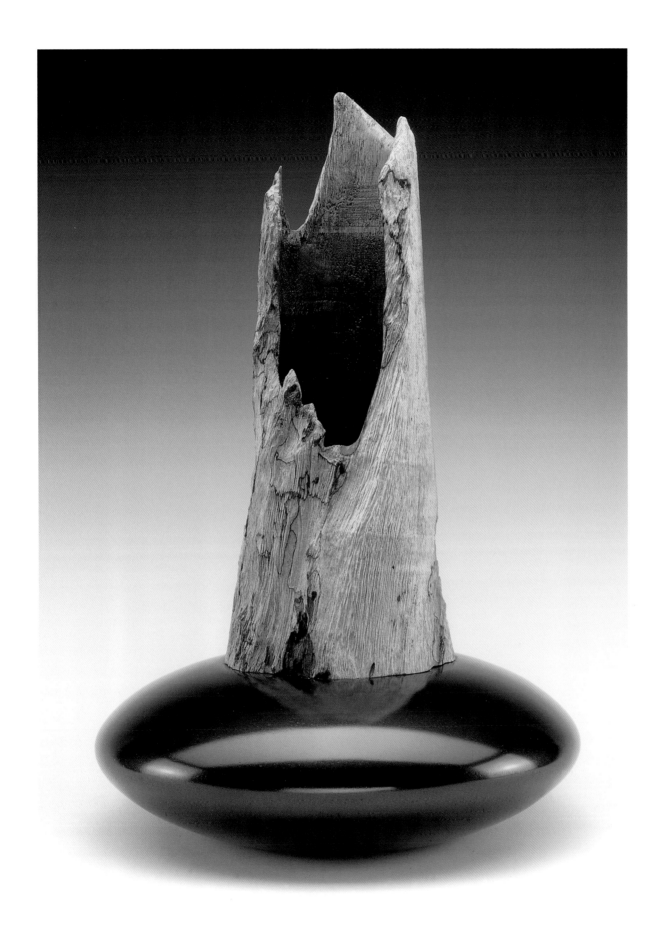

66. Johannes Michelson. *Untitled (Grey Lacquered with Spalted Maple Neck)*.
1988. Spalted maple, lathe-turned, lacquered. 17 x 10 x 10" (43.2 x 25.4 cm).
Mint Museum of Craft + Design. Gift of Jane and Arthur Mason

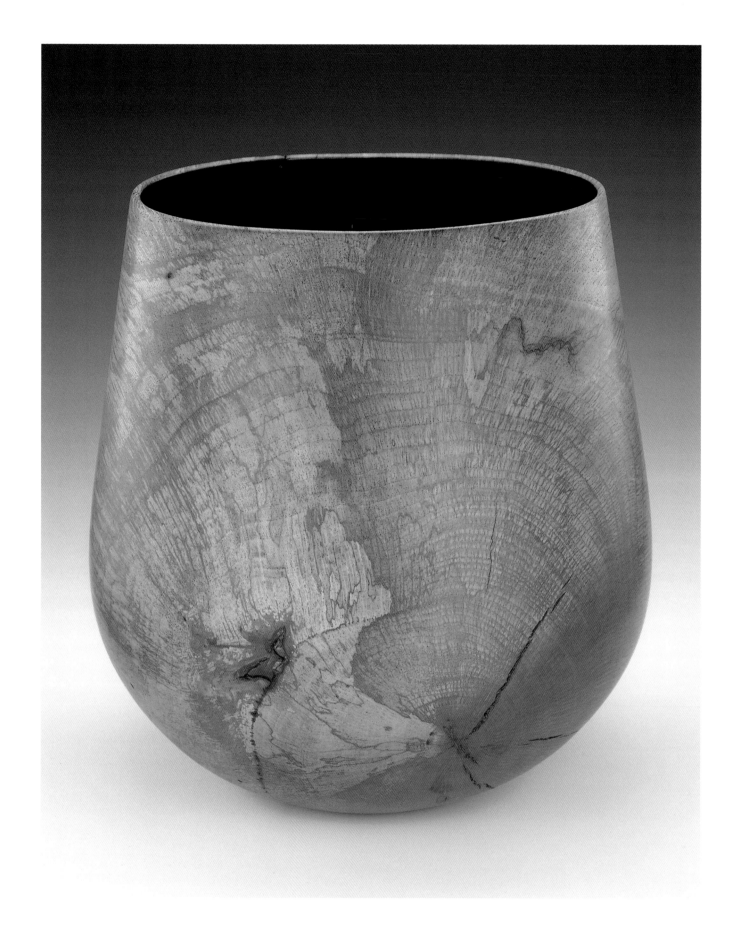

67. Bruce Mitchell. *Nocturnal Eclipse #5*. 1982. Spalted tanbark oak, lathe-
turned, painted. 8 x 7¾ x 7" (20.3 x 19.7 x 17.8 cm). Mint Museum of Craft +
Design. Gift of Jane and Arthur Mason

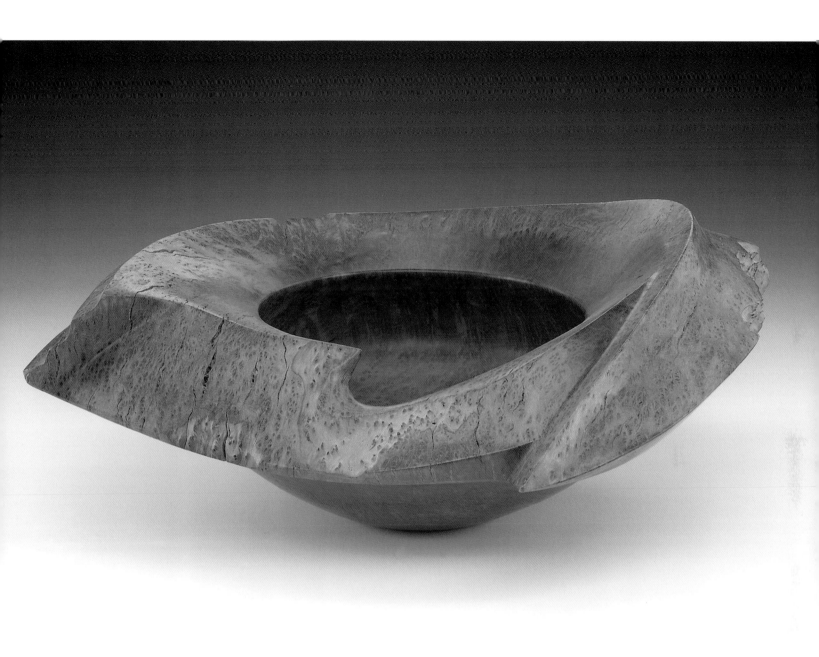

68. Bruce Mitchell. *Hovercraft for Gnomes #4*. 1988. Redwood burl, lathe-turned, carved. 8½ x 22 x 20" (21.6 x 55.9 x 50.8 cm). Mint Museum of Craft + Design. Promised Gift of Jane and Arthur Mason

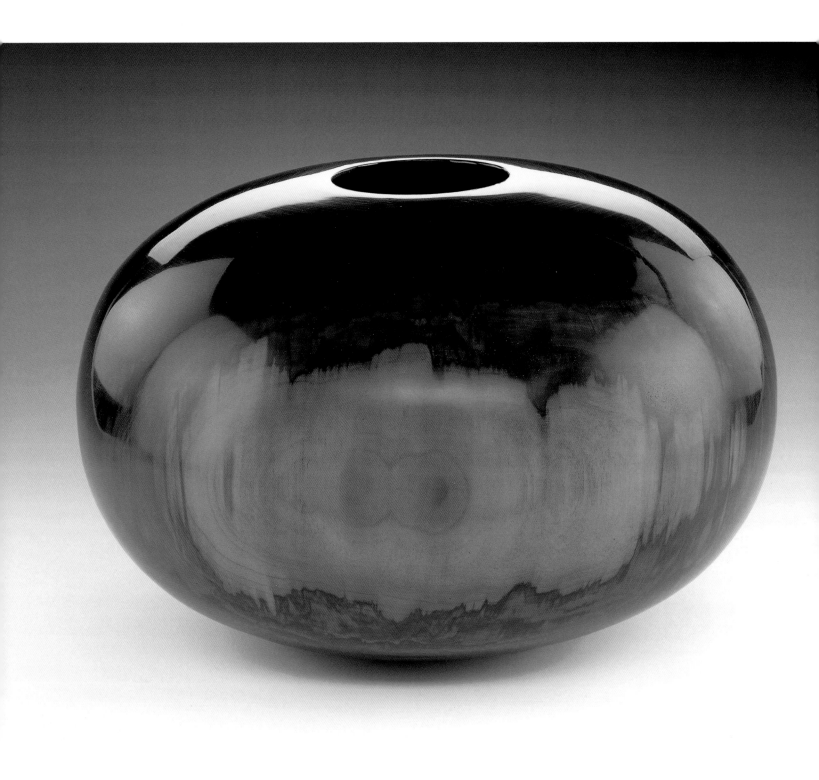

69. Ed Moulthrop. *Untitled*. 1987. Figured tulipwood, lathe-turned. 14 x 23 x 23"
(35.6 x 58.4 x 58.4 cm). Collection Thomas B. Mason

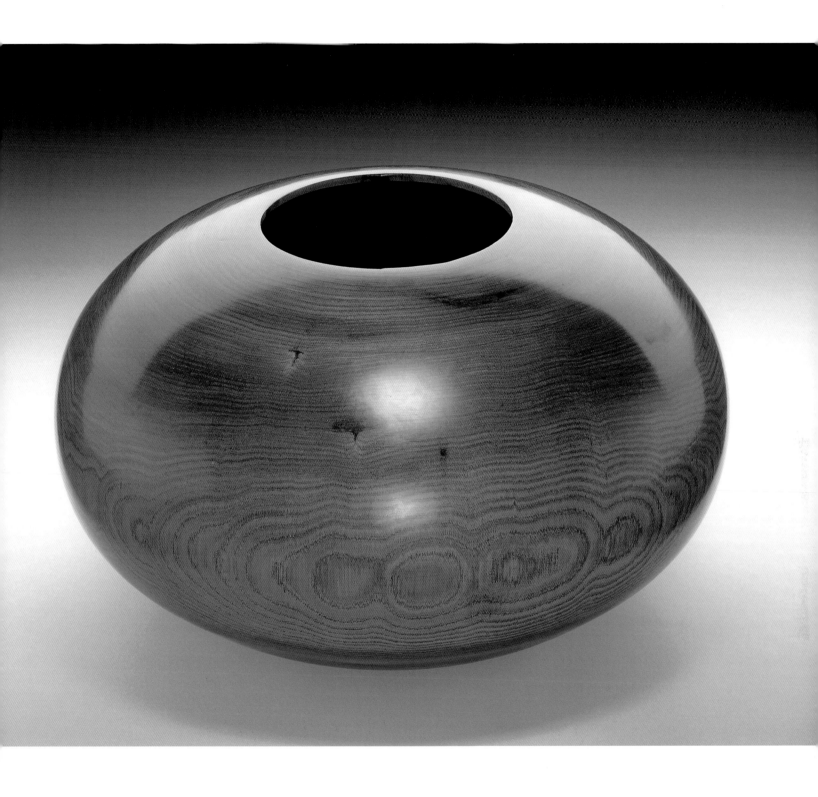

70. Ed Moulthrop. *Untitled*. 1988. American chestnut, lathe-turned. 9 x 15 x 15"
(22.8 x 38.1 x 38.1 cm). Mint Museum of Craft + Design. Gift of Jane and
Arthur Mason

71. Ed Moulthrop. *Morning Glory*. 1988. Tulipwood, lathe-turned. 10 x 12 x 12"
(25.4 x 30.5 x 30.5 cm). Mint Museum of Craft + Design. Gift of Jane and
Arthur Mason

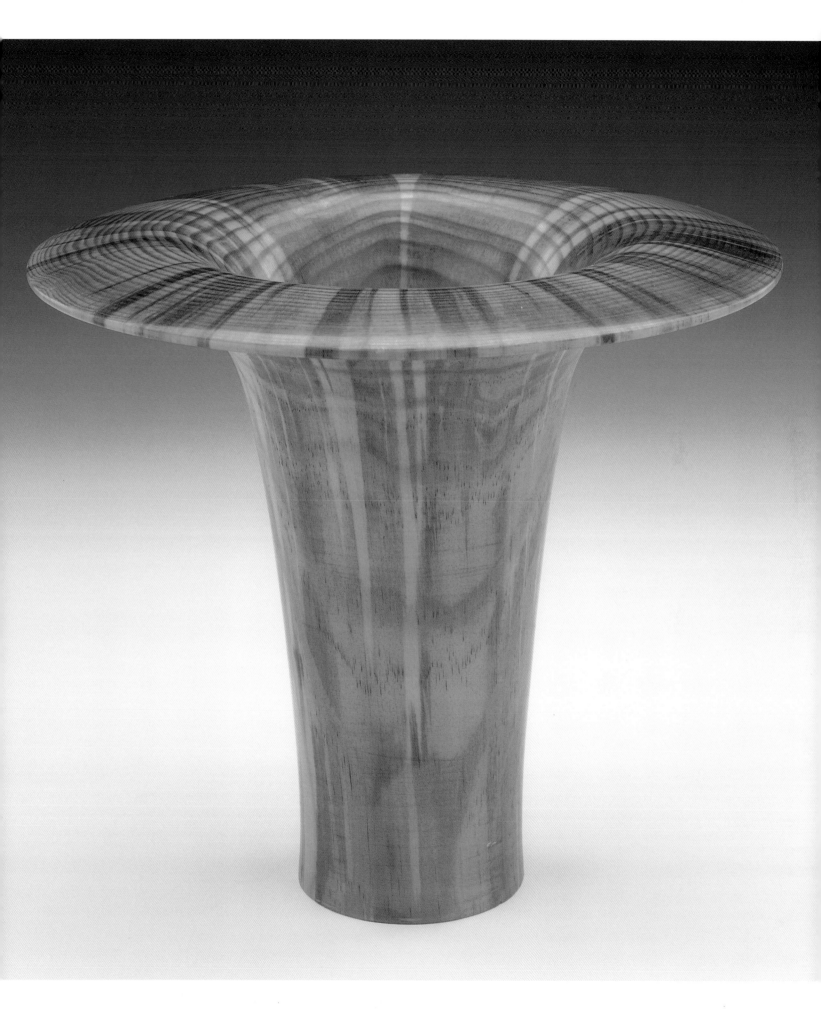

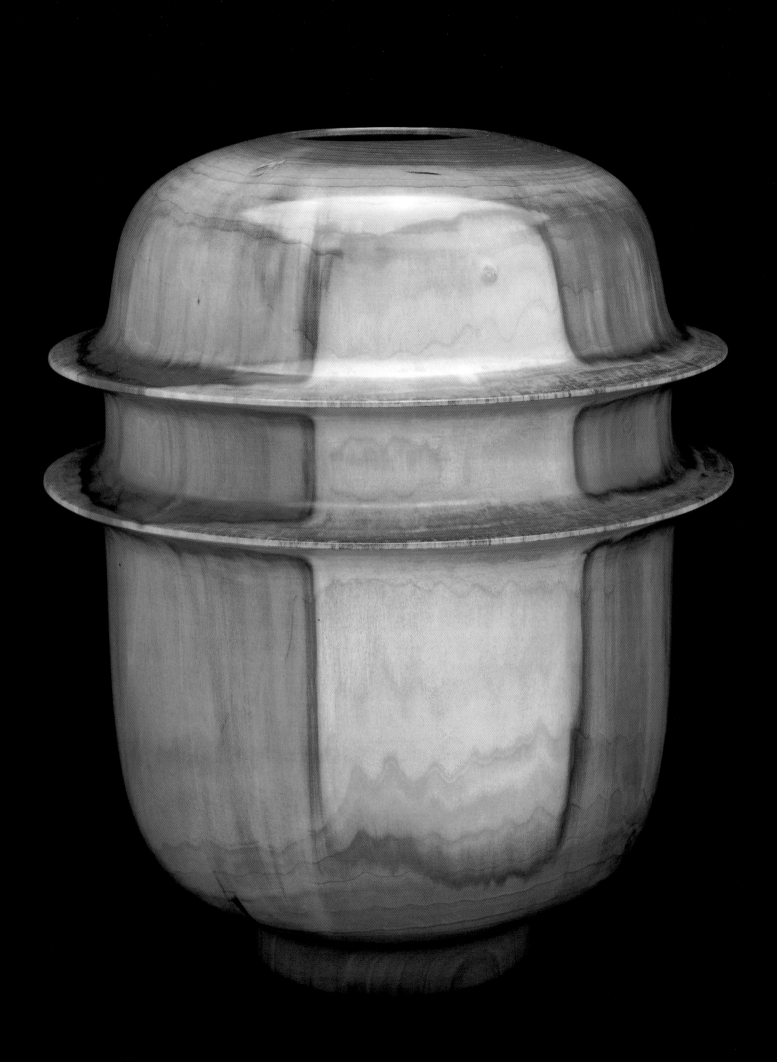

72. Ed Moulthrop. *Saturn*. 1989. Figured tulipwood, lathe-turned. 19 x 16 x 16"
(48.3 x 40.6 x 40.6 cm). Mint Museum of Craft + Design. Gift of Jane and
Arthur Mason

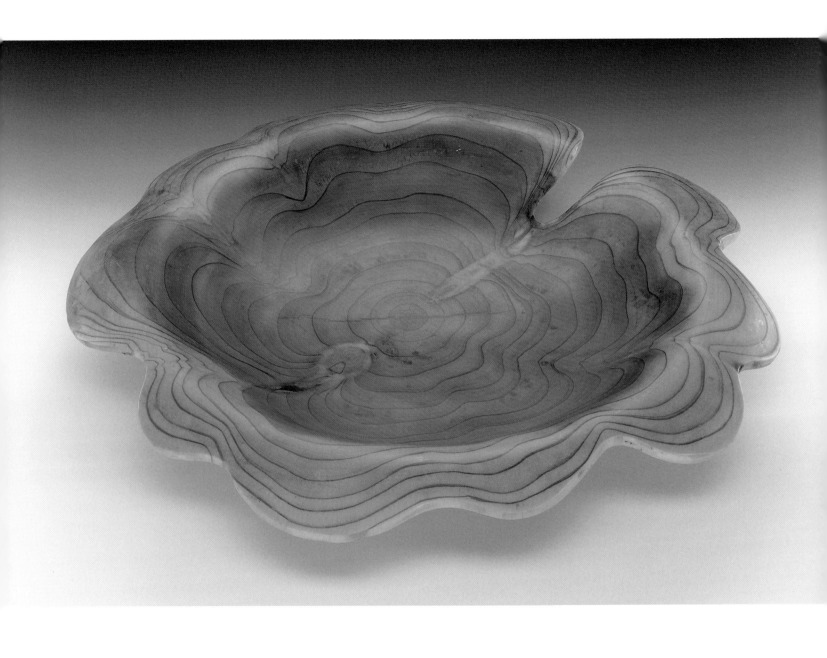

73. Ed Moulthrop. *Untitled*. 1991. Dawn redwood, lathe-turned. 3¼ x 19½ x 19½"
(8.3 x 49.5 x 49.5 cm). Mint Museum of Craft + Design. Promised Gift of
Jane and Arthur Mason

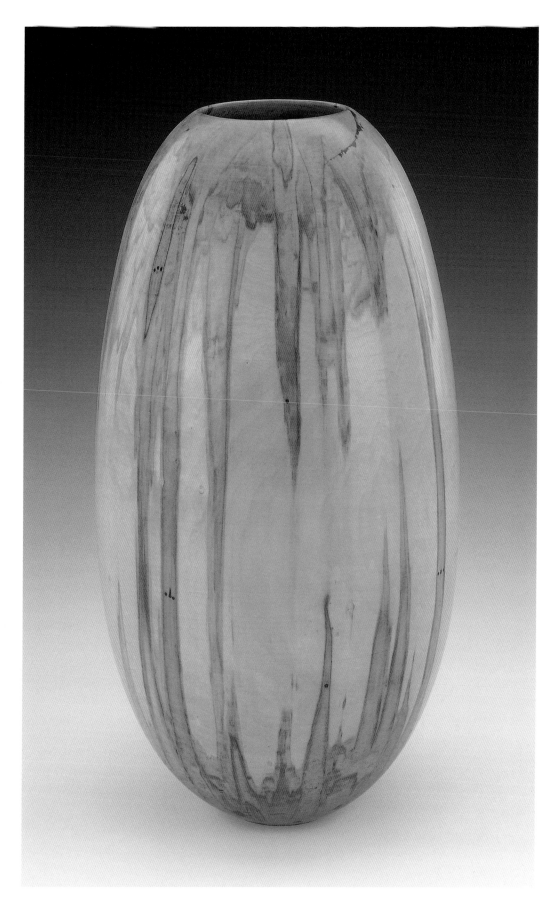

74. Philip Moulthrop. *Untitled*. 1988. Spalted ash-leaf maple, lathe-turned.
21 x 10 x 10" (53.3 x 25.4 x 25.4 cm) Mint Museum of Craft + Design.
Promised Gift of Jane and Arthur Mason

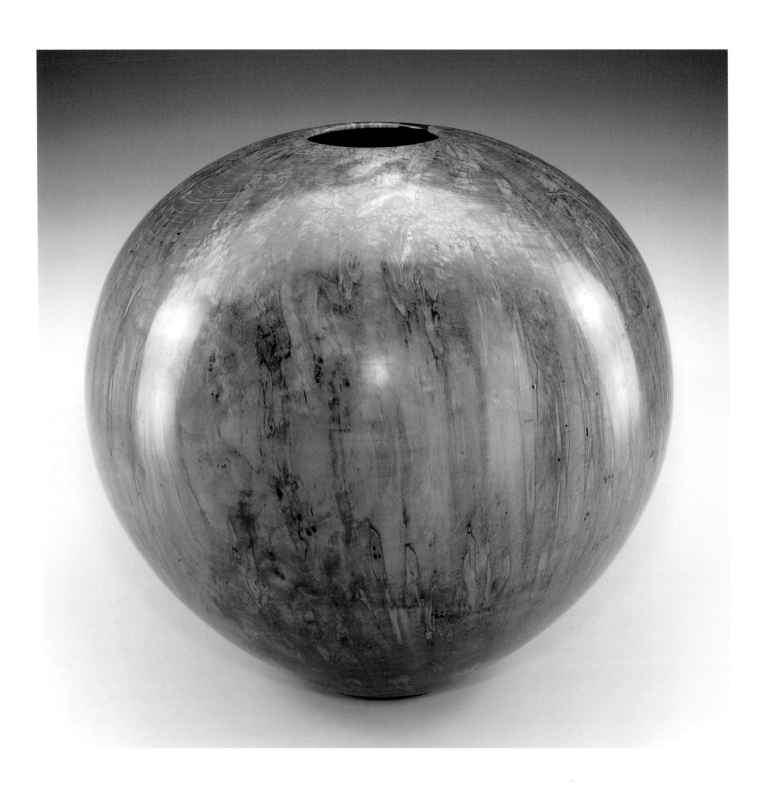

75. Philip Moulthrop. *Untitled*. 1988. Red "leopard" maple, lathe-turned.
20 x 24 x 24" (50.8 x 61 x 61 cm). Mint Museum of Craft + Design.
Gift of Jane and Arthur Mason

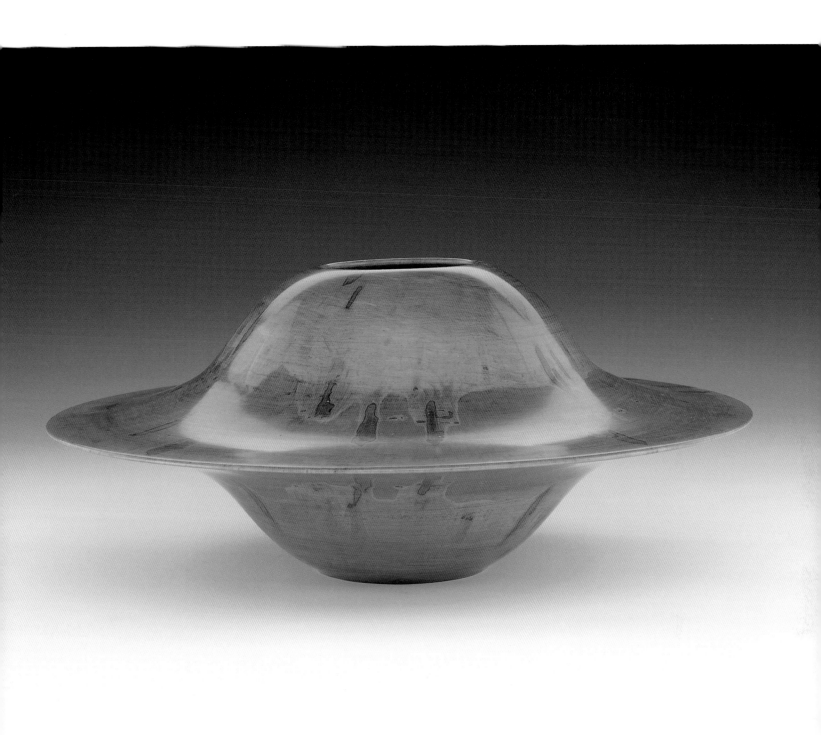

76. Philip Moulthrop. *Saturn*. 1990. Red "leopard" maple, lathe-turned.
 7 x 18½ x 18½" (17.8 x 47 x 47 cm). Mint Museum of Craft + Design.
 Promised Gift of Jane and Arthur Mason

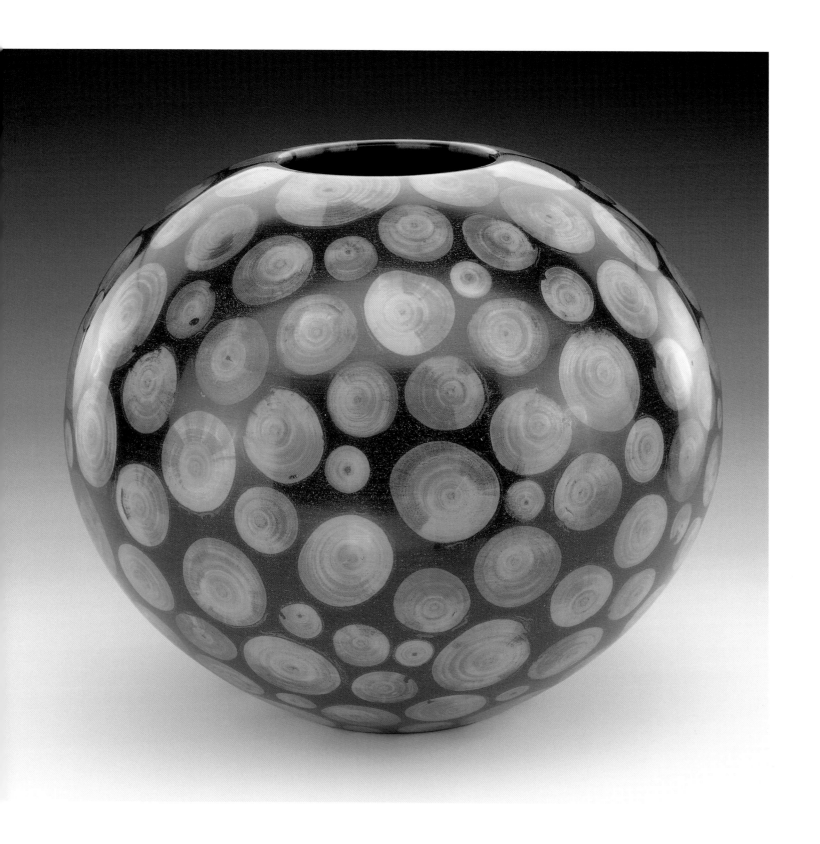

77. Philip Moulthrop. *White Pine Mosaic Bowl.* 1993. White pine, resin, lathe-turned. 9¾ x 11¾ x 11¾" (24.8 x 29.9 x 29.9 cm). Mint Museum of Craft + Design. Gift of Jane and Arthur Mason

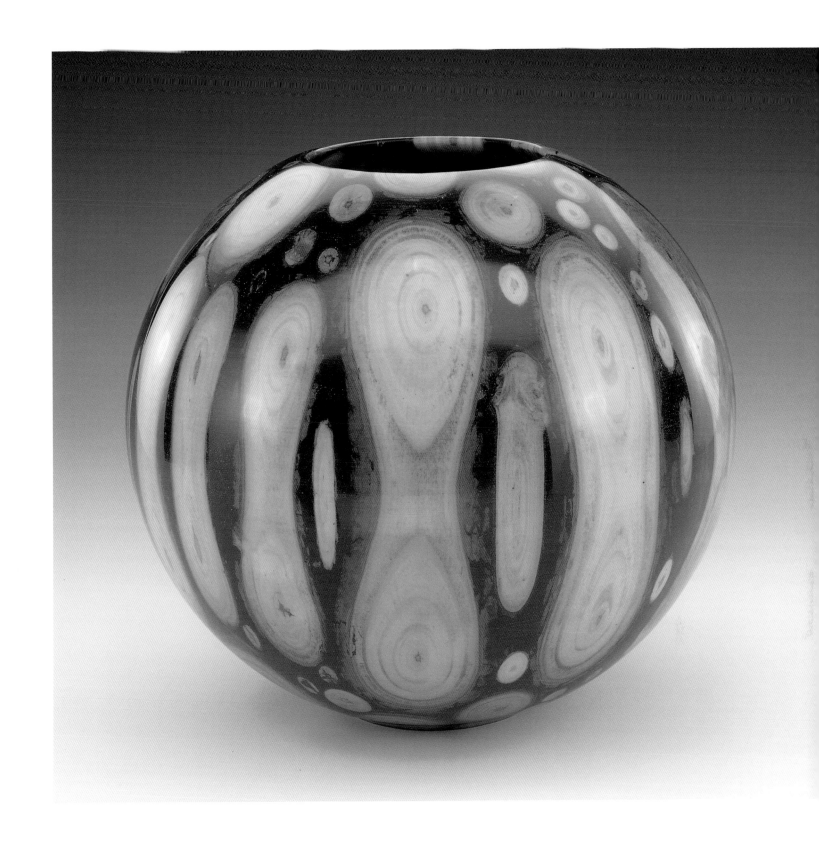

78. Philip Moulthrop. *Vertical Pine Mosaic Bowl*. 1997. White pine, resin, lathe-
turned. 8 x 9 x 9" (20.3 x 28.9 x 28.9 cm). Mint Museum of Craft + Design.
Promised Gift of Jane and Arthur Mason

79. Dale Nish. *Sandblasted Vessel #2*. 1989. Wormy ash, lathe-turned.
13 x 11½ x 11½" (33 x 29.2 x 29.2 cm). Mint Museum of Craft + Design.
Promised Gift of Jane and Arthur Mason

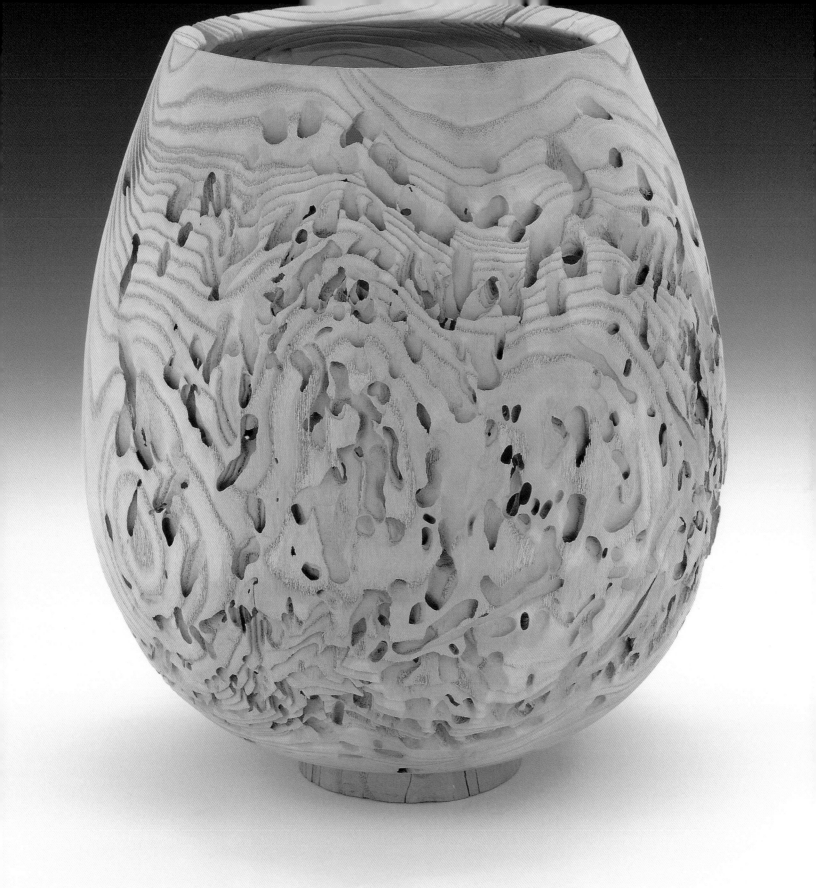

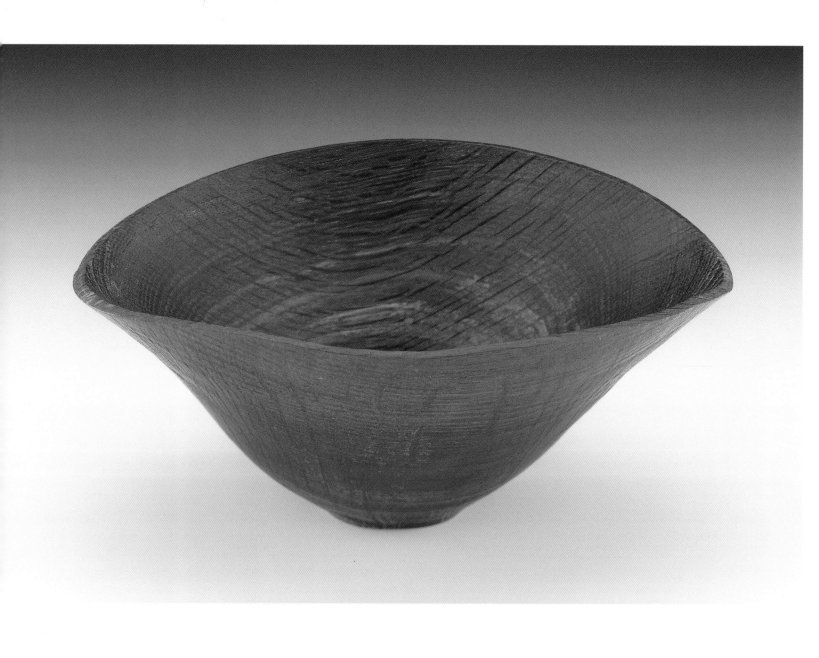

80. Liam O'Neill. *Untitled*. 1995. Bog oak, lathe-turned. 2½ x 5 x 5" (6.4 x 12.7 x
 12.7 cm). Mint Museum of Craft + Design. Gift of Jane and Arthur Mason

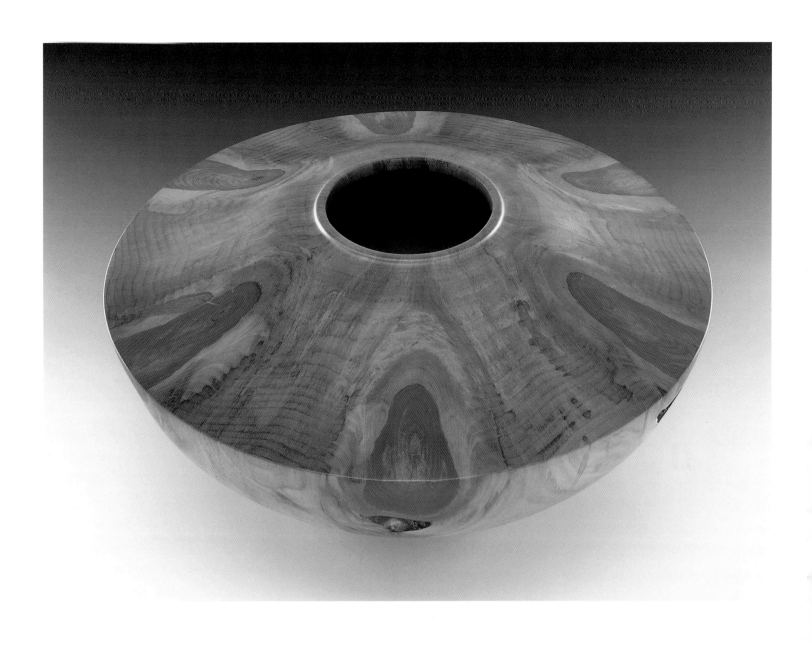

81. Liam O'Neill. *QE II Series*. From the same log as a bowl the President of Ireland
 gave Queen Elizabeth II, May 1993. Monkey puzzle, lathe-turned. 6 x 15 x 15" (15.2 x
 38.1 x 38.1 cm). Mint Museum of Craft + Design. Gift of Jane and Arthur Mason

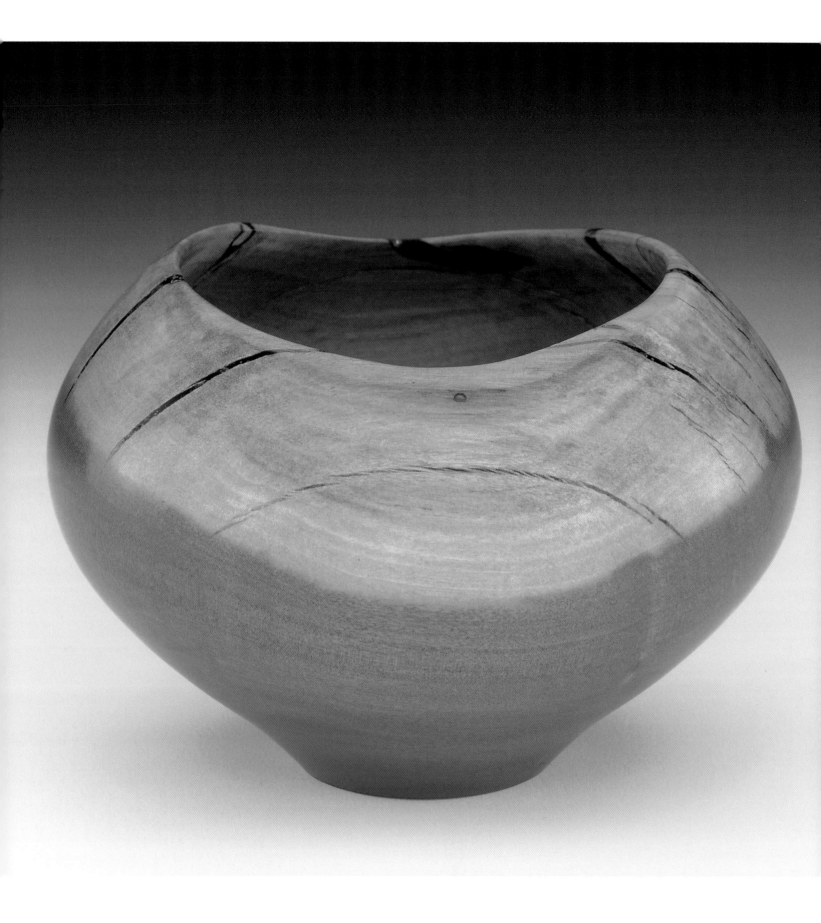

82. Rude Osolnik. *Untitled*. 1986. Pink ivorywood, lathe-turned. 3 x 4½ x 4½"
(7.6 x 11.4 x 11.4 cm). Mint Museum of Craft + Design. Gift of Jane and
Arthur Mason

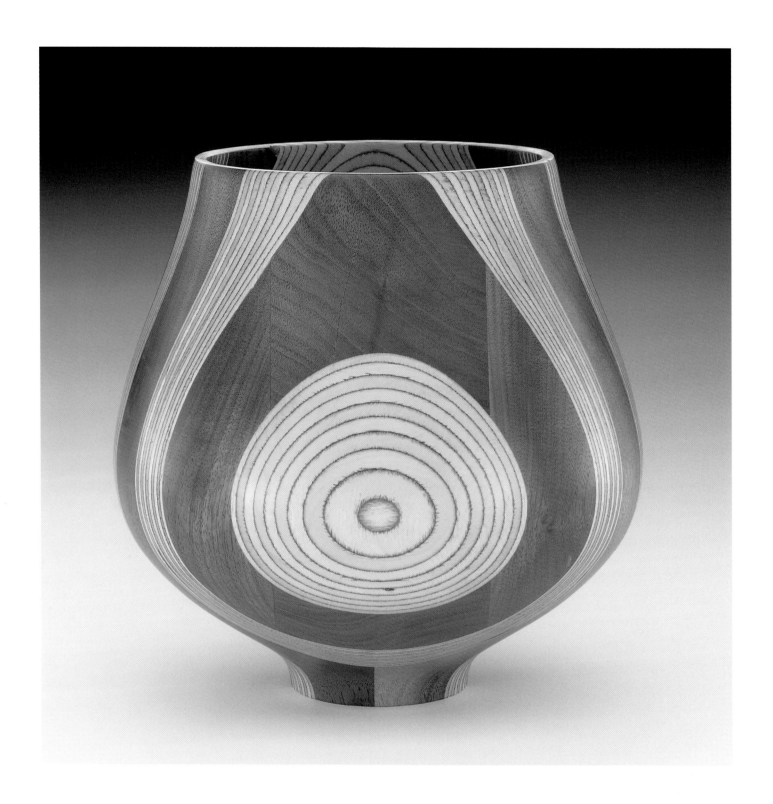

83. Rude Osolnik. *Untitled.* 1986. Black walnut, laminated baltic birch plywood, lathe-turned. 6¾ x 6½ x 6½" (17.2 x 16.5 x 16.5 cm). Mint Museum of Craft + Design. Promised Gift of Jane and Arthur Mason

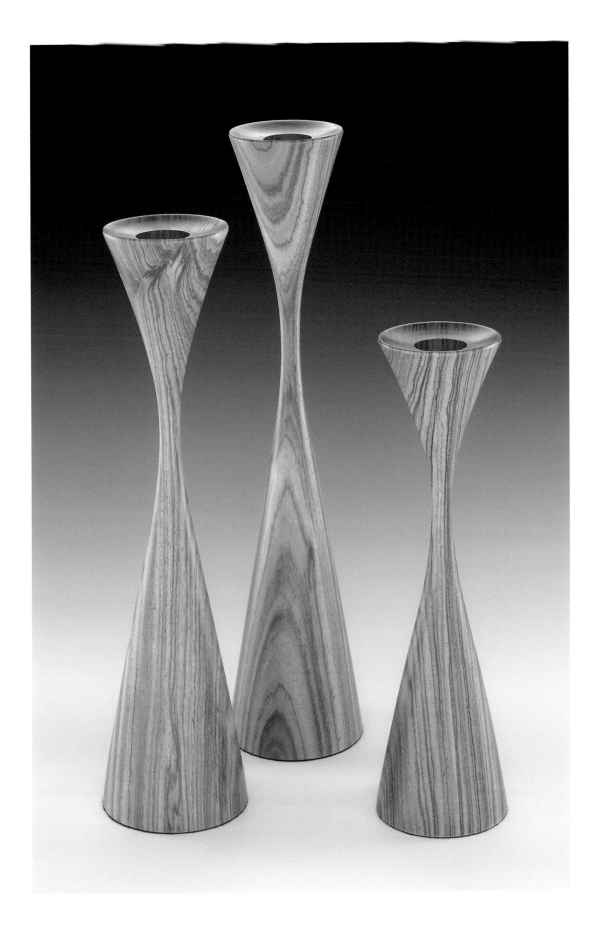

84. Rude Osolnik. *Three Candlesticks*. 1992. Tulipwood, lathe-turned.
7½, 9¼, 10½ x 2½ x 2½" (19.1, 23.5, 26.7 x 6.4 x 6.4 cm). Mint Museum
of Craft + Design. Gift of Jane and Arthur Mason

85. Jim Partridge. *From the Blood Vessel Series*. 1987. Oak burl, lathe-turned, burned. 4¾ x 11 x 8" (12 x 27.9 x 20.3 cm). Mint Museum of Craft + Design. Promised Gift of Jane and Arthur Mason

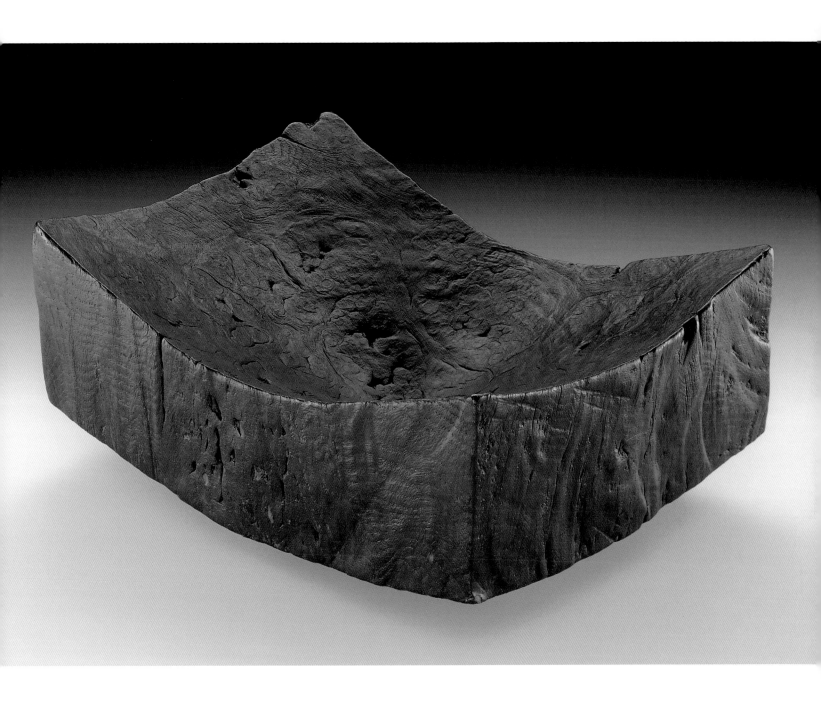

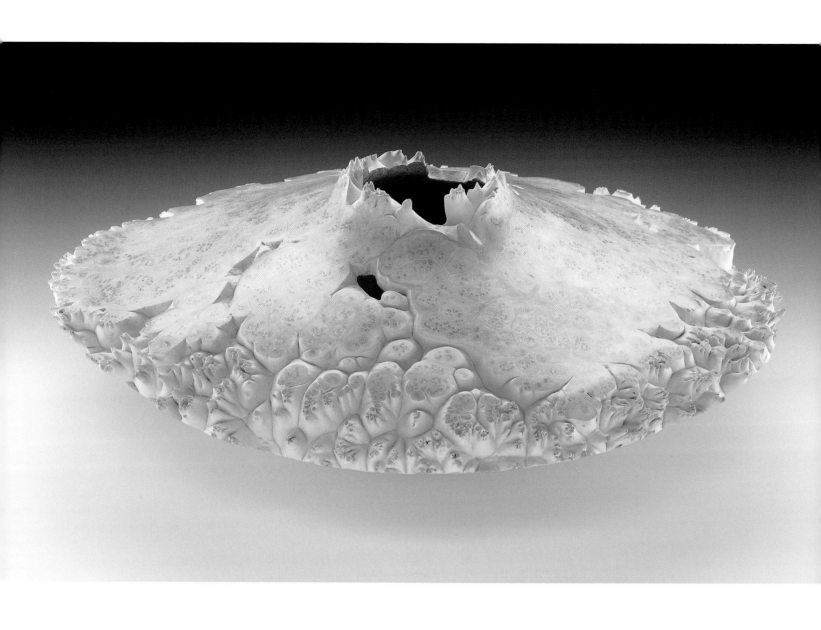

86. Michael J. Peterson. *Navaho Land, Landscape Series*. 1987. Maple burl,
 lathe-turned, bleached. 6 x 17½ x 17½" (15.2 x 44.5 x 44.5 cm). Mint
 Museum of Craft + Design. Gift of Jane and Arthur Mason

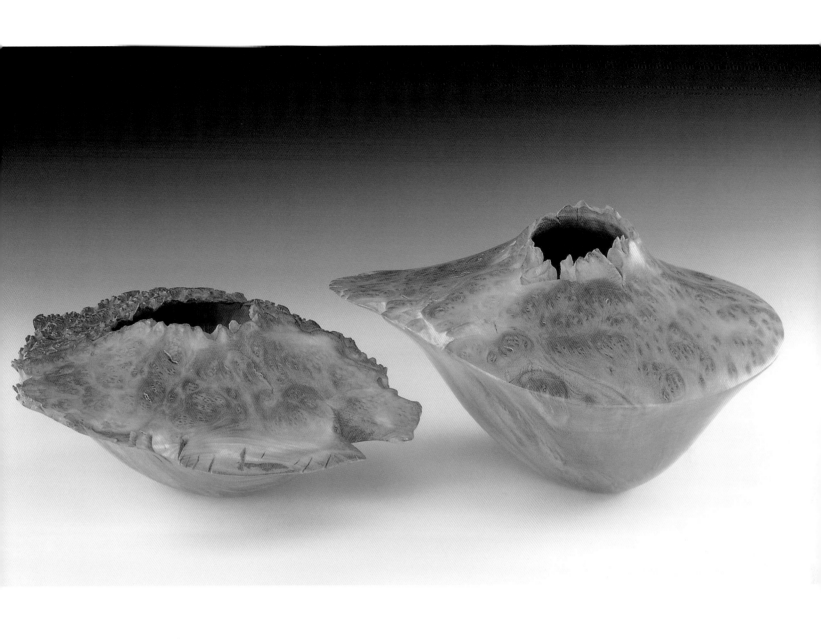

87. Michael J. Peterson. *Wind Drift and Sea Drift*. 1988. Madrone burl, lathe-
turned, carved. *Wind Drift:* 5 x 9½ x 8¾" (12.7 x 24.1 x 22.2 cm); *Sea Drift:*
3½ x 9 x 6¾" (8.9 x 22.9 x 17.2 cm). Mint Museum of Craft + Design. Gift of
Jane and Arthur Mason

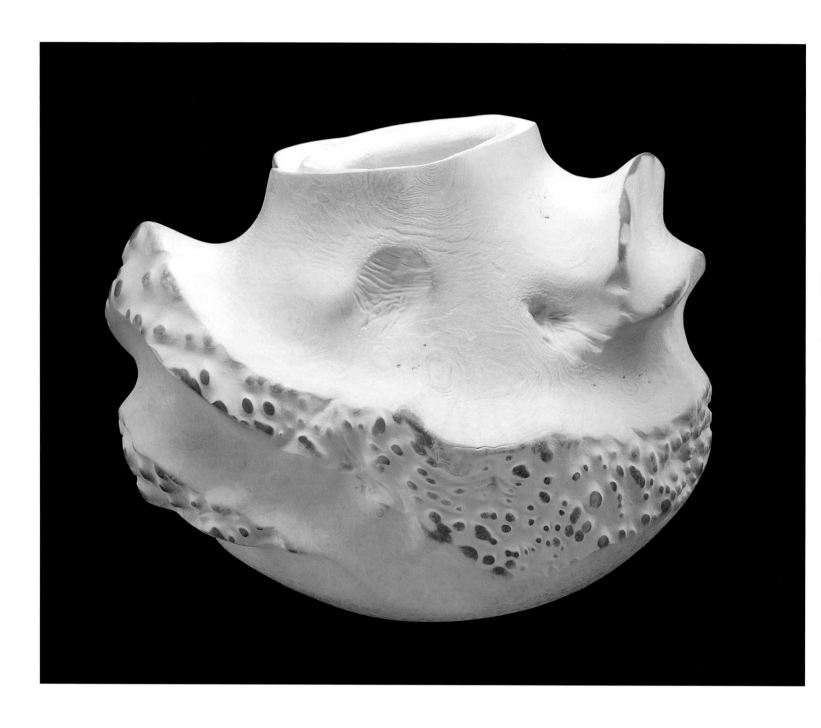

88. Michael J. Peterson. *The Kimona*. 1992. Madrone, lathe-turned, carved,
 bleached. 10 x 13½ x 12" (25.4 x 34.3 x 30.5 cm). Mint Museum of Craft +
 Design. Promised Gift of Jane and Arthur Mason

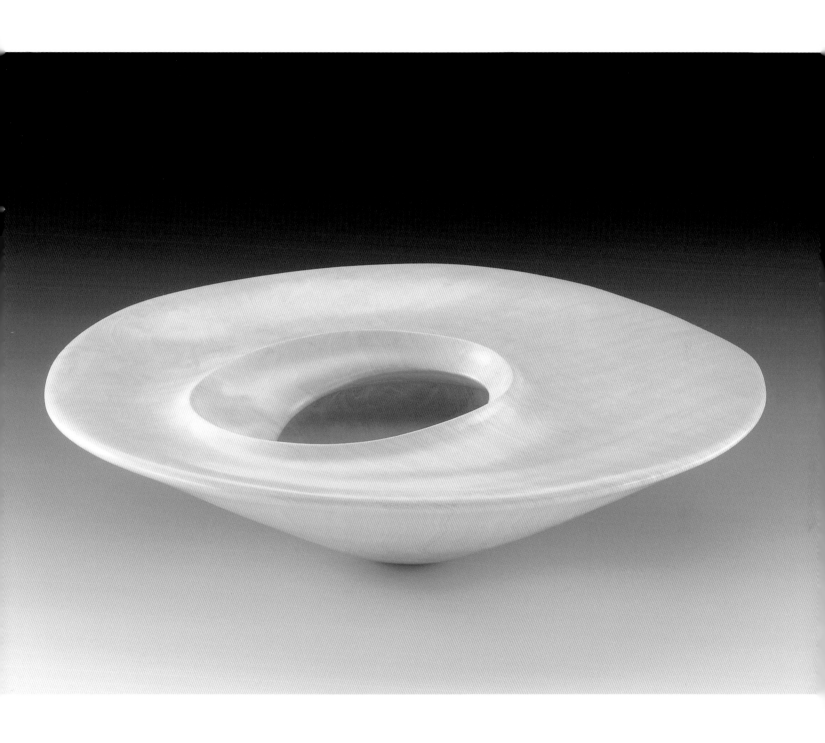

89. Michael J. Peterson. *Untitled*. 1993. Madrone, lathe-turned, carved, bleached. 3 x 9½ x 9½" (7.6 x 24.1 x 24.1 cm). Mint Museum of Craft + Design. Gift of Jane and Arthur Mason

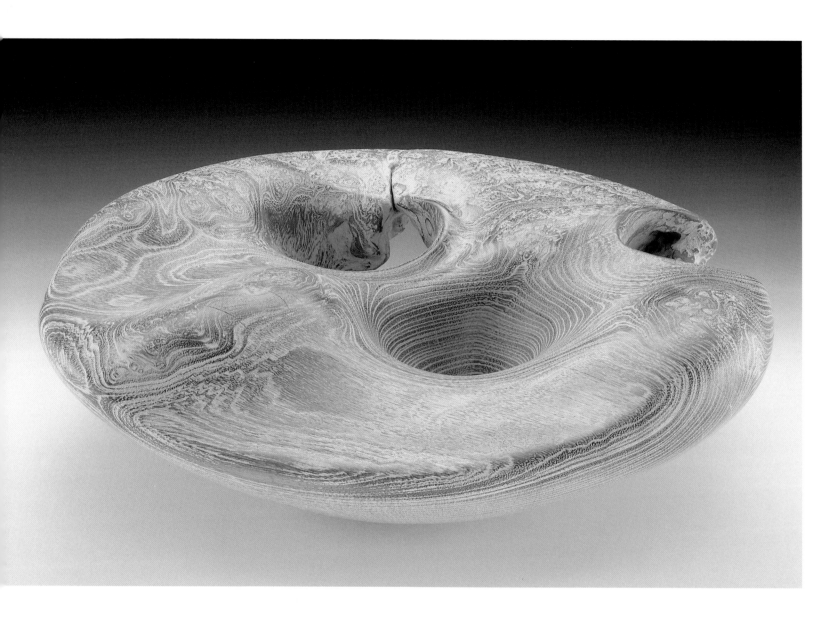

90. Michael J. Peterson. *Water Way Course, Landscape Series*. 1997. Locust
 burl, lathe-turned, carved, sandblasted. 5½ x 14 x 14" (14 x 35.6 x 35.6 cm).
 Mint Museum of Craft + Design. Promised Gift of Jane and Arthur Mason

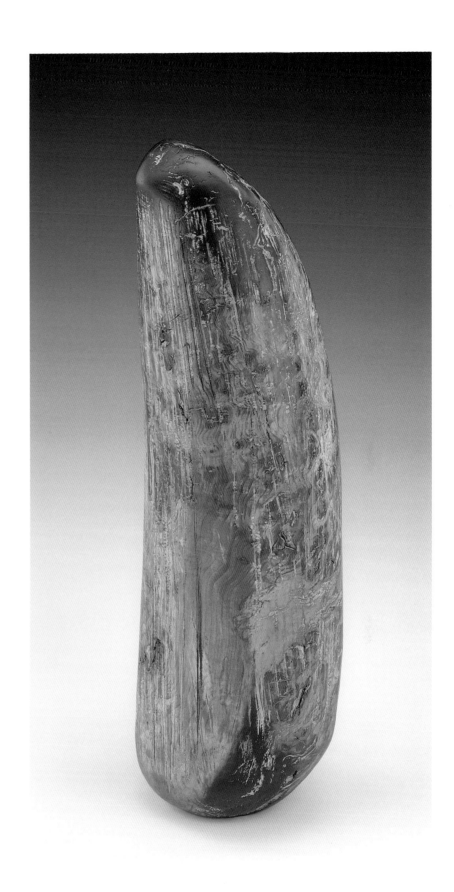

91. Michael J. Peterson. *Tusk from the Coastal Series*. 1998 Madrone burl,
 pigmented, carved, sandblasted. 21 x 6½ x 7½" (53.3 x 16.5 x 19.1 cm).
 Mint Museum of Craft + Design. Promised Gift of Jane and Arthur Mason

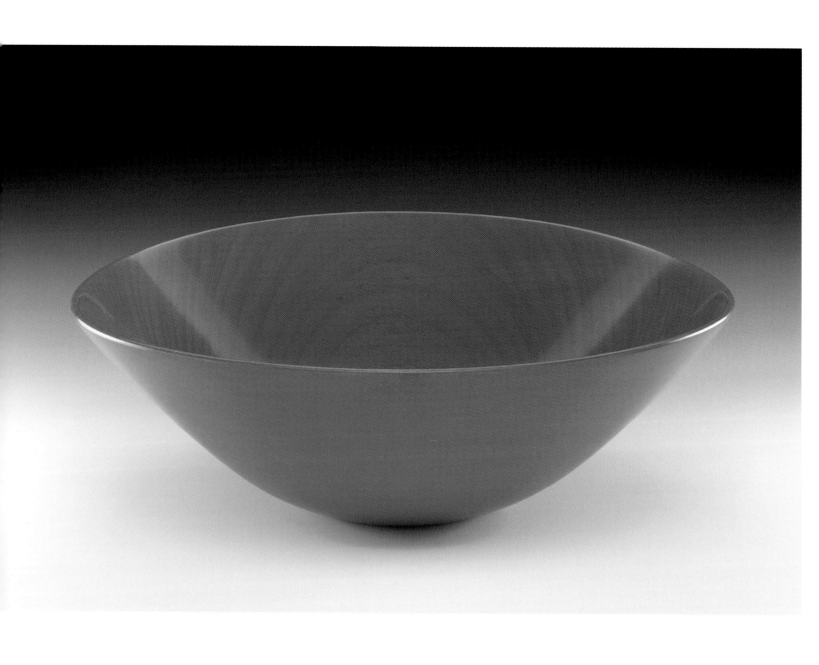

92. James Prestini. *Untitled*. 1951. Mexican mahogany, lathe-turned.
 4½ x 12½ x 12½" (11.4 x 31.8 x 31.8 cm). Mint Museum of Craft + Design.
 Gift of Jane and Arthur Mason

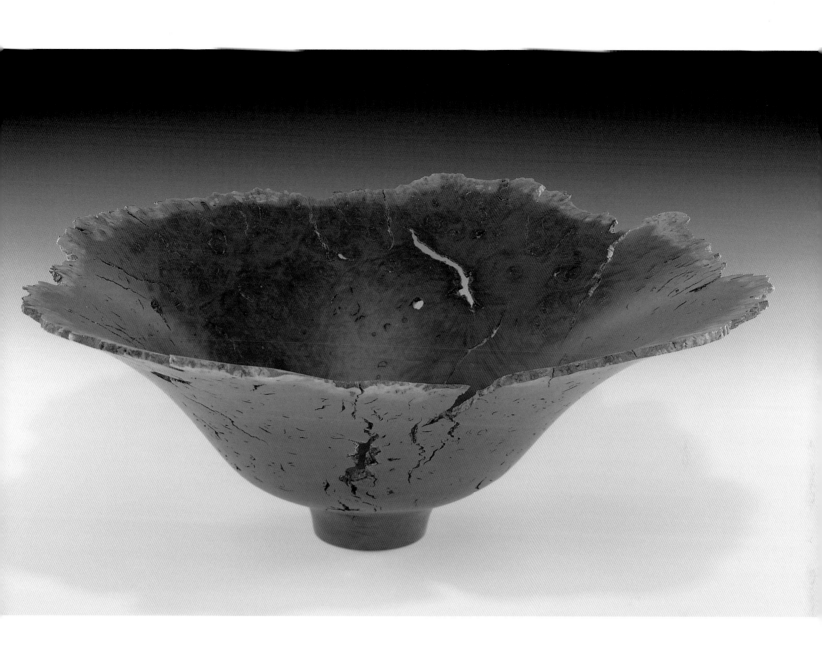

93. Hap Sakwa. *Lotus Bowl.* 1984. Wild lilac, lathe-turned. 5 x 13¼ x 13¼"
 (12.7 x 33.7 x 33.7 cm). Mint Museum of Craft + Design. Promised Gift of
 Jane and Arthur Mason

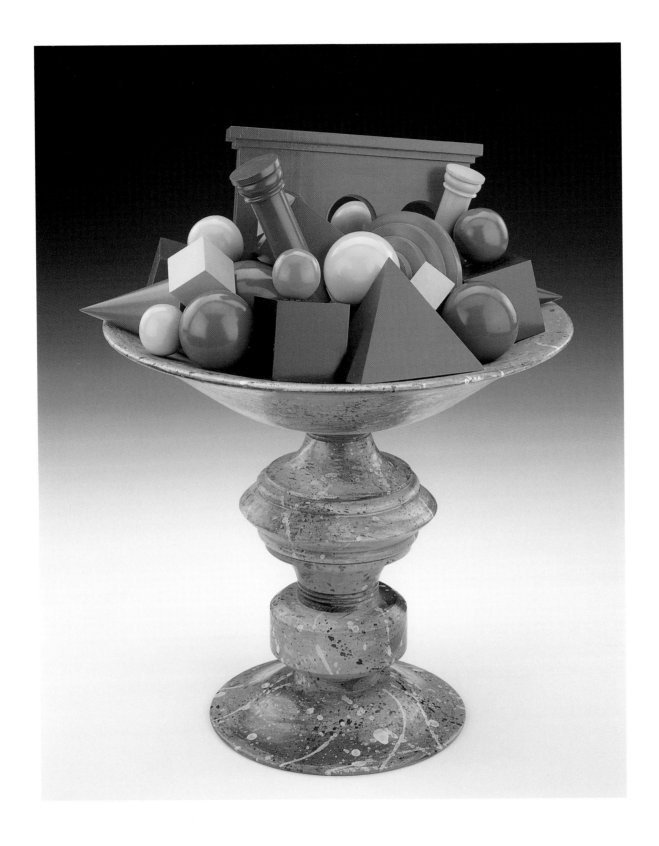

94. Hap Sakwa. *De Chirico Bowl*. 1985. Wood, lathe-turned, carved, painted, constructed. 16½ x 13 x 13" (41.9 x 33 x 33 cm). Mint Museum of Craft + Design. Promised Gift of Jane and Arthur Mason

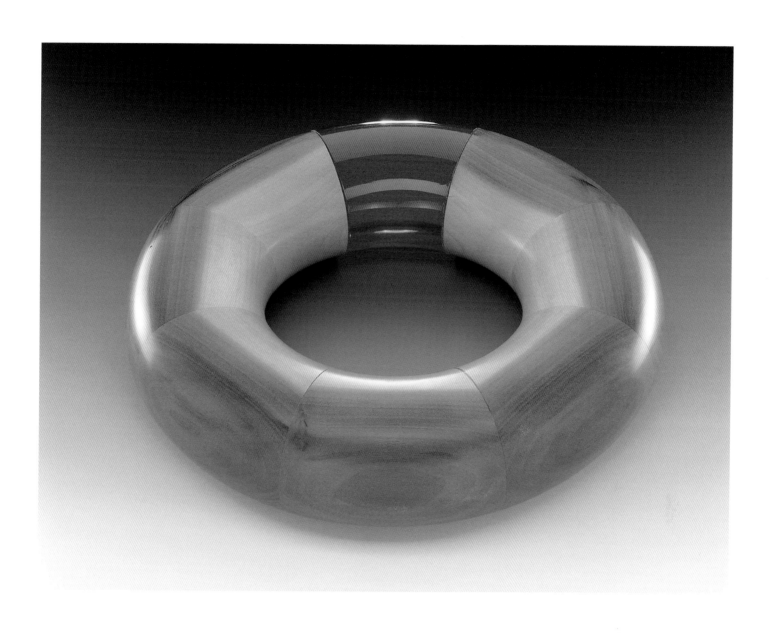

95. Merryll Saylan. *Jelly Donut*. 1979, 1989. Poplar, lathe-turned, cast polyester
 resin, constructed. 3 x 12 x 12" (7.6 x 30.5 x 30.5 cm). Mint Museum of
 Craft + Design. Gift of Jane and Arthur Mason

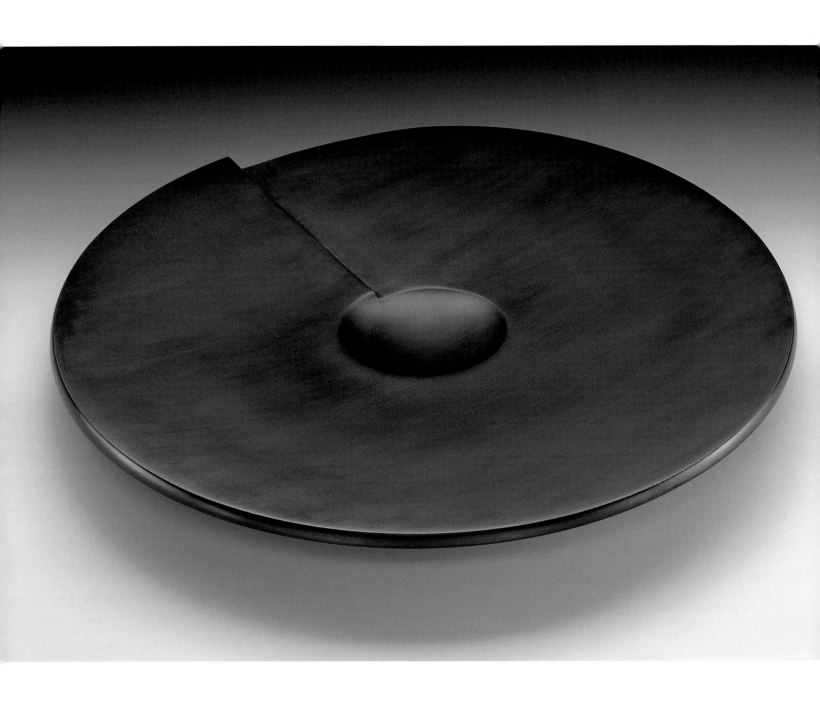

96. Merryll Saylan. *Untitled*. 1998. Maple, lathe-turned, ebonized. 1½ x 15 x 15"
 (3.8 x 38.1 x 38.1 cm). Mint Museum of Craft + Design. Promised Gift of
 Jane and Arthur Mason

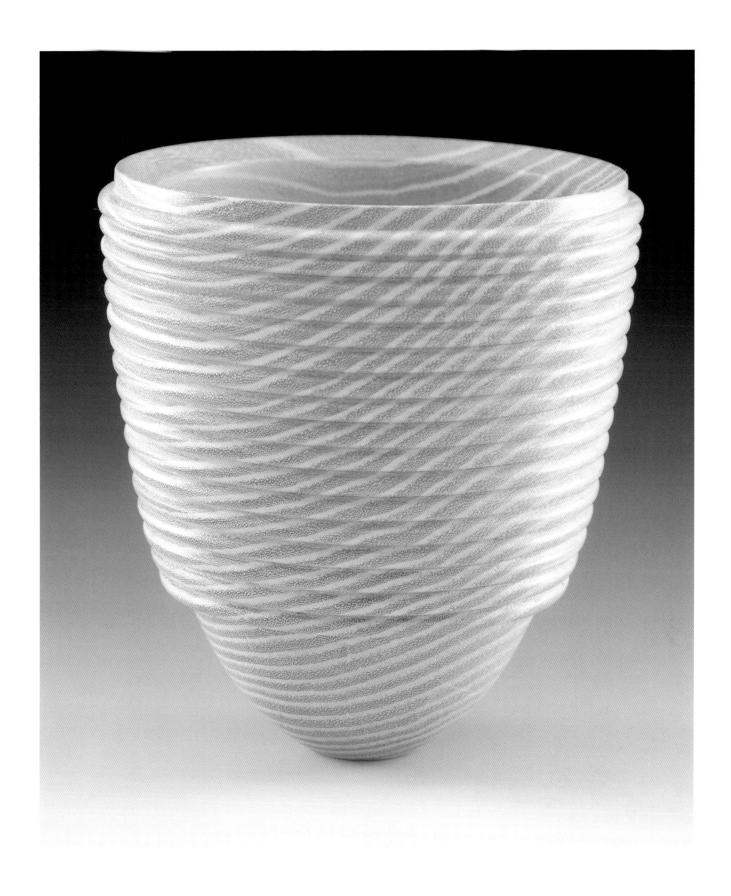

97. Betty J. Scarpino. *Untitled.* 1995. Osage orange, lathe-turned. 4 x 4 x 4"
(10.2 x 10.2 x 10.2 cm). Mint Museum of Craft + Design. Gift of Jane and
Arthur Mason

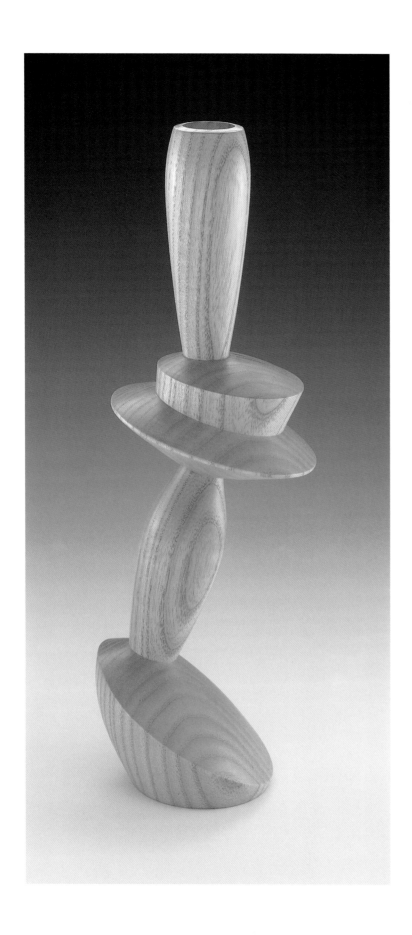

98. Mark Sfirri. *Multi-axis Candlestick #1*. 1992. Ash, multi-axis lathe-turned.
11 x 3½ x 3½" (27.9 x 8.9 x 8.9 cm). Mint Museum of Craft + Design.
Gift of Jane and Arthur Mason

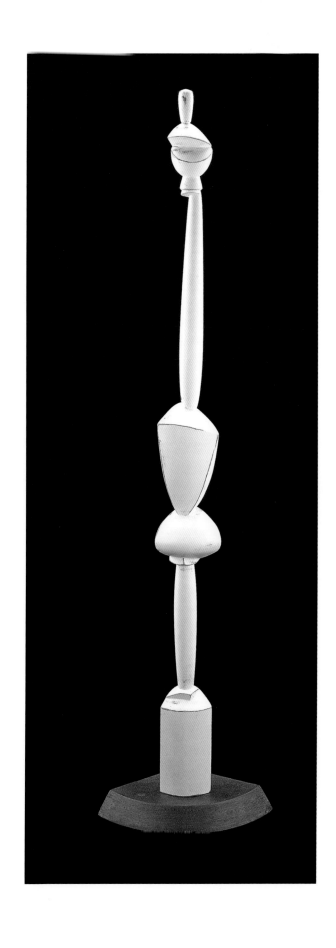

99. Mark Sfirri. *Untitled*. 1997. Maple, lathe-turned, carved, painted.
54 x 14 x 18" (137.2 x 35.6 x 45.7 cm). Mint Museum of Craft + Design.
Promised Gift of Jane and Arthur Mason

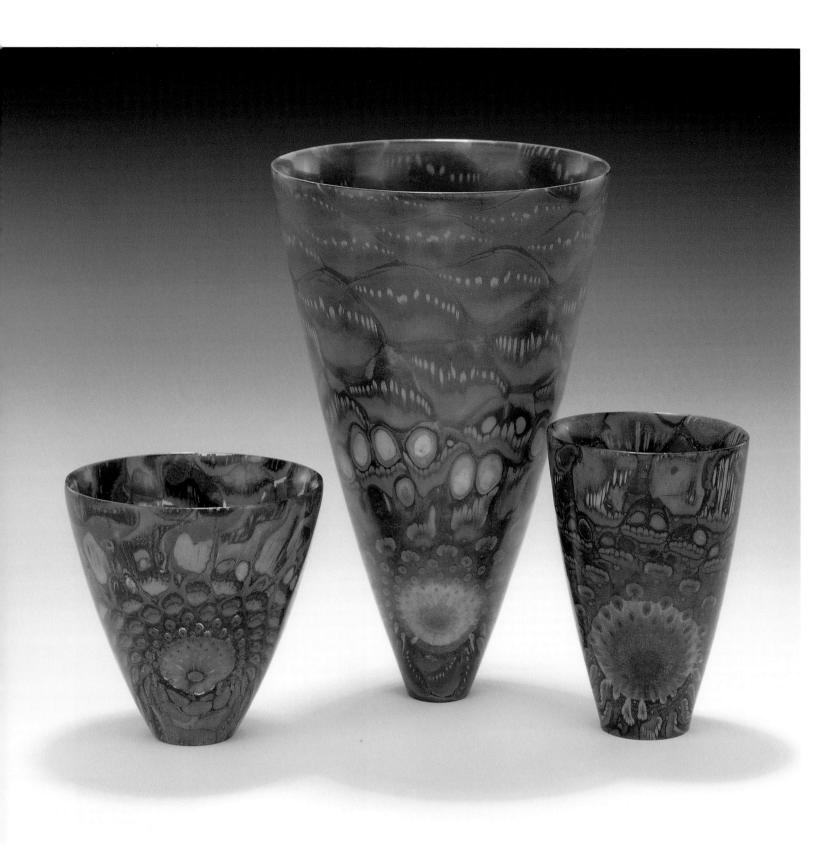

100. Mike Shuler. *#781*. 1995. Pine cone, epoxy, lathe-turned. 2½ x 2⅓ x 2⅓"
 (6.4 x 5.8 x 5.8 cm). Mint Museum of Craft + Design. Gift of Jane and
 Arthur Mason

101. Mike Shuler. *#791*. 1995. Pine cone, epoxy, lathe-turned. 5 x 3½ x 3½"
 (12.7 x 8.6 x 8.6 cm). Mint Museum of Craft + Design. Gift of Jane and
 Arthur Mason

102. Mike Shuler. *#415*. 1988. Pine cone, epoxy, lathe-turned. 3 x 2 x 2" (7.6 x 5.1
 x 5.1 cm). Mint Museum of Craft + Design. Gift of Jane and Arthur Mason

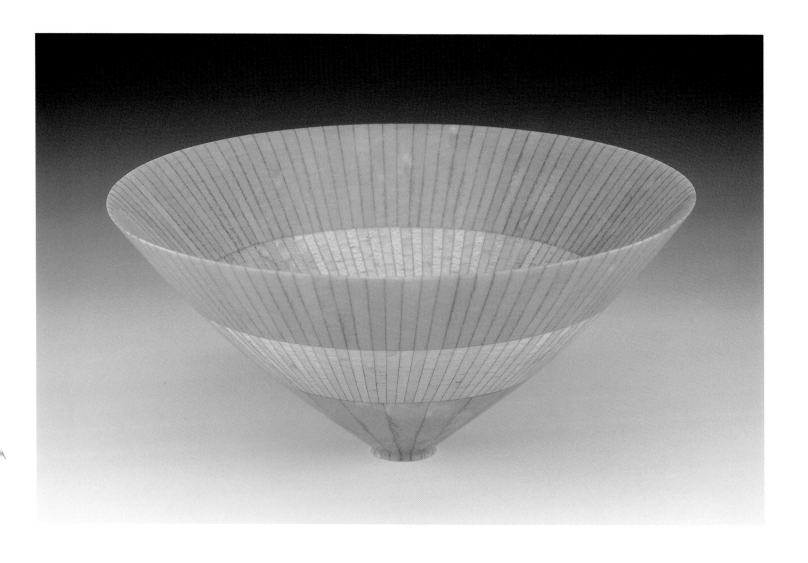

103. Mike Shuler. *#592*. 1991. Maple, segmented, lathe-turned, glue with red
 pigment. 2 x 4 x 4" (5.1 x 10.2 x 10.2 cm). Mint Museum of Craft + Design.
 Promised Gift of Jane and Arthur Mason

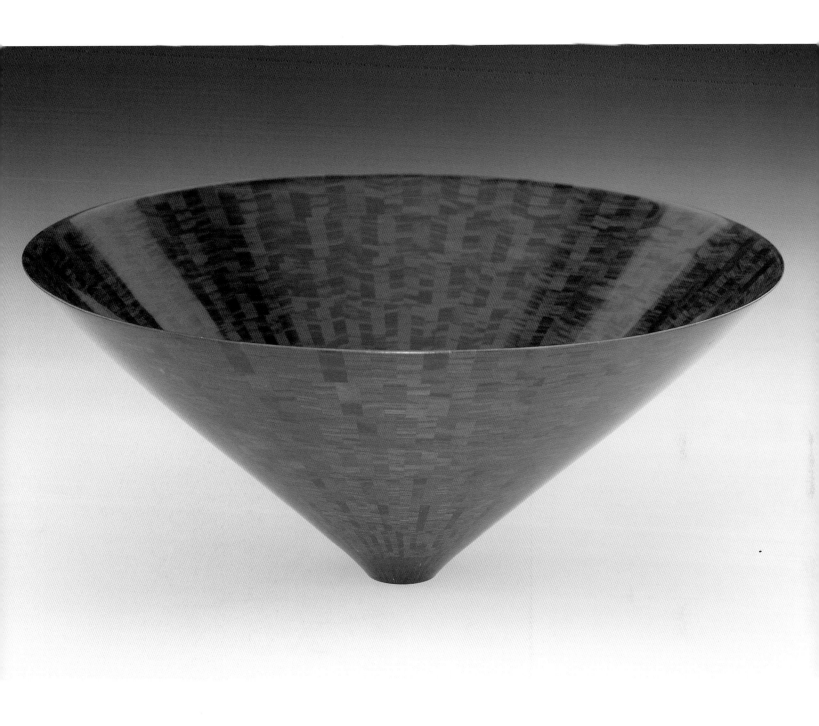

104. Mike Shuler. *#784*. 1995. Cocobolo, segmented, lathe-turned.
4¾ x 11¼ x 11¼" (12.1 x 28.6 x 28.6 cm). Mint Museum of Craft + Design.
Promised Gift of Jane and Arthur Mason

105. Jack R. Slentz. *Begin Again*. 1997. Boisdare, lathe-turned, carved, burned. 9 x 3 x 3" (22.9 x 7.6 x 7.6 cm). Mint Museum of Craft + Design. Gift of Jane and Arthur Mason

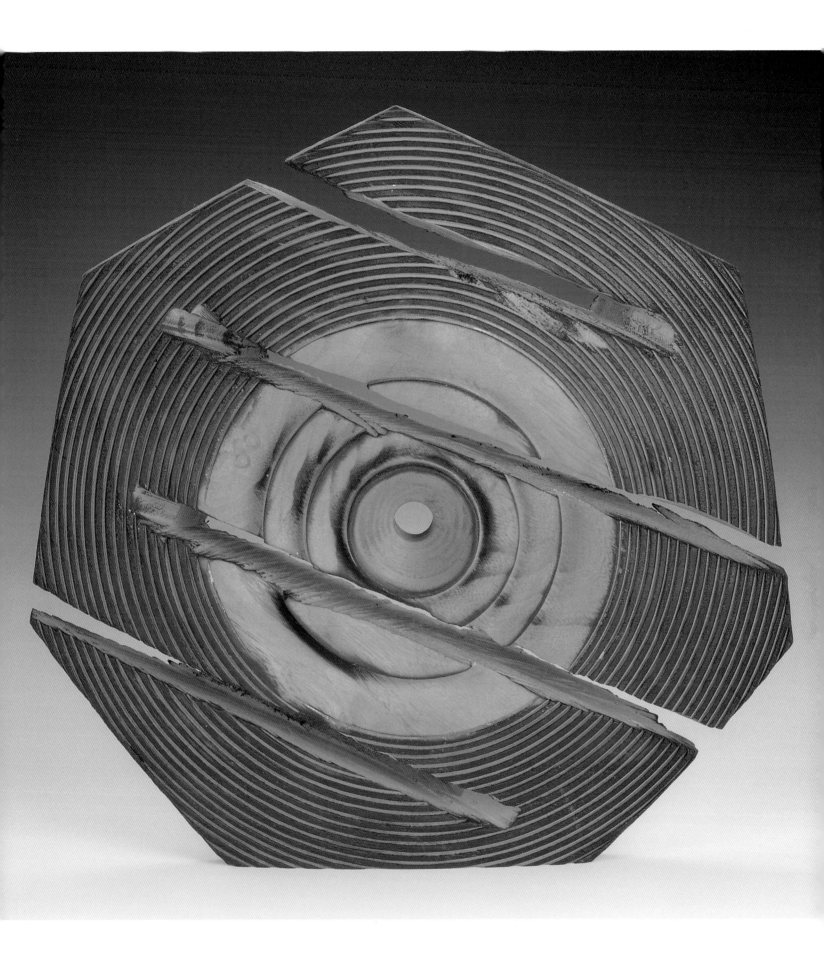

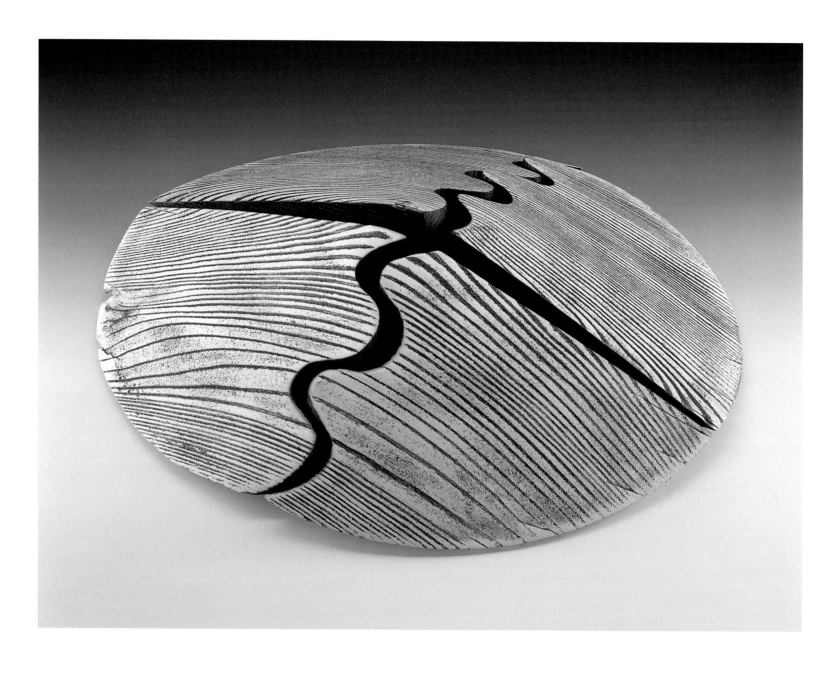

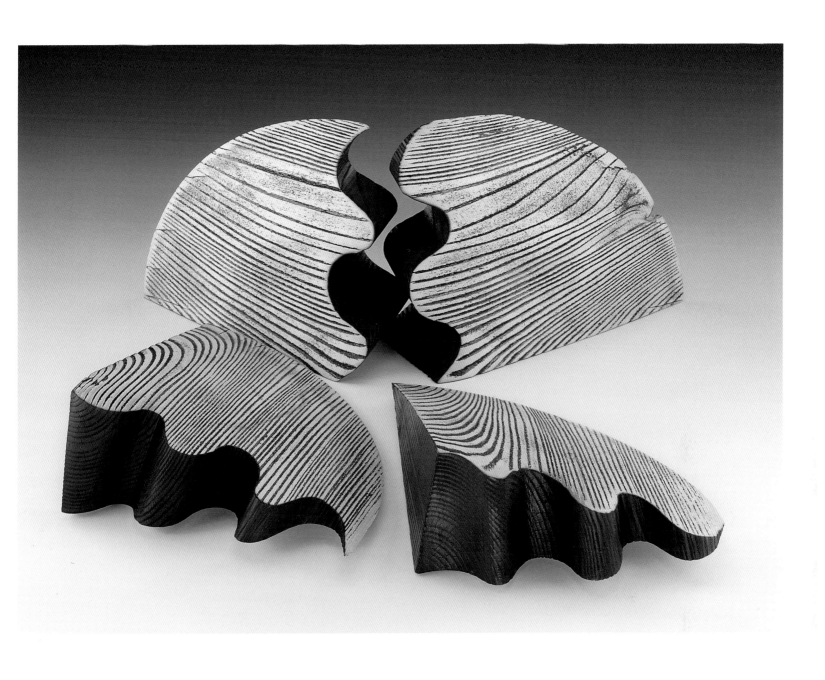

106. Jack R. Slentz. *Four Parts of the Whole*. 1998. Ash, lathe-turned, carved,
sandblasted, bleached, India ink. 3 x 17½ x 17½" (7.6 x 44.5 x 44.5 cm).
Mint Museum of Craft + Design. Promised Gift of Jane and Arthur Mason

107. Alan Stirt. *Where I Live*. 1995. Ceanothus burl, nails, barbed wire, lathe-turned, carved. 7¼ x 8 x 8" (18.4 x 20.3 x 20.3 cm). Mint Museum of Craft + Design. Promised Gift of Jane and Arthur Mason

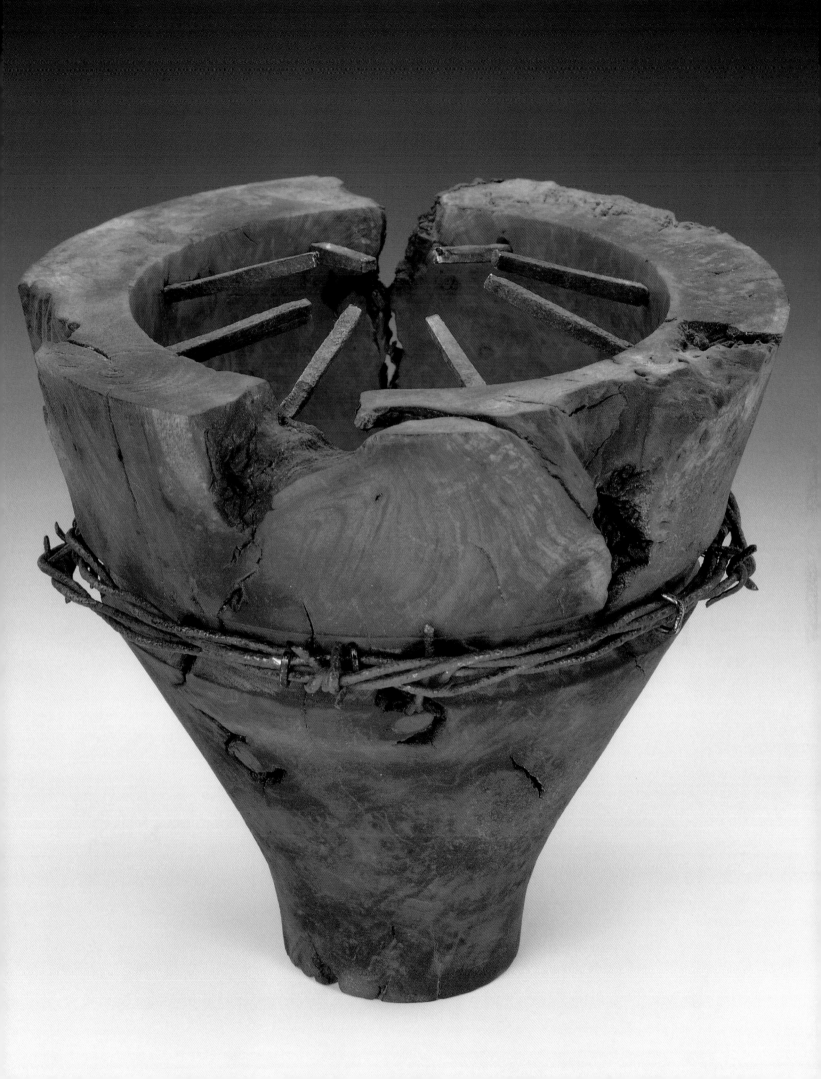

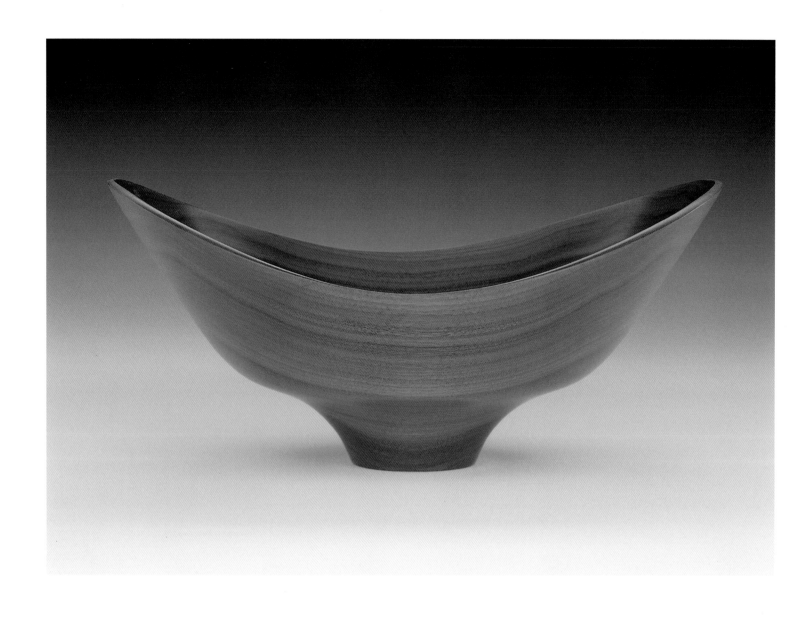

108. Bob Stocksdale. *Untitled*. 1982. Putumujo, lathe-turned. 3½ x 7½ x 6"
(8.9 x 19.1 x 15.2 cm). Mint Museum of Craft + Design. Gift of Jane and
Arthur Mason

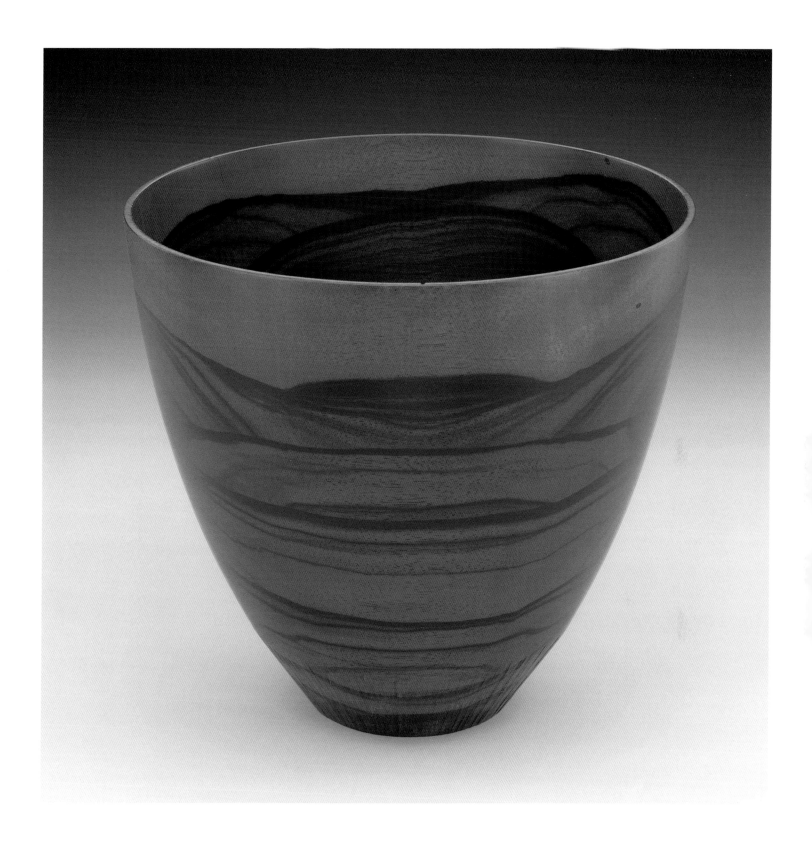

109. Bob Stocksdale. *Untitled*. 1986. Ebony, lathe-turned. 5¼ x 6 x 6"
(13.3 x 15.2 x 15.2 cm). Collection Dr. Peggy Mason

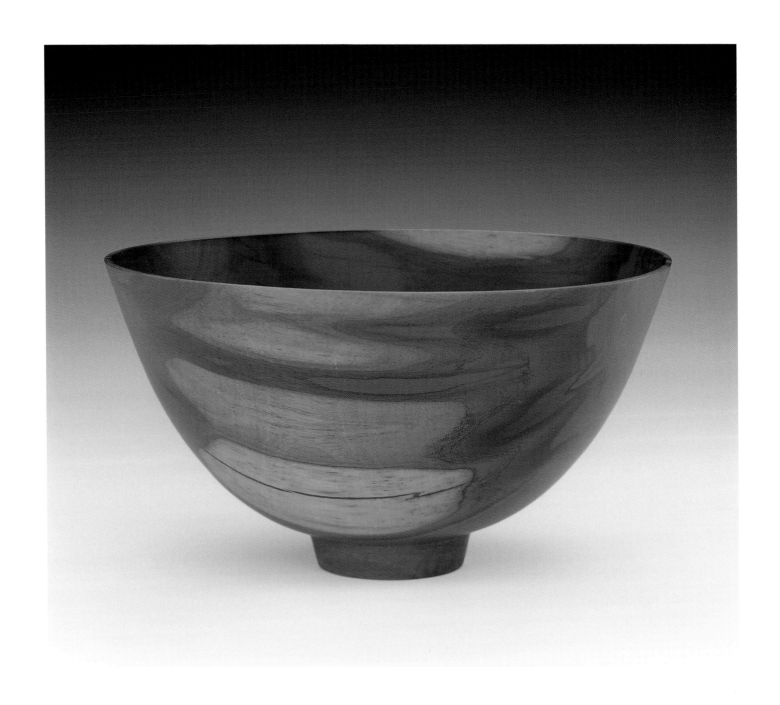

110. Bob Stocksdale. *Untitled.* 1987. Snakewood, lathe-turned. 3¾ x 6¼ x 6¼"
(9.5 x 15.9 x 15.9 cm). Mint Museum of Craft + Design. Gift of Jane and
Arthur Mason

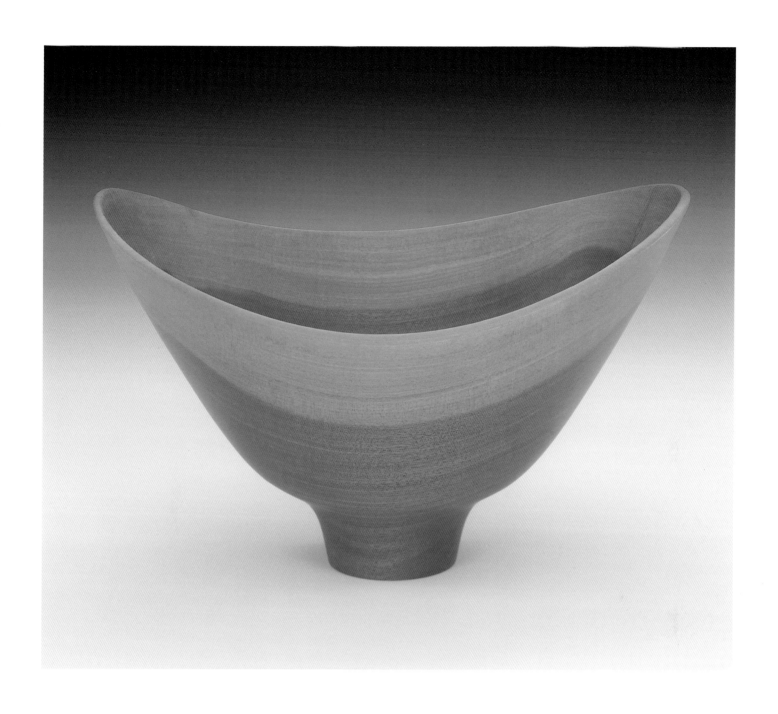

111. Bob Stocksdale. *Untitled.* 1987. Pink ivorywood, lathe-turned. 4 x 6½ x 6½"
(10.2 x 16.5 x 16.5 cm). Mint Museum of Craft + Design. Promised Gift of
Jane and Arthur Mason

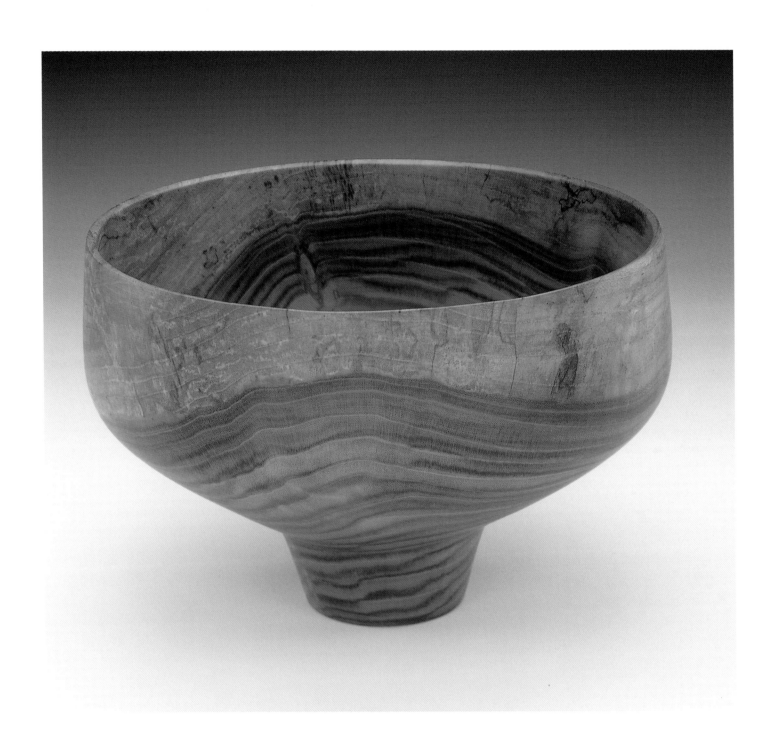

112. Bob Stocksdale. *Untitled*. 1987. Pistachio, lathe-turned. 4 x 6¼ x 6¼"
(10.2 x 15.9 x 15.9 cm). Mint Museum of Craft + Design. Gift of Jane and
Arthur Mason

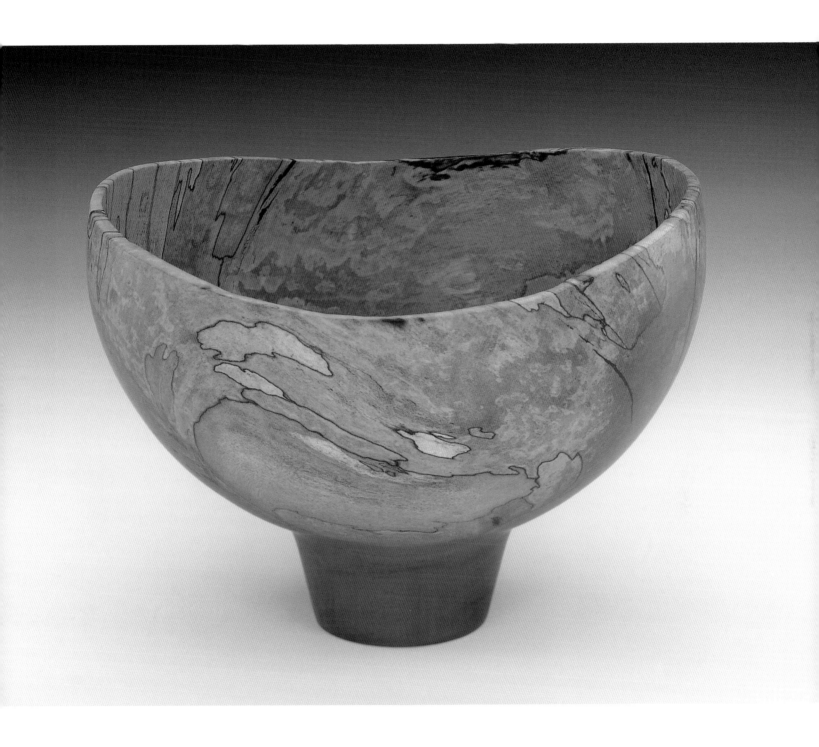

113. Bob Stocksdale. *Untitled*. 1987. Konulia, lathe-turned. 4½ x 6½ x 6½"
(11.4 x 16.5 x 16.5 cm). Mint Museum of Craft + Design. Gift of Jane and
Arthur Mason

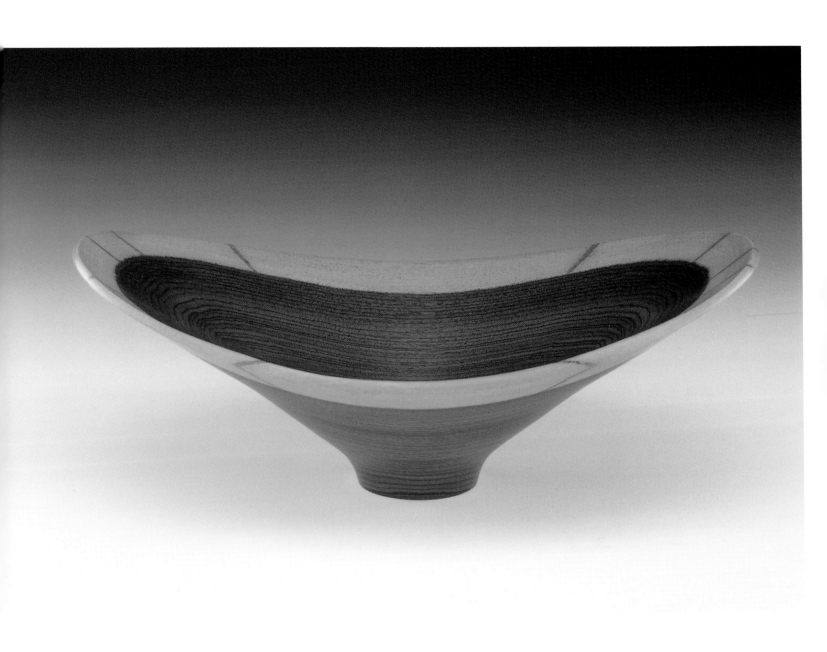

114. Bob Stocksdale. *Untitled*. 1988. Para kingwood, lathe-turned. 2⅛ x 6½ x 6½"
 (5.5 x 16.5 x 16.5 cm). Collection Dr. Peggy Mason

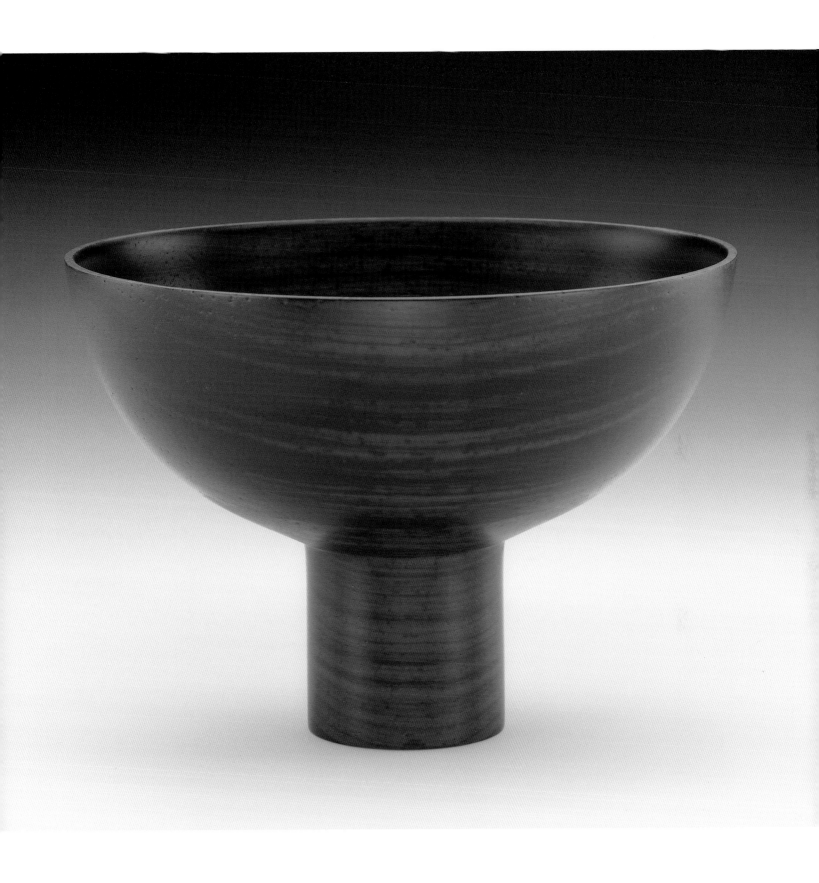

115. Bob Stocksdale. *Untitled*. 1989. Brazilian rosewood, lathe-turned. 3½ x 5 x 5"
(8.9 x 12.7 x 12.7 cm). Mint Museum of Craft + Design. Gift of Jane and
Arthur Mason

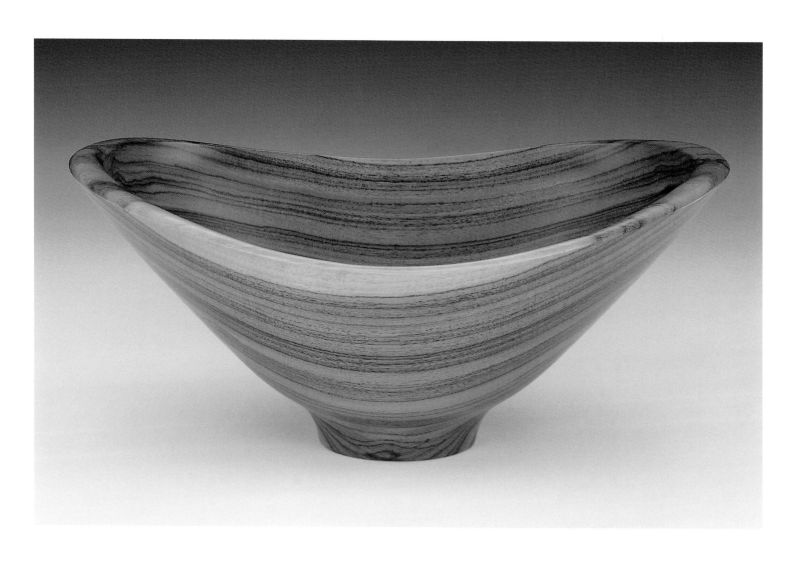

116. Bob Stocksdale. *Untitled*. 1989. Kingwood, lathe-turned. 3¼ x 7¾ x 6¾"
(8.3 x 19.7 x 17.2 cm). Mint Museum of Craft + Design. Gift of Jane and
Arthur Mason

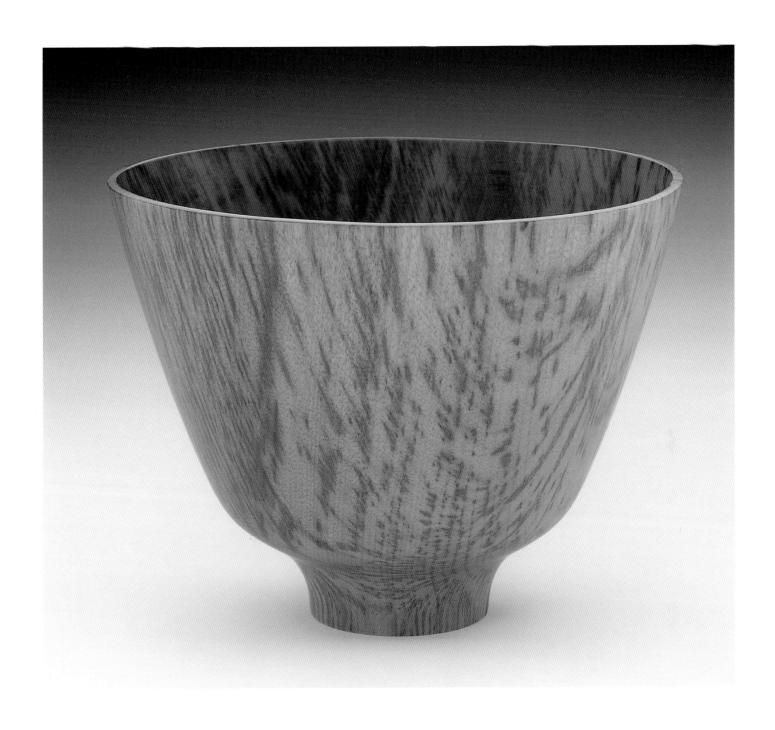

117. Bob Stocksdale. *Untitled*. 1989. Myrtle, lathe-turned. 4¾ x 6¼ x 6¼"
(12.1 x 15.9 x 15.9 cm). Mint Museum of Craft + Design. Gift of Jane and
Arthur Mason

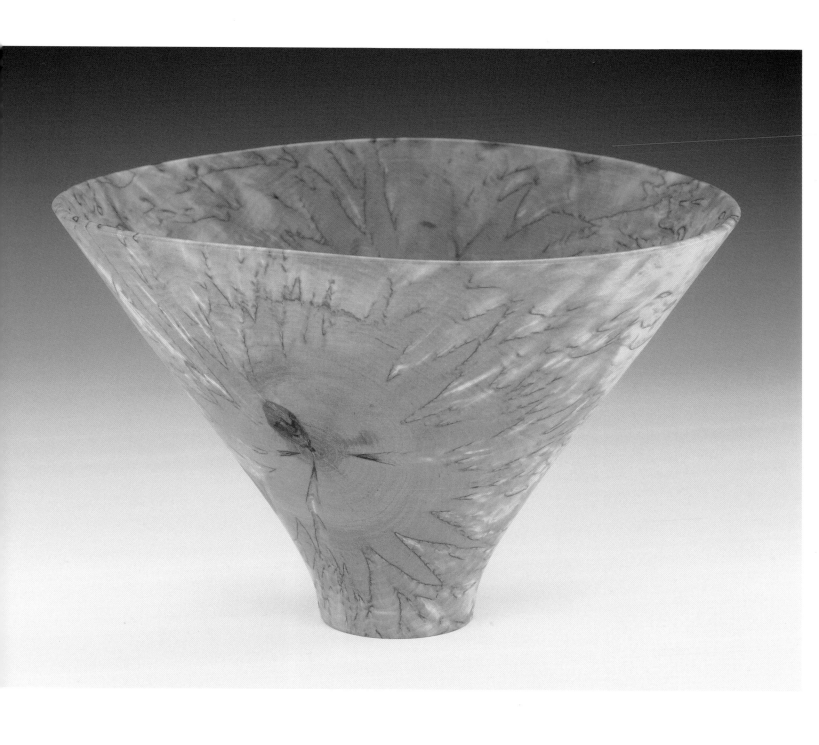

118. Bob Stocksdale. *Untitled*. 1990. Masur birch, lathe-turned. 3¾ x 6 x 6"
 (9.5 x 15.2 x 15.2 cm). Mint Museum of Craft + Design. Promised Gift of
 Jane and Arthur Mason

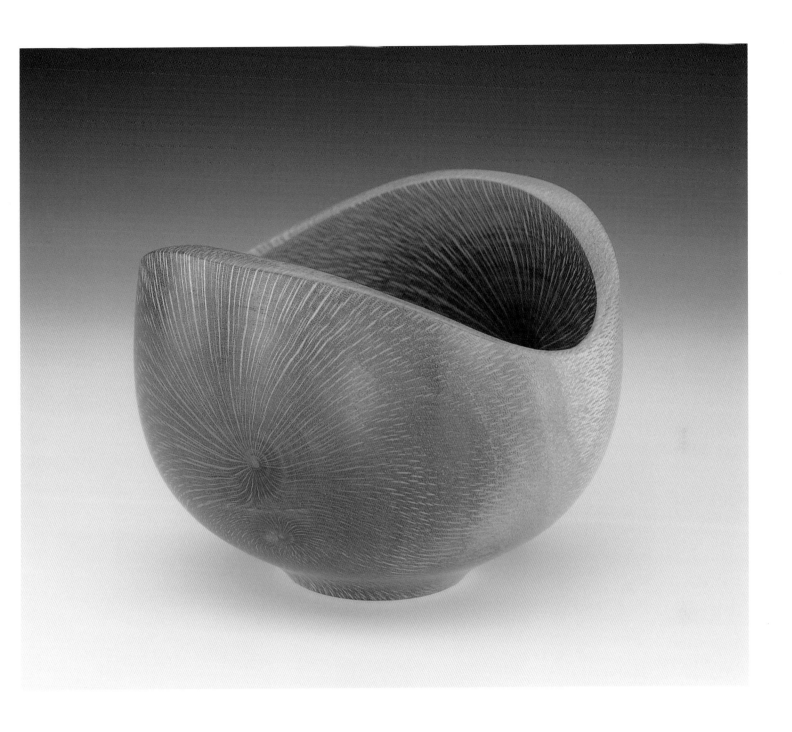

119. Bob Stocksdale *Double Star Burst*. 1991. Macadamia, lathe-turned.
5 x 4½ x 4½" (12.7 x 11.4 x 11.4 cm). Mint Museum of Craft + Design,
Gift of Jane and Arthur Mason

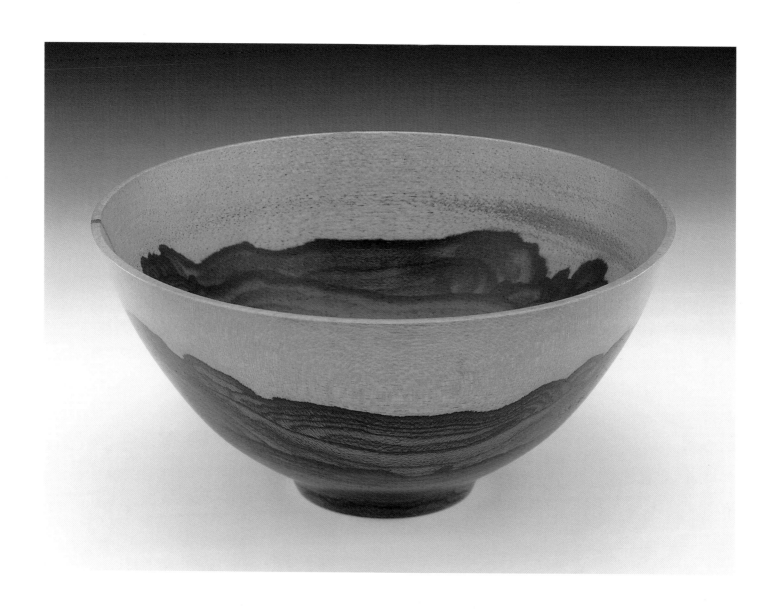

120. Bob Stocksdale. *Untitled*. 1994. Ziricote, lathe-turned. 2¼ x 5 x 5"
(5.7 x 13 x 13 cm). Mint Museum of Craft + Design. Gift of Jane and
Arthur Mason

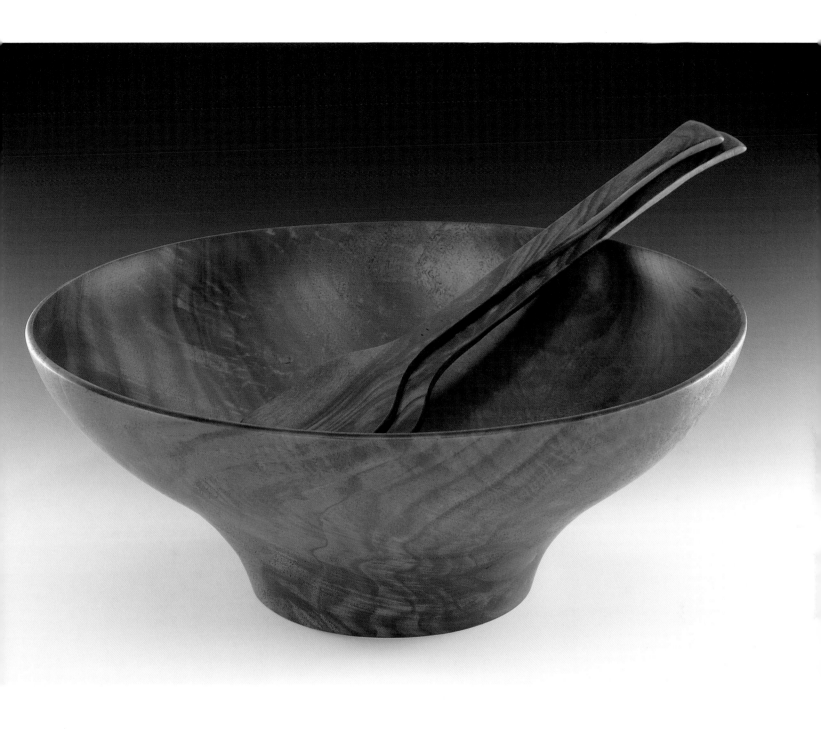

121. Bob Stocksdale. *Salad Bowl with Servers*. 1998. Figured black walnut, lathe-turned. *Salad Bowl:* 5¼ x 14½ x 14½" (13.3 x 36.8 x 36.8 cm); *Servers:* 13" (33 cm) long. Mint Museum of Craft + Design. Gift of Jane and Arthur Mason

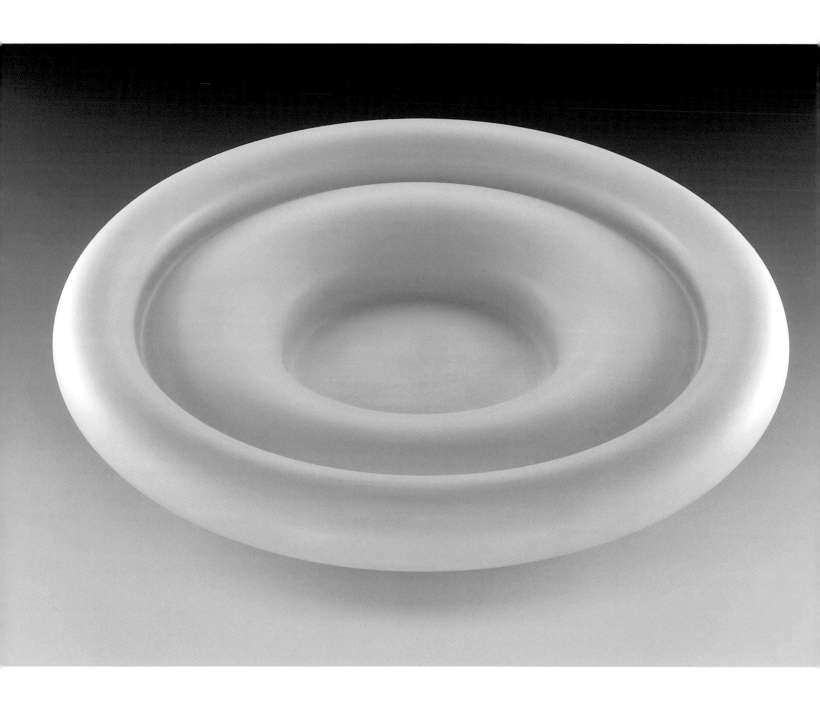

122. Maria van Kesteren. *Untitled*. 1989. Elm, lathe-turned. 2¾ x 16 x 16"
 (7 x 40.6 x 40.6 cm). Mint Museum of Craft + Design. Promised Gift of
 Jane and Arthur Mason

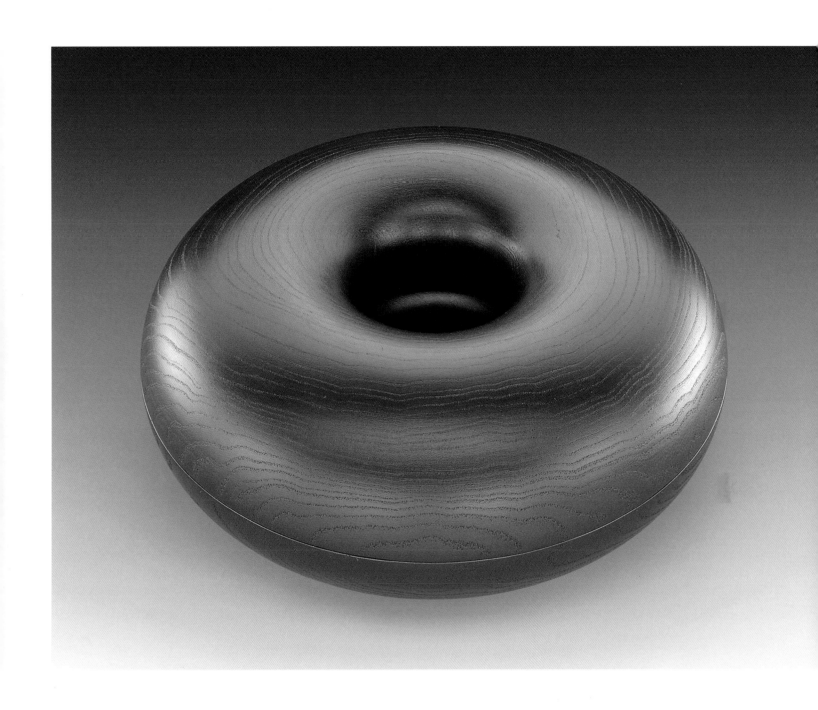

123. Maria van Kesteren. *Lidded Vessel.* 1989. Elm, lathe-turned, stained.
3¼ x 8 x 8" (8.3 x 20.3 x 20.3 cm). Mint Museum of Craft + Design.
Gift of Jane and Arthur Mason

124. Maria van Kesteren. *Container with Lid.* 1997. Elm, lathe-turned.
2½ x 6 x 6" (6.4 x 15.2 x 15.2 cm). Mint Museum of Craft + Design.
Gift of Jane and Arthur Mason

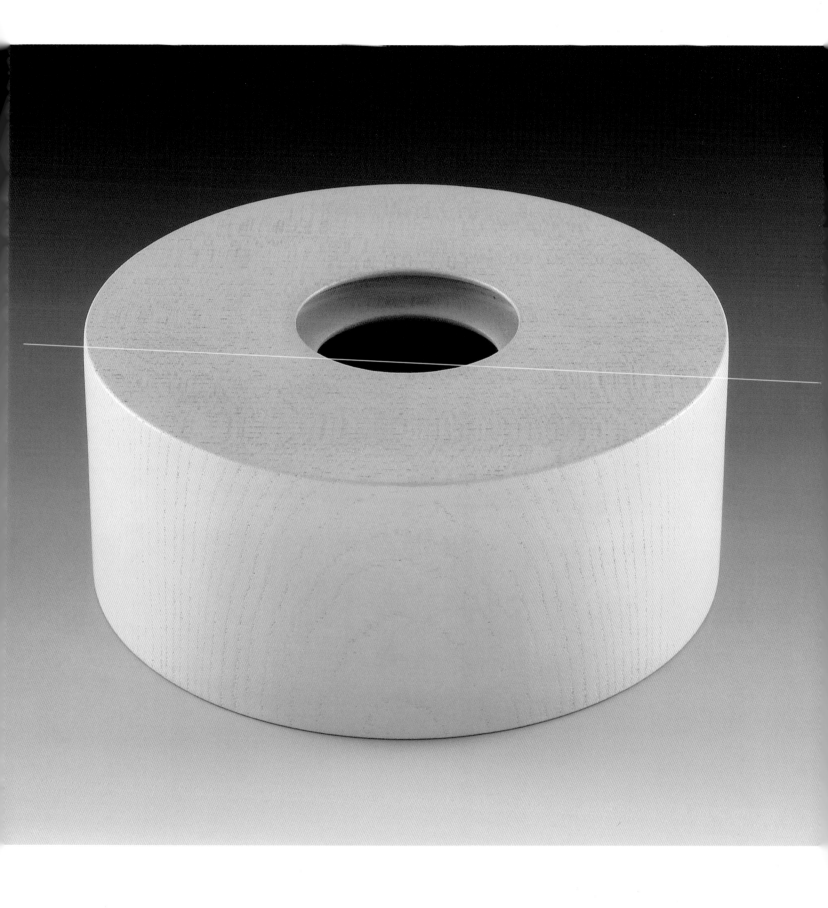

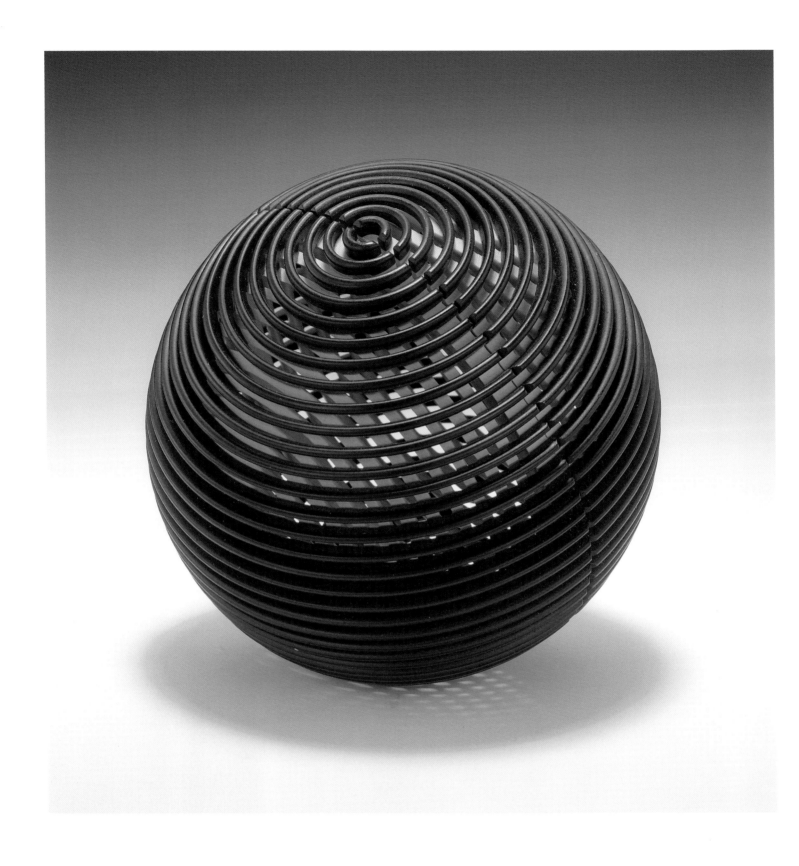

125. Hans Joachim Weissflög. *Broken Through Ball Box*. 1995. Blackwood, boxwood, lathe-turned. 3⅛ x 3⅛ x 3⅛" (8.1 x 8.1 x 8.1 cm). Mint Museum of Craft + Design. Gift of Jane and Arthur Mason

Checklist of the Exhibition

1. Anthony Bryant. *Untitled.* 1988. Figured sycamore, lathe-turned, painted. 5 x 11 x 11" (12.7 x 27.94 x 27.94 cm). Mint Museum of Craft + Design. Gift of Jane and Arthur Mason
page 49

2. Christian Burchard. *Between Heaven and Earth.* 1996. Osage orange, lathe-turned, incised. 5 x 5 x 5" (12.7 x 12.7 x 12.7 cm). Mint Museum of Craft + Design. Gift of Jane and Arthur Mason
page 50

3. Christian Burchard. *Baskets.* 1997. Manzanita, 14 parts, lathe-turned, scorched. From ½ x ½ x ½" to 5 x 5 x 5" (1.3 x 1.3 x 1.3 cm to 12.7 x 12.7 x 12.7 cm). Mint Museum of Craft + Design. Gift of Jane and Arthur Mason
page 53

4. Frank E. Cummings III. *Citrus-Citrine.* 1989. Orangewood, 22.5 mm citrine, 18 karat gold, lathe-turned, carved. 7¼ x 6¼ x 6¼" (18.4 x 15.9 x 15.9 cm). Mint Museum of Craft + Design. Gift of Jane and Arthur Mason
page 54

5. Virginia Dotson. *#86123.* 1986. Spalted maple, lathe-turned. 1¾ x 10 x 10" (4.45 x 25.4 x 25.4 cm). Mint Museum of Craft + Design. Promised Gift of Jane and Arthur Mason
page 55

6. Virginia Dotson. *#90036.* 1990. Wenge, maple, myrtle, laminated, lathe-turned. 4⅓ x 12 x 12" (11 x 30.5 x 30.5 cm). Mint Museum of Craft + Design. Promised Gift of Jane and Arthur Mason
page 56

7. Virginia Dotson. *#90041.* 1990. Baltic birch, wenge, walnut, laminated, lathe-turned. 5½ x 14¼ x 14¼" (14 x 35.2 x 35.2 cm). Mint Museum of Craft + Design. Gift of Jane and Arthur Mason
page 57

8. Virginia Dotson. *Night Music #95092.* 1995. Maple, birch, laminated, lathe-turned, dyed. 11¼ x 8¾ x 8¾" (28.6 x 22.2 x 22.2 cm). Mint Museum of Craft + Design. Gift of Jane and Arthur Mason
page 58

9. David Ellsworth. *Untitled Vessel.* 1978. Gabon ebony, lathe-turned, carved. 4 x 8½ x 8½" (10.2 x 21.6 x 21.6 cm). Mint Museum of Craft + Design. Promised Gift of Jane and Arthur Mason
page 59

10. David Ellsworth. *Untitled Vessel.* 1979. Brazilian rosewood, lathe-turned. 2 x 8¾ x 8¾" (5.1 x 22.2 x 22.2 cm). Mint Museum of Craft + Design. Gift of Jane and Arthur Mason
pages 60–61

11. David Ellsworth. *Man, and the Forest Architecture: Mother and Teen.* 1982. Spalted sugar maple, lathe-turned. *Mother:* 12½ x 12 x 9" (31.8 x 30.5 x 22.9 cm); *Teen:* 12 x 5 x 4¼" (30.5 x 12.7 x 10.8 cm). Mint Museum of Craft + Design. Gift of Jane and Arthur Mason
page 63

12. David Ellsworth. *Untitled Vessel.* 1987. Spalted beech, lathe-turned. 14 x 19 x 19" (35.6 x 48.3 x 48.3 cm). Mint Museum of Craft + Design. Gift of Jane and Arthur Mason
page 64

13. David Ellsworth. *Untitled Vessel.* 1989. Cocobolo rosewood, lathe-turned. 2½ x 3¼ x 3¼" (6.4 x 8.3 x 8.3 cm). Mint Museum of Craft + Design. Gift of Jane and Arthur Mason
page 65

14. David Ellsworth. *Signature Bowl #4.* 1989. Redwood lace burl, lathe-turned. 22 x 15 x 15" (55.9 x 38.1 x 38.1 cm). Mint Museum of Craft + Design. Gift of Jane and Arthur Mason
page 66

15. David Ellsworth. *Spirit Vessel.* 1997. Grasstree, lathe-turned. 3½ x 3 x 3" (8.9 x 7.6 x 7.6 cm). Mint Museum of Craft + Design. Gift of Jane and Arthur Mason
page 67

16. David Ellsworth. *Spirit Vessel.* 1992. Spalted sycamore, lathe-turned. 2½ x 3 x 3" (6.4 x 7.6 x 7.6 cm). Mint Museum of Craft + Design. Gift of Jane and Arthur Mason
page 67

17. David Ellsworth. *Spirit Vessel.* 1998. Cocobolo rosewood, lathe-turned. 2¼ x 2 x 2" (5.7 x 5 x 5 cm). Mint Museum of Craft + Design. Promised Gift of Jane and Arthur Mason
page 67

18. David Ellsworth. *Spirit Vessel.* 1991. Brazilian tulipwood, lathe-turned. 1½ x 2¼ x 2¼" (3.8 x 5.7 x 5.7 cm). Mint Museum of Craft + Design. Gift of Jane and Arthur Mason
page 67

19. David Ellsworth. *Spirit Vessel.* 1991. Cocobolo rosewood, lathe-turned. 2¼ x 2¾ x 2¾" (5.72 x 7 x 7 cm). Mint Museum of Craft + Design. Gift of Jane and Arthur Mason
page 67

20. David Ellsworth. *Oak Pot.* 1994. White oak, lathe-turned. 8 x 9 x 9" (20.3 x 22.9 x 22.9 cm). Mint Museum of Craft + Design. Gift of Jane and Arthur Mason
page 68

21. David Ellsworth. *Homage Pot #7.* 1998. Spalted sugar maple, lathe-turned. 15 x 7¼ x 7¼" (38.1 x 18.4 x 18.4 cm). Mint Museum of Craft + Design. Promised Gift of Jane and Arthur Mason
page 69

22. Ron Fleming. *Firebird.* 1997. Pink ivorywood, lathe-turned, carved. 5½ x 6½ x 6½" (14 x 16.5 x 16.5 cm). Mint Museum of Craft + Design. Gift of Jane and Arthur Mason
page 70

23. Giles Gilson. *Windy Day.* 1989. Walnut, brass, lathe-turned, pearlescent lacquer. 7 x 12 x 12" (17.8 x 30.5 x 30.5 cm). Mint Museum of Craft + Design. Promised Gift of Jane and Arthur Mason
page 71

24. Stephen Hogbin. *Experience.* 1995. *Book:* Maple, carved, painted; *Thimble:* Basswood, lathe-turned, carved, painted; *Needle:* Maple, lathe-turned, carved, painted. 36 x 16½ x 12" (91.4 x 41.9 x 30.5 cm). Mint Museum of Craft + Design. Promised Gift of Jane and Arthur Mason
page 72

25. Stephen Hogbin. *Walking Bowl.* 1997. Limewood, lathe-turned, painted. 10 x 11½ x 10" (25.4 x 29.2 x 25.4 cm). Mint Museum of Craft + Design. Gift of Jane and Arthur Mason
page 73

26. Michelle T. Holzapfel. *Aegina Bowl.* 1993. Ash, lathe-turned, carved, burned. 4 x 10 x 10" (10.2 x 25.4 x 25.4 cm). Mint Museum of Craft + Design. Gift of Jane and Arthur Mason
page 75

27. Michelle T. Holzapfel. *Querus.* 1998. Red oak burl, lathe-turned, carved, burned, burnished. 16 x 12 x 9" (40.6 x 30.5 x 22.9 cm). Mint Museum of Craft + Design. Promised Gift of Jane and Arthur Mason
page 76

28. Richard Hooper. *White Bipod.* 1995. Birch plywood, laminated, lathe-turned. 13 x 11 x 5¼" (33 x 27.9 x 13.3 cm). Mint Museum of Craft + Design. Gift of Jane and Arthur Mason
page 78

29. Robyn Horn. *Geode #231.* 1988. Smokewood, lathe-turned. 6¾ x 7½ x 7" (17.1 x 19 x 17.8 cm). Mint Museum of Craft + Design. Gift of Jane and Arthur Mason
page 79

30. Robyn Horn. *Narrow Spaces.* 1994. Redwood burl, carved, painted. 26 x 23 x 12" (66 x 58.4 x 30.5 cm). Mint Museum of Craft + Design. Gift of Jane and Arthur Mason
page 81

31. Robyn Horn. *Stepping Stone.* 1995. Pink ivorywood, lathe-turned, carved. 15 x 13 x 4" (38.1 x 33 x 10.2 cm). Mint Museum of Craft + Design. Promised Gift of Jane and Arthur Mason
page 82

32. Michael Hosaluk and Mark Sfirri. *Boob Box on a Stick.* 1997. Ash, birch, lathe-turned, carved, acrylic paint, dyed. 12½ x 5½ x 7" (31.8 x 14 x 17.8 cm). Mint Museum of Craft + Design. Gift of Jane and Arthur Mason
page 83

33. Todd Hoyer. *Conical Series.* 1986. Emery oak, lathe-turned. 7¼ x 12 x 10½" (18.4 x 30.5 x 26.7 cm). Mint Museum of Craft + Design. Promised Gift of Jane and Arthur Mason
page 85

34. Todd Hoyer. *Peeling Orb.* 1987. Mesquite, lathe-turned, burned. 16½ x 12 x 9" (41.91 x 30.48 x 22.86 cm). Mint Museum of Craft + Design. Promised Gift of Jane and Arthur Mason
page 86

35. Todd Hoyer. *Bowl.* 1988. Mexican blue oak, lathe-turned, burned. 10½ x 10 x 19¼" (26.7 x 25.4 x 48.9 cm). Mint Museum of Craft + Design. Gift of Jane and Arthur Mason
page 87

36. Todd Hoyer. *Untitled.* 1990. Palm, lathe-turned, burned. 12 x 14 x 14" (30.5 x 35.6 x 35.6 cm). Mint Museum of Craft + Design. Gift of Jane and Arthur Mason
page 88

37. Todd Hoyer. *Hallowed Vessel Series.* 1991. Cottonwood, lathe-turned, carved, burned. 21½ x 20 x 5½" (54.6 x 50.8 x 14 cm). Mint Museum of Craft + Design. Promised Gift of Jane and Arthur Mason
page 89

38. William Hunter and Marianne Hunter. *Untitled #1874.* 1990. Vessel: pink ivorywood, lathe-turned; Stand: constructed; Lid: *Wisteria Kimono, Edo Period*, 1991. Enamel in 24 karat gold, 14 karat gold, sterling silver, baroque pearls, opal, druzy

77. Philip Moulthrop. *White Pine Mosaic Bowl.* 1993. White pine, resin, lathe-turned. 9¾ x 11¾ x 11¾" (24.8 x 29.9 x 29.9 cm). Mint Museum of Craft + Design. Gift of Jane and Arthur Mason
page 138

78. Philip Moulthrop. *Vertical Pine Mosaic Bowl.* 1997. White pine, resin, lathe-turned. 8 x 9 x 9" (20.3 x 28.9 x 28.9 cm). Mint Museum of Craft + Design. Promised Gift of Jane and Arthur Mason
page 139

79. Dale Nish. *Sandblasted Vessel #2.* 1989. Wormy ash, lathe-turned. 13 x 11½ x 11½" (33 x 29.2 x 29.2 cm). Mint Museum of Craft + Design. Promised Gift of Jane and Arthur Mason
page 141

80. Liam O'Neill. *Untitled.* 1995. Bog oak, lathe-turned. 2½ x 5 x 5" (6.4 x 12.7 x 12.7 cm). Mint Museum of Craft + Design. Gift of Jane and Arthur Mason
page 142

81. Liam O'Neill. *QE II Series.* 1993. Monkey puzzle, lathe-turned. 6 x 15 x 15" (15.2 x 38.1 x 38.1 cm). Mint Museum of Craft + Design. Gift of Jane and Arthur Mason
page 143

82. Rude Osolnik. *Untitled.* 1986. Pink ivorywood, lathe-turned. 3 x 4½ x 4½" (7.6 x 11.4 x 11.4 cm). Mint Museum of Craft + Design. Gift of Jane and Arthur Mason
page 144

83. Rude Osolnik. *Untitled.* 1986. Black walnut, laminated baltic birch plywood, lathe-turned. 6¾ x 6½ x 6½" (17.2 x 16.5 x 16.5 cm). Mint Museum of Craft + Design. Promised Gift of Jane and Arthur Mason
page 146

84. Rude Osolnik. *Three Candlesticks.* 1992. Tulipwood, lathe-turned. 7½, 9¼, 10½ x 2½ x 2½" (19.1, 23.5, 26.7 x 6.4 x 6.4 cm). Mint Museum of Craft + Design. Gift of Jane and Arthur Mason
page 147

85. Jim Partridge. *From the Blood Vessel Series.* 1987. Oak burl, lathe-turned, burned. 4¾ x 11 x 8" (12 x 27.9 x 20.3 cm). Mint Museum of Craft + Design. Promised Gift of Jane and Arthur Mason
page 149

86. Michael J. Peterson. *Navaho Land, Landscape Series.* 1987. Maple burl, lathe-turned, bleached. 6 x 17½ x 17½" (15.2 x 44.5 x 44.5 cm). Mint Museum of Craft + Design. Gift of Jane and Arthur Mason
page 150

87. Michael J. Peterson. *Wind Drift and Sea Drift.* 1988. Madrone burl, lathe-turned, carved. *Wind Drift:* 5 x 9½ x 8¾" (12.7 x 24.1 x 22.2 cm); *Sea Drift:* 3½ x 9 x 6¾" (8.9 x 22.9 x 17.2 cm). Mint Museum of Craft + Design. Gift of Jane and Arthur Mason
page 151

88. Michael J. Peterson. *The Kimona.* 1992. Madrone, lathe-turned, carved, bleached. 10 x 13½ x 12" (25.4 x 34.3 x 30.5 cm). Mint Museum of Craft + Design. Promised Gift of Jane and Arthur Mason
page 152

89. Michael J. Peterson. *Untitled.* 1993. Madrone, lathe-turned, carved, bleached. 3 x 9½ x 9½" (7.6 x 24.1 x 24.1 cm). Mint Museum of Craft + Design. Gift of Jane and Arthur Mason
page 153

90. Michael J. Peterson. *Water Way Course, Landscape Series.* 1997. Locust burl, lathe-turned, carved, sandblasted. 5½ x 14 x 14" (14 x 35.6 x 35.6 cm). Mint Museum of Craft + Design. Promised Gift of Jane and Arthur Mason
page 154

91. Michael J. Peterson. *Tusk from the Coastal Series.* 1998. Madrone burl, pigmented, carved, sandblasted. 21 x 6½ x 7½" (53.3 x 16.5 x 19.1 cm). Mint Museum of Craft + Design. Promised Gift of Jane and Arthur Mason
page 155

92. James Prestini. *Untitled.* 1951. Mexican mahogany, lathe-turned. 4½ x 12½ x 12½" (11.4 x 31.8 x 31.8 cm). Mint Museum of Craft + Design. Gift of Jane and Arthur Mason
page 156

93. Hap Sakwa. *Lotus Bowl.* 1984. Wild lilac, lathe-turned. 5 x 13¼ x 13¼" (12.7 x 33.7 x 33.7 cm). Mint Museum of Craft + Design. Promised Gift of Jane and Arthur Mason
page 157

94. Hap Sakwa. *de Chirico Bowl.* 1985. Wood, lathe-turned, carved, painted, constructed. 16½ x 13 x 13" (41.9 x 33 x 33 cm). Mint Museum of Craft + Design. Promised Gift of Jane and Arthur Mason
page 158

95. Merryll Saylan. *Jelly Donut.* 1979, 1989. Poplar, lathe-turned, cast polyester resin, constructed. 3 x 12 x 12" (7.6 x 30.5 x 30.5 cm). Mint Museum of Craft + Design. Gift of Jane and Arthur Mason
page 159

96. Merryll Saylan. *Untitled.* 1998. Maple, lathe-turned, ebonized. 1½ x 15 x 15" (3.8 x 38.1 x 38.1 cm). Mint Museum of Craft + Design. Promised Gift of Jane and Arthur Mason
page 160

97. Betty J. Scarpino. *Untitled.* 1995. Osage orange, lathe-turned. 4 x 4 x 4" (10.2 x 10.2 x 10.2 cm). Mint Museum of Craft + Design. Gift of Jane and Arthur Mason
page 161

98. Mark Sfirri. *Multi-axis Candlestick #1.* 1992. Ash, multi-axis lathe-turned. 11 x 3½ x 3½" (27.9 x 8.9 x 8.9 cm). Mint Museum of Craft + Design. Gift of Jane and Arthur Mason
page 162

99. Mark Sfirri. *Untitled.* 1997. Maple, lathe-turned, carved, painted. 54 x 14 x 18" (137.2 x 35.6 x 45.7 cm). Mint Museum of Craft + Design. Promised Gift of Jane and Arthur Mason
page 163

100. Mike Shuler. *#781.* 1995. Pine cone, epoxy, lathe-turned. 2½ x 2⅓ x 2⅓" (6.4 x 5.8 x 5.8 cm). Mint Museum of Craft + Design. Gift of Jane and Arthur Mason
page 164

101. Mike Shuler. *#791.* 1995. Pine cone, epoxy, lathe-turned. 5 x 3⅓ x 3½" (12.7 x 8.6 x 8.6 cm). Mint Museum of Craft + Design. Gift of Jane and Arthur Mason
page 164

102. Mike Shuler. *#415.* 1988. Pine cone, epoxy, lathe-turned. 3 x 2 x 2" (7.6 x 5.1 x 5.1 cm). Mint Museum of Craft + Design. Gift of Jane and Arthur Mason
page 164

103. Mike Shuler. *#592.* 1991. Maple, segmented, lathe-turned, glue with red pigment. 2 x 4 x 4" (5.1 x 10.2 x 10.2 cm). Mint Museum of Craft + Design. Promised Gift of Jane and Arthur Mason
page 166

104. Mike Shuler. *#784.* 1995. Cocobolo, segmented, lathe-turned. 4¾ x 11¼ x 11¼" (12.1 x 28.6 x 28.6 cm). Mint Museum of Craft + Design. Promised Gift of Jane and Arthur Mason
page 167

105. Jack R. Slentz. *Begin Again.* 1997. Boisdare, lathe-turned, carved, burned. 9 x 3 x 3" (22.9 x 7.6 x 7.6 cm). Mint Museum of Craft + Design. Gift of Jane and Arthur Mason
page 169

106. Jack R. Slentz. *Four Parts of the Whole.* 1998. Ash, lathe-turned, carved, sandblasted, bleached, India ink. 3 x 17½ x 17½" (7.6 x 44.5 x 44.5 cm). Mint Museum of Craft + Design. Promised Gift of Jane and Arthur Mason
pages 170–171

107. Alan Stirt. *Where I Live.* 1995. Ceanothus burl, nails, barbed wire, lathe-turned, carved. 7¼ x 8 x 8" (18.4 x 20.3 x 20.3 cm). Mint Museum of Craft + Design. Promised Gift of Jane and Arthur Mason
page 173

108. Bob Stocksdale. *Untitled.* 1982. Putumujo, lathe-turned. 3½ x 7½ x 6" (8.9 x 19.1 x 15.2 cm). Mint Museum of Craft + Design. Gift of Jane and Arthur Mason
page 174

109. Bob Stocksdale. *Untitled.* 1986. Ebony, lathe-turned. 5¼ x 6 x 6" (13.3 x 15.2 x 15.2 cm). Collection Dr. Peggy Mason
page 175

110. Bob Stocksdale. *Untitled.* 1987. Snakewood, lathe-turned. 3¾ x 6¼ x 6¼" (9.5 x 15.9 x 15.9 cm). Mint Museum of Craft + Design. Gift of Jane and Arthur Mason
page 176

111. Bob Stocksdale. *Untitled.* 1987. Pink ivorywood, lathe-turned. 4 x 6½ x 6½" (10.2 x 16.5 x 16.5 cm). Mint Museum of Craft + Design. Promised Gift of Jane and Arthur Mason
page 177

112. Bob Stocksdale. *Untitled.* 1987. Pistachio, lathe-turned. 4 x 6¼ x 6¼" (10.2 x 15.9 x 15.9 cm). Mint Museum of Craft + Design. Gift of Jane and Arthur Mason
page 178

113. Bob Stocksdale. *Untitled.* 1987. Konulia, lathe-turned. 4½ x 6½ x 6½" (11.4 x 16.5 x 16.5 cm). Mint Museum of Craft + Design. Gift of Jane and Arthur Mason
page 179

114. Bob Stocksdale. *Untitled.* 1988. Para kingwood, lathe-turned. 2⅛ x 6½ x 6½" (5.5 x 16.5 x 16.5 cm). Collection Dr. Peggy Mason
page 180

115. Bob Stocksdale. *Untitled.* 1989. Brazilian rosewood, lathe-turned. 3½ x 5 x 5" (8.9 x 12.7 x 12.7 cm). Mint Museum of Craft + Design. Gift of Jane and Arthur Mason
page 181

116. Bob Stocksdale. *Untitled.* 1989. Kingwood, lathe-turned. 3¼ x 7¾ x 6¾" (8.3 x 19.7 x 17.2 cm). Mint Museum of Craft + Design. Gift of Jane and Arthur Mason
page 182

117. Bob Stocksdale. *Untitled.* 1989. Myrtle, lathe-turned. 4¾ x 6¼ x 6¼" (12.1 x 15.9 x 15.9 cm). Mint Museum of Craft + Design. Gift of Jane and Arthur Mason
page 183

118. Bob Stocksdale. *Untitled.* 1990. Masur birch, lathe-turned. 3¾ x 6 x 6" (9.5 x 15.2 x 15.2 cm). Mint Museum of Craft + Design. Promised Gift of Jane and Arthur Mason
page 184

119. Bob Stocksdale. *Double Star Burst.* 1991. Macadamia, lathe-turned. 5 x 4½ x 4½" (12.7 x 11.4 x 11.4 cm). Mint Museum of Craft + Design. Gift of Jane and Arthur Mason
page 185

120. Bob Stocksdale. *Untitled.* 1994. Ziricote, lathe-turned. 2¼ x 5 x 5" (5.7 x 13 x 13 cm). Mint Museum of Craft + Design. Gift of Jane and Arthur Mason
page 186

121. Bob Stocksdale. *Salad Bowl with Servers.* 1998. Figured black walnut, lathe-turned. *Salad Bowl:* 5¼ x 14½ x 14½" (13.3 x 36.8 x 36.8 cm); *Servers:* 13" (33 cm) long. Mint Museum of Craft + Design. Gift of Jane and Arthur Mason
page 187

122. Maria van Kesteren. *Untitled.* 1989. Elm, lathe turned. 2¾ x 16 x 16" (7 x 40.6 x 40.6 cm). Mint Museum of Craft + Design. Promised Gift of Jane and Arthur Mason
page 188

123. Maria van Kesteren. *Lidded Vessel.* 1989. Elm, lathe-turned, stained. 3¼ x 8 x 8" (8.3 x 20.3 x 20.3 cm). Mint Museum of Craft + Design. Gift of Jane and Arthur Mason
page 189

124. Maria van Kesteren. *Container with Lid.* 1997. Elm, lathe-turned. 2½ x 6 x 6" (6.4 x 15.2 x 15.2 cm). Mint Museum of Craft + Design. Gift of Jane and Arthur Mason
page 191

125. Hans Joachim Weissflög. *Broken Through Ball Box.* 1995. Blackwood, boxwood, lathe-turned. 3⅛ x 3⅛ x 3⅛" (8.1 x 8.1 x 8.1 cm). Mint Museum of Craft + Design. Gift of Jane and Arthur Mason
page 192

Selected Bibliography

American Craft Magazine (1991–96).

American Woodturner (1994–96).

Argüelles, José, and Miriam Argüelles. *Mandala.* Boston and London: Shambala, 1985.

Arnheim, Rudolf. *The Power of the Center: A Study of Composition in the Visual Arts.* Berkeley: University of California Press, 1982.

———. *The Split and the Structure, Twenty-Eight Essays.* Berkeley: University of California Press, 1996.

The Art of Woodworking: Woodturning. New York: Time Life Books, 1994.

Bachelard, Gaston. *The Poetics of Space.* Trans. by Maria Jolas. Boston: Beacon Press, 1969.

Barr, Alfred H., et al., *Weimar Bauhaus 1919–1925.* New York: Museum of Modern Art, 1938.

Boase, Tony. *Woodturning Masterclass: Artistry, Style, Inspiration.* East Sussex, England: Guild of Master Craftsman Publications, 1995.

Burgard, Timothy Anglin. *The Art of Craft: Contemporary Works from the Saxe Collection.* San Francisco and Boston, New York, London: Fine Arts Museums of San Francisco and Bulfinch Press/Little, Brown & Co., 1999.

Burnham, Jack. *Beyond Modern Sculpture: The Effects of Science and Technology on the Sculpture of this Century.* New York: George Braziller, 1968.

Cabanne, Pierre. *Dialogues with Marcel Duchamp.* Trans. by Ron Padgett. New York: Viking Press, 1971.

Carter, Tom. *A Way with Wood: Southern Style.* exh. cat. Huntsville, AL: Huntsville Museum of Art, 1990.

Clark, Garth, ed. *Ceramic Art, Comment and Review, 1882–1977.* New York: E. P. Dutton, 1978.

Connell, Martha Stamm. *Contemporary Works in Wood, Southern Style.* Huntsville, AL: Huntsville Museum of Art, 1983.

Crowe, Thomas Rain. "Transforming Nature's Mutations: The Turned Wood Sculpture of Stoney Lamar." *The Arts Journal* 14, no. 7 (1989).

Cummings, Frank E., III. "Design: A Practical Approach." *Woodturning Magazine* (July/Aug. 1992).

"Design—Theory and Practice." *Woodturning Magazine* (Oct. 1992).

Ditmer, Judy, and Michelle Holzapfel. "Signatures in Wood." Video documentary. 1993.

DuBois, Alan, et al. *Moving Beyond Tradition: A Turned Wood Invitational.* Little Rock, AR: The Arkansas Art Center Decorative Arts Museum, 1997.

Duncan, Robert Bruce. "Bob Stocksdale: Still on a Roll at 75." *Woodwork* no. 1 (Spr. 1989): 16–21.

Elkins, James. *The Object Stares Back: On the Nature of Seeing.* New York: Harcourt, Brace & Company, 1996.

Elliott, Iona. "Collectors' Items." *Woodturning Magazine* (Dec. 1997).

"Expression in Wood." *American Craft* (Feb./Mar. 1997).

Feininger, Andreas. *The Tree.* New York: Rizzoli, 1991.

Fine Woodworking Design Book Five. Newtown, CT: Taunton Press, 1990.

Fine Woodworking Design Book Seven. Newtown, CT: Taunton Press, 1996.

Fine Woodworking Design Book Six. Newtown, CT: Taunton Press, 1992.

Fine Woodworking Design Book Two. Newtown, CT: Taunton Press, 1979.

Fowles, John, and Frank Horval. *The Tree.* Boston: Little, Brown, 1979.

Gear, Josephine. *Beyond Nature: Wood into Art.* Coral Gables, FL: Lowe Museum of Art, 1994.

Giedion, Siegfried. *Mechanization Takes Command: A Contribution to Anonymous History.* New York: W. W. Norton, 1948.

Growth Through Sharing. Greensboro, N.C.: Guilford College Art Gallery, 1996.

Habsburg, Géza von. *Princely Treasures.* New York: Vendome Press, 1997.

Hansson, Bobby. "World Turnout." *American Craft* (Aug./Sept. 1993).

Herman, Lloyd E. *Art That Works.* Seattle: University of Washington Press, 1990.

Herman, Lloyd E., and Matthew Kangas. *Tales and Traditions: Storytelling in Twentieth-Century American Craft.* Seattle: University of Washington Press, 1993.

Hillman, James, et al. *Team Spirit.* New York: Independent Curators Incorporated, 1991.

Hobbs, Robert Carleton. *Mark Lindquist: Revolutions in Wood.* Seattle and London: University of Washington Press, 1995.

Hogbin, Stephen. *Making, Appearance, and Reality: The Visual Experience.* Cambium Press, 1998.

———. *Wood Turning,* ed. by John Ferguson. New York: Australia & Van Nostrand Reinhold, North America, 1980.

Hogbin, Stephen, et al. *Curators' Focus: Turning in Context: Physical, Emotional, Spiritual, and Intellectual.* Philadelphia: The Wood Turning Center, 1997.

Holzapfel, Michelle. "Aristocrat of Skills: James Prestini Remembered." *American Craft* (Dec. 1993/Jan.1994).

Hoyer, Todd. "My Life, My Work: A Portrait of the Artist as a Woodturner." *American Woodturner* (Mar. 1997).

"The International Turned Objects Show." *Fine Woodworking* (Feb. 1989).

"International Turning Exchange (ITE)." Interview with Mark Sfirri. *Turning Points* (1995).

Jacobson, Edward, et al. *The Art of Turned-Wood Bowls.* New York: E. P. Dutton, 1985.

Jordan, John. "The Art of Woodworking." *The Art of Woodworking: Woodturning.* New York: Time Life Books, 1994.

———. "John Jordan Makes a Lidded Vessel." *Woodturning Magazine,* no. 69 (1998).

Kent, Ron. "The Shape of My Things to Come." *Spindle Turning: The Best from Woodturning Magazine.* New York: Sterling Publishers, 1996.

Kessler, Jane. "Rude Osolnik: By Nature Defined." *American Craft.* (Feb./Mar. 1990).

Kessler, Jane, and Dick Burrows. *Rude Osolnik: A Life Turning Wood.* Louisville, KY: Crescent Hill Books, 1997.

Koedik, Otto. "Dutch Master." *Woodturning Magazine,* no. 41 (1996).

Krasner, D. "Michael Hosaluk." *American Craft* (June/July 1993).

Kraus, Bill. *Contemporary Crafts for the Home.* Madison, WI: Kraus Sikes, 1990.

Latven, Bud, and Addie Draper. *Segmented Turning.* Newtown, CT: Taunton Press, 1987.

Leach, Bernard. *A Potter's Book.* London: Faber and Faber, 1940.

LeCoff, Albert B. *Challenge V: International Lathe-Turned Objects.* Philadelphia: Wood Turning Center, 1993.

———. *Curators' Focus: Turning in Context: Physical, Emotional, Spiritual, and Intellectual.* Philadelphia: Wood Turning Center, 1997.

———. *A Gallery of Turned Wood Objects.* Provo, UT: Brigham Young University Press, 1981.

———. *Lathe-Turned Objects: An International Exhibition.* Philadelphia: Wood Turning Center, 1988.

Lier, Ray, Jay Peters, and Kevin Wallace. *Contemporary Turned Wood: New Perspectives in a Rich Tradition*. Madison, WI: Hand Books Press, 1999.

Lindquist, Mark. "Harvesting Burls." *Fine Woodworking* (July/Aug. 1995).

————. *Sculpturing Wood*. Worcester, MA: Davis Publications, 1986.

Loar, Steve. "The Mark and Mickey Show." *Woodturning Magazine* (Jan. 1994).

————. "Reflections on the Work of Maria van Kesteren." *Turning Points* 9, no. 2 (1996).

————. "Re:Turning: Works by Stephen Hogbin, Twenty Years of Innovation." *Fine Woodworking*, no. 87 (Apr. 1991).

Lydgate, Tony. *The Art of Making Elegant Wood Boxes*. Somerset, MA: Chapelle/Sterling Publishers, 1992.

————. *Po Shun Leong: Art Boxes*. Somerset, MA: Sterling Publications, 1998.

Margetts, Martina. *International Crafts*. London: Thames and Hudson, 1991.

"Mark and Melvin Lindquist at The Works." *Art Now/Philadelphia Gallery Guide* (May 1982).

Mayer, Barbara. *Contemporary American Craft Art: A Collector's Guide*. Salt Lake City, UT: Gibbs M. Smith, Inc., 1988.

————. *Rude Osolnik: A Retrospective*. exh. cat. Asheville, N.C.: Southern Handicraft Guild, 1990.

McAlpine, Daniel. "Lamar's Wood Sculpture." *Woodshop News* (Jan. 1993).

————. "More than Meets the Eye in Stockdale's Simple Turnings." *Woodshop News* (Dec. 1992).

McKinley, Donald Lloyd. "Wood-turned Forms of Stephen Hogbin." *Craft Horizon* (Apr. 1974).

Meilach, Dona. *Woodworking: The New Wave*. New York: Crown Publishers, 1981.

Mississippi, Connie. "Translation Turning." *Turning Points* 8, no. 4 (1996).

"Monochrome Assembly." *The American Woodturner* (Dec. 1989).

Monroe, Michael W. *The White House Collection of American Crafts*. New York: Abrams, 1995.

Moulthrop, Ed. "The Southern Artists." *Southern Accents* 9, no. 4 (July/Aug. 1986): 100–4.

National Museum of American Art. *Skilled Work: American Craft in the Renwick Gallery*. Washington, D.C., and London: Smithsonian Institution Press, 1998.

Nish, Dale L. *Artistic Woodturning*. Provo, UT: Brigham Young University Press, 1980.

————. *Creative Woodturning*. Provo, UT: Brigham Young University Press, 1975.

————. *Master Woodturners*. Provo, UT: Artisan Press, 1985.

————. "An Overview of the History of Fine Turned-Wood Bowls." *The Art of Turned-Wood Bowls*. New York: E. P. Dutton, Inc., 1985.

————. "Turning Giant Bowls." *Fine Woodworking*, no. 41 (July/Aug. 1983): 48–53.

Noll, Terry. "Steps into Another World." *Woodwork* (Winter 1990).

Nordness, Lee. *Objects: USA*. New York: Viking Press, 1970.

Nutt, Craig. "Lathe-Turned." *American Craft* (Feb./Mar. 1986).

"Out of the Woods: The Jacobson Collection." Video. Tempe, AZ: KAET-TV, 1990.

Out of the Woods: Turned Wood by American Craftsmen. Mobile, AL: The Fine Arts Museum of the South, 1992.

Palladino-Craig, Allys. "Mark Lindquist: Making Split Decisions." *Art Today* 4, no. 1 (Spr. 1989): 24–29.

Peacock, Leslie N. "The Strong, Silent Type." *Arkansas Times*, July 23, 1999.

Perlman, Michael. *The Power of Trees: The Reforesting of the Soul*. Dallas: Spring Publications, 1994.

Perreault, John, and Heather Sealy Lineberry. *Turned Wood Now: Redefining the Lathe-Turned Object IV*. Tempe, AZ: Arizona State University, 1997.

"Portfolio." *American Craft* (Dec.1984/Jan.1985 and Apr./May 1987).

"Profile: Virginia Dotson, Woodturner." *Woodworker West* (July/Aug. 1996).

Raffan, Richard. *Turned Bowl Design*. Newtown, CT: The Taunton Press, 1987.

————. "Turned Bowl Design." *Southwest Art Magazine* (June 1990).

————. *Turning Boxes*. Newtown, CT: Taunton Press, 1998.

Read, Herbert. *Origins of Form in Art*. New York: Horizon Press, 1965.

Regional Craft Biennial. Little Rock, AR: Arkansas Art Center, 1998.

Revolving Techniques: Clay, Glass, Metal, Wood. Doylestown, PA: James A. Michener Art Museum, 1992.

Richards, Mary Caroline. *Centering: In Pottery, Poetry and the Person*. Middletown, CT: Wesleyan University Press, 1989.

Rosen, Laura W. "Turned On!" *American Style* 1, no. 2 (1995): 36–43.

Ruskin, John. *The Lamp of Beauty: Writings on Art*. Third ed., edited by Joan Evans. London: Phaidon Press, 1995.

Saylan, Merryll. "Bob Stocksdale, Profiled Woodturning." *Journal of the Guild of Master Crafstmen* (Jan./Feb. 1993).

"Sculptured Bowls." *American Woodturner* (June 1995).

"Segmented Turning." *Fine Woodworking* (May/June 1989).

Sherwin, Reg. "Spotlight on Saskatchewan." *Woodturning Magazine* (Dec. 1996).

Silver, Eileen, Mary R. Heying, Tina C. LeCoff, eds. *International Lathe-Turned Objects, Challenge IV*. Philadelphia: Wood Turning Center, 1991.

"Six of the Best to Turn in America." *Woodturning Magazine*, no. 65 (July 1998).

Small Woodworking Projects: The Best of Fine Woodworking. Newtown, CT: Taunton Press, 1992.

Smith, Paul J. *The Art of Wood Turning*. New York: American Craft Museum, 1983.

Smith, Paul J., and Edward Lucie-Smith. *Craft Today: Poetry of the Physical*. New York: American Craft Museum and Weidenfeld & Nicolson, 1986.

"Southland Profile." *The Southern California Woodworker* (Jan. 1990).

Spielman, Patrick. *The Art of the Lathe: Award-Winning Designs*. New York: Sterling Publishing, 1996.

Star, Richard. "Woodworking on a Metal Lathe." *Fine Woodworking* (May/June, 1982).

Stone, Michael A. *Contemporary American Woodworkers*. Layton, UT: Gibbs M. Smith, Inc., 1986.

Tambini, Michael. *The Look of the Century*. Cooper-Hewitt, National Design Museum, Smithsonian Institution. London: DK Publishing, 1996.

Taragin, Davira S. *Contemporary Crafts and the Saxe Collection*. New York and Toledo, OH: Hudson Hills Press and the Toledo Museum of Art, 1993.

Thompson, D'Arcy Wentworth. *On Growth and Form*. Cambridge, England: Cambridge University Press, 1959.

Tuchman, Maurice. *The Spiritual in Art: Abstract Painting, 1890–1985*. Los Angeles: Los Angeles County Museum of Art, 1986.

Turner, Tran, Edward S. Cooke, Jr., Matthew Kangas, and John Perreault. *Expressions in Wood: Masterworks from The Wornick Collection*. Oakland, CA: The Oakland Museum of California, 1996.

U.S. Information Agency. *Three American Master Craftsmen: Rude Osolnik, Ed Moulthrop, and Bob Stocksdale*. Video. 1992.

Whitley, Robert. "Review: Melvin and Mark Lindquist, The Works Craft Gallery." *Arts Exchange* (July/Aug. 1978).

Wilde, Oscar. *The Complete Works of Oscar Wilde*. New York: Harper & Row, 1989.

Wilk, Christopher. *The Art of Woodturning*. New York: American Craft Museum, 1983.

Wilson, Janet, ed. *National Museum of American Art*. Washington, D.C.: Smithsonian Institution Press, 1995.

"Women Woodturners." *Woodturning Magazine* (Mar./Apr. 1993).

Wonders in Wood: The Art of the Woodturner. Warwick, England: Assoc. of Woodturners of Great Britain, Univ. of Warwick, 1998.

Wood Turning Center. *Enter the World of Lathe-Turned Objects*. York, PA: York Graphic Services, 1997.

Wood Turnings of Bob Stocksdale. New York: Museum of Contemporary Crafts of the American Craftman's Council, 1969.

Works off the Lathe: Old and New Faces. exh. cat. St. Louis: Craft Alliance, 1987.

"World Renowned Turner James Prestini Dies." *Turning Points* 6, no. 2 (1993).

Biographies of the Artists

ANTHONY BRYANT
Porthleven, Helston, Cornwall, England
BORN: Cornwall, England, 1960
GRANTS/AWARDS/HONORS: Major Crafts Council Grant, 1986; special grant awarded to attend Chelsea Crafts Fair, London, 1986
SOLO EXHIBITIONS: Victoria and Albert Museum, London, England, 1989; The Scottish Gallery, Edinburgh, Scotland, 1995; Univ. of Warwick, England, 1997; Centrum voor Grafishce and Ruimelijke Vormgeving, Ghent, Belgium, 1999
GROUP EXHIBITIONS: New York International Gift Fair, New York, NY, 1988; "Turning Plus," Arizona State Univ. Art Museum, Tempe, AZ, 1994; "The Banqueting Table," Contemporary Applied Art, London, England, 1998
PUBLICATIONS: Tony Boase, *Woodturning Masterclass*

CHRISTIAN BURCHARD
Ashland, Oregon
BORN: Hamburg, Germany, 1955
EDUCATION: Furniture apprenticeship, Hamburg, Germany, 1974–75; School of the Museum of Fine Arts, Boston, 1977–78; Emily Carr College, Vancouver, British Columbia, 1978
GRANTS/AWARDS/HONORS: Niche Award, 1996/1998; Oregon Arts Commission Fellowship, 1997
GROUP EXHIBITIONS: "International Lathe-Turned Objects: Challenge IV," Port of History Museum, Philadelphia, PA, and touring, 1991–92; "Challenge V: International Lathe-Turned Objects," Philip and Muriel Berman Museum, Ursinus College, Collegeville, PA, and touring, 1994–97; "Curators' Focus: Turning in Context," Philip and Muriel Berman Museum of Art, Ursinus College, Collegeville, PA, and touring, 1997; "Moving Beyond Tradition: A Turned-Wood Invitational," The Arkansas Art Center Decorative Arts Museum, Little Rock, AR, 1997; "Expressions in Wood: Masterworks from The Wornick Collection," Oakland Museum of California, 1996, American Craft Museum, New York, NY, 1997–98; "The Art of Craft: Contemporary Works from the Saxe Collection," Fine Arts Museums of San Francisco, 1999
PUBLICATIONS: *American Craft*, Oct./Nov. 1991; Albert B. LeCoff, *Challenge V: International Lathe-Turned Objects*; *Woodturning Magazine*, 1994, 1995; *American Woodturner*, 1994, 1995; *Enter the World of Lathe-Turned Objects*; Tran Turner, et al., *Expressions in Wood: Masterworks from The Wornick Collection*; Eileen Silver, et al., *International Lathe-Turned Objects, Challenge IV*; Alan DuBois, et al., *Moving Beyond Tradition: A Turned-Wood Invitational*; Albert B. LeCoff, *Curators' Focus: Turning in Context*; Timothy Anglin Burgard, *The Art of Craft: Contemporary Works from the Saxe Collection*

FRANK E. CUMMINGS III
Long Beach, California
BORN: Los Angeles, California, 1938
EDUCATION: B.A., California State University, Long Beach, 1968; M.A., California State University, Fullerton, 1971
GRANTS/AWARDS/HONORS: California State Univ. Creative Activity Award, 1979; California State Univ. Administrative Fellow Recipient, 1981
SOLO EXHIBITIONS: "Sensitivity," Long Beach Museum of Art, Long Beach, CA, 1974; "Frank E. Cummings III, an American Artist," Museum and Cultural Center, Kumist, Ghana, West Africa, and touring, 1981
GROUP EXHIBITIONS: "Six Californians," Fairtree Gallery, New York, NY, 1974; "Works off the Lathe: Old and New Faces," Craft Alliance Gallery, St. Louis, MO, 1987; "Lathe-Turned Objects, An International Exhibition," Port of History Museum, Philadelphia, PA, and touring, 1988; "Turner's Challenge III," Craft Alliance, 1989; "Challenge V: International Lathe-Turned Objects," Philip and Muriel Berman Museum of Art, Ursinus College, Collegeville, PA, and touring, 1994–97; "Revolving Techniques: Clay, Glass, Metal, Wood," James A. Michener Art Museum, Doylestown, PA, 1992; "The White House Collection of American Crafts," National Museum of American Art, Washington, DC, and touring 1995
PUBLICATIONS: Dale Nish, *Artistic Woodturning*; Dona Meilach, *Woodworking: The New Wave*; *Works off the Lathe: Old and New Faces*; Albert B. LeCoff, *Lathe-Turned Objects: An International Exhibition*; "The International Turned Objects Show," *Fine Woodworking*; "Southland Profile," *The Southern California Woodworker*; "Design—Theory and Practice," *Woodturning Magazine*; Frank E. Cummings III, "Design: A Practical Approach," *Woodturning Magazine*; Albert B. LeCoff, *Challenge V: International Lathe-Turned Objects*; Michael W. Monroe, *The White House Collection of American Crafts*; *Enter the World of Lathe-Turned Objects*

VIRGINIA W. DOTSON
Scottsdale, Arizona
BORN: Newton, Massachusetts, 1943
EDUCATION: B.F.A., summa cum laude, Arizona State University, Tempe, AZ, 1985; Wellesley College, Wellesley, MA, 1963
GRANTS/AWARDS/HONORS: Juror's Award, "Celebrate Craft," juried exhibition of Arizona Designer Craftsmen, Memorial Union Gallery, Arizona State Univ., 1992; Juror's Award, "Celebration of Fine Craft," juried exhibition of Arizona Designer Craftsmen, Arizona State Capitol West Wing Gallery, 1993; Juror's Award, "Inside Story," Mesa Arts Center, Mesa, AZ; Juror's Award for Body of Work, "Beyond Technique," Shemer Art Center, Phoenix, AZ, 1994
SOLO EXHIBITIONS: "Arizona Spotlight: Virginia Dotson—Turned Wood Vessels, Terra Cotta Ceramics," Tempe Arts Center, Tempe, AZ, 1995–96; "Virginia Dotson: Turned Wood," Joanne Rapp Gallery/The Hand & The Spirit, Scottsdale, AZ, 1997; "Virginia Dotson: New Work," Joanne Rapp Gallery/The Hand & The Spirit, Scottsdale, AZ, 1999
GROUP EXHIBITIONS: "Turner's Challenge III," Craft Alliance, 1989; "International Lathe-Turned Objects, Challenge IV," Port of History Museum, Philadelphia, PA, and touring, 1991; "Out of the Woods: Turned Wood by American Craftsmen," The Fine Arts Museum of the South, Mobile, AL, 1992, and touring Europe through 1997; "Challenge V: International Lathe-Turned Objects," Philip and Muriel Berman Museum, Ursinus College, Collegeville, PA, and touring, 1994–97; "The White House Collection of American Crafts," National Museum of American Art, Washington, DC, and touring, 1995; "Expressions in Wood: Masterworks from The Wornick Collection," Oakland Museum of California, 1996, American Craft Museum, New York, NY, 1997–98; "Moving Beyond Tradition: A Turned-Wood Invitational," The Arkansas Art Center Decorative Arts Museum, Little Rock, AR, 1997; "Turned Wood Now: Redefining the Lathe-Turned Object IV," Arizona State Univ. Art Museum, Tempe, AZ, 1997–98
PUBLICATIONS: Eileen Silver, et al., *International Lathe-Turned Objects, Challenge IV*; *Out of the Woods: Turned Wood by American Craftsmen*, Albert B. LeCoff, *Challenge V: International Lathe-Turned Objects; American Woodturner*, Dec. 1995; *The New York Times*, Dec. 21, 1995, p. C1; Michael W. Monroe, *The White House Collection of American Crafts*; "Profile: Virginia Dotson, Woodturner," *Woodworker West*; Tran Turner, et al., *Expressions in Wood: Masterworks from The Wornick Collection*; John Perreault and Heather S. Lineberry, *Turned Wood Now: Redefining the Lathe-Turned Object IV; Enter the World of Lathe-Turned Objects*; Alan DuBois, et al., *Moving Beyond Tradition: A Turned-Wood Invitational*; *American Woodturner*, Winter 1998

JOHN DAVID ELLSWORTH
Quakertown, Pennsylvania
BORN: Iowa City, Iowa, 1944
EDUCATION: B.F.A., M.F.A., University of Colorado, Boulder, 1971, 1973
GRANTS/AWARDS/HONORS: Colorado Artist Craftsman Award, 1977; Visual Artists Fellowships, The National Endowment for the Arts, 1984; Pennsylvania Council on the Arts Fellowship, 1988
SOLO EXHIBITIONS: Metropolitan State College, Denver, CO, 1973; Sheldon Memorial Art Museum, Lincoln, NE, 1979; Great American Gallery, Atlanta, GA, 1984, 1987; Bellas Artes Gallery, New York, NY, 1991
GROUP EXHIBITIONS: "The Art of Wood Turning," American Craft Museum II, New York, NY, 1983; "Works off the Lathe: Old and New Faces," Craft Alliance Gallery, St. Louis, MO, 1987; "Lathe-Turned Objects, An International Exhibition," Port of History Museum, Philadelphia, PA, and touring, 1988; Musée des Arts Decoratifs, Paris, France, 1989; "Turner's Challenge III," Craft Alliance, 1989; "International Lathe-Turned Objects: Challenge IV," Port of History Museum, Philadelphia, PA, and touring, 1991; "Out of the Woods: Turned Wood by American Craftsmen," The Fine Arts Museum of the South, Mobile, AL, 1992, and touring Europe through 1997; "The White House Collection of American Crafts," National Museum of American Art, Washington, DC, and touring, 1995; "Moving Beyond Tradition: A Turned-Wood Invitational," The Arkansas Art Center Decorative Arts Museum, Little Rock, AR; "Turned Wood Now: Redefining the Lathe-Turned Object IV," Arizona State Univ. Art Museum, Tempe, AZ, 1997–98; "Expressions in Wood: Masterworks from The Wornick Collection," Oakland Museum of California, 1996, American Craft Museum, New York, NY, 1997–98; "The Art of Craft: Contemporary Works from the Saxe Collection," Fine Arts Museums of San Francisco, 1999
PUBLICATIONS: Paul J. Smith, *The Art of Wood Turning*; Paul J. Smith and Edward Lucie-Smith, *Craft Today: Poetry of the Physical*; Dale L. Nish, *Master Woodturners*; *Works off the Lathe: Old and New Faces*; Albert B. LeCoff, *Lathe-Turned Objects: An International Exhibition*; *Out of the Woods: Turned Wood by American Craftsmen*; Tran Turner, et al., *Expressions in Wood: Masterworks from The Wornick Collection*; Michael W. Monroe, *The White House Collection of American Crafts*; *Enter the World of Lathe-Turned Objects*; John Perreault and Heather S. Lineberry, *Turned Wood Now: Redefining the Lathe-Turned Object IV*; Alan DuBois, *Moving Beyond Tradition: A Turned-Wood Invitational*; Timothy Anglin Burgard, *The Art of Craft: Contemporary Works from the Saxe Collection*

RONALD E. FLEMING
Tulsa, Oklahoma
BORN: Oklahoma City, Oklahoma, 1937
EDUCATION: Oklahoma City University, OK, 1958
GRANTS/AWARDS/HONORS: Purchase Award from the Vision Makers Show, sponsored by the

States Art Council of Oklahoma, 1989; Grant Prize Award in the 1991 American Craft Award, sponsored by Kraus Sikes, Inc.; Purchase Award from the 1992 Regional Craft Biennial, sponsored by the Arkansas Arts Center, Little Rock, AR

SOLO EXHIBITIONS: "Forms in Wood," Walters Arts Center, Tulsa, OK, 1994; "New Works in Wood," M. A. Doran Gallery, Tulsa, OK, 1995

GROUP EXHIBITIONS: "Lathe-Turned Objects: An International Exhibition," Port of History Museum, Philadelphia, PA, and touring, 1988; "Turner's Challenge III," Craft Alliance, 1989; "Turned Wood '91," del Mano Gallery, Los Angeles, CA, 1991; "International Lathe-Turned Objects: Challenge IV," Port of History Museum, Philadelphia, PA, and touring, 1991; "Challenge V: International Lathe-Turned Objects," Philip and Muriel Berman Museum, Ursinus College, Collegeville, PA, and touring, 1994–97; "The White House Collection of American Crafts," National Museum of Art, Washington, DC, and touring, 1995; "Forms in Wood," Sansar Gallery, Washington, DC, 1996; "Expressions in Wood: Masterworks from The Wornick Collection," Oakland Museum of California, 1996, American Craft Museum, New York, NY, 1997–98; "Moving Beyond Tradition: A Turned-Wood Invitational," The Arkansas Art Center Decorative Arts Museum, Little Rock, AR, 1997; "The Art of Craft: Contemporary Works from the Saxe Collection," Fine Arts Museums of San Francisco, 1999

PUBLICATIONS: Albert B. LeCoff, *Lathe-Turned Objects; Fine Woodworking Design Book Five, Book Six,* and *Book Seven;* Eileen Silver, et al., *International Lathe-Turned Objects: Challenge IV;* Albert B. LeCoff, *Challenge V: International Lathe-Turned Objects;* Michael W. Monroe, *The White House Collection of American Crafts;* Tran Turner, et al., *Expressions in Wood: Masterworks from The Wornick Collection;* Alan DuBois, *Moving Beyond Tradition: A Turned- Wood Invitational;* Timothy Anglin Burgard, *The Art of Craft: Contemporary Works from the Saxe Collection*

GILES GILSON
Schenectady, New York
BORN: Philadelphia, Pennsylvania, 1942
GRANTS/AWARDS/HONORS: Special Award, "Turned Objects Show," Philadelphia, PA, 1981; Best Dimensional Display, Growth, Inc., Upstate New York Ad Club, Inc., 1985; Mid-Atlantic Foundation for the Arts, artist in residency, 1988
GROUP EXHIBITIONS: "Works off the Lathe: Old and New Faces," Craft Alliance Gallery, St. Louis, MO, 1987; "Lathe-Turned Objects, An International Exhibition," Port of History Museum, Philadelphia, PA, and touring, 1988–92; "Turner's Challenge III," Craft Alliance, 1989; "International Lathe-Turned Objects: Challenge IV," Port of History Museum, Philadelphia, PA, and touring, 1991; "Out of the Woods: Turned Wood by American Craftsmen," The Fine Arts Museum of the South, Mobile, AL, 1992, and touring Europe through 1997; "Challenge V: International Lathe-Turned Objects," Philip and Muriel Berman Museum of Art, Ursinus College, Collegeville, PA, and touring, 1994–97; "Expressions in Wood: Masterworks from The Wornick Collection," Oakland Museum of California, 1996, American Craft Museum, New York, NY, 1997–98
PUBLICATIONS: Dale L. Nish, *Creative Woodturning; Fine Woodworking Design Book Two;* Edward Jacobson, *The Art of Turned-Wood Bowls;* Craig Nutt, "Lathe-Turned," *American Craft; Works off the Lathe;* Albert B. LeCoff, *Lathe-Turned Objects: An International Exhibition;* Albert B. LeCoff, *Challenge V: International Lathe-Turned Objects;* Albert B. LeCoff, *Lathe-Turned Objects; Out of the Woods: Turned Wood by American Craftsmen;* Tran Turner, et al., *Expressions in*

Wood: Masterworks from The Wornick Collection; Enter the World of Lathe-Turned Objects; Skilled Work: American Craft in the Renwick Gallery

STEPHEN HOGBIN
Ontario, Canada
BORN: Tolworth, London, England, 1942
EDUCATION: Rycotewood College, 1957–58; Kingston College of Art, NDD, 1961; Royal College of Art, Des RCA, 1965
GRANTS/AWARDS/HONORS: Travel scholarship to Switzerland, 1966; Canada Council Award, Established Artists
SOLO EXHIBITIONS: The Craft Gallery, Toronto, 1972; Australia Design Center, Melbourne, Australia, 1976; National Exhibition Center, Thunder Bay, Ontario, 1983; Burlington Cultural Center, Burlington, Ontario, 1991
GROUP EXHIBITIONS: "The Art of Wood Turning," American Craft Museum II, New York, NY, 1983; "Lathe-Turned Objects, An International Exhibition," Port of History Museum, Philadelphia, PA, and touring, 1988–92; "International Lathe-Turned Objects: Challenge IV," Port of History Museum, Philadelphia, PA, and touring, 1991; "Challenge V: International Lathe-Turned Objects," Philip and Muriel Berman Museum of Art, Ursinus College, Collegeville, PA, and touring, 1994–97; "Turned Wood—Small Treasures," del Mano Gallery, Los Angeles, CA, 1999
PUBLICATIONS: Donald Lloyd McKinley, "Wood-turned Forms of Stephen Hogbin," *Craft Horizon;* Stephen Hogbin, *Wood Turning;* Paul J. Smith, *The Art of Wood Turning;* Albert B. LeCoff, *Lathe-Turned Objects;* Steve Loar, "Re:Turning: Works by Stephen Hogbin, Twenty Years of Innovation," *Fine Woodworking;* Eileen Silver, et al., *International Lathe-Turned Objects: Challenge IV;* Bobby Hansson, "World Turnout," *American Craft;* Albert B. LeCoff, *Challenge V: International Lathe-Turned Objects; Enter the World of Lathe-Turned Objects;* Stephen Hogbin, *Making, Appearance, and Reality: The Visual Experience*

MICHELLE HOLZAPFEL
Marlboro, Vermont
BORN: Woonsocket, Rhode Island, 1951
EDUCATION: Marlboro College, Marlboro, VT, 1969–70; B.A., Vermont College/Norwich University, Brattleboro, VT, 1993–95
GRANTS/AWARDS/HONORS: Arts Council of Windham County Grant, 1983
SOLO EXHIBITIONS: Brattleboro Museum and Arts Center, Brattleboro, VT, 1983; "Michelle Holzapfel," Peter Joseph Gallery, New York, NY, 1991; "Family Jewels," Peter Joseph Gallery, New York, NY, 1996
GROUP EXHIBITIONS: Invitational, The Craftsman's Gallery, Scarsdale, NY, 1984; "Works off the Lathe: Old and New Faces," Craft Alliance Gallery, St. Louis, MO, 1987; "Lathe-Turned Objects, An International Exhibition," Port of History Museum, Philadelphia, PA, and touring, 1988–91; "International Lathe-Turned Objects: Challenge IV," Port of History Museum, and touring, 1991; "Turner's Challenge III," Craft Alliance, 1989; "Out of the Woods: Turned Wood by American Craftsmen," The Fine Arts Museum of the South, Mobile, AL, 1992, and touring Europe through 1997; "Expressions in Wood: Masterworks from The Wornick Collection," Oakland Museum of California, 1996, American Craft Museum, New York, NY, 1997–98; "The Renwick at 25," Renwick Gallery of the National Museum of American Art, Washington, DC, 1997
PUBLICATIONS: Richard Star, "Woodworking on a Metal Lathe," *Fine Woodworking; Works off the Lathe;* Albert B. LeCoff, *Lathe-Turned Objects;* Eileen Silver, et al., *International Lathe-Turned Objects: Challenge IV; Out of the Woods: Turned*

Wood by American Craftsmen; D. Krasner, "Michelle Holzapfel," *American Craft;* Tran Turner, et al., *Expressions in Wood: Masterworks from The Wornick Collection; Enter the World of Lathe-Turned Objects; Skilled Work: American Craft in the Renwick Gallery*

RICHARD HOOPER
Childwall, Liverpool, England
BORN: Liverpool, England, 1958
EDUCATION: B.Ed., honors, Exeter University, 1980; M.A., Brunel University, 1982
GRANTS/AWARDS/HONORS: LIHE Staff Development Grant, 1995; North West Arts Grant (Research/Production), 1995; Foundation for Sports and the Arts Grant, 1996; Arts and Cultural Industries Development Fund (ACID) Grant, 1997; LHUC Staff Research Grant, 1997
SOLO EXHIBITION: Nimbus Gallery, Benedict Arts Center, England, 1994
GROUP EXHIBITIONS: "Turning Plus," Arizona State Univ. Art Museum, Tempe, AZ, 1994–95; "Challenge V: International Lathe-Turned Objects," Philip and Muriel Berman Museum, Ursinus College, Collegeville, PA, and touring, 1994–97; "Sculpture Objects Functional Art Exposition," Navy Pier, Chicago, IL, 1998; "Curators' Focus: Turning in Context," Philip and Muriel Berman Museum of Art, Ursinus College, Collegeville, PA, and touring, 1997–99
PUBLICATIONS: Albert B. LeCoff, *Challenge V: International Lathe-Turned Objects; American Woodturner,* Mar. 1996; Albert B. LeCoff, *Curators' Focus: Turning in Context; Enter the World of Lathe-Turned Objects*

ROBYN HORN
Little Rock, Arkansas
BORN: Fort Smith, Arkansas, 1951
EDUCATION: B.A., Hendrix College, Conway, AR, 1973
GRANTS/AWARDS/HONORS: Juror's Award, Denton, TX, 1990; Purchase Awards, Arkansas Art Center Decorative Arts Museum, Little Rock, AR, 1990, 1996
SOLO EXHIBITIONS: "Turned Wooden Objects," Heights Gallery, Little Rock, AR, 1989; del Mano Gallery, Los Angeles, CA, 1990
GROUP EXHIBITIONS: "Lathe-Turned Objects, An International Exhibition," Port of History Museum, Philadelphia, PA, and touring, 1988–92; "International Lathe-Turned Objects: Challenge IV," Port of History Museum, Philadelphia, PA, and touring, 1991; "Turner's Challenge III," Craft Alliance, 1989; "Out of the Woods: Turned Wood by American Craftsmen," The Fine Arts Museum of the South, Mobile, AL, 1992, and touring Europe through 1997; "Challenge V: International Lathe-Turned Objects," Philip and Muriel Berman Museum of Art, Ursinus College, Collegeville, PA, and touring, 1994; "The White House Collection of American Crafts," National Gallery of American Art, Washington, DC, and touring 1995; "Moving Beyond Tradition: A Turned-Wood Invitational," The Arkansas Art Center Decorative Arts Museum, Little Rock, AR, 1997; "Turned Wood Now: Redefining the Lathe-Turned Object IV," Arizona State Univ. Art Museum, Tempe, AZ, 1997–98; "Expressions in Wood: Masterworks from The Wornick Collection," Oakland Museum of California, 1996, American Craft Museum, New York, NY, 1997–98
PUBLICATIONS: Albert B. LeCoff, *Lathe-Turned Objects; Out of the Woods: Turned Wood by American Craftsmen;* Albert B. LeCoff, *Challenge V: International Lathe-Turned Objects;* Michael W. Monroe, *The White House Collection of American Crafts;* Tran Turner, et al., *Expressions in Wood: Masterworks from The Wornick Collection;* Patrick Spielman, *The Art of the Lathe;* "Expression in

Wood," *American Craft*; *Enter the World of Lathe-Turned Objects*; John Perreault and Heather S. Lineberry, *Turned Wood Now: Redefining the Lathe-Turned Object IV*; Alan DuBois, *Moving Beyond Tradition: A Turned-Wood Invitational*

MICHAEL HOSALUK
Saskatoon, Canada
BORN: Invermay, Saskatchewan, Canada, 1954
EDUCATION: Kelsey Institute of Applied Arts and Science, Saskatoon, Saskatchewan
GRANTS/AWARDS/HONORS: Saskatchewan Arts Board Award, 1995; Canada Council Arts Grant, 1996
SOLO EXHIBITION: del Mano Gallery, Los Angeles, CA, 1997
GROUP EXHIBITIONS: "Works off the Lathe: Old and New Faces," Craft Alliance Gallery, St. Louis, MO, 1987; "Lathe-Turned Objects, An International Exhibition," Port of History Museum, Philadelphia, PA, 1988–92; "International Lathe-Turned Objects: Challenge IV," Port of History Museum, Philadelphia, PA, and touring, 1991; "Turner's Challenge," Craft Alliance, 1989; "A Madcap Tea Party at The Renwick," Renwick Gallery of the National Museum of American Art, Washington, DC, 1996; "All Figural—Many Media," California State Univ., Contemporary Art Gallery, Los Angeles, 1997; "Moving Beyond Tradition: A Turned-Wood Invitational," The Arkansas Art Center Decorative Arts Museum, Little Rock, AR, 1997; "Curators' Focus: Turning in Context," Philip and Muriel Berman Museum of Art, Ursinus College, Collegeville, PA, and touring, 1997–99
PUBLICATIONS: Richard Raffan, *Turning Boxes*; *Works off the Lathe*; *Fine Woodworking Design Book Five*; Martina Margetts, *International Crafts*; Eileen Silver, et al., *International Lathe-Turned Objects: Challenge IV; American Woodturner* 11, nos. 2, 4, 1996; Patrick Spielman, *The Art of the Lathe*; *Enter the World of Lathe-Turned Objects*; *Lathe-Turned Objects*; Albert B. LeCoff, *Curators' Focus: Turning in Context*; Alan DuBois, *Moving Beyond Tradition: A Turned-Wood Invitational*

TODD HOYER
Bisbee, Arizona
BORN: Beaver Dam, Wisconsin, 1952
EDUCATION: Manufacturing Technology and Design Technology, Arizona State University, Tempe, AZ, 1970–75
GRANTS/AWARDS/HONORS: Scholarship to attend the Second Woodturning Symposium, Provo, Utah, 1980
SOLO EXHIBITIONS: del Mano Gallery, Los Angeles, CA, 1987; Mendelson Gallery, Washington Depot, CT, 1987; Joanne Rapp Gallery/The Hand & The Spirit, Scottsdale, AZ, 1997
GROUP EXHIBITIONS: "Works off the Lathe: Old and New Faces," Craft Alliance Gallery, St. Louis, MO, 1987; "Lathe-Turned Objects, An International Exhibition," Port of History Museum, Philadelphia, PA, and touring, 1988–92; "Turner's Challenge III," Craft Alliance, 1989; "Challenge IV: International Lathe-Turned Objects," Port of History Museum, Philadelphia, PA, and touring, 1991; "A Double Anniversary Celebration," Renwick Gallery of the National Museum of American Art, Washington, DC, 1992; "Out of the Woods: Turned Wood by American Craftsmen," The Fine Arts Museum of the South, Mobile, AL, 1992, and touring Europe through 1997; "Challenge V: International Lathe-Turned Objects," Philip and Muriel Berman Museum, Ursinus College, Collegeville PA, and touring, 1994–97; "Expressions in Wood: Masterworks from The Wornick Collection," Oakland Museum of California, 1996, American Craft Museum, New

York, NY, 1997–98; "Moving Beyond Tradition: A Turned-Wood Invitational," The Arkansas Art Center Decorative Arts Museum, Little Rock, AR, 1997; "Turned Wood Now: Redefining the Lathe-Turned Object IV," Arizona State Univ. Art Museum, Tempe, AZ, 1997–98; "Todd Hoyer/Hayley Smith: Turned Wood," Joanne Rapp Gallery/The Hand & The Spirit, Scottsdale, AZ, 1998; "Revolving Techniques: Clay, Glass, Metal, Wood," James A. Michener Art Museum, Doylestown, PA, 1992
PUBLICATIONS: *Works off the Lathe*; Albert B. LeCoff, *Lathe-Turned Objects*; "Out of the Woods, The Jacobson Collection," video, KAET-TV, Tempe, AZ; *International Lathe-Turned Objects: Challenge IV; Out of the Woods: Turned Wood by American Craftsmen; Growth Through Sharing*; Tran Turner, et al., *Expressions in Wood: Masterworks from The Wornick Collection*; Todd Hoyer, "My Life, My Work: A Portrait of the Artist as a Woodturner," *American Woodturner*; *Enter the World of Lathe-Turned Objects*; John Perreault and Heather S. Lineberry, *Turned Wood Now: Redefining the Lathe-Turned Object IV*; Alan DuBois, *Moving Beyond Tradition: A Turned-Wood Invitational*

WILLIAM HUNTER
Rancho Palos Verdes, California
BORN: Long Beach, California, 1947
EDUCATION: A.A., Santa Monica City College, 1968; B.A., California State College, Dominguez Hills, 1971
SOLO EXHIBITIONS: "William Hunter: The Art of the Turned Wood Bowl," Marianne Friedland Gallery, Toronto, Canada, 1991; "William Hunter: Turned Wood," Okun Gallery, Santa Fe, N.M., 1994; "William Hunter," Mendelson Gallery, Washington Depot, CT, 1999
GROUP EXHIBITIONS: "Works off the Lathe: Old and New Faces," Craft Alliance Gallery, St. Louis, MO, 1987; "Lathe-Turned Objects, An International Exhibition," Port of History Museum, Philadelphia, PA, 1988–92; "Turner's Challenge III," Craft Alliance, 1989; "Out of the Woods: Turned Wood by American Craftsmen," The Fine Arts Museum of the South, Mobile, AL, 1992, and touring Europe through 1997; "Challenge V: International Lathe-Turned Objects," Philip and Muriel Berman Museum, Ursinus College, Collegeville, PA, and touring, 1994–97; "Points of View: Collectors and Collecting," Craft and Folk Art Museum, Los Angeles, CA, 1995; "Expressions in Wood: Masterworks from The Wornick Collection," Oakland Museum of California, 1996, American Craft Museum, New York, NY, 1997–98; "Moving Beyond Tradition: A Turned-Wood Invitational," The Arkansas Art Center Decorative Arts Museum, Little Rock, AR, 1997; "Curators' Focus: Turning in Context," Philip and Muriel Berman Museum of Art, Collegeville, PA, and touring, 1997–99; "The Art of Craft: Contemporary Works from the Saxe Collection," Fine Arts Museums of San Francisco, 1999
PUBLICATIONS: *Works off the Lathe*; Albert B. LeCoff, *Lathe-Turned Objects*; Albert B. LeCoff, *Challenge V: International Lathe-Turned Objects*; Davira S. Taragin, *Contemporary Crafts and the Saxe Collection*; *Woodturning Magazine*, Oct. 1995; Tran Turner, et al., *Expressions in Wood: Masterworks from The Wornick Collection*; *Enter the World of Lathe-Turned Objects*; Albert B. LeCoff, *Curators' Focus: Turning in Context*; Alan DuBois, *Moving Beyond Tradition: A Turned-Wood Invitational*; *Skilled Work: American Craft in the Renwick Gallery*; Timothy Anglin Burgard, *The Art of Craft: Contemporary Works from the Saxe Collection*

JOHN JORDAN
Antioch, Tennessee
BORN: Nashville, Tennessee, 1950
GRANTS/AWARDS/HONORS: "Award of Excellence," Cedarhurst Craft Fair, Mt. Vernon, IL, 1988; "Award of Merit," Tennessee Fall Crafts Fair, Nashville, TN, 1989
SOLO EXHIBITIONS: Centennial Arts Center, Nashville, TN, 1989; "Turned Sculpture," Zimmerman-Saturn Gallery, Nashville, TN, 1991; "Solo Exhibition," Banaker Gallery, San Francisco, CA, 1995; "Turned and Carved Wood Vessels," Connell Gallery, Atlanta, GA, 1998
GROUP EXHIBITIONS: "International Lathe-Turned Objects: Challenge IV," Port of History Museum, Philadelphia, PA, and touring, 1991; "Revolving Techniques: Clay, Glass, Metal, Wood," James A. Michener Art Museum, Doylestown, PA, 1992; "Out of the Woods: Turned Wood by American Craftsmen," The Fine Arts Museum of the South, Mobile, AL, 1992, and touring Europe through 1997; "Challenge V: International Lathe-Turned Objects," Philip and Muriel Berman Museum, Ursinus College, Collegeville, PA, and touring, 1994–97; "The White House Collection of American Crafts," National Museum of American Art, Washington, DC, and touring, 1995; "Points of View: Collectors and Collecting," Craft & Folk Art Museum, Los Angeles, CA, 1995; "Expressions in Wood: Masterworks from The Wornick Collection," Oakland Museum of California, 1996, American Craft Museum, New York, NY, 1997–98; "Moving Beyond Tradition: A Turned-Wood Invitational," The Arkansas Art Center Decorative Arts Museum, Little Rock, AR, 1997; "The Renwick at 25," Renwick Gallery of the National Museum of American Art, Washington, DC, 1997; "Wonders in Wood: The Art of the Woodturner," Association of Woodturners of Great Britain, University of Warwick, 1998; "American Woodturner's Profile II," R. Duane Reed Gallery, Chicago, IL, 1999
PUBLICATIONS: Eileen Silver, et al., *International Lathe-Turned Objects: Challenge IV; Out of the Woods: Turned Wood by American Craftsmen*; Albert B. LeCoff, *Challenge V: International Lathe-Turned Objects*; John Jordan, "The Art of Woodworking," *The Art of Woodworking*; John Jordan, "John Jordan Makes a Lidded Vessel," *Woodturning Magazine*; Michael W. Monroe, *The White House Collection of American Crafts*; Tran Turner, et al., *Expressions in Wood: Masterworks from The Wornick Collection*; Patrick Spielman, *The Art of the Lathe: Award-Winning Designs*; Alan DuBois, *Moving Beyond Tradition: A Turned-Wood Invitational; Wonders in Wood: The Art of the Woodturner*

RONALD E. KENT
Kailua, Hawaii
BORN: Chicago, Illinois, 1931
EDUCATION: B.S.M.E., University of California, Los Angeles, 1957
GRANTS/AWARDS/HONORS: Three Craft Excellence Awards; Best Three-Dimensional Award; Award of Merit; works by the artist presented to: President William Clinton by the state of Hawaii; Presidents Ronald Reagan and George Bush by the Hawaii Republican Party; and Emperor Akahito of Japan by the Consulate General of Japan
SOLO EXHIBITION: Hana Coast Gallery, Hana, Maui, 1991
GROUP EXHIBITIONS: "The Art of Wood Turning," American Craft Museum II, New York, NY, 1983; "Lathe-Turned Objects, An International Exhibition," Port of History Museum, Philadelphia, PA, 1988–92; "Turner's Challenge III," Craft Alliance, 1989; "Out of the Woods: Turned Wood by American Craftsmen," The Fine Arts Museum

of the South, Mobile, AL, 1992, and touring Europe through 1997; "The White House Collection of American Crafts," National Museum of American Art, Washington, DC, and touring, 1995; "Turned Wood Now: Redefining the Lathe-Turned Object IV," Arizona State Univ. Art Museum, Tempe, AZ, 1997–98; "Expressions in Wood: Masterworks from The Wornick Collection," Oakland Museum of California, 1996, American Craft Museum, New York, NY, 1997–98; "Curators' Focus: Turning in Context," Philip and Muriel Berman Museum of Art, Collegeville, PA, and touring, 1997–99

PUBLICATIONS: Paul J. Smith, *The Art of Wood Turning*; Albert B. LeCoff, *Lathe-Turned Objects*; *Out of the Woods: Turned Wood by American Craftsmen*; Michael W. Monroe, *The White House Collection of American Crafts*; Ron Kent, "The Shape of My Things to Come," *Spindle Turning: The Best from Woodturning Magazine*; Tran Turner, et al., *Expressions in Wood: Masterworks from The Wornick Collection*; Michael Tambini, *The Look of the Century*; John Perreault and Heather S. Lineberry, *Turned Wood Now: Redefining the Lathe-Turned Object IV*; Albert B. LeCoff, *Curators' Focus: Turning in Context*

DAN KVITKA
Corvallis, Oregon
BORN: Portland, Oregon, 1958
EDUCATION: B.S., Art Center College of Design, Pasadena, CA
SOLO EXHIBITIONS: "Turned Forms by Dan Kvitka," Opus 5 Gallery, Eugene, OR, 1985; Banaker Gallery, San Francisco, CA, 1995; "Dan Kvitka," Margo Jacobsen Gallery, Portland, OR, 1995, 1996
GROUP EXHIBITIONS: "Lathe-Turned Objects, An International Exhibition," Port of History Museum, Philadelphia, PA, and touring, 1988–92; "Dan Kvitka and Eva Gallant," The Society of Arts and Crafts, Boston, MA, 1989; "Five Rising Stars," Mendelson Gallery, Washington Depot, CT, 1990; "Turning Plus," Arizona State Univ. Art Museum, Tempe, AZ, 1995; "Expressions in Wood: Masterworks from The Wornick Collection," Oakland Museum of California, 1996, American Craft Museum, New York, NY, 1997–98; "The Renwick at 25," Renwick Gallery of the National Museum of American Art, Washington, DC, 1997; "The Art of Craft: Contemporary Works from the Saxe Collection," Fine Arts Museums of San Francisco, 1999
PUBLICATIONS: Albert B. LeCoff, *Lathe-Turned Objects: An International Exhibition*; *Fine Woodworking Design Book Five*; Tran Turner, et al., *Expressions in Wood: Masterworks from The Wornick Collection*; *Skilled Work: American Craft in the Renwick Gallery*; Timothy Anglin Burgard, *The Art of Craft: Contemporary Works from the Saxe Collection*

STONEY LAMAR
Saluda, North Carolina
BORN: Alexandria, Louisiana, 1951
EDUCATION: B.S., Appalachian State University, Boone, NC, 1979; Assistant to Mark and Melvin Linquist, Henniker, N.H., 1984–85
GRANTS/AWARDS/HONORS: Juror's Award, "Someone to Watch Over Me," Arrowmont School of Arts and Crafts, Gatlinburg, TN, 1985; Juror's Award, "Materials Hard and Soft," Greater Denton Arts Council, Denton, TX, 1989; Juror's Award, "Woodturning: Vision and Concept II," Arrowmont School of Arts and Crafts, Gatlinburg, TN, 1991; Purchase Award, "Addicted to the Rhythm M#1," Arkansas Art Center Decorative Arts Museum, Little Rock, AR, 1995; Arida Arts Symposium Artist of the Year, Hendersville, NC, 1998

SOLO EXHIBITIONS: "Fifth Annual Lathe-Turned Objects Show: Stoney Lamar," Sansar Gallery, Washington, DC, 1992; "Fall Color," Blue Spiral 1, Asheville, NC, 1994; Mendelson Gallery, Washington Depot, CT, 1998
GROUP EXHIBITIONS: "Works off the Lathe: Old and New Faces," Craft Alliance Gallery, St. Louis, MO, 1987; "Lathe-Turned Objects, An International Exhibition," Port of History Museum, Philadelphia, PA, and touring, 1988–92; "Turner Challenge III," Craft Alliance, 1989; "Turned Vessel Defined," Society of Arts and Crafts, Boston, MA, 1990; "Contemporary Works in Wood, Southern Style," Huntsville Museum of Art, Huntsville, AL, 1990; "International Lathe-Turned Objects: Challenge IV," Port of History Museum, Philadelphia, PA, and touring, 1991; "Out of the Woods: Turned Wood by American Craftsmen," The Fine Arts Museum of the South, Mobile, AL, 1992, and touring Europe through 1997; "Contemporary Crafts and the Saxe Collection," The Toledo Museum of Art, Toledo, OH, 1993; "Challenge V: International Lathe-Turned Objects," Philip and Muriel Berman Museum of Art, Ursinus College, Collegeville, PA, and touring, 1994–97; "Curators' Focus: Turning in Context," Philip and Muriel Berman Museum of Art, Collegeville, PA, and touring, 1997–99; "Moving Beyond Tradition: A Turned-Wood Invitational," The Arkansas Art Center Decorative Arts Museum, Little Rock, AR, 1997; "Turned Wood Now: Redefining the Lathe-Turned Object IV," Arizona State Univ. Art Museum, Tempe, AZ, 1997–98; "Expressions in Wood: Masterworks from The Wornick Collection," American Craft Museum, New York, NY, 1997–98; "Revolving Techniques: Clay, Glass, Metal, Wood," James A. Michener Art Museum, 1992
PUBLICATIONS: Martha Stamm Connell, *Contemporary Works in Wood, Southern Style*; Barbara Mayer, *Contemporary American Craft Art: A Collector's Guide*; Thomas Rain Crowe, "Transforming Nature's Mutations: The Turned Wood Sculpture of Stoney Lamar," *The Arts Journal*; Eileen Silver, et al., *International Lathe-Turned Objects: Challenge IV*; *Out of the Woods: Turned Wood by American Craftsmen*; Davira S. Taragin, *Contemporary Crafts and the Saxe Collection*; Daniel McAlpine, "Lamar's Wood Sculpture," *Woodshop News*; Albert B. LeCoff, *Challenge V: International Lathe-Turned Objects*; Albert B. LeCoff, *Curators' Focus: Turning in Context*; *Enter the World of Lathe-Turned Objects*; John Perreault and Heather S. Lineberry, *Turned Wood Now: Redefining the Lathe-Turned Object*; Alan DuBois, et al., *Moving Beyond Tradition: A Turned-Wood Invitational*

BUD LATVEN
Tajique, New Mexico
BORN: Philadelphia, Pennsylvania, 1949
EDUCATION: Delaware County College, Philadelphia, PA, 1970–72; University of New Mexico, Albuquerque, N.M., 1972–73
GRANTS/AWARDS/HONORS: Craftsman's Choice Award, The Smithsonian Craft Show, Washington, DC, 1987; Award for Excellence, The American Craft Exposition, Evanston, IL, 1988, 1989; Award for Excellence, The Smithsonian Craft Show, Washington, DC, 1989, 1990; Best of Show Award, The American Craft Exposition, Evanston, IL, 1990; Award for Craftsmanship, The Philadelphia Craft Exposition, PA, 1990
SOLO EXHIBITIONS: "1993: Year of American Craft," Albuquerque Museum, Albuquerque, N.M., 1993; Susan Conway Gallery, Washington, DC, 1998
GROUP EXHIBITIONS: "Works off the Lathe: Old and New Faces," Craft Alliance Gallery, St. Louis, MO, 1987; "Lathe-Turned Objects, An

International Exhibition," Port of History Museum, Philadelphia, PA, and touring, 1988–92; "Turner's Challenge III," Craft Alliance, 1989; "International Lathe-Turned Objects: Challenge IV," Port of History Museum, Philadelphia, PA, and touring, 1991; "Out of the Woods: Turned Wood by American Craftsmen," The Fine Arts Museum of the South, Mobile, AL, 1992, and touring Europe through 1997; "Challenge V: International Lathe-Turned Objects," Philip and Muriel Berman Museum, Ursinus College, Collegeville, PA, and touring, 1994–97; "Moving Beyond Tradition: A Turned-Wood Invitational," The Arkansas Art Center Decorative Arts Museum, Little Rock, AR, 1997; "The Renwick at 25," Renwick Gallery of the National Museum of American Art, Washington, DC, 1997; "Expressions in Wood: Masterworks from The Wornick Collection," Oakland Museum of California, 1996, American Craft Museum, New York, NY, 1998
PUBLICATIONS: Bud Latven and Addie Draper, *Segmented Turning*; *Works off the Lathe*; Albert B. LeCoff, *Lathe-Turned Objects*; Eileen Silver, et al., *International Lathe-Turned Objects: Challenge IV*; *Out of the Woods: Turned Wood by American Craftsmen*; Albert B. LeCoff, *Challenge V: International Lathe-Turned Objects*; Tran Turner, et al., *Expressions in Wood: Masterworks from The Wornick Collection*; Alan DuBois, et al., *Moving Beyond Tradition: A Turned Wood Invitational*; *Enter the World of Lathe-Turned Objects*; Alan DuBois, *Moving Beyond Tradition: A Turned-Wood Invitational*

PO SHUN LEONG
Winnetka, California
BORN: Northampton, England, 1941
EDUCATION: Architectural Association School of Architecture, London, England, 1959–64
GRANTS/AWARDS/HONORS: Travel Scholarship, Michael Ventris Memorial Award, 1966; Two First Prizes, National Furniture Competition, Mexico, 1981; Craftsman Award, Philadelphia Craft Show, 1988; Merit Award, American Craft Awards, New York, 1989; Best of Show and First Prize, California Woodworking, 1990
GROUP EXHIBITIONS: "Another State of Mind," California Crafts Museum, San Francisco, CA, 1987; "Bewitched by Craft," American Craft Museum, New York, NY, 1989; "New Art Forms Exposition," Lakeside Group, Navy Pier, Chicago, IL, 1992; "The White House Collection of American Crafts," National Museum of American Art, Washington, DC, and touring, 1995; "Asian Influences," Philadelphia Museum of Art, Philadelphia, PA, 1994
PUBLICATIONS: Lloyd E. Herman, *Art That Works*; Bill Kraus, *Contemporary Crafts for the Home*; Terry Noll, "Steps into Another World," *Woodwork*; Tony Lydgate, *The Art of Making Elegant Wood Boxes*; Michael W. Monroe, *The White House Collection of American Crafts*; Tony Lydgate, *Po Shun Leong: Art Boxes*

MARK LINDQUIST
Quincy, Florida
BORN: Oakland, California, 1949
EDUCATION: B.A., New England College, Henniker, NH, 1971; M.F.A., Florida State University, Tallahassee, FL, 1990
GRANTS/AWARDS/HONORS: MacDowell Colony Fellowship, MacDowell Colony, Petersborough, N.H., 1979; Individual Artist Grant, New Hampshire Commission on the Arts, 1984; New Works Grant, Brockton Art Museum Commission Award, Massachusetts Council on the Arts and Humanities, 1985; Southern Arts Federation/NEA Fellowship, 1989; Honorary Board Member, James Renwick Alliance, 1996
SOLO EXHIBITIONS: "Featured Object

May/June," National Museum of American Art, Washington, DC, 1982; Brevard Art Center and Museum, Melbourne, FL, 1986

GROUP EXHIBITIONS: "The Edward Jacobson Collection of American Turned Wood Bowls," Arizona State Univ. Art Museum, Tempe, AZ, and traveling, 1985; "Art for the Tabletop," benefit auction, American Craft Museum, New York, NY, 1985; "New Work/Crafts 1986," Brockton Art Museum, Brockton, MA, 1986; "Inaugural Show—The Poetry of the Physical," American Craft Museum, New York, NY, and touring, 1986; "Works off the Lathe: Old and New Faces," Craft Alliance Gallery, St. Louis, MO, 1987; "Lathe-Turned Objects, An International Exhibition," Port of History Museum, Philadelphia, PA, 1988; "Out of the Woods: Turned Wood by American Craftsmen," The Fine Arts Museum of the South, Mobile, AL, 1992, and touring Europe through 1997; "The Art of Wood Turning," American Craft Museum II, New York, NY, 1993; "Contemporary Crafts and the Saxe Collection," The Toledo Museum of Art, Toledo, OH, 1993; "The White House Collection of American Crafts," National Museum of American Crafts, Washington, DC, and touring, 1995; "Expressions in Wood: Masterworks from The Wornick Collection," Oakland Museum of California, 1996, American Craft Museum, New York, NY, 1997–98; "The Art of Craft: Contemporary Works from the Saxe Collection," Fine Arts Museum of San Francisco, 1999

PUBLICATIONS: Paul J. Smith, *The Art of Wood Turning*; Dale L. Nish, *Master Woodturners*; Mark Lindquist, *Sculpturing Wood*; Paul J. Smith and Edward Lucie-Smith, *Craft Today: Poetry of the Physical*; *Works off the Lathe*; *Enter the World of Lathe-Turned Objects*; Allys Palladino-Craig, "Mark Lindquist: Making Split Decisions," *Art Today*; *Out of the Woods: Turned Wood by American Craftsmen*; Davira S. Taragin, *Contemporary Crafts and the Saxe Collection*; Josephine Gear, *Beyond Nature: Wood into Art*; Mark Lindquist, "Harvesting Burls," *Fine Woodworking*; Robert Carleton Hobbs, *Mark Lindquist: Revolutions in Wood*; Michael W. Monroe, *The White House Collection of American Crafts*; Timothy Anglin Burgard, *The Art of Craft: Contemporary Works from the Saxe Collection*

MELVIN LINDQUIST

Quincy, Florida
BORN: Kingsburg, California, 1911
EDUCATION: B.S., Oakland Polytechnic College of Engineering, CA, 1935
GRANTS/AWARDS/HONORS: New England Living Art Treasure Award, Univ. of Massachusetts at Amherst, 1983; National Woodturning Conference Award for outstanding achievements in studio woodturning, Arrowmont School of Arts and Crafts, 1985; Lifetime Member, American Association of Woodturners, 1993
GROUP EXHIBITIONS: "The Art of the Turned Bowl," Renwick Gallery of the National Museum of American Art, Washington, DC, 1978; "Twentieth-Century Decorative Art," Metropolitan Museum of Art, New York, NY, 1978–79; "The Art of Wood Turning," American Craft Museum II, New York, NY, 1983; "The Edward Jacobson Collection of American Turned Wood Bowls," Arizona State Univ. Art Museum, Tempe, AZ, and touring, 1985; benefit auction, American Craft Museum, New York, NY, 1986; "Works off the Lathe: Old and New Faces," Craft Alliance Gallery, St. Louis, MO, 1987; "Lathe-Turned Objects, An International Exhibition," Port of History Museum, Philadelphia, PA, 1988; "Contemporary Works in Wood, Southern Style," Huntsville Museum of Art, Huntsville, AL, 1990; "Out of the Woods: Turned Wood by American Craftsmen," The Fine Arts

Museum of the South, Mobile, AL, 1992, and touring Europe through 1997; "Contemporary Crafts and the Saxe Collection," The Toledo Museum of Art, Toledo, OH, 1993; "The White House Collection of American Crafts," National Museum of American Art, Washington, DC, and touring, 1995; "The Art of Craft: Contemporary Works from the Saxe Collection," Fine Arts Museums of San Francisco, 1999

PUBLICATIONS: Robert Whitley, "Review: Melvin and Mark Lindquist, The Works Craft Gallery," *Arts Exchange*; Dale L. Nish, *Artistic Woodturning*; "Mark and Melvin Lindquist at The Works"; Martha Stamm Connell, *Contemporary Works in Wood, Southern Style*; Paul J. Smith, *The Art of Wood Turning*; Edward Jacobson, *The Art of Turned Wood Bowls*; Dale L. Nish, *Master Woodturners*; *Works off the Lathe*; Albert B. LeCoff, *Lathe-Turned Objects*; *Out of the Woods: Turned Wood by American Craftsmen*; Davira S. Taragin, *Contemporary Crafts and the Saxe Collection*; Michael W. Monroe, *The White House Collection of American Crafts*; *Enter the World of Lathe-Turned Objects*; Timothy Anglin Burgard, *The Art of Craft: Contemporary Works from the Saxe Collection*

JOHANNES MICHELSON

Manchester Center, Vermont
BORN: Copenhagen, Denmark, 1945
SOLO EXHIBITION: Boston Design Center, Boston, MA, 1990
GROUP EXHIBITIONS: "Vessels: Turned and Carved," Sansar Gallery, Washington, DC, 1988; "Turner's Challenge III," Craft Alliance, 1989; Society of Arts and Crafts, Boston, MA, 1990–91; "Challenge IV: International Lathe-Turned Objects," Port of History Museum, Philadelphia, PA, and touring, 1991; "Challenge V: International Lathe-Turned Objects," Philip and Muriel Berman Museum of Art, Ursinus College, Collegeville, PA, and touring, 1994–97; "Smithsonian Craft Show," Smithsonian Institution, Washington, DC, 1996; "Turned Wood—Small Treasures," del Mano Gallery, Los Angeles, CA, 1996
PUBLICATIONS: Eileen Silver, et al., *International Lathe-Turned Objects: Challenge IV*; Albert B. LeCoff, *Challenge V: International Lathe-Turned Objects*; *Enter the World of Lathe-Turned Objects*

BRUCE MITCHELL

Point Reyes, California
BORN: San Rafael, California, 1949
EDUCATION: University of California, Santa Barbara, CA, 1970–71
GRANTS/AWARDS/HONORS: Best of Show, "The Turned Object Show," a national invitational exhibition, The Works Gallery, Philadelphia, PA, 1981; Merit Award, Marin County Juried Arts and Crafts Festival, San Rafael, CA, 1983; Merit Award, San Francisco Art Festival, 1983
SOLO EXHIBITIONS: Great American Gallery, Atlanta, GA, 1980; Mendolson Gallery, Washington Depot, CT, 1989; Banaker Gallery, San Francisco, CA, 1995
GROUP EXHIBITIONS: High Museum of Art, Atlanta, GA, 1987; "Works off the Lathe: Old and New Faces," Craft Alliance Gallery, St. Louis, MO, 1987; "Lathe-Turned Objects, An International Exhibition," Port of History Museum, Philadelphia, PA, 1988; "Turner's Challenge III," Craft Alliance, 1989; "American Crafts: The Nation's Collection," Renwick Gallery of the National Museum of American Art, Washington, DC, 1992–93; "Turned Wood—Small Treasures," del Mano Gallery, Los Angeles, CA, 1996; "Expressions in Wood: Masterworks from The Wornick Collection," Oakland Museum of California, 1996, American Craft Museum, 1997–98; "Moving Beyond Tradition: A Turned-Wood Invitational," The

Arkansas Art Center Decorative Arts Museum, Little Rock, AR, 1997
PUBLICATIONS: Albert B. LeCoff, *A Gallery of Turned Wood Objects*; *Works off the Lathe*; *Enter the World of Lathe-Turned Objects*; Albert B. LeCoff, *Lathe-Turned Objects*; "Sculptured Bowls," *American Woodturner*; Tran Turner, et al., *Expressions in Wood: Masterworks from The Wornick Collection*; Alan DuBois, *Moving Beyond Tradition: A Turned-Wood Invitational*

EDWARD MOULTHROP

Atlanta, Georgia
BORN: Cleveland, Ohio, 1916
EDUCATION: B.A., Case Western Reserve University, Cleveland, OH, 1939; M.F.A., Princeton University, NJ, 1941
GRANTS/AWARDS/HONORS: "Craftsmen U.S.A.," first National Crafts Show of The American Craft Council, Award of Merit, 1966; American Institute of Architects Award, 1978, 1980; Georgia Governor's Award, 1981; Fellow, American Craft Council, 1987
SOLO EXHIBITION: High Museum of Art, Atlanta, GA, 1987
GROUP EXHIBITIONS: "Crafts, Art, and Religion," The Vatican Museum, Rome, sponsored jointly by the Smithsonian Institution and the Vatican Museum, 1978; "The XIII Olympic Art Exhibition," Lake Placid, NY, 1980; "The Art of Wood Turning," American Craft Museum II, New York, NY, 1983; "Works off the Lathe: Old and New Faces," Craft Alliance Gallery, St. Louis, MO, 1987; "Lathe-Turned Objects, An International Exhibition," Port of History Museum, Philadelphia, PA, 1988; "Turner's Challenge III," Craft Alliance, 1989; U.S. Information Agency, "Craft Today, U.S.A.," European exhibition, 1989–91; "Contemporary Works in Wood, Southern Style," Huntsville Museum of Art, Huntsville, AL, 1990; "International Lathe-Turned Objects: Challenge IV," Port of History Museum, Philadelphia, PA, and touring, 1991; "Out of the Woods: Turned Wood by American Craftsmen," The Fine Arts Museum of the South, Mobile, AL, 1992, and touring Europe through 1997; "Challenge V: International Lathe-Turned Objects," Philip and Muriel Berman Museum, Ursinus College, Collegeville, PA, 1994–97; "The White House Collection of American Crafts," National Museum of American Art, Washington, DC, and touring, 1995; "Wonders in Wood," Connell Gallery, Atlanta, GA, 1996; "Curators' Focus: Turning in Context," Philip and Muriel Berman Museum of Art, Collegeville, PA, and touring, 1997–99; "Ed and Philip Moulthrop: Master Wood-turning Artists," Gump's Store, San Francisco, CA, 1999; "The Art of Craft: Contemporary Works from the Saxe Collection," Fine Arts Museums of San Francisco, 1999
PUBLICATIONS: Paul J. Smith, *The Art of Wood Turning*; Dale L. Nish, "Turning Giant Bowls," *Fine Woodworking*; Martha Stamm Connell, *Contemporary Works in Wood, Southern Style*; Dale N. Nish, *Master Woodturners*; Paul J. Smith and Edward Lucie-Smith, *Craft Today: Poetry of the Physical*; Ed Moulthrop, "The Southern Artists," *Southern Accents*; *Works off the Lathe*; Eileen Silver, et al., *International Lathe-Turned Objects: Challenge IV*; *Out of the Woods: Turned Wood by American Craftsmen*; Albert B. LeCoff, *Challenge V: International Lathe-Turned Objects*; Michael W. Monroe, *The White House Collection of American Crafts*; Albert B. LeCoff, *Curators' Focus: Turning in Context*; *Skilled Work: American Craft in the Renwick Gallery*; Timothy Anglin Burgard, *The Art of Craft: Contemporary Works from the Saxe Collection*

PHILIP MOULTHROP

Marietta, Georgia

BORN: Atlanta, Georgia, 1947

EDUCATION: B.A., West Georgia College, Carrolton, 1996; L.L.D., Woodrow Wilson College of Law, Atlanta, GA, 1978

SOLO EXHIBITIONS: "Philip Moulthrop," Heller Gallery, New York, NY, 1997; "Philip Moulthrop: New Work," Joanne Rapp Gallery/The Hand & The Spirit, Scottsdale, AZ, 1998; "Philip Moulthrop: Metamorphosis from a Tree to a Bowl," Creative Expressions, Taos, NM, 1999

GROUP EXHIBITIONS: "Works off the Lathe: Old and New Faces," Craft Alliance Gallery, St. Louis, MO, 1987; "Lathe-Turned Objects, An International Exhibition," Port of History Museum, Philadelphia, PA, 1988; "Turner's Challenge III," Craft Alliance, 1989; "Contemporary Works in Wood, Southern Style," Huntsville Museum of Art, Huntsville, AL, 1990; "International Lathe-Turned Objects: Challenge IV," Port of History Museum, Philadelphia, PA, and touring, 1991; "Invitational Turned Wood Exhibition," California Crafts Museum, San Francisco, CA, 1992; "Out of the Woods: Turned Wood by American Craftsmen," The Fine Arts Museum of the South, Mobile, AL, 1992, and touring Europe through 1997; "Challenge V: International Lathe-Turned Objects," Philip and Muriel Berman Museum of Art, Ursinus College, Collegeville, PA, and touring, 1994–97; "The White House Collection of American Crafts," National Museum of American Art, Washington, DC, and touring, 1995; "Expressions in Wood: Masterworks from The Wornick Collection," Oakland Museum of California, 1996, American Craft Museum, New York, NY, 1997–98; "Curators' Focus: Turning in Context," Philip and Muriel Berman Museum of Art, Ursinus College, Collegeville, PA, and touring, 1997–99; "Spotlight '98," Annual Juried Exhibition of the American Craft Council Southeast Region, Gatlinburg, TN, 1998

PUBLICATIONS: Martha Stamm Connell, *Contemporary Works in Wood, Southern Style; Works off the Lathe;* Albert B. LeCoff, *Lathe-Turned Objects: An International Exhibition;* Eileen Silver, et al., *International Lathe-Turned Objects: Challenge IV; Out of the Woods: Turned Wood by American Craftsmen;* Albert B. LeCoff, *Challenge V: International Lathe-Turned Objects;* Michael W. Monroe, *The White House Collection of American Crafts;* Tran Turner, et al., *Expressions in Wood: Masterworks from The Wornick Collection;* Albert B. LeCoff, *Curators' Focus: Turning in Context; Skilled Work: American Craft in the Renwick Gallery*

DALE L. NISH

Provo, Utah

BORN: Cardston, Alberta, Canada, 1932

EDUCATION: B.S., M.S., Brigham Young University, UT, 1957, 1958; Ed.D., Washington State University, 1967

GRANTS/AWARDS/HONORS: Faculty Award of Excellence, College of Engineering Science and Technology, Brigham Young Univ., 1981; Lifetime Achievement Award, American Association of Woodturners, 1985; Outstanding Contributor Award of Woodturners, 1985; Honorary Lifetime Membership, American Association of Woodturners, 1992

SOLO EXHIBITION: "Woodturning '78," Harris Fine Arts Gallery, Brigham Young Univ., Provo, UT, 1978

GROUP EXHIBITIONS: "The Edward Jacobson Collection of American Turned-Wood Bowls," Arizona State Univ., Tempe, AZ, and touring, 1985; "Lathe-Turned Objects, An International Exhibition," Port of History Museum, Philadelphia, PA, 1988; "Turner's Challenge III," Craft Alliance 1989; "American Association of Woodturners," Presenters Gallery, Denton, TX, 1991; "Out of the Woods:

Turned Wood by American Craftsmen," Fine Arts Museum of the South, Mobile, AL, 1992, and touring Europe through 1997; "Turned Wood—Small Treasures," del Mano Gallery, Los Angeles, CA, 1997

PUBLICATIONS: Dale L. Nish, *Creative Woodturning;* Dale L. Nish, *Artistic Woodturning;* Dale L. Nish, "An Overview of the History of Fine Turned-Wood Bowls," *The Art of Turned-Wood Bowls;* Dale L. Nish, *Master Woodturners;* Richard Raffan, *Turned Bowl Design;* Albert B. LeCoff, *Lathe-Turned Objects: An International Exhibition; Out of the Woods: Turned Wood by American Craftsmen*

LIAM O'NEILL

Spiddal, Co. Galway, Ireland

BORN: Dublin, Ireland, 1949

GRANTS/AWARDS/HONORS: Dr. Muriel Grahan Development Grant Scholarship, sponsored by Irish American Cultural Institute at R.D.S. Competition, 1983; One Man Show in Royal Dublin Society Library at R.D.S. Competition, 1984; joint first prize in Turned Wood Section of R.D.S. Crafts Competition, 1985

SOLO EXHIBITIONS: R.D.S. Library, Dublin, Ireland, 1985; Grand Ave Gallery, St. Paul Minnesota, 1986

GROUP EXHIBITIONS: Worlds Crafts Council European Conference Exhibition, Dublin, Ireland, 1983; "European Crafts Exhibition," Tokyo and Osaka, Japan, 1986; "Lathe-Turned Objects, An International Exhibition," Port of History Museum, Philadelphia, PA, 1988; "QEII Series," del Mano Gallery, Los Angeles, CA, 1994

PUBLICATIONS: Albert B. LeCoff, *Lathe-Turned Objects: An International Exhibition; Enter the World of Lathe-Turned Objects*

RUDE OSOLNIK

Berea, Kentucky

BORN: Dawson, New Mexico, 1915

EDUCATION: B.F.A., Bradley University, Peoria, IL, 1937; M.F.A., Bradley University, Peoria, IL, 1950

GRANTS/AWARDS/HONORS: National Award for Contemporary Design, Lifetime Member, Southern Highland Handicraft Guild, Asheville, NC, 1950; Best Utilization of Waste Wood, Museum of Science & Industry, Chicago, IL, 1955; founder and lifetime member, Kentucky Guild of Artisans and Craftsmen, 1960; fellow, Kentucky Guild of Artisans and Craftsmen, 1986; Best of Show, PBS Juried Exhibition, Louisville, KY, 1992; Milner Award, Governor's Award for Lifetime Achievement, 1992; Juror's Honorary Award, "Transition '94," Louisville, KY, 1994; elected to American Craft Council College of Fellows, 1994

SOLO EXHIBITIONS: "Rude Osolnik: A Retrospective," Folk Art Center, Southern Highland Handicraft Guild, Asheville, NC, touring exhibition, 1989; "A Tribute to Rude Osolnik," TriArt Gallery, Louisville, KY, 1997

GROUP EXHIBITIONS: "The Art of the Turned Bowls," Renwick Gallery of the National Museum of American Art, Washington, DC, 1986; "Works off the Lathe: Old and New Faces," Craft Alliance Gallery, St. Louis, MO, 1987; "Lathe-Turned Objects, An International Exhibition," Port of History Museum, Philadelphia, PA, and touring, 1988; "Turner's Challenge III," Craft Alliance, 1989; "Contemporary Works in Wood, Southern Style," Huntsville Museum of Art, Huntsville, AL, 1990; "Collecting American Decorative Arts, 1971–91," Museum of Fine Arts, Boston, MA, 1991; "Out of the Wood: Turned Wood by American Craftsmen," The Fine Arts Museum of the South, Mobile, AL, 1992, and touring Europe through 1997; SOFA Show, Connell Gallery, Chicago, IL, 1996

PUBLICATIONS: Martha Stamm Connell, *Contemporary Works in Wood, Southern Style;*

Dale L. Nish, *Master Woodturners;* Albert B. LeCoff, *Lathe-Turned Objects;* Barbara Mayer, *Contemporary American Craft Art: A Collector's Guide;* Barbara Mayer, *Rude Osolnik: A Retrospective;* Jane Kessler, "Rude Osolnik: By Nature Defined," *American Craft;* Tom Carter, *A Way with Wood: Southern Style; Out of the Woods: Turned Wood by American Craftsmen;* Jane Kessler and Dick Burrows, *Rude Osolnik: A Life Turning Wood; Enter the World of Lathe-Turned Objects*

JIM B. PARTRIDGE

Oswestry, Shropshire, England

BORN: Leeds, England, 1953

EDUCATION: John Makepeace School for Craftsmen in Wood, 1977–79, Fellow in Wood, Alsager College of Higher Education, 1983–84

GRANTS/AWARDS/HONORS: Prize winner, Jugend Gestaltet, Exempla, Munich, Germany, 1981; prize winner, Worlds Craft Council International Exhibition, Bratislava, Czechoslovakia, 1986; first Craftsman-in-Residence, Grizedale, Cumbria, England, Northern Arts Council, 1986–87

SOLO EXHIBITIONS: "Jim Partridge: Woodworker," Crafts Council Gallery, London, England, 1989; "Jim Partridge, from Broaches to Bridges," Site Specific Gallery, Arundel, England, 1993; "Jim Partridge Woodworker," Ruthin Crafts Center, England, and touring, 1993–94

GROUP EXHIBITIONS: "Lathe-Turned Objects, An International Exhibition," Port of History Museum, Philadelphia, PA, and touring, 1988–92; "Turner's Challenge III," Craft Alliance, 1989; Crafts Council, "The Furnished Landscape," touring, 1992; Crafts Council, "Objects of Our Time," touring, 1996; "Expressions in Wood: Masterworks from The Wornick Collection," Oakland Museum of California, 1996, American Craft Museum, New York, NY, 1997–98; "Curators' Focus: Turning in Context," Philip and Muriel Museum of Art, Ursinus College, Collegeville, PA, and touring, 1997–99

PUBLICATIONS: Albert B. LeCoff, *Lathe-Turned Objects: An International Exhibition;* Tran Turner, et al., *Expressions in Wood: Masterworks from The Wornick Collection; Enter the World of Lathe-Turned Objects;* Albert B. LeCoff, *Curators' Focus: Turning in Context*

MICHAEL JAMES PETERSON

Lopez Island, Washington

BORN: Wichita Falls, Texas, 1952

EDUCATION: Association of Arts and Design, Edmonds Community College, WA, 1979

GRANTS/AWARDS/HONORS: Juror's Award, Whatcom Museum of History and Crafts Annual Northwest Art Competition, 1986; Juror's Award, Vessels and Forms Exhibit, Houston, TX, 1987

GROUP EXHIBITIONS: "The Art of Turned Bowls," Renwick Gallery of the National Museum of American Art, Smithsonian Institution, Washington, DC, 1986; "Lathe-Turned Objects, An International Exhibition," Port of History Museum, Philadelphia, PA, and touring 1988–92; "Challenge IV: International Lathe-Turned Objects," Port of History Museum, Philadelphia, PA, and touring, 1991; "Turner's Challenge III," Craft Alliance, 1989; "Out of the Woods: Turned Wood by American Craftsmen," The Fine Arts Museum of the South, Mobile, AL, 1992, and touring Europe through 1997; "Sculpture Objects Functional Art Exposition," Navy Pier, Chicago, IL, 1998; "Expressions in Wood: Masterworks from The Wornick Collection," Oakland Museum of California, 1996, American Craft Museum, New York, NY, and touring, 1997–98; "Moving Beyond Tradition: A Turned-Wood Invitational," The Arkansas Art Center Decorative Arts Museum, Little Rock, AR, 1997

PUBLICATIONS: Richard Raffan, "Turned Bowl Design," *Southwest Art Magazine*; Albert B. LeCoff, *Lathe-Turned Objects: An International Exhibition*; *Fine Woodworking Design Book Five*; Eileen Silver, et al., *International Lathe-Turned Objects: Challenge IV*; *Out of the Woods: Turned Wood by American Craftsmen*; Tran Turner, et al., *Expressions in Wood: Masterworks from The Wornick Collection*; Alan DuBois, *Moving Beyond Tradition: A Turned-Wood Invitational*

JAMES PRESTINI

BORN: Waterford, Connecticut, 1908
DIED: Berkeley, California, 1993
EDUCATION: Apprentice machinist, Trade School in Westerly, RI, 1922–24; B.S., Yale University, New Haven, CT, 1930; studied at the Institute of Design, Chicago, under László Moholy-Nagy
GRANTS/AWARDS/HONORS: Lifetime Membership Award, American Association of Woodturners, 1992
GROUP EXHIBITIONS: "Lathe-Turned Objects, An International Exhibition," Port of History Museum, Philadelphia, PA, and touring, 1988–92; Craft and Folk Art Museum, Los Angeles, CA, 1992
PUBLICATIONS: Albert B. LeCoff, *Lathe-Turned Objects: An International Exhibition*; "World Renown Turner James Prestini Dies," *Turning Points*; Michelle Holzapfel, "Aristocrat of Skills: James Prestini Remembered," *American Craft*; Iona Elliott, "Collectors' Items," *Woodturning Magazine*; *Skilled Work: American Craft in the Renwick Gallery*

HAP SAKWA

Baywood Park, California
BORN: Los Angeles, California, 1950
EDUCATION: University of Maryland, College Park, 1968–70
GROUP EXHIBITIONS: Cooper-Hewitt Museum, New York, NY, 1984; "The Art of Turned Bowls: The Edward Jacobson Collection," Arizona State Univ. Art Museum, Tempe, AZ, 1985; Renwick Gallery of the National Museum of American Art, Washington, DC, 1986; "Works off the Lathe: Old and New Faces," Craft Alliance Gallery, St. Louis, MO, 1987; "Lathe-Turned Objects, An International Exhibition," Port of History Museum, Philadelphia, PA, and touring, 1988–92; "Expressions in Wood: Masterworks from The Wornick Collection," Oakland Museum of California, 1996, American Craft Museum, New York, NY, 1997–98
PUBLICATIONS: "Portfolio," *American Craft*; *Works off the Lathe*; Albert B. LeCoff, *Lathe-Turned Objects: An International Exhibition*; Tran Turner, et al., *Expressions in Wood: Masterworks from The Wornick Collection*; *Enter the World of Lathe-Turned Objects*

MERRYLL SAYLAN

San Rafael, California
BORN: Bronx, New York, 1936
EDUCATION: B.A., University of California, Los Angeles, 1973; M.A., California State University, Northridge, 1979
GRANTS/AWARDS/HONORS: Merit Award, "A Gallery of Turned Objects," 1981; Certificate of Honor, "Women in Design International," 1982; Artist-in-Residence, Grizedale, Cumbria, England, Northern Arts Council, 1990
SOLO EXHIBITION: del Mano Gallery, Los Angeles, CA, 1988
GROUP EXHIBITIONS: "The Art of Wood Turning," American Craft Museum II, New York, NY, 1983; "Works off the Lathe: Old and New Faces," Craft Alliance Gallery, St. Louis, MO, 1987; "Lathe-Turned Objects, An International Exhibition," Port of History Museum, Philadelphia,

PA, and touring, 1988–92; "Turner's Challenge III," Craft Alliance, 1989; "Women in Wood," Banaker Gallery, San Francisco, CA, 1994, 1996; "Moving Beyond Tradition: A Turned-Wood Invitational," The Arkansas Art Center Decorative Arts Museum, Little Rock, AR, 1997; "Turned Wood Now: Redefining the Lathe-Turned Object IV," Arizona State Univ. Art Museum, Tempe, AZ, 1997–98; "Curators' Focus: Turning in Context," Philip and Muriel Berman Museum of Art, Ursinus College, Collegeville, PA, and touring, 1997–99; "Feature Exhibition," Joanne Rapp Gallery, Scottsdale, AZ; SOFA/NYC, 1998
PUBLICATIONS: *Fine Woodworking Design Book Two*; Paul J. Smith, *The Art of Wood Turning*; "Portfolio," *American Craft Magazine*; *Works off the Lathe*; *Enter the World of Lathe-Turned Objects*; Albert B. LeCoff, *Lathe-Turned Objects*; "Women Woodturners," *Woodturning Magazine*; Albert B. LeCoff, *Curators' Focus: Turning in Context*; John Perreault and Heather S. Lineberry, *Turned Wood Now: Redefining the Lathe-Turned Object IV*; Alan DuBois, *Moving Beyond Tradition: A Turned-Wood Invitational*

BETTY J. SCARPINO

Indianapolis, Indiana
BORN: Wenatchee, Washington, 1949
EDUCATION: B.S., University of Missouri, Columbia, 1981
GRANTS/AWARDS/HONORS: Honorable Mention, Candle Holder Design Award, American Association of Woodturners, 1988; Second Place Purchase Award, Forest Heritage and Education Center of the South, Annual Woodturning Show, Oklahoma, 1986; Best of Show, Woodturning, Cryderman Productions Wood Show, Ontario, Canada, 1991; Merit Award, Indiana Artist-Craftsmen, "Celebration: Year of the Crafts," Leah Ransburg Gallery, 1993
GROUP EXHIBITIONS: "Turning Plus," Arizona State Univ. Art Museum, Tempe, AZ, 1995; "Women in Wood," Banaker Gallery, San Francisco, CA, 1996; "Turned Wood: Small Treasures," del Mano Gallery, Los Angeles, CA, 1997; "Moving Beyond Tradition: A Turned-Wood Invitational," The Arkansas Art Center Decorative Arts Museum, Little Rock, AR, 1997; "Indiana Woods in Motion," The John Waldron Arts Center, Bloomington, IN, 1998
PUBLICATIONS: Judy Ditmer and Michelle Holzapfel, "Signatures in Wood," video documentary; *The Art of Woodworking: Woodturning*; Patrick Spielman, *The Art of the Lathe*; Alan DuBois, *Moving Beyond Tradition: A Turned-Wood Invitational*

MARK SFIRRI

New Hope, Pennsylvania
BORN: Chester, Pennsylvania, 1952
EDUCATION: B.F.A., Rhode Island School of Design, Providence, 1974; M.F.A., Rhode Island School of Design, Providence, 1978
GRANTS/AWARDS/HONORS: Pennsylvania Council on the Arts fellowship, 1987
GROUP EXHIBITIONS: "Works off the Lathe: Old and New Faces," Craft Alliance Gallery, St. Louis, MO, 1987; "Lathe-Turned Objects, An International Exhibition," Port of History Museum, Philadelphia, PA, and touring, 1988–92; "International Lathe-Turned Objects: Challenge IV," Port of History Museum, Philadelphia, PA, and touring, 1991; "Turning Plus," Arizona State Univ. Art Museum, Tempe, AZ, 1995; "ITE" (International Turning Exchange), Philip and Muriel Berman Museum of Art, Ursinus College, Collegeville, PA, 1996; "Curators' Focus: Turning in Context," Philip and Muriel Berman Museum of Art, Ursinus College, Collegeville, PA, and touring, 1997–99

PUBLICATIONS: Albert B. LeCoff, *Lathe-Turned Objects*; Eileen Silver, et al., *International Lathe-Turned Objects: Challenge IV*; Steve Loar, "The Mark and Mickey Show," *Woodturning Magazine*; "International Turning Exchange (ITE)," interview, *Turning Points*; *Growth Through Sharing*; Reg Sherwin, "Spotlight on Saskatchewan," *Woodturning Magazine*; Albert B. LeCoff, *Curators' Focus: Turning in Context*; *Enter the World of Lathe-Turned Objects*

MICHAEL SHULER

Santa Cruz, California
BORN: Trenton, New Jersey, 1950
GRANTS/AWARDS/HONORS: Merit Award, Houston Festival, Vessels & Forms Exhibition, 1987
GROUP EXHIBITIONS: "50th Anniversary Exhibition," Contemporary Crafts Gallery, Portland Oregon, 1987; "Works off the Lathe: Old and New Faces," Craft Alliance Gallery, St. Louis, MO, 1987; "Works off the Lathe: Old and New Faces," Crafts Alliance Gallery, St. Louis, MO, 1987; "Lathe-Turned Objects, An International Exhibition," Port of History Museum, Philadelphia, PA, and touring, 1988–92; "Turner's Challenge III," Craft Alliance, 1989; "Out of the Woods: Turned Wood by American Craftsmen," The Fine Arts Museum of the South, Mobile, AL, 1992, and touring Europe through 1997; "Challenge V: International Lathe-Turned Objects," Philip and Muriel Berman Museum, Ursinus College, Collegeville, PA, and touring, 1994–97; "The White House Collection of American Crafts," National Museum of American Art, Washington, DC, and touring, 1995; "Expressions in Wood: Masterworks from The Wornick Collection," Oakland Museum of California, 1996, American Craft Museum, New York, NY, 1997–98; "Curators' Focus: Turning in Context," Philip and Muriel Berman Museum of Art, Ursinus College, Collegeville, PA, and touring, 1997–99; "The Art of Craft: Contemporary Works from the Saxe Collection," Fine Arts Museum of San Francisco, 1999
PUBLICATIONS: *Works off the Lathe*; Albert B. LeCoff, *Lathe-Turned Objects*; "Monochrome Assembly," *The American Woodturner*; "Segmented Turning," *Fine Woodworking*; *Small Woodworking Projects: The Best of Fine Woodworking*; *Out of the Woods: Turned Wood by American Craftsmen*; Albert B. LeCoff, *Challenge V: International Lathe-Turned Objects*; *American Craft Magazine*, June/July 1994; Michael W. Monroe, *The White House Collection of American Crafts*; Tran Turner, et al., *Expressions in Wood: Masterworks from The Wornick Collection*; Albert B. LeCoff, *Curators' Focus: Turning in Context*; *Enter the World of Lathe-Turned Objects*; Timothy Anglin Burgard, *The Art of Craft: Contemporary Works from the Saxe Collection*

JACK R. SLENTZ

Little Rock, Arkansas
BORN: Oklahoma City, Oklahoma, 1963
EDUCATION: B.A., University of the Ozarks, Clarksville, AR, 1994; M.A., University of Arkansas, Little Rock, AR, 1996; M.F.A., University of Memphis, TN, 1998
GRANTS/AWARDS/HONORS: Outstanding Student Award, Kiwanis, Univ. of the Ozarks, 1990; Outstanding Senior Kiwanis, Univ. of Ozarks, 1994; Imogene Ragon Art Award Scholarship, Univ. of the Ozarks, 1994; Alpha Epsilon Lambda (Graduate Honorary Society), Univ. of Arkansas, 1996; Certificate of Merit, Service as Graduate Teaching Assistant, Univ. of Memphis, 1997; The Rude and Daphne Osolnik Woodturning Scholarship, Arrowmont School of Craft and Design, 1997; Certificate of Merit, Service as

Graduate Teaching Assistant, Univ. of Memphis, 1998; Chairman's Outstanding Initiative Award, Univ. of Memphis, 1998

SOLO EXHIBITIONS: "Master Thesis Show," Univ. of Arkansas, Little Rock, AR, 1996; Todd Crockett Gallery, Little Rock, AR, 1996; Univ. of Ozarks, Clarksville, AR, 1997; Southern Arkansas Univ., Magnolia, AR, 1997; Arkansas River Valley Art Center, Russellville, AR, 1998; del Mano Gallery, Los Angeles, CA, 1998

GROUP EXHIBITION: "14th Annual Delta Exhibition," Arkansas Arts Center, Little Rock, AR, 1997

PUBLICATIONS: "Six of the Best to Turn in America," *Woodturning Magazine*; The Arkansas Art Center Decorative Arts Museum, *Regional Craft Biennial*; Leslie N. Peacock, "The Strong, Silent Type," *Arkansas Times*; Ray Lier, Jay Peters, and Kevin Wallace, *Contemporary Turned Wood: New Perspectives in a Rich Tradition*

ALAN STIRT
Enosburg Falls, Vermont
BORN: Brooklyn, New York, 1946
EDUCATION: B.S., Harper College, State University of New York, NY
GRANTS/AWARDS/HONORS: Lifetime Membership in the American Association of Woodturners, 1997
GROUP EXHIBITIONS: "The Art of Turned Wood Bowls," Renwick Gallery of the National Museum of American Art, Washington, DC, and touring, 1986; "Works off the Lathe: Old and New Faces," Craft Alliance Gallery, St. Louis, MO, 1987; "Lathe-Turned Objects, An International Exhibition," Port of History Museum, Philadelphia PA, and touring, 1988–92; "Turner's Challenge III," Craft Alliance, 1989; "International Lathe-Turned Objects: Challenge IV," Port of History Museum, Philadelphia, PA, and touring, 1991; "A Decade of Craft: Recent Acquisitions," American Craft Museum, New York, NY, 1992; "Out of the Woods: Turned Wood by American Craftsmen," The Fine Arts Museum of the South, Mobile, AL, 1992, and touring Europe through 1997; "Challenge V: International Lathe-Turned Objects," Philip and Muriel Berman Museum of Art, Ursinus College, Collegeville, PA, 1994; "The White House Collection of American Crafts," National Museum of American Art, Washington, DC, and touring, 1995; "Curators' Focus: Turning in Context," Philip and Muriel Berman Museum of Art, Ursinus College, Collegeville, PA, and touring, 1997–99; "Moving Beyond Tradition: A Turned-Wood Invitational," The Arkansas Art Center Decorative Arts Museum, Little Rock, AR, 1997
PUBLICATIONS: Dale L. Nish, *Master Woodturners*; Edward Jacobson, *The Art of Turned Wood Bowls*; *Works off the Lathe*; Albert B. LeCoff, *Lathe-Turned Objects*; Eileen Silver, et al., *International Lathe-Turned Objects: Challenge IV*; *Out of the Woods: Turned Wood by American Craftsmen*; Albert B. LeCoff, *Challenge V: International Lathe-Turned Objects*; Lloyd E. Herman and Matthew Kangas, *Tales and Traditions: Storytelling in Twentieth-Century American Craft*; Michael W. Monroe, *The White House Collection of American Crafts*; Alan DuBois, *Moving Beyond Tradition: a Turned-Wood Invitational*; Patrick Spielman, *The Art of the Lathe*; *Enter the World of Lathe-Turned Objects*; Albert B. LeCoff, *Curators' Focus: Turning in Context*

BOB STOCKSDALE
Berkeley, California
BORN: Warren, Indiana, 1913
GRANTS/AWARDS/HONORS: Fellow, American Craft Council, 1978; California Living Treasures, 1985; Gold Medal, American Craft Council, 1995
SOLO EXHIBITIONS: "Bob Stocksdale: Wood Turnings," Museum of Contemporary Crafts, New York, NY, 1965; "Bob Stocksdale," Newark Museum, Newark, N.J., 1992; "Bob Stocksdale," Oakland Museum of California, Oakland, CA, 1993
GROUP EXHIBITIONS: "The Art of Wood Turning," American Craft Museum II, New York, NY, 1983; "Works off the Lathe: Old and New Faces," Craft Alliance Gallery, St. Louis, MO, 1987; "Lathe-Turned Objects, An International Exhibition," Port of History Museum, Philadelphia, PA, and touring, 1988–92; "Turner's Challenge III," Craft Alliance, 1989; "Out of the Woods: Turned Wood by American Craftsmen," Fine Arts Museum of the South, Mobile, AL, 1992, and touring Europe through 1997; "Revolving Techniques: Clay, Glass, Metal, Wood," James A. Michener Art Museum, Doylestown, PA, 1992; "Contemporary Crafts and the Saxe Collection," The Toledo Museum of Art, 1993; "Marriage in Form: Kay Sekimachi and Bob Stocksdale," Palo Alto Cultural Center, Palo Alto, CA, and touring, 1993–96; "Expressions in Wood: Masterworks from The Wornick Collection," Oakland Museum of California, 1996, American Craft Museum, New York, NY, 1997–98; "Studio Craft Movement 1945–65," American Craft Museum, New York, NY, 1997–98; "The Art of Craft: Contemporary Works from the Saxe Collection," Fine Arts Museums of San Francisco, 1999
PUBLICATIONS: *Wood Turnings by Bob Stocksdale*; Lee Nordness, *Objects: USA*; Paul J. Smith, *The Art of Wood Turning*; Michael A. Stone, *Contemporary American Woodworkers*; *Works off the Lathe*; Albert B. LeCoff, *Lathe-Turned Objects*; Robert Bruce Duncan, "Bob Stocksdale: Still on a Roll at 75," *Woodwork*; U.S. Information Agency, *Three American Master Craftsmen: Rude Osolnik, Ed Moulthrop, and Bob Stocksdale*, video; David McAlpine, "More than Meets the Eye in Stocksdale's Simple Turnings," *Woodshop News*; *Out of the Woods: Turned Wood by American Craftsmen*; Davira S. Taragin, *Contemporary Crafts and the Saxe Collection*; Merryll Saylan, "Bob Stocksdale, Profiled Woodturning," *Journal of the Guild of Master Craftsmen*; *Enter the World of Lathe-Turned Objects*; Tran Turner, et al., *Expressions in Wood: Masterworks from The Wornick Collection*; Timothy Anglin Burgard, *The Art of Craft: Contemporary Works from the Saxe Collection*

MARIA VAN KESTEREN
Hilversum, The Netherlands
BORN: Leyden, The Netherlands, 1933
SOLO EXHIBITIONS: Garth Clark Gallery, Los Angeles, CA, 1990; "Retrospective from 1960," Stedelijk Museum, Amsterdam, The Netherlands, 1996; Singer Museum, Leerdam, The Netherlands, 1997
GROUP EXHIBITIONS: "Lathe-Turned Objects, An International Exhibition," Port of History Museum, Philadelphia, PA, and touring, 1988–92; "Lathe-Turned Objects Defined III: Functional and Sculptural," Philadelphia, PA, 1992; "Made in Holland: Design aus den Niederlanden," Museum für Angewandte Kunst, Köln, Germany; "Aspects of European Design," Louisiana Museum of Modern Art, Copenhagen, Denmark, 1996; Nationaal Glasmuseum, Leerdam, The Netherlands, 1996; Presentation for "25 Years Amsterdam Fund for Art," Amersfoort, The Netherlands, 1997; "Curators' Focus: Turning in Context," Philip and Muriel Berman Museum of Art, Ursinus College, Collegeville, PA, and touring, 1997–99
PUBLICATIONS: Albert B. LeCoff, *Lathe-Turned Objects: An International Exhibition*; Martina Margetts, *International Crafts*; Connie Mississippi, "Translation Turning," *Turning Points*; Steve Loar, "Reflections on the Work of Maria van Kesteren," *Turning Points*; Otto Koedik, "Dutch Master," *Woodturning Magazine*; *Enter the World of Lathe-Turned Objects*

HANS WEISSFLÖG
Hildesheim, Germany
BORN: Hoennersum, Germany, 1954
EDUCATION: Mechanical Engineer, 1976; Graduated Designer, 1982
GRANTS/AWARDS/HONORS: Federal State Reward for Creative Trade in Niedersachsen, 1993
GROUP EXHIBITIONS: "Challenge IV: International Lathe-Turned Objects," Port of History Museum, Philadelphia, PA, and touring, 1991–92; "Revolving Techniques: Clay, Glass, Metal, Wood," James A. Michener Art Museum, Doylestown, PA, 1992; "Challenge V: International Lathe-Turned Objects," Philip and Muriel Berman Museum of Art, Ursinus College, Collegeville, PA, and touring, 1994–97; "Curators' Focus: Turning in Context," Philip and Muriel Berman Museum of Art, Ursinus College, Collegeville, PA, and touring, 1997–99; "Expressions in Wood: Masterworks from The Wornick Collection," Oakland Museum of California, 1996, American Craft Museum, New York, NY, 1997–98; "Sculpture Objects Functional Art Exposition," 7th Regiment Armory, New York, NY, 1999; "The Art of Craft: Contemporary Works from the Saxe Collection," Fine Arts Museums of San Francisco, 1999
PUBLICATIONS: Eileen Silver, et al., *International Lathe-Turned Objects: Challenge IV*; Albert B. LeCoff, *Challenge V: International Lathe-Turned Objects*; Albert B. LeCoff, *Curators' Focus: Turning in Context*; *Enter the World of Lathe-Turned Objects*; Timothy Anglin Burgard, *The Art of Craft: Contemporary Works from the Saxe Collection*

Index

Page numbers in *italics* refer to illustrations.

Photograph Credits

All color photographs by Bruce Miller except pages
108, 115: David Ramsey

Black-and-white illustrations
Page 16: courtesy Nationalmuseet, Copenhagen;
17: courtesy New York Public Library, Map
Division; 18: Eric E. Miller; 19: Joseph Szaszfai;
23: © Sarah Wells; 24: D. James Dee; 25: ©
Andreas Feininger; 27: Courtesy McKee Gallery,
New York; 29: © Asian Art Museum of San
Francisco; 30, above: courtesy National
Aeronautical Space Archives; 30, below: John
Carlano